CREATING EXHIBITIONS

Collaboration in the Planning, Development, and Design of Innovative Experiences

Polly McKenna-Cress | Janet A. Kamien

WILEY

Library of Congress Cataloging-in-Publication Data:
McKenna-Cress, Polly.
Creating exhibitions: collaboration in the planning, development, and design of innovative experiences/ Polly McKenna-Cress, Janet A. Kamien.
pages cm
Includes index.
ISBN 978-1-118-30634-5 (pbk.); 978-1-118-41994-6 (ebk); 978-1-118-42167-3 (ebk)
1. Museum exhibits. 2. Museum exhibits--Planning. 3. Museums--Management. I. Kamien, Janet. II. Title.
AM151.M42 2013
069'.5—dc23
2013004578

Printed in the United States of America

10 9 8 7 6 5 4 3 2 1

CONTENTS

To my mentors and friends; Mike Spock, Elaine Gurian, and George Hein, my dearest friends Jeff, Paul, Polly, Sing, Kathryn, Leslie, and eLbow . . . and of course my partner, mentor and love Anibal.

—Janet

To my immediate and extended family, both personally and professionally, without whose patience and continued support we would not have been able to accomplish this feat. I love you Isabelle, Sabine, and Henry . . . and my true and dearest love Richard.

Also and forever to my mentor, confidant, girlfriend, and hero . . . Janet . . . I love you and will miss you everyday.

—Polly

"Two dyslexics walk into a museum . . . one turns to the left and the other turns to the left . . . and they find a meaningful relationship."

—Janet & Polly

ACKNOWLEDGMENTS

There are too many people to thank who helped enormously in this venture. To start at the beginning, however, we are indebted to Alina Wheeler without whom this book would not have come into existence. Her professional and personal support all the way through the process gave us the conviction to keep going "because the field needs this book."

Special thanks to our diverse group of contributors who possess depth of experience and knowledge; you were crucial in enriching this book. Leslie Bedford, Lath Carlson, Richard Cress, Jeff Hayward, Lauren Helpern, Erika Kiessner, Traci Klainer Polimeni, Donna Lawrence, Richard Lewis, Paul Martin, Rachel McGarry, Dottie Miles Hemba, Jessica Neuwirth, Diane Perlov, Dana Schloss, Leslie Swartz, Charlie Walter, Shari Rosenstein Werb, and Katherine Ziff.

To the Wiley Hoboken team: launched and lead by Margaret Cummins, with Penny Makras, Mike New, Lauren Poplawski, and Doug Salvemini.

Extra thanks and love to all the amazing people who formed Team Janet: Anibal Cicardi, Aldo & Dario Cicardi, Leslie Bedford, Tatiana Falcon, Sing Hanson, Tom Harris, Jeff Hayward, Elaine Heumann Gurian, Kathryn Hill, Paul Martin, Pam Parkhurst, Michael Spock, and Leslie Swartz. Particularly Jeff Hayward and Leslie Swartz who in the darkest periods helped support the efforts to keep the book on track and to the publisher, your generosity, both intellectual and emotional, is what helped guide this book to completion. Particularly Paul Martin whose professional and personal friendship over the years has been so critical . . . you are a rock star!

Mark Dahlager and Anne Butterfield for reading the whole dang thing . . .more than once. David Kahn and Carole Charnow our quintessential Institutional Advocates who read early chapters and gave important feedback.

Alusiv, Inc. crew: Amy Hughart for giving editing support; Becky Boone for refining the design; and Richard, of course, who spent countless hours ensuring the book was professionally refined and designed.

Those professors, colleagues, and friends who covered for me while on sabbatical and offer important intellectual and moral support over the years: Keith Ragone, Dottie Miles Hemba, Aaron Goldblatt, and Lauren Duguid.

All the UArts Museum Studies students from 1990-today but particularly those who were with me on this wild ride of writing this ultimate thesis: MEPD Class of 2011: Amy, Christine, Jamie, Kelly, Kim, Maggie, Rebecca, Sarah C, Sarah (SAS), and Zach. MEPD Class of 2012: Karl, Rayna, Isabelle, Bin, Tamera, Megan, Liz, Anita, Megan, Dan, Nini, and Cat. MEPD Class of 2013: Layla, Daria, Maya, Meghann, Dan, Jihea, Jordan, Moaza, Brittany, and Renee. MEPD Class of 2014: Louise, Leah, Erin, Ksenia, Ashley, Noah, Xander, Skye, Ariel, and Breanna. Specifically the two students, now professionals, who helped us visualize the book: Isabelle Hayward and Meghann Hickson.

Kate Quinn and Craig Bruns for providing images, thoughtful input, as well as your unwavering support when things were darkest. Your words meant more than you know. Jeff Hoke and the Museum of Lost Wonder, Steve Feldman, Kathy McLean, Andy Merriell, Jim Roe, and Jim Volkert for active discussions over the years, reading chapters and giving essential feedback.

The CLR Design crew of Gary Lee, Jon Stefansson for giving open access, Nancy Worby for sorting and scanning images, John R Collins, Jr. for his incredible skill and talent, and Jon Coe for sketches, master planning, and for being an early and important mentor.

Michael John Gorman for his interview time and all the inspiring innovative collaborative work Science Gallery achieves. Lyn Wood and Kathy Gustafson-Hilton from Hands On! For sketches and illustrations plus creating great work.

The University of the Arts support: Sean Buffington, Kirk Pillow, Christopher Sharrock, and Jim Savoie particularly Dean Steve Tarantal for believing in me and supporting my sabbatical, and to Regina Barthmaier, Neil Kleinman, and Laura Hargreaves for their encouragement.

Mira Zergani for reading and being a great friend both professionally and personally. David Ucko for sitting all day in the early incubation stages asking solid and tough questions to reveal the soft spots. Jane and Ed Bedno for different conceptual foundations of this book but also for bringing Janet and me together.

To the many colleagues who contributed thoughts, provocations, writing, and images: Minda Borun, Anne El-Omami, Robert Garfinkle, Viv Golding, Victoria Jones, Sean Kelley, Jeanne Maier, Janet Marstine, Gerry Palumbo, Diane Perlov, Barbara Punt, Judy Rand, Jeff Rudolf, Helen Shannon, Steve Snyder, Leslie Stein, Beverly Serrell, Dan Spock, Doug Simpson, Beth Twiss-Houting, Robert Vosberg, and David Young.

American Alliance of Museums (AAM) for being such a strong advocate for the work we all do. National Association for Museum Exhibitors (NAME) for great journals, colleagues, conversations, and for recognizing Janet with its first Lifetime Achievement Award for all she did for the field. The Museum Group (TMG) who have been key leaders in moving our field forward as well as being indispensable colleagues. Science Museum Exhibit Collaborative (SMEC) a number of contributors and examples for this book came from this nationwide collaborative of innovative science museum professionals; thank you for being so smart and dedicated.

To my talented designer, photographer, thorough editor, and husband Richard who worked so hard to ensure this book was well conceived and designed with cohesive photographic examples of what our narrative expresses. My three wonderful and patient children, Isabelle, Sabine, and Henry who let me follow my dream to develop and write this book . . . I am forever grateful. To my whole family parents, brothers, sisters-in-law, nieces, and nephews for being supportive through my frustrations and celebrations.

To Janet's family: Her loving and passionate husband, Anibal Cicardi, who patiently supported Janet's museum obsession. Her stepsons, Aldo & Dario Cicardi, who brought her great pride and deep love. And to Tatiana Falcon, who was at her side through the toughest times.

Janet mixed her personal and professional friends and families together with the warmth and humanity she brought to her work. We are all one world—her world—in which we became better professionals and people. A mix of personal and professional thanks: Andrew Anway, Tamara Biggs, Carol Bossert, Susan Bruce Porter, Debbie Gonzalez Canada, Lynn Dierking, Richard Duggan, John Falk, Joseph Gonzales, Geoffrey Grove, Joe Gurian, Carl Hanson, George Hein, Aylette Jenness, Dorothy Merrill, Lori Mitchell, Phyllis Rabineau, Pat Steuert, Eve Wachhaus, and Lin Witte.

Janet is not here to write her gratitude so I ask forgiveness of those who were missed and should be recognized. Please know we are forever grateful for all you did and do.

And the most important acknowledgment . . . to Janet for all the mentoring, push back, compassion, stubbornness, and deep friendship you showed so many people.

The two years we spent on this book were among one of the most remarkable gifts that I have ever been given.

FOREWORD

When I was first asked to write the foreword to this book, I was flattered but skeptical. Having only just become the leader of Boston Children's Museum, I knew there had to be many museum directors more qualified than I to introduce this important work. But, as soon as I read the first chapter I understood their reasoning; for, as a newcomer to the complex and challenging art of creating museum exhibits, I found that *Creating Exhibitions* opened my eyes to a world of understanding and knowledge, offering many new concepts and ideas, and some that were surprisingly familiar.

As a producer of opera and theater, in *Creating Exhibitions*, I recognized the parallel process of production. We first decide upon an opera or play to produce, which is similar to the exhibition content or subject matter. The book then describes the advocacy positions of the creative team, each of which has a direct counterpart in operatic production: the project advocate assembles the team (the opera producer); the curator advocates for the subject matter (as does the conductor); the exhibit developer/educator advocates for the visitor/audience (just like the opera director); and both exhibits and operatic production employ designers and production managers. Both projects proceed in a similar way, navigating the turbulent shoals of creative collaboration. Being the Institutional Advocate for the theater and now for a museum, this text assured me of roles I knew well, but also opened up new clarity on the particulars of this interactive and participatory field. The heading, "No One Said Collaboration Was Easy" rang true

as I know that guiding a team through a collective creative process can be exhausting. But, as McKenna-Cress and Kamien assert, it is worth the effort and can push the limits of imagination, innovation, and engagement.

In its nine chapters, *Creating Exhibitions* provides an essential guide to exhibit development and design. Its practical open-ended style of offering considerations vs. rules takes the novice and the experienced professional through exhibit planning from inception to post-opening; starting with the collaborative process, working through the all-important visitor experience, to design, budgets, fabrication, and evaluation. The open-ended quality allows teams the flexibility to create their own process and practice. Each chapter is beautifully illustrated and includes an invaluable collection of case studies that serve to focus and inspire. This is a book written by experts in their craft and thoughtful teachers who draw us into the mind of the visitor, urging us to connect with our passion and love of the subject matter so that we can create an experience that is educational but also emotionally engaging and deeply relevant.

For museum directors/institutional advocates every day is show time and *Creating Exhibitions* will help anyone who is seeking to stage the most thrilling, transformative, and engaging exhibitions for its audience. For newcomers and veterans alike, this book offers fresh inspiration and guidance from two legendary leaders in the field.

Carole Charnow
President and CEO
Boston Children's Museum

INTRODUCTION

Whatever worthiness a museum may ultimately have derives from what it does, not from what it is. —Stephen E. Weil[1]

Beyond information, values, and experience, what else of social utility might museums provide to their public? Let me suggest two: stimulation and empowerment. Here we approach the museum visit not as an end in itself but as the starting point, rather, for a process intended to continue long after the visitor has left the museum's premises. —Stephen E. Weil[2]

Museums are at a precipice facing a future that is unknown. It is no longer reasonable to rely solely on an old foundation that has been around since the first human placed an object on a pedestal for others to admire. It is no longer "enough" to simply keep and display things for a casual observer. Like libraries, over time the museum mission has shifted from a function of collecting and preserving to one of education, and now to one of relevancy, advocacy, and social responsibility.

The first seismic shifts in the modern museum landscape turned attentions from object to observer, with exhibitions' purpose "not only being *about* some*thing* but *for* some*one*." More recent shifts have turned visitor into collaborator. A number of museum professionals not only have embraced these shifts but also are the provocateurs that had pushed such issues from the start. These risk-takers have helped reshape many museums and heritage sites from static organizations into dynamic, inclusive, and relevant institutions. But museums can do more, can be more.

[1] www.lukeweil.com/_pages/stevePage.html

[2] *Rethinking the Museum,* 1990

Far better is it to dare mighty things, to win glorious triumphs, even though checkered by failure . . . than to rank with those poor spirits who neither enjoy nor suffer much, because they live in a gray twilight that knows not victory nor defeat.

—Theodore Roosevelt

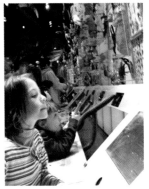

Figure I.1: Young awe-struck visitors are bristling with questions about what they see. Many museums want to better understand those questions. This shifts the museum's stance from "what we want to tell you" to a new dynamic "what do you want to know?" as the basis of developing exhibitions. *Photo courtesy of Richard Cress*

How dramatically have these conditions changed the museum mission and how we achieve it?

The interconnected collaboration inherent in any exhibition initiative is complex, and many institutions have not adequately analyzed or assessed *how* and with *whom* they have engaged the creation of their exhibitions. Rather, focus has remained more on the end product, which may be lovely but is not always achieving all that is possible through this medium. If the plan is to display material culture in a beautiful setting, that is one step. However, the field, funders, community, and society have set higher expectations that public institutions must address.

Those expectations point right back to the questions of *how* and by *whom* the exhibitions are created, not only in terms of skillful execution, but also in terms of the full tactical process of assessing and creating. The authors, with many decades between them working with all forms of institutions and firms in the profession and students studying the field, have found the most important needs are to understand an underlying process, to be perpetually pursuing interesting ways to engage meaningful teamwork and to ensure that visitors are at the center of all decisions. That is the purpose of this book. Our efforts exhibit for you the collaborative processes needed for developing and designing exhibitions of any kind, addressing interesting approaches in the field, and allaying possible fear of failure that can come with new or complex practices.

Here is where fear comes into play—fear of change, of offending someone, of not knowing what to do, and, of course, of failure and loss of credibility. This book was developed to allay these fears. In these nine chapters, we outline approaches to best utilize existing resources, both staff and money, to create visitor-engaged, forward-thinking exhibitions (Figures I.1 and I.2). That being said, this book is not a step-by-step "how to" manual. We do not proscribe singular techniques. We have been deliberately suggestive, collecting for you a guide to best practices and various considerations that can be taken into account when creating exhibitions. In some instances, we may say "you must pay attention to this," but mostly these are possible directions, reminders, and guides.

WHY DID WE WRITE THIS BOOK?

Because innovation, relevancy and ultimately survival is important for our field! With the need for museums to evolve as the world evolves, and at what seems to be an increasingly more rapid pace, viable twenty-first-century institutions must understand *who*, *what*, and *how* they are *advocating* for and the critical role that *collaboration* plays in achieving those goals.

There are few resources that students and professionals can turn to when they need information or confirmation about certain types of museum practice. Yes, there are design books, and yes, there are process books, but ironically there is no collection of information that can help all members of an exhibition team understand each other's issues and organize their work in a collaborative fashion. This book is a reference tool for students, museum professionals, and museum stakeholders (boards, funders, community members) who want to be better informed about the practices to put together new and imaginative teams and processes to move their institutions, exhibitions, and programs forward.

We also wanted to ensure this book expressed a balance of theory and new thinking, yet always was grounded in practice and effective application of the thinking. Plus, there are so few museum-oriented books that tackle practice that we wanted this book to help build the canon for the ever-growing museum studies programs.

We hope readers will use this book to better understand their own work, to question how these ideas could be adopted and adapted for their own teams and institutions, to rethink the roles of team members and learn to become better collaborators, to realize new applications for skills and helpful techniques, to employ the design and development processes, or just simply to be reminded of a few tidbits of useful information. Most importantly, we hope you will be inspired by the thoughts collected in these pages.

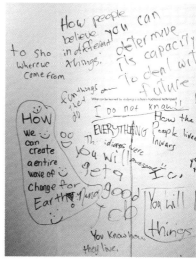

Figure I.2: Beyond basic display, how do we involve visitors in the conversation? This panel is from *Imagine Africa* an exhibition prototype installed by University of Pennsylvania Museum of Archeology and Anthropology. The exhibits pose questions to the audience about what they might want to know about the objects in the collection. The question, *What can be learned by studying a culture's traditional techniques?* sparked such answers as "You can determine its capability to deal with the future," "How people believe in different things," and "To show where we come from." With this information the museum will reinstall the collection based on the community's curiosity. *Photo courtesy of Polly McKenna-Cress*

OUR PROCESS

Writing this book was very much like the experience of making an exhibition:

First, we found ourselves to be like some of the subject matter specialists we speak of in the following pages—too close to our material. How will we strike the right note between too much basic information and not enough? Where are the starting points for people? What will interest them? Well, we approached this collaboratively. We engaged professionals in the field to contribute on best practice topics and critique the book's various iterations. Our contributors and "test group" of readers are composed primarily of people who have as much or more experience as we do. Additionally, we benefit from the gift of teaching graduate students and of working with a variety of clients in the field; both perspectives provided valuable insights.

Second, was maintaining all levels of organization. No matter how we looked at it, this subject was complex. We needed to find a way for readers in all manner of museum positions to recognize themselves in descriptions of roles within a team, job titles within an institution, or activities within phases of the work, but most importantly to have an immediate resource that might help solve an immediate problem. From the top down, we needed to define terms and contextualize the many facets of this field about which we are so passionate. For us, "exhibition" refers to the totality of content, context, and physicality (including the media, programming, and collateral materials) that work within the space and extend the experience beyond the walls. Therefore, an exhibition is a fully realized experience from the imprint of the external marketing to the tangible interactions the visitors have in the space to the intellectual impact that sparks lasting impressions (Figure I.3). Thumb through these pages when at you are at wits end (or maybe before), and we think you will find at least a small nugget to help you.

Finally, we sought to define and describe the process and phases of exhibition creation. Some of our most experienced readers worried that this whole process, if couched solely in the familiar steps of the architectural field (concept, schematic, design/development, and construction documentation), would be a formula for killing creativity akin to

"teaching to the test." In the end, we felt that professionals in this field do need some kind of framework that can address complex needs, but we have gone further to describe it (repeatedly) as a *flexible* framework that *the exhibition team molds to the particular needs of the project.* The bonus is that this process framework maintains language that is used widely in the field and understood by many people.

BOOK STRUCTURE

We have written an expanded table of contents to clearly delineate what each chapter covers. We have structured our content through thought and action— beginning with our philosophical underpinning that collaboration and advocacy positions are an important way to think about team structure and roles, and balancing this with practical analysis of specific skills and methods of the field, how those with advocacy positions might go about their work, an annotated discussion of process and phases, and a visual map of the overall process.

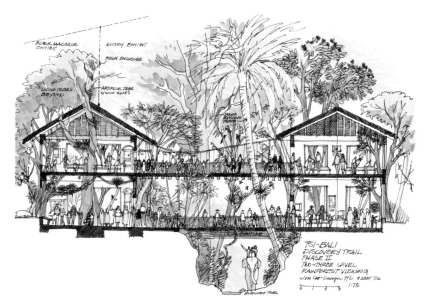

Figure I.3: Exhibitions should be considered from many different vantage points—Who is the audience? What will be the full experience? Why should anyone come? Conceptual sketch of live animal habitats and viewing/interpretation areas. *Illustration by Jon Coe, John Coe Designs, Pty Ltd. Victoria, Australia.*

Our chapters ask three critical questions for readers' consideration as they seek to apply some of this thinking to their process. These questions are somewhat rhetorical; the answers will be conditional to readers' individual issues, and of course the investigation and inquiry are part of the process. Each chapter also sets up approaches and philosophies, which in our expert view, provides guidance for how readers might best approach the particular advocacy or process being presented.

Chapters are peppered with action steps, dangers, and potential pitfalls to look for, as well as examples and case studies demonstrating the application of the approaches and philosophies discussed. As a design-oriented book, it has substantial references to design process and problem solving. The examples, anecdotes, and other professional contributions are included to give readers additional perspectives from which to critically analyze the approaches outlined. There are additional resources and bibliographies at the end of chapters with specific references for further reading.

WHAT THIS BOOK WON'T DO FOR YOU

It won't make you a creative genius. If we can address some of the mundane, yet thorny, issues of exhibit-making and collaborative teamwork, it will free you creatively—and you will at least have a better time doing your work!

It does not have proscriptions for the best way to work in your particular circumstance. Some readers looking for a silver bullet solution will consider this bad news. But we are all different; each of our organizations is different, and each exhibition is different. While there are general rules of thumb and tried-and-true methods for various aspects of this work to share, there is no single right way to do anything. What works well in one situation may be a poor choice in another.

The good news is that this book has collected, analyzed, discussed, and presented you with a tool that you can make your own. Readers new to the creation of exhibition might read the whole thing. More experienced readers might start with your team role and learn how other roles are engaged in this collaborative process. If you are in the middle of an exhibition process, confused about something or feeling stuck, you

might thumb through for a bit of specific advice. With your colleagues and a modicum of goodwill and common sense, you can use this tool to design and implement creative exhibitions that serve both you and your audiences well.

In the end, our conclusion about the exhibition work we all do is that it's best done collaboratively. We think this work is more like making a movie or mounting a stage play than delivering a monologue. It takes many different kinds of expertise, and no one is expert at all of the parts and pieces. We must rely on and trust one another in order to get it done well.

WHO WE ARE

Polly McKenna-Cress and Janet Kamien have been making exhibitions for many decades and in a variety of professional circumstances. They are passionate about the museum field and understand the frustrations and the joys of doing this work. They have learned a lot from each other, their own mentors, the many colleagues they have engaged here and abroad, and the inspirational students in the Museum Studies programs at the University of the Arts in Philadelphia.

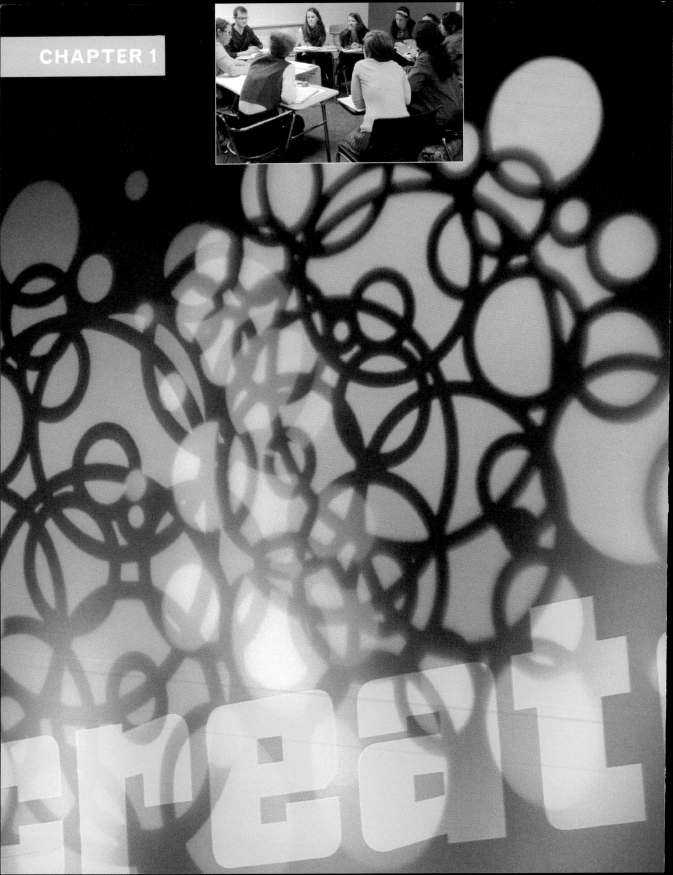

CHAPTER 1

COLLABORATION

Teamwork is the ability to work together toward a common vision, the ability to direct individual accomplishments toward organizational objectives. It is the fuel that allows common people to attain uncommon results.

—Andrew Carnegie

Collaboration is not a naturally occurring instinct. For most people it is learned behavior. Studies are revealing that societies are actually beginning to evolve to become better collaborators, and the notion of survival of the fittest may be shifting. So why do we need to engage in this practice? As we move further into the twenty-first century, recognizing the continued need to advance from relying on a single decision maker to a more democratized approach is becoming the standard by which most organizations are run. To prepare the next generation of professionals and citizens, schools are placing emphasis on their students being able to collaborate, to work with others in a creative, innovative, and flexible environment. The twenty-first-century skill set must include critical thinking, communication, creative problem solving, and collaboration. We see this need emerging not only in the field of education but also in any field where a complex narrative is being crafted—whether film, theater, or gaming or for the more institutional narratives of mission and vision for corporations and big business. Museums have also taken up the collaboration charge, from how institutions are run to how exhibitions are developed, taking advantage of contributions from multiple sources to shape rich exhibitions for visitors. .

Large photo: Liberty Science Center, Jersey City, NJ. Photo courtesy of Richard Cress.
Inset photo: Collaborative group. Photo courtesy of Polly McKenna-Cress

COLLABORATION UNPACKED

Collaboration, as defined in this book, is the intersection of thoughts and ideas from varying points of view to create multifaceted narratives and diverse experiences for a public audience.

What collaboration does not mean is "design by committee" or "groupthink." Strong points of view of varied individuals provide opportunities to assess, engage, agree or disagree, in order to make significant contributions to the depth of discussion and strength of final outcomes. For the museum, the collaborative group includes the exhibition team and institutional staff as well as outside stakeholders, experts, and funders. It also must include visitors, as they are the customers or end users of the museum "product" (Figure 1.1).

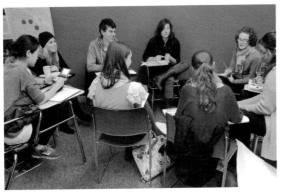

Figure 1.1: Strong points of view of varied individuals provide opportunities to assess, engage, and strengthen outcomes. *Photo courtesy of Polly McKenna-Cress*

What Is Collaboration?

collaboration | kəˌlabəˈrā·sh·ən | *noun*

1 the action of working with someone to produce or create something

The *Oxford Electronic Dictionary*'s general definition is couched in the basic singular sense—one person working with another person. However, although an individual may have unique ideas for conveying a particular subject, new and innovative thinking will remain unrealized unless there are opportunities to shape ideas by involving others. The essence of collaboration means different parties are sharing information and developing ideas to produce *something*. This book deals with the larger, more elaborate collaborations in the creation of museum exhibitions, involving multiple individuals, groups, and/or multiple institutions that have a shared goal to create rich experiences meeting many requirements. The potential for greatness is significant, and it's important to understand that the opportunities of collaborative groups are broader and deeper than any one individual could achieve.

Collaboration in its fullest sense is the intersection of different ideas from different points of view to create multifaceted and "new" thinking.

No One Said Collaboration Was Easy

Collaboration can be a difficult, exhausting, and time-consuming experience. At times it seems that only an imminent crisis with lives on the line can motivate a group to work together; it appears that motivation does not naturally occur otherwise. Intellectually we understand the merits, emotionally we feel the support, and physically it is nice to share the workload, but it can be stressful when opinions and egos collide.

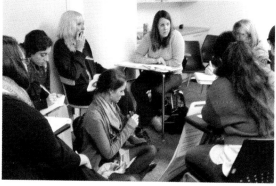

Figure 1.2: Shaping big ideas and mission for an exhibition through a group brainstorm discussion of descriptive terms. *Photo courtesy of Polly McKenna-Cress*

Teams that are working toward a common goal often begin at the path of least resistance: a kickoff meeting to delegate responsibilities. This may pass for collaboration, but it isn't the same. It's simply task distribution—an important activity, but not one that will result in a breakthrough product. Teams must recognize that simply meeting as a group in a room together to talk once a week does not collaboration make. *Intentions* are the difference. Collaboration requires a shared commitment in which each person persistently pushes themselves and others to expand their thinking and engage in achieving common goals. This bears repeating: success depends on the *shared commitment*. One or two doubters—or participants with their own narrow agendas—can derail the entire process.

Coming together is a beginning. Keeping together is progress. Working together is success.

—Henry Ford

An essential first step for the team leader is to establish the expectations of the team, its purpose, and the commitment that will be needed to meet goals (Figure 1.2). Some good old-fashioned cheerleading and positive energy never hurts for group buy-in of the process. There are individuals who, when asked to join a collaborative process, react with negativity: "oh, it never works" they might say, or "people end up not liking each other" or "I always get stuck doing all the work." Such individuals have probably never been part of a truly dynamic, successful collaboration and have not experienced the benefits and deep satisfaction that result when it works effectively. It's important to recognize that, while the process is not going to be easy, it will be worthwhile.

WHY COLLABORATE?

In his *Scientific American* article, *Why We Help* (July 2012), Dr. Martin A. Nowak posits "far from being a nagging exception to the rule of evolution, cooperation has been one of its primary architects." He discusses the five mechanisms for the evolution of cooperation that works *in tandem* with competition, not against it as previously thought.

> Millions of years of evolution transformed a slow, defenseless ape into the most influential creature on the planet, a species capable of inventing a mind-boggling array of technologies that have allowed our kind to plumb the depths of the oceans, explore outer space and broadcast our achievements to the world in an instant. We have accomplished these monumental feats by working together. Indeed, humans are the most cooperative species—super cooperators, if you will.

In the long history of humankind (and animal kind, too) those who learned to collaborate and improvise most effectively have prevailed.

—Charles Darwin

Literature from other professional fields, such as business or medical research, bears this out and makes clear that top thinkers have embraced collaboration as an important way of working. Dr. Nowak's article goes on to discuss the need for all human beings to collaborate in the conservation of rapidly dwindling resources of our earth for collective survival. In short, if we don't collaborate, we can't evolve and may not even survive. We in the museum field can learn from this.

To Share Knowledge

Alone we can do so little; together we can do so much.

—Helen Keller

In James Surowiecki's book *The Wisdom of Crowds,* he discusses how groups of people large and small can come together to create solutions to critical problems. He outlines moments in history where aggregate knowledge was imperative and, in some cases, saved lives. Many of his examples are particular problems with objective solutions as opposed to open-ended, subjective outcomes. But his important hypothesis is that the more minds focused on solving a common problem, the quicker, more complex the solution that is reached. Is this collaboration? Maybe not, but shared knowledge is an important ingredient in collaboration.

To Create Community

Social networks have brought people together for personal, professional, and political reasons, for serious discussions and frivolous entertainment. Social networks have been continually evolving as "the newest"

form of communication and, perhaps more important, as *community*. Even as of this writing, we have not yet imagined all the possibilities or impact of social networks on our society. These connections will continue to affect us all. And, as museums strive to be leaders in their communities, we need to keep pace with change.

To Facilitate Decision Making

Every tool has appropriate times and situations for its use. As a tool, the collaborative process is no different, and it should *not* be employed at all times or in all situations. Collaborative engagements should be considered carefully. Collaborative efforts should facilitate the important decisions that must be made to yield the best results. Sometimes, it's best to have a single decision maker who can drive the progress. For team-based initiatives, this means recognizing the moment when shared commitment must shift over to trust in leadership.

WHY COLLABORATE IN MUSEUMS?

We can understand in the broadest sense how collaboration has advanced human achievements and has applied to different professional disciplines. Still we often hear "why should we collaborate? Should museums be particularly concerned with a collaborative process at all? How can collaboration help museums to thrive?"

Most good museum exhibitions are the ultimate examples of inter-, cross- and multidisciplinary enterprises. Their creation requires diverse people with multiple viewpoints and diverse skill sets during all phases of development because visitors come to exhibitions with varied knowledge bases and interests, and from different backgrounds and cultures.

Many ideas grow better when transplanted into another mind than the one where they sprang up.

—Oliver Wendell Holmes

Visitors are our most important collaborators, and their opinions, needs, and input must be considered in the creation of the experience. Just because you build it does not mean they will come. If they do come, they may not care. As society becomes more and more user-centric and customer feedback opportunities abound, it's simply not smart to leave your ultimate customer out of the conversation. The entertainment industry cares about its audiences and meeting their needs and expectations. Museums are in the same business—competing for audience attention, commitment, and satisfaction.

As museum teams plan, develop, and design exhibitions, collaboration is the critically important element in creating elegant, creative solutions that continually engage diverse visitor audiences who care and come back. We've said it once before: if we don't collaborate we can't evolve and may not even survive.

Survival Instincts

There are three main survival instincts museums must possess that are best fueled by collaborative models in the development and design process:

- Varied points of view
- Interdisciplinary engagement
- Innovation

Varied Points of View

Teams should not meld the richness of viewpoints into one diluted generality. Rather, they should allow strengths of conviction to come through, trusting collaborators—including visitors—to understand that there are many ways to approach a problem or create a solution. The intersection of ideas does not mean the obliteration of viewpoints (Figures 1.3 and 1.4).

Figure 1.3: Visitor's Note from a "Talkback Wall" at the National Constitution Center. *Photo courtesy of Polly McKenna-Cress*

There are numerous methods to gather museum visitor points of view. One that is frequently employed is to pose questions and provide sticky note pads and response board for visitors to post their written feedback. Visitors tend to be very candid and honest in this approach.

Interdisciplinary Engagement

Historically, people have sought to apply taxonomies to everything in our world, sometimes to the detriment of revealing important connections and deeper understandings. "Interdisciplinary" is a term that has become ubiquitous, yet it is meaningful all the same. Museums understand that interdisciplinary engagement—the act of creating opportunities for interconnectedness across varied disciplines—is a critical function.

Figure 1.4: Visitor's Note from a "Talkback Wall" at the Independence Seaport Museum. *Photo courtesy of Ricahrd Cress*

Innovation

Basing program and exhibit development on the limited experience and knowledge of a single person is simply not acceptable in an age where access to information, knowledge, and people are at one's fingertips. Visitors are increasingly demanding innovation beyond what they can find on the Internet themselves, and museums must rise to the challenge.[1]

HOW TO COLLABORATE

Collaboration is often a misunderstood practice. Many people believe a collaborative process requires that those involved make all decisions collectively with little or no disagreement or friction. This notion is one of the fastest killers of this process. Trying to make every decision as a group makes for a long and protracted experience that will exhaust and frustrate everyone involved. Avoiding friction leads everyone to place importance on "getting along" instead of putting that energy into pushing each other to craft the best solutions. While shared knowledge is an important ingredient, a frequent misconception is that collaboration needs many participants—bigger must be better. But bigger frequently slows or even stalls the process, with too many cooks in the kitchen. Participants entering into collaboration need to understand the different forms of group engagement, the potential models of successful teamwork, and how natural human behaviors will affect the process. (See our Science Gallery case study at the end of this chapter.)

There is a creative act involved by the receiver as well as by the sender and that makes for innovation. Both sides are equally important.[1]

—J. Kirk Varnedoe
formally chief curator of the Department of Painting and Sculpture at the Museum of Modern Art

Collaborative Methods

There are subtle yet important distinctions in understanding how collaboration works; identifying differences between the "collaboration" and "teamwork" structural models has proven helpful. In a collaborative model, individuals work together to achieve an intersection of each other's ideas by contributing thoughts, knowledge, and experiences to create a new "something."

The teamwork model is well illustrated by a baseball analogy: players on the team have distinctly defined roles, each demonstrating separate

[1] http://creatingminds.org/quoters/quoters_v.htm

efforts that support the same desired outcome: to win the game. Catchers and pitchers do not combine the "content" of their roles; rather, their roles are distinct complements to one another. Awareness of the methods being engaged and each participant's role helps a team confidently proceed forward.

To correlate these working methods to the creation of exhibition: The *collaborative* discusses and defines the mission, goals, and audience for the exhibition. Once those criteria are set, the *team* may go off and produce individual deliverables—graphic treatments, script, multimedia elements, marketing strategies, and the like—that all support the outcomes established by the collaborative.

Collaborative Models

A teacher (manager) who learns how to use team-learning methods to transform "groups" into "teams" (like water into steam) will be able to create a learning experience for students (staff) that is extraordinarily powerful.

—L. Dee Fink, *director of the Instructional Development Program at the University of Oklahoma*

Without vision and shared passion, people may go through the motions but may not jell as a team or produce fruitful outcomes. There are several models for successful collaboration, and at the core of each is an ideal that everyone supports. The following models have worked well in many different fields, but particularly for museums.

Core Group Collaboration

This may be the most often used model. It is a small and agile core group that has a strong collective vision for how the project needs to proceed, though the members might vary in the methods they use to achieve the same ideal. Members encourage each other to stretch boundaries for themselves and the best solutions. The core group typically brings in outside contributors for critical input to realize the vision and enhance outcomes.

Visionary Collaboration

In this model, a single visionary leads the group, although it may seem counterintuitive to collaboration. The distinction is that the visionary needs collaborators to share the passion, understand the vision, and support its development so that the project can be accomplished. This model is dependent on the visionary recognizing his or her role as a leader of a collaborative team and not a dictator (Figure 1.5).

The City Museum

St. Louis, Missouri

Bob Cassilly (1949–2011), founding director, launched this idiosyncratic museum with a strong vision for how a museum built from recycled parts of the city could reflect the true identity of St. Louis. From the City Museum's airplanes and high-wire tunnels to the historic roof-deck Ferris wheel, there were many individuals who shared this one man's vision and helped build this labor of love. The strength of these collaborative efforts continues today as the museum tries to sustain the vision beyond the man.

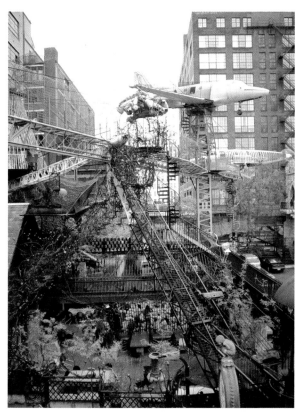

Figure 1.5 The City Museum, Saint Louis, Missouri, is the vision of an individual who rallied a city to support turning the vision into a reality. *Photo courtesy of Paul Martin*

Greater Purpose Collaboration

This model has a strong vision and has clear, objective outcomes that are easily understood by many people. It is external and public. It does not have to be embodied by one visionary, but it is driven by societal issues and needs that can be scalable. Although the goals are clear, the means of getting there is the work of the collaborative. This model is one that can typically sustain more than one institutional partner (Figures 1.6 and 1.7).

Race: Are We So Different?

A traveling exhibition developed by the Science Museum of Minnesota and the American Anthropological Association is the result of a "greater purpose collaboration." The team was clear and passionate about the project's goal: to illustrate that race is not scientifically based but is a social construct that has been used by society to define people throughout history. The collaborative engaged in tough considerations of sensitive subjects to determine how it would accomplish this thought-provoking exhibition. By helping visitors to better understand the concept of race through the lenses of history, science, and lived experience, the team created a powerful exhibition that inspires visitors to share, discuss, and rethink their assumptions.

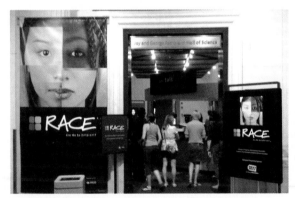

Figure 1.6: *Race: Are We so Different?* A traveling exhibition created by the American Anthropological Association in collaboration with the Science Museum of Minnesota. *Photo courtesy of Science Museum of Minnesota*

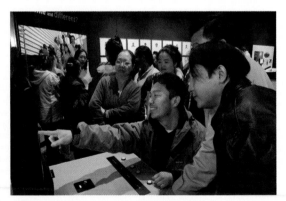

Figure 1.7: *Race: Are We so Different?* Here a family is sharing and discussing the contents of the interactive exhibit. *Photo courtesy of Science Museum of Minnesota*

Roles and Resources

The critical first step in any collaborative process is to establish roles, a schedule, a budget, and resources. When one of these elements is unclear, the situation becomes ripe for conflict. All participants must understand parameters and agree on the needs, rules, and behaviors that define how the team will work together. Doing so provides clarity and awareness. When entering into a collaborative process, no one should be of the mindset "we will ask forgiveness later." If the team is aware of issues or problems early enough, it can work toward solving them or addressing them. But if any team member avoids or diminishes problems, for whatever reason, other team members will lose trust in each other.

Trust and Understanding

People do their best work in a trusting environment. Ultimately, trust and understanding are the most important attributes for collaborators to possess, because these are key to a shared commitment. Trust is built in any relationship when there is confidence that one can freely address mistakes. If individuals believe that they are expected to work flawlessly, swiftly, and without issue, then an inherent defensiveness, a need to cover, justify, or blame others will override progress when the inevitable mistakes occur. If the team is allowed to take risks and make mistakes, a productive and constructive environment naturally emerges, one that facilitates learning and growing.

Decision Criteria

The team and stakeholders must work together to establish and "own" objective criteria used to assess the exhibition components or programs and make decisions during development. These criteria are the mission, goals, objectives, and audience impact. The team should also establish clear decision criteria and a team hierarchy for addressing problems during the process. Decision making is not about democracy at all times; otherwise, no real decisions will get made. The team should establish who has authority at various stages during the process; this authority will naturally shift according to the work being engaged in.

Once all criteria are established, the team and stakeholders can move forward and make decisions, never losing sight of the ultimate mission of the undertaking.

Mutual Respect

Successful collaboration is not based on friendship but rather on building and sustaining mutual respect. The respect team members develop for one another is also a respect for the process and the goals established. If team players do not respect each other, the process is extremely difficult to bring to a successful conclusion. Even when individuals do not necessarily enjoy being together socially, they can be respectful toward one another in order to develop successful outcomes. In most instances, the preferred relationship is not "chummy," but simple civil discourse.

Process Example

Kate Quinn, Director of Exhibitions at the Penn Museum (University of Pennsylvania Museum of Archaeology and Anthropology), discussed the frustrations expressed by the team when deadlines are missed. When she took her position, Ms. Quinn was responsible for "schedule creation." When deadlines were missed, she became aware that the schedule was viewed as "hers" and not the team's responsibility. To remedy the problem, she made adjustments and involved the curators, developers, designers, and other team members for input on the schedule parameters. By collaborating on the creation of the schedule, the team took ownership of it and realized their responsibilities. The different staff members could now see how their work fit into the whole and how others' needs and the success of the overall project depended on their timely completion of work. The schedule changed from single ownership into a shared ownership.

Five Dysfunctions of a Team

- **Absence of Trust**

 For all teammates, including the leader, can vulnerability be expressed without repercussion? Can a teammate say openly, "I don't know?"

- **Fear of Conflict**

 Productive ideological conflict is good. If teammates fear repercussions—real or imagined—from expressing counter viewpoints, the team environment can become unhealthy, and frustrations can come out in other divisive ways. Dialogue and debate should be encouraged, even when there is not agreement; the team leader should recognize when it's time to resolve debate and put issues to bed.

- **Lack of Commitment**

 Without healthy debate, there will not be commitment. However, once decisions are made following debate, the entire team must get behind them. Team members need to be able to say, "I may not agree with your ideas, but I understand them and respect them, and I'll support the team's final decision."

- **Avoidance of Accountability**

 If you don't have commitment, there is no buy-in and, therefore, no accountability. Commitment leads to a sense of camaraderie and collegiality needed for a team effort. If "letting the team down" is abhorrent to an individual, he or she is more likely to be accountable for his or her actions and the outcomes of the team.

- **Inattention to Results**

 If the team members are not accountable, they will take care of only themselves rather than of the entire team. When team dynamics go awry, the team goals get subverted for individual goals. What is team one in your mind—the team you are on or the team you lead? You must be a good, solid team member before you can be a good solid leader.

From Patrick Lencioni's *Five Dysfunctions of a Team: A Leadership Fable*, San Francisco, CA: Jossey-Bass/John Wiley & Sons, 2002.

Figure 1.8: Complaining: When there is too much time spent on complaining and being negative nothing of worth gets accomplished. Collaborators need to stop whining and focus on moving forward. *Illustration by Meghann Hickson*

Figure 1.9: Criticizing: When people feel that they cannot offer much that will not be criticized they will shut down and stop being contributing members of the team. Any and all new ideas can be picked apart and overly criticized; the team needs to give ideas a chance to grow and become great. *Illustration by Meghann Hickson*

When Things Get Tough

Knowing How to Fix Problems

Collaboration is important, but like anything else problems can arise. Collaboration, like a newborn baby, needs to be constantly fed, nurtured, and closely watched; if left unguarded, something inevitably will go awry. If we didn't address problems here we would only be taking care of half the job. It cannot be stressed enough that defining roles, resources, and decision-making criteria is critical. Most problems arise from paying inadequate attention to any or all of these items. A dysfunctional team will most likely yield dysfunctional results. Recognizing problematic conditions and behaviors and addressing them head on are necessary.

Collaboration Killers to Watch For

There are four factors that are always present in collaborative environments because they are common to human interaction: *complaining, criticizing, conflict,* and *compromise.* Be observant and direct in dealing with each factor as it emerges. Maintaining a balanced approach to these factors is important to the success of the team.

Complaining

One of the hardest parts of working in a group is to mitigate the "bitching factor" and commiseration as a form of team bonding. A certain amount of "blowing off steam" is important in any group process, but when complaining turns to constant negativity, it's simply draining on the team. Having a common enemy is one of the fastest ways for individuals to align but bonding through negativity toward others will inevitably turn team members against one another. This can be a hard threshold to identify, so the team must be self-aware and address this threat before it gets out of hand. Negativity, at the extreme, can derail a project (Figure 1.8).

Criticizing

As the team works to build its trust and collegiality, a major obstacle can be the overly critical individual or small group. In many teams, there are risk-takers and people who love to generate ideas. There are others who sit back, offer no ideas, only comment critically on what's being generated, and they often can't provide solutions to their criticisms. This is not constructive. This leads to overall team frustration and the breakdown of the shared commitment. It's important to encourage debate and discussion, but when the time comes, to get on board and make decisions as a team (Figure 1.9).

Figure 1.10: Conflict: If disagreement leads to finger-pointing, it will destroy the collaborative process and have lasting consequences on the project. *Illustration by Meghann Hickson*

Conflict

The collaborative process naturally breeds conflict, some good and some destructive. Disagreeing on issues is important to facilitating critical analysis and building awareness. But conflict can start out as simple friction and seem benign; if not attended to, it can lead the team toward hurtful, unprofessional, and destructive behavior. Disagreement, if not managed well, can destroy the process and have lasting consequences (Figure 1.10).

Compromise

Too much conflict is a bad thing, but too much compromise can be deadly. When conflict arises, teammates generally recognize the need for mitigation. Some may feel that a successful collaborative process just means giving in. You don't want compromise to dull down an effort to the point of banality. Compromise can actually be the antithesis of collaboration; we want to be building upon one another's ideas and pushing each other to look at the subject in new ways. Conceding a point or agreeing without question may simply be avoiding important discussions. The challenge is to strike the right balance between conflict and compromise so that the outcome is the strongest solution (Figure 1.11).

Figure 1.11: Compromise: Collaborators want to find the balance between conflict and compromise. Too much compromise might render the project banal and boring. *Illustration by Meghann Hickson*

A Case Study in Extraordinary Collaboration
Science Gallery at Trinity College

Dublin, Ireland

Three people in a room cannot dream this big. You need to tap into people and networks to create these types of complex experiences.

—Michael John Gorman, Director, *Science Gallery*

Launched in 2008 under the direction of Michael John Gorman, the Science Gallery (SG) at Trinity College, Dublin, Ireland, employs one of the most effective uses of the collaborative process as has been developed anywhere for a public exhibition forum. The mission of the Science Gallery is to recognize and be deeply involved in "inspiring, nurturing and recruiting talented young people to bring a lasting excellence to research and innovation that is so crucial in today's society." With a target audience of 15–25 year olds, the Science Gallery inspires and transforms curious minds through an ever-changing program of exhibitions, public experiments, challenges, festivals, debates, and workshops to help people discover, express, and pursue their passion for science. "The Science Gallery is a world first. A new type of venue where today's white-hot scientific issues are thrashed out and you can have your say. A place where ideas meet and opinions collide"[2] (Figure 1.12).

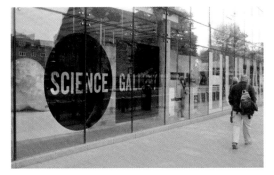

Figure 1.12: Science Gallery at Trinity College during the installation of *Human+: The Future of our Species,* spring 2011. *Photo courtesy of Polly McKenna-Cress*

Although the focus of SG is on science, the museum expands the way science is typically explored. Collaborators exploit contemporary art making, engineering, and design thinking as ways to understand our world and express powerful and meaningful ideas. Physicists, engineers, musicians, lawyers, artists, humanities curators, and teenagers compose the Leonardo Group. This interdisciplinary group of curators taps into its different networks of experience to ensure that the group covers a broad range of thought from which a "seed idea" or theme for a show is generated.

These seed ideas are then outlined in an "open call" that is sent out to an international group of innovators from a variety of backgrounds and disciplines. Proposals submitted to the Leonardo Group are reviewed and discussed. Projects that are deemed to best provoke new thinking and innovation are selected to be prototyped, developed, and implemented in the 2,500 sq. ft. gallery space.

The innovators/creators of the selected projects are invited to participate in the exhibition as lecturers, to run workshops, or simply to be in the space interacting with the public over the course of its installation.

The SG has a mission to invest in high-risk projects. Selected projects range from existing products or experiments to completely speculative ideas and proposed processes. These "speculative designers and scientists" as Mr. Gorman refers to them, are not planning for today but proposing what could be in the future. He goes on to explain that a key goal for the SG is to introduce not only proven ideas, but also conjectural projects. This is not only a way for visitors to the gallery to be part of the development and incubation of new concepts, but also creates a space from which new thinking and projects actually emerge (Figures 1.13 and 1.14).

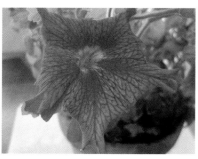

If life does anything, it makes copies of itself. It is one of the traits every living thing shares with every other living thing. Since the dawn of agriculture and animal husbandry, humans have developed increasingly elaborate strategies for preventing this self-copying behaviour when they view its product as undesirable. The reasons for doing this are as numerous as the means by which it is accomplished. Included in this exhibit is a small selection of strategies of reproductive control that have been developed and used in modern times.

HOW HAVE HUMANS SHAPED THE EVOLUTION OF THE PLANT?
The Center for PostNatural History is a public outreach centre dedicated to exploring the intersection of culture, nature and biotechnology. The PostNatural refers to the life forms that have been intentionally altered by humans through domestication, selective breeding and genetic engineering. Towards this end, the CPNH maintains a collection of living, preserved and documented specimens of PostNatural origin.

Figures 1.13 and 1.14: *Human+: The Future of Our Species* includes innovative installations such as a new species of flower genetically engineered from DNA of a petunia and from the artist, Eduardo Kac. The label provokes visitors by asking questions such as "How Have Humans Shaped the Evolution of the Plant?" and to think in a new ways with statements such as "The PostNatural refers to the life forms that have been intentionally altered by humans through domestication, selective breeding and genetic engineering." Visitors wonder what a plant with their DNA may grow up to be. *Photos courtesy of Polly McKenna-Cress*

Levels of Engagement

The Science Gallery system fosters engagement from internal communities of Trinity professors and external research scientists and artists. Trinity College borders on one of the most economically depressed parts of Dublin, so the Science Gallery has positioned itself as a conduit between the academic side of the street and the underserved communities across the way. All these groups are encouraged to be a part of the

The creators don't want to simply send their work in a crate to be hung on a wall but come and interact in the space with the public. They enjoy the buzz of mixing with the community in the space, and new projects are inevitably born from that exchange.[3]

—Michael John Gorman, Director, *Science Gallery*

Science is never about the individuals it is always about a team. . . individuals with different strengths that complement your own working together to build something new and innovative.[2]

Shane Bergin, *Trinity College graduate in Physics and member of the Leonardo Group at the Science Gallery, spring 2011*

exciting creative power of the space in the hope of igniting new passions for science and potential careers.

As young visitors return and get more involved, they are tracked and invited to volunteer as docents in the gallery. If the visitors remain engaged, they can move up in the Engagement Pyramid and can ultimately be invited to join the Leonardo Group—continuing the feedback loop of collaboration. With participants as young as 17 serving as volunteers, long-term engagement is an extremely successful way to encourage individuals who may otherwise never have considered engaging in cutting-edge professional science experiments or pursuing science-based creative careers.

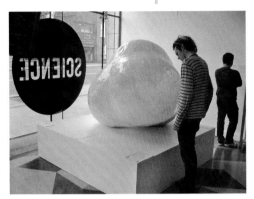

Figure 1.15: A personal biosphere or "individual cocoon habitat" conceived and created by Zbigniew Oksiuta. *Photo courtesy of Polly McKenna-Cress*

A number of the projects presented in the SG space have received national and international recognition. With this awareness, funders have approached different creators/researchers and offered seed money to support efforts in advancing projects to the next level.

Innovation comes from the clash of ideas. Innovation comes from tension. . . Ideas meet and collide at the Science Gallery.[2]
Chris De Burgh, musician and member of the *Leonardo Group at the Science Gallery, spring 2011*

Science Gallery is a prime example of a public exhibition space that employs key models of collaboration: as an imperative for innovation, intellectual, and economic growth; as currency to move forward science and technological advances; and as a means to share global knowledge and ultimately build a stronger community (Figure 1.15).

This case also demonstrates the key survival instincts we've identified where collaboration can serve particularly well in a public forum. Those involved in this project seek varied points of view from the Leonardo Group, interdisciplinary creators/artists, and the diverse audiences the Science Gallery serves. They encourage an interdisciplinary approach, marrying science, engineering, design, humanities, and the arts. By positioning themselves so smartly within the community, they've made inclusivity and diversity key goals. There are very few environments that exist, particularly public ones, that could claim to be more innovative at incubating ideas.

[2] www.sciencegallery.com/this_is_science_gallery

[3] Interview with Michael John Gorman at the Science Gallery, April 2011

AN INTRINSIC IMPERATIVE

Collaboration is not a fad or a buzzword. It is an *intrinsic imperative* if we intend our museums to be current as well as culturally and socially responsible. We do not advocate for museum authority to be dissolved, which is a fear of some museum professionals. Rather, we assert that institutional authority can only be strengthened if it is rooted with the survival instincts we've outlined in this chapter. It is not enough to be a collector, connoisseur, or simply educational institution anymore. In order to survive, museums must be actively relevant for contemporary audiences.

In the chapters that follow, we'll explore where and when certain critical decisions should be made and suggest who should be involved in making them.

FURTHER READING

Collins, Jim. *Good to Great: Why Some Companies Make the Leap...and Others Don't*. New York, NY: HarperCollins, 2001.

Collins, Jim. *How The Mighty Fall: And Why Some Companies Never Give In Collins Business Essentials*. New York, NY: HarperCollins, 2009.

Lencioni, Patrick. *Five Dysfunctions of a Team: A Leadership Fable*. San Francisco, CA: Jossey-Bass/John Wiley & Sons, 2002.

Lencioni, Patrick. *Overcoming the Five Dysfunctions of a Team—A Field Guide for Leaders, Managers, and Facilitator*. San Francisco, CA: Jossey-Bass/John Wiley & Sons, 2012.

Surowiecki, James. *The Wisdom of Crowds*. New York: Anchor Books, a division of Random House, 2005.

ADVOCACIES AND ACTION STEPS

An idea is like a play. It needs a good producer and a good promoter even if it is a masterpiece. Otherwise the play may never open; or it may open but, for a lack of an audience, close after a week. Similarly, an idea will not move from the fringes to the mainstream simply because it is good; it must be skillfully marketed before it will actually shift people's perceptions and behavior.[1]

> —David Bornstein, *How to Change the World: Social Entrepreneurs and the Power of New Ideas*

ADVOCACY POSITIONS AS A TEAM CREATION STRATEGY

In this chapter, we'll try to lay out the most important tasks exhibition teams need to carry out to best serve the visitor, the content, and the institution, and offer a way to think about the roles of the players who take these tasks on.

Questions the Team Should Ask

At the onset of any team process, the persons involved should set up a kick-off meeting to discuss schedules, budget, and goals, but most importantly to establish an initial understanding of *how* the team will work together.

[1] www.goodreads.com/quotes/tag/advocacy

Questions about roles should drive this meeting:

- What advocacy positions need to be represented on any exhibition team?
- What skills are needed for each of these positions?
- What constitutes success—or failure—in carrying out the tasks associated with each advocacy?

This chapter concerns itself with the higher-level objectives that must be carried out on any exhibit team in order to create exemplary products. We'll discuss these responsibilities as *advocacy positions* that must be filled in any team rather than assignments to traditional staff positions. Why? Because it strikes us that it's easy to get hung up in titles or job descriptions, and not pay enough attention to the work that actually has to get done. It also strikes us that true collaborative processes might be easier to launch when we are most interested in thinking not only about what needs to get accomplished, but about why it needs doing and who on any given team—regardless of title—might be best at doing it. "Not in my job description" and "get off my turf" are both collaboration killers.

FIVE ADVOCACIES NEEDED FOR EVERY TEAM

Naturally, depending on the size of the project, the budget, and the setting, there might be any number of people involved in the development, design, and fabrication of an exhibition, but we propose that there are only five main areas or *advocacies* that need to be represented on any and all teams:

1. Advocacy for the Institution
2. Advocacy for the Subject Matter
3. Advocacy for the Visitor Experience
4. Advocacy for the Design (physical and sensory)
5. Advocacy for the Project and Team

Ordinarily, each of these is embodied in a single person on a team, but in smaller institutions, an individual may need to take on more than one role, and in larger institutions with larger projects, there may be a multitude of people working from the point of view of a specific advocacy.

Figure 2.1: Museum banner, National Museum of Ireland, Dublin. *Photo courtesy of Richard Cress*

The very aim and end of our institutions is just this: that we may think what we like and say what we think.

—Oliver Wendell Holmes

What follows is a definition of each of these advocacies, the responsibilities of the role, and the skills that are needed to play it.

1. Advocacy for the Institution

An advocate for the institution creates the means for the project to happen in the first place, has a clear idea of how this project fits into the greater scheme of things, and knows why it's important for the organization to do it. This person should also provide final approval for the project—deeming it "good enough" or "not good enough" to represent the institution to the public—and may act as an arbiter for any irresolvable issues that come up within the team during the development. In other words, this person is the "client" for the exhibition *on behalf of the institution*, and as such, has ultimate responsibility for it (Figure 2.2).

In midsize to large institutions, the client role is usually filled by a *director*, a *division manager*, or a *vice president*—someone with enough power within the organization to (1) envision how the project will further institutional goals, (2) assemble the resources necessary to do the project, (3) sell the idea to a board or other higher-ups, (4) find funds for the project, and so forth. In smaller institutions, this person may still be the director, but in that role, he or she may also be doing some of the other tasks we'll be describing later. In any of these scenarios, this figure may not be the person who originally came up with the idea for the project, but he or she will have recognized the utility of the idea and be able to create the landscape within the institution to see it through.

The skills needed to play this role well include strategic thinking, administrative ability, persuasiveness, critical thinking, and clarity of thought and presentation. This advocate will not only need to be able to recognize and encourage useful ideas and organize useful resources, but will often also need to enlist others to the cause.

Sometimes, the person advocating for the institution's needs is seen by other members of the team only as a kind of necessary evil, someone who must be reported to and who may require things of the team that are inconvenient. This is shortsighted. The role this person plays is as necessary to the success of the endeavor as that of any other team member, and it's important to keep him or her in the loop as the project progresses and active in any milestone approval system. Figures like this

Figure 2.2: The advocate for the institution truly has the weight of the institution on his or her shoulders in that this advocate must address positioning issues so that the institution has the most impact in the community, locally or globally. *Illustration by Meghann Hickson*

[A good museum makes] a positive difference in the quality of people's lives.

—Stephen E. Weil, *Making Museums Matter*, 2002

may also be instrumental in putting other institutional resources to work for the good of the project, such as fundraisers or public relations and marketing personnel.

Sometimes, organizations will put the power of the client in the hands of an "exhibits committee" of some kind, rather than in the hands of a single individual. There are often good reasons for this decision, but it's rarely the best move for a project, as it diffuses the energy of the advocacy position and blurs lines of authority and responsibility. Clarity—the hallmark of a good client—is harder to attain when this scheme is used.

2. Advocacy for the Subject Matter

The first thing that comes to mind when we begin to speak about an advocate for the subject matter is finding someone whose title is "curator," but that isn't the only way to think about it. What's needed is someone (or a group of someone's) who can bring passion for the subject matter to the process and who is able to transfer some of that excitement to others on the team and, therefore, eventually to the visitor. This advocate should be able to identify the most important aspects of the topic from the academic point of view and help prioritize messages in order to edit out the less salient aspects of the content. If there are objects, artifacts, archives, or specimens involved, this member of the team needs to be able to speak with authority to the quality of material available, its conservation needs, what other material might be needed, and what might be available from other organizations for loan or sale (Figure 2.3).

Some projects may require original research by persons who did not begin as experts in that particular topic, but whose research skills are exemplary and who also know how to seek out experts who can advise about and review information. Above all, subject matter advocates must be able to ensure the accuracy of what is being presented.

The specific notion of "curator," is historically tied to custodianship of libraries and archives, and from this comes the notion of a "keeper" of object collections, a term still employed in some institutions. The high-level subject matter expertise of the keeper is understood to be tied not only to his or her education and experience, but also to his or her intimacy with a good collection.

Figure 2.3: In many instances, the responsibilities of the subject matter advocacy require more than just one person. Although there is a need for accuracy and perhaps an ultimate decision maker, everyone shares responsibility to be passionate about the subject matter so that visitors can engage as passionately. *Illustration by Meghann Hickson*

The term "curator" rather than "keeper" is more generally used to describe the highest level of subject matter expertise in the United States, but it can mean different things in different kinds of institutions. In many larger natural history museums, the word "curator" denotes someone who may be intimate with a specific collection, but more importantly, is an active researcher, potentially adding to that collection. He or she may not actually attend to or "keep" a collection except in the most distant administrative sense. That job may be left to collections managers or even conservation staff. In history museums, there may be a "curator of the collection" as a whole, or—especially in larger institutions—individual curators for aspects of the collection such as "Decorative Arts." Or the institution may not use the term "curator" at all, but prefer "historian" to denote the person or persons with subject matter expertise and control over the collection. It's also less usual for children's museums and science museums to have curators, mainly because they are less likely to have a collection, although some do.

Art museums might also have divisions such as "Decorative Arts," but will probably also have sections of the collection that are designated by time period (such as "Twentieth Century Art") (Figure 2.4). Curators in art museums often have very tight control over a specific collection, and besides expertise in the subject matter of that collection, their title may further imply a level of connoisseurship not often attained by others. And unlike exhibitions in most other kinds of museums, specific art exhibits are often overtly seen as the vision of such an expert as regards a specific artist, art form, or period.

Of course, staff with any of these kinds of expertise would be obvious choices for exhibit team membership, regardless of title.

However, the truth is that in many museums there is no such thing as a "curator," even when there is a collection.

Even when such job titles do exist, we may still want to get opinions from outside the institution about our chosen subject matter. We can look to academia for people who are researching, teaching, and writing

Figure 2.4: Architecture and Design Department, Museum of Modern Art, New York City. *Photo courtesy of Richard Cress*

about the content, or to professional fields where practitioners are directly engaged in the art or science that interests us. We might also look to academics or professionals outside the specific field for insight: What might a historian have to say about the cultural and socioeconomic milieu of the Impressionists? What insights might a psychologist offer to an exhibit that touches on themes of loss or death?

In our pursuit of team members who may act as advocates for the content, the other important potential partners are members of the community and/or the public. This is especially important when we are dealing with culturally and/or regionally specific subject matter, but we might want to involve community members when dealing with sensitive or potentially controversial subject matter as well.

3. Advocacy for the Visitor Experience

Identifying an advocate for the visitor experience is a relatively new idea, based on the notion that knowledge of the visitor and visitor studies, of learning theory, and of the exhibition's cultural milieu is as important to the project's currency and success as expertise about the subject matter or great design skills. This advocacy will involve thinking deeply about the kind of experience the visitor will have and setting both cognitive and affective goals for that experience. This kind of advocacy is about reminding us all that the visitor is at the heart of the exhibition endeavor—that most importantly "it's for some*one*, not just about some*thing*" (Figure 2.5).

Figure 2.5: The advocacy for the visitor experience must be a role that all team members truly believe in. Although the exhibition developer, educator, and evaluator have particular responsibilities to this advocacy, those in the other four advocacy positions are also working for the end users. *Illustration by Meghann Hickson*

When this advocacy is represented as a specific role, it's often called *exhibit (or program) developer*, but it may also go by the name of *interpretive planner*, or sometimes *educator*. (In some large institutions, "advocate for the visitor" may be its own job title, with exhibit development left to an exhibit developer.) Its original invention in the 1960s is attributed to Michael Spock, then director of the Children's Museum in Boston. The idea was that to truly have a vision for a project, both passion for the content and equal passion for the visitor had to be present. He invented the title of "program developer" for the people who "carried the torch" for a specific project and could then assemble a team and resources around that vision to see it through, undiluted by other concerns. In the earliest form of visitor experience development, developers

had responsibility for everything about an exhibition project—concept, both visitor and content research, school programs, "try-out" of mocked-up exhibit elements, prototypes, tone and voice, collections material—everything except the design and production, although they might participate in that as well (Figure 2.6).

Other institutions invented other versions. Also in the 1960s, the Exploratorium developed its prototyping model of people working on specific exhibit ideas in an open shop, taking things out on the floor for try-out, and then further refining them back in the shop as many times as necessary, before finally installing them—with then director Frank Oppenheimer's approval—on the floor. Were these people artists? Scientists? Designers? Educators? Fabricators? Yes, yes, yes, and yes.

Figure 2.6: The prototype from the Ontario Science Centre tested if it was clear that different programming tokens went in different spots on the robot. For the Weston Family Innovation Centre at the Ontario Science Centre. *Photo courtesy of Erika Kiessner*

Team Approach for Visitors

The "Team Approach," launched by Carolyn Blackmon at the Field Museum in the early 1980s, demanded that exhibit teams include an educator, with the express purpose of introducing a person concerned with the public onto the traditional natural history museum team of curator and designer.

Whatever the model, the basic idea remains important: Although all exhibitions are indeed "about something," the most important outcome is that they be of interest, meaning, and utility to the end user and that nothing should be allowed to get in the way of that ultimate aspiration. The most straightforward way to make sure that this necessity is actually carried out is to personify it on the team, usually in the form of an "exhibit developer."

However this advocacy is realized on the team (and it could be through a number of people, depending on the size and complexity of the project), there is an overriding task that this role is ultimately responsible for: pulling the whole together for the visitor. When all the best items have been chosen from the collection, when all the imperative messages have been articulated, when all the school group

Do what you do so well that they will want to see it again and bring their friends.

—Walt Disney

curriculum standards have been accounted for, when all the bells and whistles bound to appeal to various age and interest segments have been thought through, is there still an understandable story? Is there an overarching and compelling idea or feeling that the visitor can grab onto and walk away with? Is there a recognizable unity, or is it just a bunch of vaguely related stuff? It's a visitor advocate's job to make sure that the whole visitor experience actually is greater than the sum of its parts and to provide leadership within the team for the articulation of specific cognitive, emotional, and experiential visitor goals (Figure 2.7).

Figure 2.7: Interactive media allow visitors to select and find out more information on specific objects in the Robert H. and Clarice Smith New York Gallery of American History, New York Historical Society Museum & Library. *Photo courtesy of Polly McKenna-Cress*

Exhibition developers can come from almost any kind of background, as long as they are willing and able to put the visitor first. Most often, however, these kinds of people come from education or arts backgrounds, or are people whose passionate study of a specific subject matter has morphed over time into a passion to transfer some of that knowledge to others. Useful skills include an understanding of and enthusiasm for visitor research; a gift for metaphoric and analogous thinking; good research, writing, and teaching skills; some understanding of learning theory and human development; some understanding of visualization strategies; and an ability to think across disciplinary lines.

This advocacy can overlap significantly with others. Indeed, when those team members who are most concerned with content and physical design are truly tuned in to visitor issues, the job of visitor advocacy is made significantly easier and may become more technical—creating documents for milestone reviews, or doing such tasks as writing clear label copy, organizing visitor research efforts, developing and testing specific media or interactive elements, or organizing and consulting with advisory and community groups.

4. Advocacy for the Design

Perhaps the most straightforward of all these advocacies is that of the advocate for the physical and sensory design. It's pretty clear that this must be a person or persons who have real design skills and understanding—or, in the smallest and most strapped of organizations, at least a "good eye." But of course, this advocacy is not just about how visually pleasing a space is, but also about how comfortably it functions as an environment, how interesting it is, how visitors are drawn into and through it, how it's lit, how it sounds, how it feels, how it smells, how it supports the content, how well its individual elements function, and in general, how the physical and sensory aspects of the ultimate space serve to support and enhance the overall cognitive, affective, and experiential goals of the project for the visitor (Figure 2.8).

Design Skills Needed

The skills needed here are many and may not be able to be embodied in a single individual. These include:

- **Space-planning and way-finding precepts** (including ADA requirements and safety issues such as emergency exit needs or fire ratings on materials) (Figure 2.9).

Figure 2.8: The advocates for the design create effective and thoughtful experiences that engage the visitor. Responsibilities are not only to the successful expression of the exhibition itself but also to the process, presentations, and communications during the development of the exhibition to support the team's and other stakeholders' understanding, participation, and approval. *Illustration by Meghann Hickson*

Figure 2.9: Floor plan sketch with scale visitors to understand flow and personal space needs. *Image courtesy of Jon Coe, CLR Design, Inc.*

- **Custom cabinet design, graphic design, interior design** (color and texture systems, object arrangement, lighting and physical comfort assessment) (Figure 2.10).

- **Interactive design** (especially of mechanical systems that might be used to explain or demonstrate processes or phenomena).

- **Understanding of media and media options** and the technology that supports them.

- **Universal design** (understanding the precepts that allow all users access in spite of size, age, first language, or disability).

- **Green design** (essentially, knowledge of materials, their sources, and their properties and possible effects on collections objects).

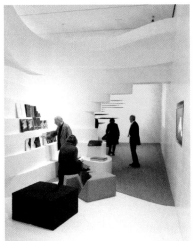

Figure 2.10: *Zaha Hadid: Form in Motion* exhibition. Benches add opportunity for comfort and reflection. Philadelphia Museum of Art. *Photo courtesy of Polly McKenna-Cress*

- **Ability to sketch up, scale, detail, and document** any and all of these, first for review, and then for fabrication. Often, this role also oversees fabrication and installation on behalf of the team (Figure 2.11).

Figure 2.11: Exploded view of "ruin" structure construction. *Image courtesy of Jon Coe, CLR Design, Inc.*

Like subject matter advocates, design advocates will probably have specific training in a field such as architecture, industrial design, graphic design, theatrical design, or a related area. Like advocates for the visitor, they will probably have to actively continue to pursue skills and knowledge in specific areas needed to create exemplary exhibitions, for few courses of study can hope to inform beginners of all that will be required of them in the creation of each custom-made environment.

Of all the advocacy positions we are describing, this is the one most likely to be hired out to an outside individual or firm, and this has both good and bad points. This is usually done because the institution does not have the capacity in-house, because it has no design function at all, or because that person or staff cannot manage all the work that's being assigned. Sometimes, decision makers hire outside to reinvigorate what is seen as repetitive in-house solutions, or to improve the "level of finish," or to bring higher technical or materials solutions to the floor than in-house design and production seem capable of or perhaps interested in.

Whatever the reason, it's important that institutions be very clear about what it is they are seeking. Some firms are prepared and indeed prefer to create "turnkey" exhibit solutions; that is, they take authority (and responsibility) for the whole product and require little from the client organization besides general approval for the approach and a budget. Other firms may expect that the hiring organization will bring deep and articulate clarity about the audience and didactic goals for the exhibition, and provide all the content research to support these. Still others may be prepared to have the organization supply all content and exhibit development while they act only as 2-D and 3-D designers and oversee fabrication. Obviously, all these decisions have not only staffing and cost implications, but ownership issues, so a thorough understanding of "who is doing what" is essential for these contracts to succeed for both parties.

5. Advocacy for the Project and Team

An advocate for the project and the team is an advocacy that is often ignored—much to the peril of the product, for when there is no

Figure 2.12: The project and team advocate or project manager is responsible for everyone. He or she is the budget and schedule wrangler who must keep an eye on the bigger picture to ensure a smooth and efficient process. Some have renamed this job the "professional nag," but all team members are responsible for themselves and should not leave the PM holding the bag. *Illustration by Meghann Hickson*

advocacy for the project itself, budgets are often overspent, schedules may go awry, and friendly disagreements can devolve into polarized standoffs that can make everyone feel bad and bring progress to a standstill. The title most often given to this role is "project manager" but these advocates may also be called "project administrators," "brokers," or even "assistants" of some kind. The skills needed here are in both planning and process, and both areas need to be approached in a highly collaborative fashion in order to be successful. They involve the schedule, the budget, and the overall health of the team and its process (Figure 2.12).

The planning tasks include creating an overall schedule, creating a system and schedule for review and approval, and, especially for larger projects, creating more detailed schedules for specific products that will go through many hands. A good example of this is label copy: a graphic hierarchy and format must be agreed upon; text written, reviewed, edited, and approved; imagery researched, chosen, and reviewed, and all of these pieces skillfully brought together in order for text panels to go into production. It's imperative that the content expert not be on vacation the week that the final review needs to be done! Obviously, such a schedule will have to be created with everyone's participation and with everyone's needs in mind.

The second part of this task—actually overseeing the overall schedule as it progresses—is even trickier. Some team members may not be very good at keeping to a schedule or may simply choose not to bother, later pleading ignorance or "other duties more important than this." In other cases, illness or other emergencies may force a change in plans. This advocate must be adroit enough to hold people to agreed-upon tasks, agile enough to figure something out when that fails, and skilled enough to get everyone else to go along with the fix.

The other big planning piece is the budget. This may be a given, needing only to be laid into a system and tracked, or it may be something quite fluid, which needs constant work in estimating and apportioning. Nasty budget surprises will require agility and creativity to resolve, and necessary cuts and compromises will require a cool-headed mediator. Resulting disappointments within the team will need a sympathetic ear.

Evaluating Efficacy

But above all, someone must be on top of the health of the process as a whole, evaluating the effectiveness of the work:

- Are meetings productive?
- Are team members well informed?
- Is there a process for documentation and appropriate dissemination of project decisions both within and outside of the team?
- Do higher-ups feel they are "in the loop"?
- Are other departments in the museum being included at the right times and in useful ways (such as security, marketing, or floor volunteers)?
- Are team members pulling their weight, and is everyone, more or less, getting along?

Advocates for the project must be the ultimate facilitators, pushing everybody to work to their strengths and gently pulling people out of their comfort zones to get the most out of all the team players. They must know how to call, run, and document a meeting. They must be objective in their analysis of what needs tweaking within the process, yet sympathetic to all players and to their varying points of view. They must also be able to see when a problem has become irresolvable and take it to another level within the organization.

There are some common pitfalls to watch out for in this role. First, the tasks are often given to a team member as a role to play above and beyond his or her first project commitment. When designers, developers, or clients find themselves saddled with this role as well, they may find themselves in over their heads. Next, the role may be given to someone who has neither the skills nor the clout to play it effectively. It may sound easy ("Just keep track of this budget and schedule for the rest of us"), but of course it isn't. Good software products can help, but the skills needed here must be developed over time. It's helpful if this is recognized by the team as a whole. Finally, it's also possible that an experienced person will forgo objectivity and use the many powers of this role to shape project decisions and outcomes in a manipulative or clandestine way. This advocate must be like a good parent, nagging when necessary, but allowing the team true independence.

ACTION STEPS

Each advocacy will need to be aware of the series of steps that all their work products are dependent on, which are described in the following sections.

Researching

Every action step begins with research, whether this is research into one's own or others' exhibits on the same subject, research into equipment costs, content research, research in the collections and archives, materials research, photo research, or any of the other hundreds of arenas that the creation of an exhibition will demand looking into. Good research will result in some kind of documentation of what's been discovered and where it was discovered.

Organizing

Data and information are of little use unless they can be organized in a usable (and retrievable) format. This format should be one that all team members can easily access. This might mean using a graphic such as a pie chart or a graph, it might mean prose in an outline format, or it might mean the creation of some kind of matrix. In large, complex projects, it may mean using a program especially made to hold and organize various kinds of data.

Analyzing, Synthesizing, Visualizing

Once material has been organized, we can then go on to the task of making meaning of it and imagining the ways in which we might employ it in our work. Moving research and abstract ideas into tangible experiences requires us to be able to visualize and imagine what can be. How might we employ what we've learned as an element of an exhibition? How might visitors view, interact with, and be involved with this material?

Documenting, Managing, Presenting

In order to reveal the strengths, weaknesses, and potential uses of our inquiries to others, we might want to show all our documentation to the rest of the team, or we might decide that time will be better spent in

summarizing our findings in a document to present in a team meeting in which the whole group will decide the outcome. Ideally, we will present the pros and cons of our research with enough examples and context for our organizational and analytical thinking to create a whole picture for our teammates, and then make a recommendation about if or how we might make use of this resource.

As we work through these action steps in each area of our work—whether it be budget creation, content development, visitor research, or the selection of objects from the collection—we need to be aware that these tasks are often reiterative. In other words, we will in each project phase be coming to a "closer approximation" of the overall shape of the exhibition, the budget, the interactives, the collections list, and so on, until each is eventually in its final form going into the Fabrication phase. It will be necessary for each advocacy to find appropriate and accessible ways to present the next iteration of their work to the team at large for review. It's important that these iterative reviews consistently occur and that we not assume that the budget and list of elements we made on day one will be the same budget and list of elements we'll have just prior to the Construction phase. We need to plan for continual refinement throughout the process.

DANGERS AND PITFALLS

Simply naming five people to represent five points of view does not guarantee a successful project. As noted in the previous chapter about collaboration, team members need to develop trust in each other in order for the group to work well together. Who actually holds power and who is perceived to hold power within the team is often an issue that makes or breaks teams (Figure 2.13).

The advocacy strategy discussed here is a way to think about allocating power within a team. Each advocacy has a base:

- The institutional advocate holds ultimate power over the whole project. As a client, he or she has

Figure 2.13: There are dangers that lurk, like giant polar bears, if the team has not committed to trusting one another. *Image courtesy of Gary Lee, CLR Design, Inc.*

approval or veto power over every aspect and ultimatcly holds the purse strings.

- The subject matter advocate has the power of content and object knowledge and speaks from a passion for the importance and accuracy of these basic building blocks of exhibition.
- The visitor experience advocate's power is based on skilled and passionate leadership for the development of an exhibition that is engaging, serves visitors and the community, and meets its user goals.
- The design advocate's power is based on the skills that make an exhibition a living, breathing, three-dimensional experience, not just a series of objects strung together by a series of ideas.
- The project and team advocate's power is based on control over the budget and schedule and on his or her ability to cross over all other lines of responsibility within a team in order to serve as an overall manager.

Day-to-day leadership of a project may be vested in any of these advocacies, but is usually placed with the exhibit developer, as the person most responsible for the user experience; the designer, as the person most responsible for the physical results; or sometimes with the project manager, as the person most responsible for the budget and schedule. (See Chapter 3 for some common patterns used in team organization.)

But, regardless of who is on a team, how it is organized, and how willing everyone is to work collaboratively, power issues are bound to come up. It's not just a game of rock-paper-scissors: no one's issue or passion trumps everyone else's in reliable ways. Although viewing decisions through the eyes of advocacy can help, goodwill, trust, and a desire to create an exemplary product for visitors—and not just to win today's argument—will go a long way.

For some kinds of standoffs, data can help. Testing ideas, storylines, and prototypes of various kinds with the public can render an otherwise heated argument moot. For more intractable issues, it may be that a decision must be made by fiat by the client or other higher-up.

Each of these advocacies is critical for the success of a given project: forgetting to attend to any of them can spell disaster.

Of course, in one way or another, all team members are advocates for all these areas or should be, as there are all kinds of overlap. In well-functioning, collaborative teams, this is a plus, for it means that people have each other's backs and things are not overlooked. In paranoid or divisive teams, it can cause friction and disagreement as people squabble about turf and "face."

In smaller institutions, team members may have to adopt a kind of "split personality" as they may have to play more than one role and advocate simultaneously for more than one point of view. This is not at all impossible to do. Outlining the various advocacies and who will play each role, at the outset, will allow all the players to do each job well and be respectful of the work others are contributing.

ADVOCACY FOR THE INSTITUTION

CREATING THE LANDSCAPE FOR EXEMPLARY EXHIBITIONS

The main job of the advocate for the institution is to provide the impetus, resources, and approval for exhibition generation that furthers both the immediate and the overarching goals of the organization. Ideally, these goals are firmly tied to the institution's overall mission, a mission that is not only understood but enthusiastically supported by both staff and board.

Three Critical Questions

- How are exhibition ideas generated?
- What is an appropriate balance between "micromanaging" and delegating authority?
- Who's in charge?

Approach and Philosophy

The exhibition and program are primary devices in the toolkit for reaching your audiences. They can be harnessed to drive attendance, drive change, or drive mission fulfillment. Clarity and internal agreement about why the institution will pursue a particular path, and what can be expected as a result, are the first and most important questions for you, the advocate, to ask. Exhibition is a critical tool, but often an expensive one. We need to be sure from the outset that it is really the tool we want to deploy. Many organizations do exhibitions—especially traveling exhibitions—mainly to create marquee change, and this is a perfectly reasonable goal. Change gives the organization something to publicize and a

Photo: Philadelphia Museum of Art and Fairmount Waterworks Interpretive Center, Philadelphia, PA. Photo courtesy of Richard Cress

new reason for the public to consider a visit. But change for change's sake will not necessarily deepen the institution's bonds with its audience or community or even its funders and friends. Change for change's sake will not automatically develop or sharpen the skills of the staff, or take best advantage of the collections, grounds, or other resources, nor will it necessarily further the institution's mission. New exhibition and program initiatives can do all this and more. It's your job to figure out how to leverage these opportunities to best serve both your audience's needs *and* your institution's goals (Figure 3.1).

Figure 3.1: Advocates for the institution bear the weight of responsibility for the whole institution, so it is in everyone's best interest that they be strategic delegators and collaborators. *Illustration by Meghann Hickson*

LAYING THE FOUNDATION

First Big Question to Ask

Most organizations have a mission statement. The first big question to ask is: "Does our mission statement reflect our institution's current thinking/master planning and is it crafted in a way that is useful in thinking about the creation of exhibitions and programs?" It's important to have articulated a statement that not only guides program direction, but also describes and supports the philosophical

Figure 3.2: National Museum of the American Indian, Smithsonian Institution, located on the National Mall opened in 2004. *Photo courtesy of Richard Cress*

Figure 3.3: Master plan drawing for live animal habitats, interpretive exhibits, and other amenities. Sketch plans are helpful in early stages of the planning process to envision how the project may come together. *Image courtesy of CLR Design, Inc.*

stance of the institution. Sometimes, a perfectly usable and believable mission statement exists, but has somehow in practice been ignored or subverted. If any of these things may be an issue for your organization, it might be well to review the statement and, if necessary, to change it. This is best done in collaboration between staff and board. Ideally your mission statement—and any corollary materials, such as vision or value statements—really will help to guide exhibition teams in such issues as topic selection, visitor goals, and community involvement.

The Planning Jargon Crib Sheet:

- *Institutional mission statement:* A brief description of the purpose of the organization and its overall goal. It must be clear enough to serve as a guide to decision making regarding both program choices and the business strategies that support them.

- *Vision statement:* An aspirational articulation of the grandest possible future for the organization, e.g., "We will transform science education in the United States." Even though your institution cannot immediately realize this aspiration, this is the bold statement of what you are striving to be.

- *Values:* Organizational values shape institutional culture and staff interactions, inform business practices, and serve as criteria for end-user interactions and products. For instance, you may value *honesty*, *risk taking*, *friendliness*, and *collaboration*. Subscribing to these organization-wide will influence how you do your work, and how you relate to colleagues, community, and visitors.

- *Strategic plan:* A 3–5 year plan that describes and establishes the near-term activities of the organization, and how it will allocate its time and resources to achieve specific goals and objectives that support the loftier aims of the mission and vision statements.

- *Goals and objectives:* Goals are aspirational; objectives are measurable. Objectives support goals and are, in turn, supported by tasks or action steps, usually within a specific time allotment.

- *Master plan:* A design document that presents both physical and interpretive solutions to describe the best use of space and other

resources to create optimal environments for both visitors and staff, to meet agreed-upon goals. Typically, MPs also include budget estimates and will often be seen as a step in fulfillment of a larger strategic planning effort.

- *Interpretive plan:* A plan for exhibits, programs, and outreach that takes into account an organization's mission and vision statements, community and visitor needs, organizational resources and values, and revenue aspirations. Typically, IPs will be done by, or in concert with, staff and will contain cognitive, emotional, and experiential goals for users. IP creation may exist independently, be an action step within a strategic planning process, or be a part of a larger master planning process.

- *SWOT (strengths, weaknesses, opportunities, and threats) analysis:* An analysis of the organization's strengths and weaknesses, and the opportunities and threats presented by the environment in which the organization exists, with the aim of capitalizing on the strengths and opportunities and limiting the impact of the weaknesses and threats. Some items may show up on more than one list!

- *Benchmarking study:* A report that analyses the organization in relationship to others in the same community or region and/or against national benchmarks, in order to provide rational and achievable goals for such things as attendance and fundraising. Visitor research to gauge the reputation of the organization may also be a part of this.

- *Feasibility study:* An analysis of the likely prospects for a specific initiative—usually an ambitious one—such as a new museum, new wing, or capital fund drive. Such studies might include physical assessments and audience potential as well as financing issues.

- *Business plan:* A document that outlines an organization's strategies to promote its survival and development within a time frame, typically with a focus on stabilizing or increasing revenues and on dealing with potential risks to that end.

PLANNING MAJOR CHANGE

If your organization is planning really major changes, you may want to do a more thorough review of your current situation and future plans by engaging in a strategic planning process. This can be done in-house, but it's useful to hire an outside planner/facilitator to ensure that this process is as helpful as possible, and to prevent it from being hijacked by any single point of view, either on the staff or on the board. Strategic planning processes should scrutinize and question your organization's current mission and vision, goals and objectives, and values and aspirations to create a plan that will allow you to reach the outcomes you have defined as a group. The process also analyzes organizational strengths and weaknesses and can include some kind of benchmarking and/or feasibility study to assess the viability of your ambitions. (You may want to increase your audience tenfold or raise $50m in a new capital campaign, but when all the research about your situation within the local community and comparable data from other similar institutions has been analyzed, it may be clear that neither of these outcomes is actually achievable in the foreseeable future.)

Planning Your Planning

Strategic plans usually lay out a 3–5 year window of activities and milestones and may include (or call for) staff or consultants to create an interpretive plan to look specifically at exhibition and program initiatives that support the aspirations the strategic plan outlines. If big changes are needed in building and grounds as well, an overall master planning process that looks at both physical and interpretive issues may be more useful. This kind of planning will make use of design professionals who can help you think through the larger space and plant issues, prioritize goals, and make budget estimates and recommendations for implementation (Figure 3.4).

While this sounds like a lot of time and money to invest, if your institution does not have this kind of conscientious planning in place, or if stakeholders and

Figure 3.4: California Academy of Sciences interior infrastructure. *Photo courtesy of Richard Cress*

plan implementers are not on the same page about important fundamentals, it can be difficult for you to know what exhibition and program initiatives will work best for your organization, and even more difficult to get them to happen.

One of the benefits of planning with outside consultants is that you may simply have a better chance of actually getting it done. In so many organizations, review of assumptions about the current program and planning for the future program are just never achieved—everyone is just too busy and overwhelmed by the day-to-day. Of course one reason people feel so crazed may be that they don't have a clear path before them. Even small decisions need weighing and conversation before they can be acted upon, which takes up an awful lot of time and

Figure 3.5: California Academy of Sciences new brand and entry signage.
Photo courtesy of Richard Cress

Figure 3.6: The completely rebuilt 400,000-sq.-ft. building, brand identity, and infrastructure of the new California Academy of Sciences, opened in 2008 across Golden Gate Park from the also fully rebuilt de Young Museum dedicated to the fine arts. The environmentally friendly and earthquake-resilient building produces 50 percent less wastewater than the previous building, recycles rainwater for irrigation, and uses natural lighting in 90 percent of its occupied spaces. The building also utilizes 60,000 photovoltaic cells and is covered by a 2.5-acre "green roof." *Photo courtesy of Richard Cress*

energy: time and energy that might be better spent . . . well . . . planning! When you are actually paying for experts to come and help you in this work, it is more likely that time *will* get set aside, stakeholders *will* find the energy to engage, conversation and debate *will* occur, and a plan *will* be produced that can be a template for institutional progress (Figures 3.5 and 3.6).

Of course, it's also possible to spend all your time planning, never getting to the implementation. Repeated planning processes can become a way to delay action. This is usually because people are afraid, or lack confidence in their decisions. While it's wise to examine all the pros and cons and dig deeply into questions of resources and anticipated outcomes, simply standing pat as the world around you changes can also lead to disaster. To avoid this, it can be useful for leaders like you to invest in coaching to help build courage and to cheerlead, so that needed changes in institutional direction can take hold (Figure 3.7).

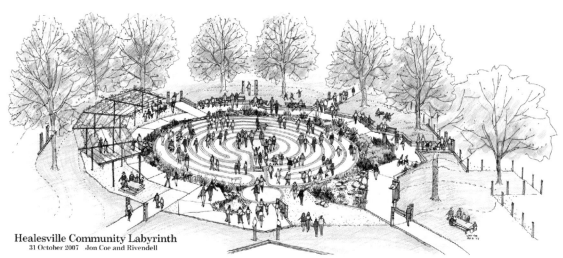

Healesville Community Labyrinth
31 October 2007 Jon Coe and Rivendell

Figure 3.7: Although planning feels like an endless labyrinth, there are professionals who can guide you to the light. Healesville Community Labyrinth. *Design and drawing by Jon Coe, Jon Coe Design, Pty. Ltd. and Rivendall, 2007*

Plan Ahead: A Short Overview of the Planning Process

by Jon Coe, May 2005

Benefits of Planning

Planning allows institutions to make the most of all their resources. Benefits include the ability to:

- Anticipate and shape their future

- Prioritize actions

- Budget time and dollars

- Improve internal communications

- Improve coordination and cooperation

- Sell their agenda internally and externally

- Raise funds

- Evaluate their programs later

Why Do Plans Fail?

Planning may have unfairly acquired a tarnished reputation. Master plans fail when:

- They are unrealistic and unachievable

- They aren't supported by business and implementation plans

- They are imposed from above without involvement and support of those responsible for their implementation

- Their chief supporters leave the institution

- They can't adapt to changing times

- A poorly managed process leads to "planning paralysis," unnecessarily delaying needed actions

What about the Next 100 Years?

By Leslie Swartz Senior Vice-President for Research and Program Planning at Boston Children's Museum

Boston Children's Museum celebrates its 100th anniversary in 2013. It is the second-oldest and one of the largest, most frequently emulated children's museums in the world, and this occasion is a milestone for museums of all types.

At the 50th anniversary, BCM turned a corner under the leadership of Mike Spock, who famously removed the DO NOT TOUCH signs from the dusty glass cases and created hands-on exhibitions and programs while also shifting the focus to the client. BCM developed a laser-like focus on the developmental and educational needs and interests of children.

Not an Easy Act to Follow

Over the past decade, BCM staff and board have danced around this question, undertaking audience research, master planning, a major renovation and expansion, new leadership, a revised mission and vision, revised values, and a new strategic plan. These efforts kept circling back to a major misconception. Contrary to the name, our actual audience is roughly 49 percent adult. And this large and vociferous audience is not entirely happy with their experience at BCM. Many adults complain that they are bored during their visit. The most frequently heard praise is that BCM is a great place to take the kids on a rainy day. Ouch! It's possible that many adults never understood what we were really about.

To check this out, we commissioned a study of the extent to which adults expected to learn something during their visit, and whether this self-perception affected the quality of their experience. The researcher found that most adults did not see themselves as learning during their visit to BCM, but, when they did, their experience was more satisfying and educational for all.

Turning 100

As BCM turns 100, we have decided to tackle our institutional identity as perceived by a large percentage of our audience. Whom are we for? Our name says that we are for children, but the kids come with adults. For many years, staff and board have talked about changing our mission to include explicitly adults or families. In naming this audience, we must then address what we are doing for them. How can we better engage the adults, drawing them into parent-child and their own learning experiences? Beyond simple amenities (more and better seating—always), what would we do differently in exhibitions to improve the quality of the experience for the adults?

Planning for Parents, Too

BCM's institutional ideology posited that the experience be child focused and child directed. A child could follow her own curiosity at her own pace, developing process skills unencumbered by factual discussion of the phenomenon, say of bubbles. Case in point: the first "science" exhibits had no signage beyond the title (e.g., Bubbles, Raceways). Maybe three decades later, the overall gallery was called Science Playground, an ambivalent nod to the discipline. The most recent iteration presents multi-layered, bilingual signage in two big swaths: cues for the adults wanting to encourage the kid's exploration, and more detailed (and lengthy, for a children's museum) explanations of the physics. What exactly was the goal of this new signage, and was it accomplished? In the report on adult learning in BCM, the researchers found that these graphics were roundly ignored and rarely remembered in exit interviews.

Figure 3.8: Construction Zone exhibition with building blocks for older children and adult visitors, Boston Children's Museum. *Image courtesy of Boston Children's Museum*

Two other experiments with exhibit copy gained more traction. In Construction Zone, designed for the young ones, a trailer off to the side offered an intriguing selection of building blocks for the older children and adults. There the signage talks directly to parents about what kids are thinking and learning while building with blocks. Set in easily recognized WORK AHEAD style,

the text is brief, direct, powerful, and memorable (Figure 3.8). In Peep's World™, a preschool science exhibit, the exhibit text focuses exclusively on what an adult might say to the child to expand her/his play and experimentation. Evaluators heard the words spoken regularly in the exhibit (Figure 3.9).

Adult Engagement Is Key

Neuroscience has now become children's museums' best friend. The big take-away messages are (1) that babies are very smart and learning at a phenomenal clip from the get-go, (2) that adult engagement is critical to the child's brain development, and (3) that positive environmental stimulation not only enhances a child's healthy development but can even mitigate the worst effects of toxic stress caused by poverty, depression, and violence. So, we are now inviting adults in on the secret behind the whole experience, making the learning visible and explicit to the adults. Listen adults: there is method to the madness, with research to back it up.

The centennial milestone, neuroscience, and the push for more educational dollars prior to kindergarten have all converged to create a great opportunity for BCM to let adults in on the secret. Through rebranding and new marketing efforts, we are changing what we say about ourselves. In thinking about exhibitions, we carefully consider what the adults will do, learn, say, take home, talk about, and explore further. We are experimenting with communicating important messages to adults through new media. We are taking a clearer look at who really is the audience for the text, and we write to that audience. An exhibit's components and activities address its multigenerational use, demanding that the adult role be meaningful. We take very seriously the concept of parents as first teachers, and just as we had taken on teacher training as a serious responsibility, we are now thinking about new ways to educate parents as well.

Figure 3.9: Peep's World exhibition, label directed at adult visitors, Boston Children's Museum. *Image courtesy of Boston Children's Museum*

NEW EXHIBITION INITIATIVE

The second big question to ask is: "What is the institutional need for a new exhibition initiative?" You may need to drive more attendance or diversify your audience. You may need to fulfill mission priorities or a promise to a donor or a staff person. You may need to be opportunistic about a funding possibility to create immediate change. You may need to create titles that support school curricula. You may need to experiment with new ways of doing exhibitions, develop new topics, or begin to create systemic change in the overall exhibition program.

Developing Exhibitions that Reflect Institutional Identity

By Charlie Walter, Executive Director of the New Mexico Museum of Natural History and Science, Albuquerque, New Mexico

Core Ideology as a Framing Tool

It is a daunting task beginning an exhibit master planning process. It was the late 1990s, and I was working as vice president of interpretation at the Fort Worth Museum of Science and History. We had envisioned four major exhibitions that would be part of a capital campaign. We had called museum consultant Roy Shafer and asked him to help guide us through the process. I envisioned spending a few days with Roy brainstorming exhibit ideas. I was wrong. Roy spent his first day with us talking with all senior staff about the capital campaign and our aspirations for the exhibits we would build. At the end of the day, Roy simply said, "I don't think you are ready to start developing exhibits. You need to first get a better idea of who you are as an institution, so that you can measure success against this."

Roy's comment started a series of workshops with senior staff based on the work of Jim Collins and Jerry Porras in their book *Built to Last*. An initial step was to choose a staff "Moon Group." The idea here was: If we were going to build an exact duplicate of our museum on the moon

and had limited space aboard our rocket, who would need to be on that ship to create the new museum? This initial step forced us to think systemically about the organization, seeing how our various departments were connected and aligned to create the visitor experience we offered.

Core Values

Our next job was to create core values, something we had never considered before. Starting by brainstorming our personal values, we ultimately came up with a list of the museum's core values (*our essential tenets*):

- Respect

- Integrity

- Families and Children

- Warm, Friendly, Accessible

- Learning

From these values and a strong sense of mission, we then developed a statement of our core ideology (*our aspiration for 100+ years*):

Learn: To Change the World

And finally a statement of our core business (*our vehicle by which we pursue our aspiration*):

Provide: Extraordinary Learning Environments

With this framework of ideology and values in place, we hired the firm Hands On! Inc. to help us begin with exhibit development. At least we thought we were ready to begin. Hands On! challenged us by asking a series of questions. Just what is an "Extraordinary Learning Environment?" What will a visitor do in one? What are the outcomes of such an environment? We worked together to answer these questions and ultimately came up with a framework we could use to judge whether or not we had succeeded in creating an exhibit (now called an Extraordinary Learning Environment) that met our aspirations.

Definition of an Extraordinary Learning Environment (ELE): An ELE is a stimulating, multidimensional, immersive place where visitors have opportunities to hear real stories, interact with cool stuff (including our collections), and construct their own knowledge—and because of their experience, the visitors will never be the same.

What an ELE should be: Fun, immersive (for a while you forget everything else), encouraging discovery, learner driven, stimulating, multidimensional, accessible, resource efficient, connected.

Visitors will have the opportunity to: See and touch cool real stuff, hear stories, test their ideas, have fun, catch themselves doing something they never thought they would do, do things they cannot do at home or in school, play, interact with others, experience "a-ha!"

What happens to visitors because of their ELE experience?

Short term: Laugh, eyes light up, curious, emotionally stimulated, out of the ordinary experience, gain confidence/competence

Long term: Gain confidence/competence, achieve deeper relationship with their world, develop perspective, experience personal growth

As we developed our first exhibit under this framework, an exhibit called *RISK!* for the Science Museum Exhibit Collaborative, we utilized this new framework to guide the development process (Figure 3.10). We knew we were no longer just developing exhibitions. We were

Beam Walk (Exterior)　　　Exit　　　Extreme Gallery　　　Headlines

Figure 3.10: Initial sketches for the *RISK!* traveling exhibition developed and designed in a partnership between the Fort Worth Museum of Science and History and Hands On! Inc., an exhibition planning, design, and fabrication firm. In this exhibition, visitors discover the emotional, intellectual, scientific, and social complexities of risk. *Image created by and courtesy of Hands On! Inc.*

developing Extraordinary Learning Environments. From this exhibit onward, we would utilize two criteria to help us determine success: (1) To what extent visitors grasped our big idea and learning goals, and (2) How well we met the goals as outlined in our framework (Figures 3.11 and 3.12).

Figure 3.12: The "I-Beam Walk" at the entry of the RISK! traveling exhibition from Fort Worth Museum of Science and History. This Extraordinary Learning Environment dares visitors to teeter along an I-beam that gives the illusion of performing the "high-risk" job of a construction worker high atop a skyscraper structure. *Photo courtesy of Hands On! Inc.*

Figure 3.11: Visitors are not just told about the science behind risk, but are also asked to take chances and to truly feel as if they are taking a risk. An Extraordinary Learning Environment taps into the emotional and affective responses in visitors, so they will "catch themselves doing something they never thought they would do, or do things they cannot do at home or in school." *Photo courtesy of Hands On! Inc.*

There are no wrong answers, and it's also possible that an initiative can fulfill more than one purpose. It's simply important to know what you are aiming for. You—and everyone involved in the initiative—should be able to briefly answer the following questions about your project with confidence and enthusiasm:

- What are we doing?
- For whom are we doing it?
- In the end, what will success look like?

Where Do Exhibition Ideas Come From?

In some organizations there seems to be no end to the ideas circulating from staff, board, community, and even potential funders. In others, viable concepts seem in short supply. Clarity about your purpose in mounting new exhibitions can help you sort through and prioritize ideas that bubble up from all these sources. If, on the other hand, there is a lack of interesting topics to consider, trying one of the following strategies may help.

Brainstorming

How to set up and manage this technique is discussed in Chapter 8. Who will be invited to participate and who will facilitate the session or sessions are questions for you to carefully consider if you're to get at the best, most useful ideas.

Charrette

This technique usually involves outside designers and developers with input—especially around subject matter and resources—from staff. Charrettes often take place over a 2–3 day period and are an intense effort to bring forth, organize, and document as many good ideas and strategies as possible for the organization to consider. Another possible benefit of this approach is the opportunity to meet and briefly work with some professionals you might want to contract later to see through some of the ideas you've selected. Read more about using this technique in Chapter 8 (Figure 3.13).

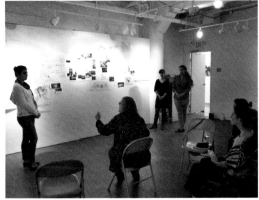

Figure 3.13: Charrette with institutional advocate giving feedback to the development and design team. *Photo courtesy of Polly McKenna-Cress*

Interview

Meeting in small groups or even one-on-one with specific individuals from a variety of departments within the museum may reveal ideas and passions that, for whatever reason, aren't shared in larger venues. Providing ways for even the shyest, most diffident, or most tentative of staff to air their hopes for new exhibition and program may reveal some excellent starting points.

Visitor Research

Asking visitors by interview, questionnaire, or "talk-back" in the museum or on your website about the kinds of exhibitions, programs, or events they might want to see can be very helpful. "Topic testing," or finding formal or informal ways to get visitor and/or potential visitor feedback about a list of possible titles and approaches, is also a very useful step. Read more about visitor research applications in Chapter 8.

In reviewing the data you have gathered, consider these two issues:

- In your mind, is the selection of a specific topic dependent on the point of view an exhibition will espouse, or on a specific approach to the content? Can you get agreement about this internally? Is this point of view or approach consistent with the mission?

- Is it really an exhibit? Often a topic is tempting and highly mission correlated, but an exhibition may not be the best way to deal with it. If there is any question, spend some time thinking through with colleagues if this subject might better be pursued through programming, events, web solutions, or other vehicles before a final selection is made. (This work won't be wasted. If you decide it will become an exhibition, you will already have begun the thinking about potential connected experiences possible for various audiences.)

Analyzing Resources

Now that you have selected an idea and you feel confident that it's a viable one, how do you get it off the ground? How will you know if you have the right combination of resources to successfully pull a project off?

Staff

Do you have on staff the necessary talent, skill, and staffing hours to do this project? Do you know how much time it will need? Can you find ways to free personnel up to take this work on? If the answer to any of these questions is no, are you prepared to hire contractors to make up the differences? If so, do you have the necessary internal means to find, interview, hire, contract, oversee, and pay for the work of outside firms or other labor?

Collections

Are there unexploited treasures lurking in your artifact collection or archives? Is there enough retrievable documentation about various aspects of the material to even answer this question? Are potential materials in good enough shape to be placed on exhibit? If major conservation is needed before objects can be displayed, do you have the resources to accomplish it (Figure 3.14)?

Figure 3.14: Collection storage at Thomas Jefferson's Poplar Forest. *Photo courtesy of Richard Cress*

Physical Plant

Hidden issues within your physical plant can take you by surprise, especially if you hope to do an exhibition that is substantially different in approach from projects that have come before. For instance, older buildings may not always have the electrical capacity or accessibility to easily run new media applications or better lighting. Poor climate control may create problems for both objects and visitors—especially if your new initiative brings in more people. Poor acoustics might make exhibit spaces uncomfortable for visitors and need remediation, or there may be accessibility challenges for visitors who have a disability. It's better to know these kinds of limitations in advance, in order to anticipate budget and schedule needs (Figure 3.15).

Tools

Computers and software will be needed by internal staff, and design staff will need Macs to do their best, most efficient work, even if your IT people hate the idea. Printers, white boards, and room to display drawings and matrix boards and have team meetings will also be needed. If you are planning to prototype or perhaps even build in-house, carpentry tools, mount-making tools, and the environmental

Figure 3.15: Interior restoration at Thomas Jefferson's Poplar Forest. *Photo courtesy of Richard Cress*

supports to use these safely will be important. Conservation is another area that will demand a special environment and special tools. Even if you do not intend to create much capability for in-house work, considering the object handling, conservation, and mount making as in-house tasks makes sense because moving collection items off-site for any of these functions is expensive and potentially risky.

Funds

Lack of funds is often used as the reason exhibitions remain old and stale. The truth is that good, even great, exhibits can be done with limited monetary resources. The mantra of "Cheap, fast, good: pick two" suggests that "slow and cheap" is a possible strategy (Figure 3.16). Indeed, if you have the time to invest in getting in-kind contributions of materials or even labor, or can schedule the sparing use of limited staff time or carefully supervised volunteer time, you may slowly—yet still with excellence—manage to create impressive results. The most important things necessary are a compelling idea and real passion to develop and share it.

Figure 3.16: "Cheap, fast, good: pick two."

Taking one's time can also be a way to thoughtfully develop ideas through prototyping on the floor with visitors or in the community. Once a team has done this careful, if low tech, kind of work, they will also be better prepared to write successful proposals.

Who Should Be on the Team?

Personnel who represent the five advocacy areas we've discussed are the essential team members. In small organizations working on small-scale projects, some of these roles might be filled by the same person. In large organizations working on large projects, the team might have those characters, plus a whole raft of others working on specific aspects of the undertaking.

Choosing this team, or choosing a team leader who will create the team and oversee the project on a day-to-day basis, is one of most important decisions the institutional advocate for the exhibition will make.

Regardless of the kind of model chosen, collaboration can be at the heart of the working style. Even quite hierarchical models with a clear team leader and decision maker can—and should strive to—be collaborative in their work. (See diagrams of possible team organizational structures at the end of this chapter.)

As a higher-up in the organization, you can make a big difference in how teams under your jurisdiction will work, by modeling useful behavior for your staff. No one—including you—needs to be best friends with his or her coworkers, but if you model and support an ethos that is tolerant, actively seeks new ideas, gives credit where it's due, and is passionate about both the subject matter and the visitors and community for whom we are working, you stand a much better chance of creating the landscape for exemplary products.

Delegation and Authority

Unless you are imagining that you are in fact the team leader, you will be delegating day-to-day authority for this project to the team you have selected, but at the same time, you will need to find ways to stay in touch with the project. This is one of the most difficult tasks for you to take on: you need to keep close enough to the work so that you understand what's going on (or not going on . . .), so that you can act as an intelligent critic and client during reviews, or even to intervene if a project seems to be stalled or to be going off the tracks. Yet, you must also allow the team to operate independently—unless you want another full-time job. If they do not feel they are independent, they will be looking for your approval for every step they take, for fear of doing something wrong. Some team members might even use your interest to sabotage those to whom you have delegated authority.

It's important that you and the team, especially those members you may have appointed as leaders, understand the organizational model you wish them to work through and feel that the authority you have delegated to them is real.

In-House or Out-of-House: That Is the Question

Do it oneself or ask for help. Producing exhibits requires a number of professional skills—design, multimedia, project management, evaluation, writing, curatorial—and there may be times when you are faced with a decision whether to produce an exhibition with in-house staff or hire out-of-house consultants. Whether driven by staffing capabilities, workload, money, or scheduling, of course there are pros and cons to consider for each option.

Out-of-house firms bring the inherent advantage of an objective point of view, as they are physically outside the museum environment. Larger-scale projects might be especially suited to external firms because they can tap into skills and experience that museum staff may not possess. Firms also have greater resources in terms of the number of people and array of skill sets that they can focus on the project. Without the demands of day-to-day museum operations and visitor needs, firms can stay on task and be more efficient in meeting exhibition timeline dates. Finally, hiring an outside consultant on a flat-fee terminal contract may be less expensive in the long run than maintaining a full-time in-house staff.

In-house staff, on the other hand, have important advantages as well. Staff benefit from living with their creations every day and seeing what works and, more important, what does not. They can test and prototype their concepts right away on the floor, and make adjustments based on visitors' responses. Staff generally are aware of insider information and know how their visitors will react and what concepts simply will not work. They know how and by whom exhibitions will be maintained, are on-site to troubleshoot, and can upgrade the exhibitions to ensure sustainability. They may be more adept at broader collaboration from an exhibition start to closing because they work directly with all facets of the museum, visitor and interpretive services, development, marketing, and maintenance staff. Finally, they have a sense of "ownership" of exhibitions they create and so have a vested interest in ensuring that their creations are sustainable past opening day.

The pros and cons of staff versus consultant options are situational, and therefore a decision one way or another must be weighed against the particular project needs, capital and labor resources at hand, and ongoing maintenance of the exhibition over time.

REVIEW, CRITIQUE, AND APPROVAL

Your role now becomes that of "the client": one of review, critique, and approval. Staying engaged enough in the work so that you can actually make informed decisions, yet staying far enough out of the process that you let the team do their jobs, is a delicate balance.

A reporting structure in which team leadership has time with you each week is often a good strategy. Some administrators ask that team leaders write a weekly report, but in our estimation, face-to-face meetings and occasional attendance at a working team meeting will be far more useful. A schedule for milestone reviews and a demand for milestone documentation you really understand and can respond to are absolutely necessary.

Review Milestones

Material for review should include both visual descriptions and written documents that grow more detailed at each milestone. Such materials should be sent to you at least a few days before a presentation so that you are familiar with the work beforehand and can have your questions and comments ready. At a minimum, at least four such milestone reviews should be scheduled over the course of a project, based on both written and visual presentations of the following materials (The next set of four sketches/drawings, Figures 3.17–3.20, illustrate what visual form may be typically included in these four milestones.):

1. A concept plan, with visitor research results and a guesstimated budget (Figure 3.17). Drawings are done to facilitate clients' expectations and approvals.

2. A schematic plan with visitor research results and an estimated budget (Figure 3.18).

Figure 3.17: Sketches and drawings are important to visually mark these milestones and further facilitate clients' expectations and approvals. Utah's Hogle Zoo bridge entry gate. *By John Collins Jr. Image courtesy of CLR Design, Inc.*

3. A design/development plan with visitor research results and a refined budget (Figure 3.19).

4. Construction documents, final object/image lists, draft copy, and a final budget (Figure 3.20).

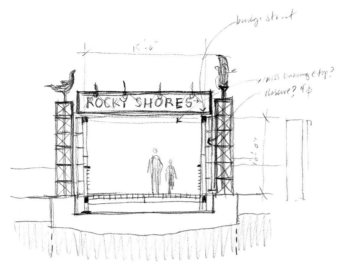

Figure 3.18: Utah's Hogle Zoo: A Schematic Design Sketch. *By John Collins Jr. Image courtesy of CLR Design, Inc.*

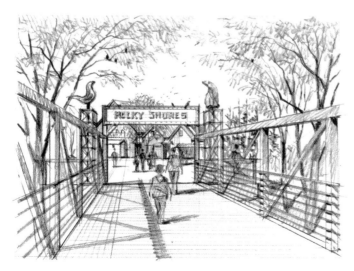

Figure 3.19: Utah's Hogle Zoo: A Design Development Perspective. *By John Collins Jr. Image courtesy of CLR Design, Inc.*

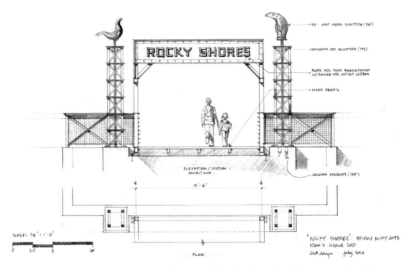

Figure 3.20: Utah's Hogle Zoo: Measured/scale drawing (Construction Document). *By John Collins Jr. Image courtesy of CLR Design, Inc.*

For large, elaborate projects, we would counsel more frequent formal client reviews, perhaps every 3 to 6 months. In fact, depending on size, the team may find it useful—or even necessary—to batch materials into smaller phases. (For more details about project phases and the kinds of deliverables typically produced in each phase by developers, subject matter specialists, designers, project managers, and visitor researchers, see Chapter 9.)

How to Comment

As a client, you will need to review presentation materials carefully, ask questions (even if they feel like dumb questions), and make clear statements about aspects you find worrisome, or just not as good as you think they should be. Your input can be very useful in comparing the "big picture" of the exhibit as you understand it to the particulars of the exhibit that are emerging from the work. Do they match? Are we still aiming at the agreed-upon audiences and goals, and are we still in sync with the overall mission? Do the continuing stages of visitor research suggest that visitors will understand what we're trying to do and be engaged by it? As team members become more concerned with the detailed aspects of the project, your overview can be a truly useful barometer.

You may also put yourself in the shoes of prospective visitors and ask yourself how engaged you are in the presentation, and if you really understand what the team is trying to teach through the exhibit, or what emotions or attitudes they intend to evoke.

The most important thing will be your ability to be clear about what does not seem to work, and to put your worry into language that tells the team why you think something is not working, not just that "you don't like it." And, it's not your job to "fix" the problem by showing up with a new design solution; rather, it's your job to give clear voice to problems and to be willing to demand revisions until you see the problem you have described being solved.

Not Ready to Approve?

But what if you just don't feel up to it? What if you don't feel you have the skills to really judge whether or not the product your staff and/or consultants are creating is good enough for your audience? Get help. Ask a colleague you trust to review materials with you, or even to go to presentations with you. If you are dealing with a big project and a lot of money, it may even be wise to hire some advisors or a client representative who "speaks design," or to invite a visitor researcher into a closer relationship with the project, to help you see things through another lens.

However, when using such help, it will be very important that you ensure that the attitude of critique and review is not a confrontational one: "I don't have confidence in your ideas, Team, so I'm taking it outside for a 'vote.'" Instead, assure the team that any outside expertise or any visitor research you request is simply feedback that will help to ensure the best possible product. Ultimately, remember your original goals and defend them, because it is all too easy to be sidetracked by other errant ways of defining your success or failure, internally and externally.

Providing Other Resources

You can also be useful to the project by engaging other departments that can offer skills such as fundraising capabilities or marketing expertise. As the team member who represents the project to the institution at large, you may be in the best position to make such connections in support of the exhibition effort.

As a mentor, you might also encourage the team leader or the team as a whole to think about other resources they might engage, from outside the institution. Sometimes teams are so wrapped up in the internal struggles of the work that they don't think about this, or they may feel that the responsibility to solve all the creative and technical problems is all theirs. You might make it possible for them to think outside the institutional box and talk to scholars from related fields, or invite in designers from local theater, or speak with learning theorists or preschool teachers or performance artists—giving them permission to engage with anyone who might push their thinking.

INSTITUTIONAL CULTURE AND RISK

In the end, you are the judge of whether or not the material, approach, and tone of the exhibition are appropriate for your institution, community, and stakeholders. Often, the institutional advocate is the figure who will have to make hard choices about specific content, or about the tone or voice through which difficult or controversial ideas are presented.

It's easy to be frightened by what might happen if something in the exhibition rubs a stakeholder, community member, or funder the wrong way. It's important to remember a few things:

1. Visitor research reports that the majority of visitors are not just ready for, but often will only be satisfied by, "the truth." Most visitors come to history museums hoping to hear it—not a glossed-over version made up of comfortable clichés. Likewise, visitors to natural history museums know before they come that such organizations believe in and espouse evolution as a scientific tenet. They won't be surprised to find it in your institution. And most art patrons know that contemporary art often pushes limits. They wouldn't be coming to your institution if they weren't ready for that. All that being said, every organization has its limits. In exhibitions containing difficult or controversial elements, you will be the person to ultimately define those limits and defend the choices, internally and externally.

2. It's rarely "the visitor" who is made uncomfortable—usually it is forces within the institution or the board that become afraid of criticism. Visitor research can be a wonderful antidote to the fears some may express.

3. Insisting on careful work with community members, during the exhibit's development, around issues of possible concern to specific groups can prevent you from being blindsided in that arena and is another way to allay initial fears and avoid problems later down the road.

In addition, you may need to use your powers of persuasion to lay fears to rest and protect the integrity of the project and the ongoing work of the team.

ASSESSING RESULTS AND LEARNING FROM THEM

Some of your assessment may be quite straightforward and completely quantitative, answering questions such as: "Did our attendance numbers improve?" "Were we able to diversify our audience?" Other subtler measures are equally, perhaps more, important.

Formal summative research and evaluation aimed directly at the audience are an opportunity to find out much more about how well a new program serves your constituencies. Too often, we imagine that evaluation is a judgment like a grade on an exam, or that it means that an "outsider" will define our success or failure in their terms and not ours. No wonder evaluation can make people nervous! But in fact, in the museum world, evaluation tends to be a thoughtful collaborative practice from which we can learn quite a lot that we can bring forward into subsequent projects.

So this phase of visitor research is more like other phases than we might realize, since it is mostly about "taking the pulse" of the audience, finding out what they are thinking and how this new experience jives with their expectations and interests—as well as something new that we have great interest in: what people do in the exhibit and what their behavior tells us about our goals. In other words, the enlightened path that visitor evaluation provides should be—especially for you, the institutional advocate—a step in a longer path of strategic/master/interpretive planning. (See more about summative evaluation of exhibits as a tool in measuring success in Chapter 8.)

Working Group Diagrams

Top-Down Models (Figure 3.21 and Figure 3.22):

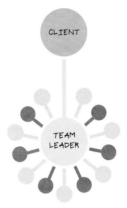

Figure 3.21: The team leader may be anyone on the team—including you—but usually a plan like this has a designer, a developer, or a subject matter expert at the helm, holding the vision and voice for the project. The model assumes that everyone else on the team reports to this person, except for you, the client. In large teams, a variety of others may report to each of these direct reports.

Figure 3.22: Again, the team leader may be anyone on the team, but again, it will probably be a designer, developer, or subject matter expert. This model suggests a less hierarchical arrangement, with advocates and other staff in a more equal relationship with the leader—rather like a stage director surrounded by the expertise of the designers, actors, stage manager, and playwright.

Flattened Models (Figure 3.23 and Figure 3.24):

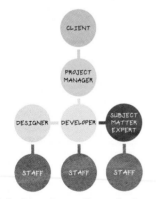

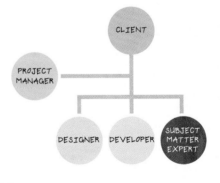

Figure 3.23: In this scheme, the project manager keeps the project in order and is the only member of the team who reports directly to the client. This creates equality among the other players and may give them some creative freedom.

Figure 3.24: In this scheme, all the players report directly to the client—very egalitarian, but can be hard to manage.

All these models are, to a great extent, scalable. In very large projects, for instance, the design advocate may oversee a cast of other designers and outside fabricators. Visitor experience advocates may have researchers, writers, and assistant developers as reports and subject matter experts may have other scholars and researchers as well as collections managers and conservators. Project managers may have assistants and may supervise in-house fabrication. These kinds of reporting systems can be set up in a variety of ways, keeping in mind the skill sets and capacities of individual members. In smaller teams, more than one of these roles may be filled by a single individual.

FURTHER READING

Collins, Jim, and Jerry I. Porras. *Built to Last: Successful Habits of Visionary Companies*. New York, NY: Harper Business Essentials, HarperCollins, 1994.

Collins, Jim. *Good to Great: Why Some Companies Make the Leap…and Others Don't*. New York, NY: HarperCollins, 2001.

Lencioni, Patrick. *Five Dysfunctions of a Team: A Leadership Fable*. San Francisco, CA: Jossey-Bass/John Wiley & Sons, 2002.

Lencioni, Patrick. *Overcoming the Five Dysfunctions of a Team—A Field Guide for Leaders, Managers, and Facilitators*. San Francisco, CA: Jossey-Bass/John Wiley & Sons, 2012.

CONGRESSIONAL ELECTIONS

ADVOCACY FOR THE SUBJECT MATTER

IT'S ABOUT SOMETHING TOO!

Again and again in this book we have reiterated that the visitor is at the core of our exhibit-making efforts, as if what the exhibit is about, what we are trying to teach, or the feelings we are trying to evoke or instill are devoid of content. This, of course, is not true. The content is our reason for being, and the collections, the research functions, and the exhibitions and programs that support that content internally and externally are our intellectual property and our most valuable possessions (Figures 4.1 and 4.2).

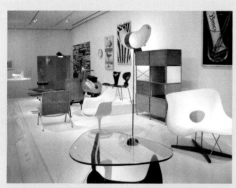

Figure 4.1: Furniture Show 1950s-1960s, Museum of Modern Art, New York, NY.
Photo courtesy of Richard Cress

Figure 4.2: Hippopotamus (*Hippopotamus amphibius*), Behring Hall of Mammals—National Museum of Natural History, Washington, DC.
Photo courtesy of Richard Cress

Three Critical Questions

- How much information is too much information?

- How can we satisfy both the casual visitor and the amateur enthusiast within the limited format of an exhibition?

- How can we honor our passion for the content and the needs and wishes of visitors, too?

APPROACH AND PHILOSOPHY

The creation of exemplary exhibitions requires that we understand not only the topic, but also some things about the end users and about the forms and media that will be used to convey that content to them. While other members of your team may have more knowledge about visitor behavior and the advantages and limitations of exhibition as a device, those advocating for the subject matter will need to have some idea about what exhibitions can and cannot do and the ways that various kinds of visitors are apt to act within them (Figure 4.3).

Figure 4.3: The subject matter advocate is responsible for research, accuracy, and inspiration of the team on why the public should care about this topic. *Illustration by Meghann Hickson*

The role of subject matter expert can be a difficult one: you are being asked to advocate for the content (and possibly a collection) but seem constantly to be told that the complete depth of your expertise will not, cannot be plumbed. Finding the balance point between what an exhibition can usefully and engagingly present to visitors and the enormous amount of expertise, information, and supporting materials that can be made available is daunting, and possibly irritating. Yet, the balance must be found. For if we don't start at the beginning for visitors or we overwhelm them with too much information and too much work, we run the very real risk that visitors will simply walk away.

The super-emphasis on the visitor noted above comes out of generations of museums and other similar institutions placing priority first on the display of objects, then later on teaching about those objects, and only more recently on the possible meaning of the objects and the relevancy of that meaning to the lives and interests of visitors. In other words, while the objects and the facts they embody remain important, it is the ideas and emotions raised by them and by the visitors that currently take precedence in the creation of contemporary exhibition.

Why? There are several reasons, one of which is the impact of the Internet, which makes viewing artifacts and getting information about them very easy. What can exhibitions provide that the Internet cannot? One might be the kind of personal and emotional connection with objects and artifacts that will inspire ongoing curiosity about a particular topic. Another is that it's become clear that, as our educational and technological infrastructure changes, fulfilling our mission is dependent on our ability not only to show objects that can just as easily be viewed on the Net, or to write down facts about these objects that could just as easily be found on a wiki, but to get people interested and engaged enough to further pursue the topics and ideas our exhibitions illuminate and make more tangible. This means the creation of emotional connections, not just factual or intellectual ones. Museums have found they must offer something that is both different from and complementary to the learning we can do online, and one way to do that, which has always been important if unacknowledged, is by engaging visitors' emotions.

For these and other reasons, exhibitions are better understood to be about encouraging the interests in the uninitiated, or "beginning learner" (someone who is just learning about the topic) rather than providing an encyclopedic lesson for the initiated.

Example Exhibition

An installation at the Metropolitan Museum of Art of Egyptian artifacts illustrates how both the beginner and the initiated can be served simultaneously. Visitors entered through a dramatic recreation of a tomb to discover a spare, beautifully installed exhibition of extremely fine examples of ancient materials. Text panels described them in terms both of their use and their aesthetic value. Visitors could also detour to adjoining rooms in which a huge number of other artifacts were installed, cheek by jowl, in crowded cases, almost as if one had been invited behind-the-scenes into the collection itself. This "study storage" approach works best for users who already have some sense of what they are looking at. The sheer number of alabaster bowls wows those of us who don't have much experience with ancient Egypt, even though we're unlikely to draw any important conclusions about ancient Egyptians or our own contemporary world. Even someone more knowledgeable, who

can appreciate such a collection in all its richness, will see an installation like this as a simple pleasure or as a supplement to his or her studies and not a replacement for a graduate school seminar.

Didactic Information and Facts

The preceding being said, how can we best use our often vast content resources to engage, move, and enlighten visitors (Figure 4.4)? This is not to say that exhibition cannot teach new facts and ideas. It can. But we will have to be aware of two things in our pursuit of didactic learning:

- We'll have to be very goal-oriented and potentially iterative in our attempts to teach specific facts, and this pursuit may take up quite a lot of the exhibition's resources and our visitor's time.

- Our visitors may or may not be interested in learning the facts we deem most important. If they aren't, they may choose to ignore us.

Figure 4.4: In the past, these types of specimens at the American Museum of Natural History may not have been on display, and if they were, there would have been little to no interpretation. Visitors would not have fully understood why or for what purpose these objects where collected. *Photo courtesy of Richard Cress*

These realities can be a real challenge for the subject matter expert for whom the material to be exhibited is a life's passion. Naturally, we'll want to share our love of and our expertise about the topic, but few of us truly expert in a subject can remember what it was like to be a beginner knowing almost nothing, or what the first steps were in our own engagement in the subject matter that eventually led us to become experts and connoisseurs.

Subject matter experts may also have trouble communicating with their teammates who may appear to be constantly "dumbing down" the material in their search for a starting point for the visitor—and maybe for themselves. It's usually wiser to help them find those beginning ideas and then, depending on the institution's audience intentions, to work with teammates to add more complex ideas and resources in interesting ways than to seek a more complex and challenging view of the material as a first step.

Back to the Spark of Interest

For subject matter experts, the most important first step may be to try to remember and understand how one's passion for

the subject arose in the first place. Was it a specific experience, a special teacher, content ubiquitous in one's family, a book, a film, a trip, or a series of such exposures? While the exhibition may not be able to reconstruct one's own important experiences for the visitor, this kind of personal examination can be useful in identifying potential first steps for others by revealing what was exciting about this material for a specific beginning learner: you.

Another strategy is to ask oneself, "When I speak casually to people about my expertise, what most interests them?" (Figure 4.5)

Talk to People

Yet another is to begin directly speaking with visitors to your institution. You might work with teammates in informal ways to do this or even set up some informal opportunities yourself, or you might ask to become part of the interview force of a more formal visitor studies effort. Be prepared to be taken aback by how little solid information many visitors actually have about your specialty.

Experiences like these should help you to be creative about possible starting points for the exploration of your subject matter in an exhibition, and they will also prepare you for the fact that not everything you might like to see in the exhibition can actually be there.

You'll have to think through all the same issues as your teammates as regards the cognitive, affective, and experiential goals of the exhibition; the target audience and overall narrative; and the organizational structure. (You can review some of these exhibit development issues in Chapter 5.) You can best serve the concerns of subject matter by being very clear about the basic information that will need to come across to visitors.

Establishing Goals with the Team

To help establish the educational, emotional, and experiential goals with teammates and to support their further research and

Figure 4.5: We know mummies were once living human beings, but then what? Addressing this simple visitor question, the Penn Museum of Archeology and Anthropology's memorable and humorous "A raisin is a mummy you can eat!" is interpretation that says it all. From the *Secrets of the Silk Road* exhibition. *Photo courtesy of Polly McKenna-Cress*

thinking, you should expect to answer the following kinds of questions for the team:

- What is the most basic information visitors will need to know in order to begin understanding this content?

- What, in your experience, are the issues/ideas that nonexperts find most interesting and/or moving? Most confusing or counterintuitive?

- Are there any tools or processes associated with this subject matter that might form the basis of an active exhibit element or program?

- What, in your experience, are the misconceptions about this material you most often run into?

- What objects, specimens, archives or ephemera are available for our use? Which of these materials might be the most exciting and engaging for visitors to see?

- Is there other material we should think about trying to acquire through loan or purchase?

- What are some materials team members might read/watch that will provide trustworthy information?

- What new work is being done in this field?

- Who else in this field (or community) should we being trying to consult?

- What, if any, are the basic differences of opinion among various experts in this field?

- Are there places we should visit, such as other museums, sites, or landmarks?

OBJECT OR IDEA DRIVEN

Some subject matter experts who are deeply engaged with a collection may not immediately see the difference between the notion of an exhibition being driven primarily by objects and an exhibition being driven primarily by ideas: Doesn't the object elucidate the idea? In an art museum, aren't the object and the idea exactly the same thing? For subject matter experts immersed in art products or material culture, a single object can speak volumes (Figure 4.6). And the deep specimen or fossil collections of a natural history museum can tell detailed stories to those with the ability to read them (Figure 4.7).

Figure 4.6: Visitor contemplates Willem de Kooning's painting without interpretation, Museum of Modern Art, New York, NY. *Photo courtesy of Richard Cress*

Apart from certain kinds of objects that the majority of us have come to recognize (a reconstructed dinosaur (Figure 4.8), King Tut's mask, Degas' Ballerina), many, if not most, displays of objects speak mainly to the initiated. In other words, we must bring appropriate prior knowledge in order to parse the object's meaning and significance. There are a number of different exhibition approaches we might base on this notion. Which ones we pay attention to and act upon will depend on what we're trying to do with a specific exhibit area in the first place. For instance:

1. We can use collections materials to teach the basic information that visitors need but may not come to the museum knowing, hoping to instill a beginning appreciation for the material so that, eventually, these visitors may find that such objects begin to speak as directly to them as they do to us.

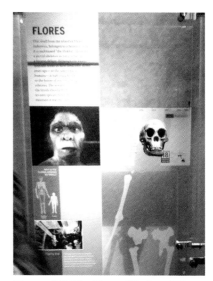

Figure 4.7: The Flores Skull, or "The Hobbit," found in 2004 gave scientists profound new information and has sparked debate about human evolution. American Museum of Natural History, New York, NY. *Photo courtesy of Richard Cress*

Figure 4.8: Tyrannosaur, American Museum of Natural History, New York, NY. *Photo courtesy of Richard Cress*

2. We can use collections materials primarily as the support for ideas within an exhibition, much as we would use film, photos, or illustrations, but also understanding the power of the "real thing" in getting an idea across.

3. We can put collections materials out in traditional ways and depend on the innate appeal of the material (rarity or beauty or strangeness or sheer numbers [Figure 4.9]) to engage at least some of our novice visitors, knowing that viewing such displays often more than satisfies our more content-sophisticated visitors.

Subject matter experts who are less engaged with collections materials may find that "idea-driven" sounds like a good approach, thus with every aspect of the exhibition, the big ideas need to be carefully parsed and subject to the same disciplined rules as every other part.

Figure 4.9: Display of gold, National Museum of American Indian, Washington, DC. *Photo courtesy of Richard Cress*

Exhibition as Medium

The fact is exhibition is a very limited medium or form of direct communication. Although it can tap a huge variety of communication methods, users are still moving through space on potentially tired feet, having to work to "get" what the exhibition is about by reading, thoughtful looking, and other forms of engagement. There are no particular payoffs for all this effort—no diploma, no raise, no improved G.P.A.—only personal satisfaction. And there are no punishments for simply cruising through.

Additionally, what research tells us about leisure time museum visits is that they are usually socially driven. We are going to spend quality time with family or friends or we have found the perfect place to take Aunt Maude when she comes to town. These relationships can be much more important to visitors than the specific exhibition they find themselves in.

A Focused Contract

With relationships there are "agreements," and an exhibition is a contract between its creators and the visitor. Of course, visitors *do* want to see what we have and *do* want to know at least some of what we know, but they want to do so in an environment that is engaging and accessible,

that starts with *focused attention* to their needs (and not the makers), and that allows them to capitalize on the social value of the occasion as well.

So, we may be able to get a fundamental idea across, such as: *The machines of the early textiles mills of New England were driven by water-power. Those who owned water rights could grow rich.* However, we can't also teach a comparative history of such endeavors across the New England states, and biographies of the 10 most important mill owners, and how steam eventually replaced water, and what machines and fuels supported that transition, and who got rich in this way, or a hundred other equally interesting connected ideas. We have to have a clear understanding of just what we are trying to get across and focus our energies on that. Also, if we hope visitors will retain such messages and even become more interested in the subject matter, we will need to build in some affective or emotional goals and experiential approaches as well. The combination of the cognitive, the affective, and the sensory is often what makes things stick.

Layering Content

All this is not to say that exhibition must only repeat one simple note. There are lots of strategies for sharing more detailed information that don't create such visual chaos within the exhibition as to render it unintelligible. For instance:

- **Layered label copy:** In this strategy, label copy (and even objects and interactives) are pitched to various age groups and/or levels of interest in the topic. Basic information is readily accessible and in the boldest formats. More layers of information can also be included in smaller type or in other vehicles—such as low cases that only children are likely to see (Figure 4.10).

- **"Pull-ups":** (Not the diapers!) Pull-ups are another of those vehicles. In this strategy, small panels containing more information (or a specific kind of information, such as biographies, for instance), can be pulled up from sleeves mounted on walls or within reading rails without the

Figure 4.10: California Academy of Natural Sciences, San Francisco, CA. *Photo courtesy of Richard Cress*

visual confusion created by placing all of this information on the wall (Figure 4.11).

- **Study or resource areas:** These areas can contain books, staff, computers, objects, a place to borrow videos or activity kits, and the kiosks to use them in—all of this providing more exposure to the subject matter and/or tailor-made experiences for specific groups, such as families.

Figure 4.11: The "Pull-up" or pull-down quill pen is the visitor's means to answer prompted questions and start an interactive map of the revolution that erupted between the New and Old Worlds. Education Center at Mount Vernon, George Washington's Virginia home. *Photo courtesy of Richard Cress*

- **Hand-outs:** Hand-outs are a traditional and quite useful way to provide more information. In addition, if they are handsome enough to be kept, they can be a way to provide visitors with a reminder of the exhibition and their visit.

- **Web sites:** Web sites are probably consulted more often by people who are anticipating a visit, but there are ways to encourage follow-up visits, such as asking visitors to sign up within the exhibition for email engagements and reminders, or through the use of free apps, as well as multiple emerging technologies.

- **Catalogs, magazines, or other publications:** These are traditional and quite useful ways to extend the reach and depth of an exhibition.

DANGERS FOR THE SUBJECT MATTER EXPERT

It's exciting to work on exhibition in one's subject matter, but it can be problematic:

- **I will be judged poorly by my academic peers for "dumbing down" content.** To the expert, the simplification of a complex idea may feel like leading visitors to unfounded conclusions, but we have to start somewhere. Most of your teammates and potential visitors will not have your sophistication and will not attain it in their lifetimes. Still, they can enjoy and profit from exposure to the material if you make it engaging and don't make them feel too dumb to get it.

- **This isn't my expertise! How did I get roped into being responsible for this?** When you are drafted for your research skills and not

your specific expertise, it may feel awkward. However, our advice is to take it as a compliment!

- **I have a very specific point of view about this content that I feel it is my obligation to promote—my teammates see this as only one possible attitude and want to see "multiple points of view"—I can't support this!** This is a more serious issue that may need adjudication by the advocate for the institution, as it is potentially a question of how the mission of the museum is being constructed in the program.

- **Visitor research reveals that most potential visitors aren't very interested in the specific aspect of the content area that most interests me.** Remember that visitor research is not "voting." We are simply trying to find out how to best approach visitors with the content we want to present. However, there are some situations in which visitor research may reveal so little interest on the part of users that we may find it wiser to put our energies into another topic, or another aspect of the larger topic.

To Be Expert, or Not to Be

It's often true that the institution has no subject matter expert working in the specific field in which it wishes to create exhibition. Sometimes, this means that the exhibit developer becomes responsible for researching and documenting content and finding experts to interview to establish content goals and later to review final materials for accuracy. It can also mean that someone on staff who has good research skills or subject matter expertise—just not in THIS exact subject matter—is drafted to create the content package.

Increasingly, it's also possible that an itinerant subject matter expert will come in to freelance in this role. While museums—especially art museums—have always used "guest curators," in many institutions full-time staff roles have been cut to a minimum in a variety of specialties so more consultants, temporary staff, and freelance experts are being used. It's also possible that subject matter expertise might be found in local universities or in other museums and that institutional arrangements can be made to tap these resources by creating a partnership.

All Content and All Collections Are *Not* the Same

We have been speaking about subject matter expertise and collections as if they were the same across the various kinds of museums, zoos, arboreta, and so forth. This is, of course, not true. Exhibitions using materials from and expertise about China, for instance, might render very different results in a maritime museum interested in the China trade, a children's museum interested in the third grade social studies curriculum and diversity as a value, an art museum with an exquisite scroll collection, and a natural history museum exploring recent fossil finds. To this end, we asked two curators to add their points of view about how they have applied their expertise in the creation of exhibition.

Exhibiting History through Objects

By Jessica Neuwirth, Curator
Natick Historical Society, Natick, MA

I came to working in museums from academia—specifically American Studies, with an emphasis on material culture studies and historical archaeology. In general, my subject was household objects, American and European, seventeenth to early twentieth century. My training was object focused, research and connoisseurship based. My audience consisted of my teachers and my peers. I struggled through the first years of work. My training in material culture included requisite study of buildings and artifacts—I weighed, measured, and counted ceramic shards, made scale drawings of construction details of eighteenth-century buildings, studied the chemical composition of glazes and enamels. But it was the documentary side of things—research into probate inventories, court cases, diaries, and advice books—that was most interesting. Room by room, inventories opened a lens on what people were really doing with their things—did people really have portable, adult potties in dining rooms? (Yes, they did in some parts of America in the early nineteenth century, Figure 4.12). Suddenly I could see that objects could reveal something about different times and places—after all, how different would I be had I lived in a world that thought a potty was properly placed in the dining room?

As I moved into museum work, the most useful aspect of my graduate training was a transformation in my thinking about the meaning of things. I came to realize that none of these methods of study really made these objects speak, and indeed, objects didn't speak at all—the meanings of things came to light by looking at the role of things in daily life. I had that moment of recognition when I read the first part of this chapter on advocating for subject matter in exhibition development while preparing to write this piece. . . . It says "For subject matter experts immersed in . . . material culture, a single object can speak volumes . . . But apart from certain kinds of objects that the majority of us have to come to recognize . . . many, if not most, displays of objects speak to the initiated." This is both a theoretical and a practical insight into the meaning of things, and how we can go about bringing those things to a general audience. Objects are not inherently meaningful—they cannot speak volumes to those who don't already know a lot about them. The meaning of things is socially constituted in action—objects gain meaning in use, misuse, and reuse. Because objects gain their meanings in the many ways that people talk about and transform them in daily life, the same solid object can indeed have many meanings for different users. So, if we really want visitors to use objects as a portal to other times and places, to help them experience and understand another world, then we have to recognize that we have to build a story world around the objects so that they can be meaningful. . . . We have to think about what we include in exhibit text and what contexts we use to display objects.

How did this affect my exhibition work? When it came time to display objects for other people, I wanted to make the meanings of things clear to people. The details of construction or materials used wouldn't necessarily help people understand the people who used the objects or the meanings these things had had for their users and makers at some point in history. For example, when creating an exhibit about dining wares from the early nineteenth century in rural New England I had to consider three-tined forks. I had the choice to describe the makers, materials, and process, and even where these came from and how that reflected changing patterns of trade. Or I could talk about how, when

Figure 4.12: Author's historic potty chair in the dining room of her c.1765 Elfreth's Alley home . . . but only used as a chair! *Photo courtesy of Richard Cress*

Figure 4.13: One can see how difficult and unfashionable it would be to eat with a two-tined fork. *Photo courtesy of Jessica Neuwirth*

three-tined forks came to rural New England in the early to mid-1800s, some people eagerly bought and used them, and others were nervous, didn't know what to do, or thought the new forks were pretentious. Some steadfastly kept to two-tined forks even though there were foods it was harder to eat with them . . . and watched new-fangled fork users try new foods and experiment with new manners—there was a lot to do about forks. What fork you used at the table and with guests said everything about where you stood in the new versus traditional manners and lifestyle debate that raged . . . three-tined forks transformed their users into up-to-date fashionistas (Figure 4.13).

This exhibit and others like it, where I worked to use objects to elucidate the interior worlds of past people, helped me to know that I wanted to say something beyond the facts of manufacturing and the like, but I still struggled with how. For me, the answer for talking with nonexperts, and for exhibiting history, was story or creating what gamers call story worlds. But what kind of story? The idea that we should use story to convey information has gotten a lot of press—many people believe and have argued that stories are the best way to get information to visitors. Story is not just description of events, or a collection of ideas; it has to be about solving a problem, a transformation, a journey from beginning to end with detours in the middle that explains why something is the way it is, or why someone feels they must change from x to y, cause and effect. But I would argue that story is not a vehicle to pass information—it's the journey itself, because story is narrative, and narrative is how we make sense of the world around us. When you commit to story as a method of making sense of something for someone else, you have to focus on the story and leave out lots of detail about the thing. There just isn't enough room for all the detail. A story is not about a subject per se, but about the transformation and change—some bigger theme or idea.

In the short format of an exhibition, you have to be very clear about what bigger idea you want to talk about. In the preceding example, the idea was to show the dramatic moment of change in people's lives brought about by the Industrial Revolution. To tell the story of nineteenth-century tablewares as a collision of old versus new meant I couldn't exhibit all the other information about manufacturer, materials, and so on. What I could tell was a story about the struggles of

aspiring middling folk and how they experienced one aspect of what we call the Industrial Revolution in their daily lives. As historians, we engage our storytelling imaginations all the time when we analyze data—and we are drawn to the stories we find in our research that elucidate larger points we want to make. However, as we construct our arguments in defense of our ideas, we focus on the data—we forget the power of story. I wouldn't argue to change the way historians conduct their research, but merely how we take that research and bring it to a larger public.

An Art Historian's Perspective

Rachel McGarry, Associate Curator,
Minneapolis Institute of Arts, Minneapolis, MN

Exhibitions in art museums generally fall into three categories: exhibitions drawn from the permanent collection, exhibitions organized internally with loaned artworks, and touring exhibitions organized by an outside institution. For curators, the different types dictate vastly different investments of time and energy. The organization and execution of a major loan exhibition, especially if you're doing a catalogue, represents years and years of work, much of it spent not researching and writing, but rather seeing to matters of staging and logistics— negotiating major loans (cashing in chits, favors, and unborn children to borrow the Rembrandts), seeking partners, applying for grants, writing loan letters, assessing conservation needs, applying for indemnity, requesting photography and image rights for the publication, and more. The makeup of the exhibition team, those who will transform the exhibition from a concept (and a lot of paperwork) into a reality, depends on the scope. Bigger, more ambitious exhibitions, such as our sold-out *Rembrandt in America* show, require massive teams and many meetings, starting six years ahead of opening day. For many exhibitions, the main curator and museum director may be the only people who see a show from its beginning stages to the final reading of lumen power in the gallery. They support and supply the continuity

and vision. Many exhibition team members—exhibition designers, graphic designers, interactive media producers, editors, art preparators, development officers, educators, programming coordinators, marketing specialists—come onto a project years into its preparation, and work on many different exhibitions simultaneously. Yet these individuals have a major impact on what visitors see and the show's ultimate success.

The first meeting of your newly assembled team is a very exciting moment, particularly when you have been laying the groundwork for years in relative isolation. This group wants to hear far more than just the elevator pitch. They want details, stories, color, superlatives. Their interest, enthusiasm, and ideas will ignite the project in new ways. Now the show has a fresh, dynamic team of promoters who will transform it into a far richer project than what a few curators or administrators could have envisioned alone.

The guiding principle behind any exhibition I organize is how to engage our diverse audience with the art, ideas, and the period of art or history featured in the show. The pluralism of a museum's audience—local and global, young and old, curious and jaded, sophisticated museum-goers and first-time visitors, scholars and entertainment-seekers, athletes and artists—requires that we offer a range of opportunities for engagement. You hope that something about the exhibition—the objects, labels, signage, audio guide, brochure, docent tour, lecture, concert, art class, art station, social media buzz, extended hours, or specially named coffee drink in the cafe—will catch a visitor's interest and offer a point of entry into the subject or art. This is where the exhibition team is key. Drawn from across different fields, each member brings a distinct set of goals and experiences to a show. Unanimity is not the point. Instead, you want to invite diverse viewpoints, assess which fits with your vision, and then harmonize them into a cohesive presentation that best serves a range of visitors. Here are some examples of how team members at the Minneapolis Institute of Arts solved different exhibition challenges.

Most Minnesotans Cannot Read Chinese

In 2010, I built a small but prominent exhibition around the arrival in the Twin Cities of Matteo Ricci's 1602 map of the world, a monumental woodcut produced by the Jesuit priest in Beijing to show the Chinese, and particularly their emperor, the world as Europe knew it in the Age of Exploration. I rounded out the exhibition with contemporary Western maps, Ming dynasty objects, Catholic Reformation devotional objects, and Jesuit missionary prints and books, but the centerpiece was this rare, fascinating map. Its impressive scale, comprising six large sheets of paper, gave it considerable wall power. A good deal of the print was devoted to Ricci's extensive commentary about the world, which mixed knowledgeable descriptions of faraway people and cultures with fantastical reports of, for example, a nation of crane-fearing foot-tall dwarves in Russia, humans with oxen feet in Turkey, and one-eyed people in Kazakhstan. As Ricci's comments were written in Chinese, the challenge was to present a representative selection of his writing without overwhelming the visitor with text. Our talented graphic designer came up with a brilliant design for a large didactic panel, which included enlarged extracts of fourteen of Ricci's descriptions, along with concise "curator's notes." This copy was elegantly arranged on a grayed reproduction of the map and color coded by continent. The design invited casual skimming as well as more careful reading. Our exhibition designer placed this panel on the back of a baffle in the gallery, so visitors saw it only after looking at the map. They could spend time reading it while glancing back at the actual map or skip it entirely (Figure 4.14). Our web developer created an accompanying exhibition page so that further translations could be accessed from nearby computer kiosks. To my surprise, many people did this, too.

Figure 4.14: Installation of Ricci's 1602 map of the world with interpretation to the left and a bench for contemplative viewing. From "Global Positioning c. 1600: A Rare World Map," Cargill Gallery, Gallery 103, Minneapolis Institute of Arts, Minneapolis, MN. *Photo courtesy of Minneapolis Institute of Arts*

No Small Matter

Recently our curator of African art suggested we co-curate an exhibition about the role of small, portable religious objects in the spread of religions throughout the world. Here the challenge was display. How could we install a gallery full of tiny works of art without (a) overwhelming the works with a profusion of object cases and (b) putting off visitors more accustomed to appreciating large-scale works? To solve the clutter problem, our exhibition designer installed long, narrow cases against each wall with niches into the background panels of the cases to accommodate the broader works. To engage casual visitors walking through the installation and to signal which works were must-sees, we gave important objects—such as a French fourteenth-century ivory diptych and a Japanese seventh-century Kannon—prominent placement and lots of breathing space. We also used dramatic changes in wall color, midnight blue against white, and shifts in lighting to send visual cues. A well-placed bench invited visitors to sit, rest, and study at their ease.

The Hear and Now

Exhibition audio guides offer wonderful opportunities to respond to those visitors who have a passion for information. Because of my specialty in Italian sixteenth-century art, I was asked to site-curate an exhibition of Venetian painting and drawings from the National Gallery of Scotland. In addition to didactic materials (we customarily create our own didactics, even for traveling shows), we chose 14 artworks to feature in a guided audio tour. There was information the curators wished to highlight at each stop as well as important themes we wanted to weave throughout the exhibition. Before recording began, the curators worked with our education staff and an outside audio guide producer to review the content we proposed, what knowledge could and could not be taken for granted, and how to create an overarching narrative for the exhibition. The producer, working from recorded conversations with curators, and the director of our museum and the lending institution, created a lively, informal, concise, melodious tour of the show. Layers of information were offered

at each stop, so visitors could choose to hear just an overview or select as many as three further in-depth discussions. They were in control of the amount and kind of information they heard.

Each of these scenarios is evidence of how the voices of gifted team members contributed to rich, layered, and accurate content for our visitors, and helped define our museum as a place where they have the choice to actively experience, selectively peruse, or skip altogether, according to their interests and mood.

ADVOCACY FOR VISITOR EXPERIENCES

DEVELOPING EXHIBITION CONTENT FOR VISITORS

Ideas for exhibitions may come from almost anywhere in the institution, but as the old adage says, "Ideas are cheap." What's difficult is not so much choosing a topic (although considering risky or controversial topics may be different) but realizing the potential of that topic for your audience and for your institution. As visitor experience advocates, exhibit developers must work closely with other team members to make that happen. Because the role of the exhibit developer has advocacy for visitors and the visitor experience at its heart, the primary mission is to see to it that visitors are served through such efforts as making the point of an exhibition clear to visitors, constructing an appealing overall narrative, integrating engaging approaches to the material for diverse users, attending to the social, emotional, and cognitive values and, if necessary, skillfully translating material from "academese" into language lay audiences can understand, appreciate, and be engaged by (Figure 5.1).

Figure 5.1: Visitor
Experience Advocate

Illustration by Meghann Hickson

From a practical point of view, fulfilling this mission will mean providing leadership for the team's creation of thematic clarity, for the cognitive, affective, and experiential goals and objectives, and for all kinds of research throughout the process about the ideas, needs and preferences of visitors (Figure 5.2). It will also mean the thoughtful creation of working documents for the team and descriptive devices for milestone critiques and approval that go hand in hand with the design advocates' products such as floor plans and models. Developers are also often charged with the creation (or at least oversight) of final products such as label copy or media scripts and should be working in tandem with educators throughout the process to identify topics for potential programs and places to do them—possibly within the exhibition.

The visitor experience advocate comes in many forms: the exhibition developer, the museum educator and, of course, the evaluator. They are concerned with developing content and story always with end-users in mind.

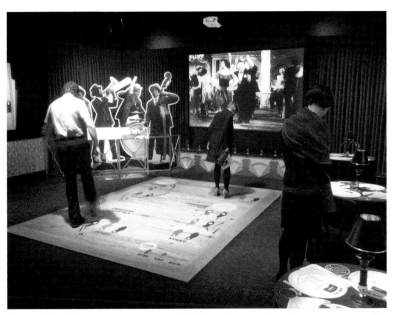

Figure 5.2: Affective engagement: Visitors immerse into the roaring twenties by trying the steps of the Charleston in the re-created speakeasy section of the traveling exhibition *American Spirits: The Rise and Fall of Prohibition* developed and designed by the National Constitution Center, Philadelphia, PA. *Photo courtesy of Richard Cress*

Three Critical Questions

- How do we go from ephemeral ideas to concrete visitor experiences?
- How do we keep the clarity of a vision while still collaborating with other points of view within the process?
- What are the differences between an instinct, a whim, and a go-to-the-mat necessity?

Approach and Philosophy

As we discussed in Chapter 2, the main philosophical issue for exhibit teams in exhibit development is to keep a primary focus on the needs of visitors. But what are these needs, and how do we know? And, how do we bring these needs together with the requirements of the subject matter and the goals of the institution?

How to Select Exhibition Topics

At the very outset of our work, we might think about this in a number of ways, employing one or more of the following kinds of strategies:

- Defining the audience
- What is in popular culture?
- Content Needs of the Institution
- Why do I care about this content?

Defining the Audience

First, we might ask, "*Who is the primary audience for this exhibition?*" Usually, there is a specific reason for mounting an exhibition, and it's helpful when this reason is connected to audience: either we are trying to satisfy (or even increase the numbers of) the kind of audience we ordinarily attract, or we are trying to somehow expand our audience types. But, there may be confusion in trying to answer this question. People often wrongly assume that targeting a specific group means that we are leaving all others behind, and we know that, in most museums, exhibitions need to be able to serve whoever

Figure 5.3: Young visitors to the North Carolina Aquarium, Roanoke Island, North Carolina, can crouch to watch the fish swimming or can be daring enough to peak over the top of the water line to look the alligator in the eye! Taller visitors have to confront the reptiles. *Photo courtesy of Richard Cress*

walks in the door: we rarely have the luxury of being perfectly specific in our audience goals (as we sometimes do in programs).

What's meant by a "primary" or "target" audience is that these visitors will definitely find the things they need, and we want to make the visit enjoyable and accessible to them, and that, secondarily, other audiences will find some experiences or information that they enjoy as well. So, for instance, in an exhibit specifically designed for families, we might find two layers of text, physical and more visual experiences in pairs, with some objects or activities positioned at a lower viewing level for younger kids (Figure 5.3). In the same exhibit, we might also find more sophisticated information in other formats in quieter corners. The point is, that by identifying the audience you primarily want to serve, you'll be able to gauge what basic visitor needs you'll be addressing, both in the level of sophistication of the content you'll be presenting and in the possible delivery methods you might use. You'll also have a template to decide with whom to test your ideas and prototypes and a way to measure your success at the end.

The nicest thing to notice about working in this way is that being specific about a particular audience, and their needs and wishes, often (surprisingly) seems to improve the exhibition experience for everyone (Figure 5.4).

Figure 5.4: Parents and kids interact in the *Goose bumps! The Science of Fear* traveling exhibition from the California Science Center, Los Angeles, CA, using a slider to compare the amygdala portion of the brain in chickens, dogs, mice, turtles, and human beings. The amygdala is the part of the brain that is considered the "threat center." *Photo courtesy of California Science Center*

What Is in Popular Culture?

We might also ask, "*What is popular culture saying about this subject matter right now?*" It's possible that the answer is "*absolutely nothing.*" However, it's also possible that there are films, blogs, TV programs, websites, common misconceptions, news headlines, books, school curricula, and so forth that can provide insight into how diverse people of various ages and inclinations are accessing ideas about this content and what they might be bringing from the great cultural soup into the exhibit with them. So, for instance, if the only thing many people know about the ancient Maya civilization is that they "predicted the end of the world," this prediction,

no matter how false, may provide a hook for an exhibit or at least a signal of what misconceptions your exhibit may need to battle. Ultimately, popular information sources can provide insights into what lay audiences might find attractive about the subject matter and what starting points might be most useful (Figure 5.5).

Content Needs of the Institution

We can ask, *"What is the main need of my institution regarding this subject matter?"* If we have the world's best armor collection and we need to make the most of it, we might use visitor research to deeply investigate what the allure is for the audience of aficionados that already exists and then try to use those insights to broaden that allure for a more general audience. Or, perhaps we have a mission statement that demands that we approach the subject with a particular goal in mind, such as ocean conservation, that provides us with a ready-made focus for our work. If we think strategically about our institutional needs and the strengths of our collections and site, we may find ways to approach exhibition experiences in new and interesting ways (Figure 5.6).

Why Do I Care About This Content?

We can ask, *"What do I want to know about this subject matter? What turns me on about it as an adult? What, if anything, interested me about it as a kid?"* These kinds of questions may be seen by some as too personal, but tapping into the wellspring of your own memories, passions, and curiosity can be extremely useful, especially as a starting point, and as long as it does not become your only idea. Making the assumption that if you like or dislike something that everyone else will too is never a

Figure 5.5: In the artifact-based exhibition, *Maya 2012: Lords of Time,* the Penn Museum, Philadelphia, PA, addressed and capitalized on the media and popular cultural references to the "end of the world" right up front as the entry to the exhibition. The exhibition then turns fiction into fact and reveals what the intricate ancient Mayan calendar did truly predict about December 21, 2012. This exhibition was developed and designed under the direction of Director of Exhibits, Kate Quinn. *Photo courtesy of Penn Museum*

Figure 5.6: Visitor looks through recreated "stereoscope" and is immersed into a moment when 3-D imagery was born. (Two photographs taken at slightly different angles are brought together with the stereoscopic viewer to create depth.) Being able to interact with a historic object brings new depth to the experience for visitors. From the Minnesota History Center, St. Paul, MN. *Photo courtesy of Polly McKenna-Cress*

As part of my personal collection of experiences, I have frequently tapped these powerful and useful memories throughout my professional career. I remembered that kids, like me, were always looking for ways to conquer unapproachable ideas and emotions that lurked in our childhood imaginations and nightmares. What was a more important goal than having the museum become a safe place for exploring those scary ideas? (Figure 5.7)

—Michael Spock

good idea, but using your own accumulated ideas, experiences, and questions to inspire you almost always is.

Learning Theory and Human Development

What can we learn from learning theory and human development? There are hundreds of theorists and practitioners who have written about educational theory, but far fewer who have tried to apply this huge array of material specifically to museums. While this can be useful for us to read, there can be some dangers in trying to apply strictly school-based pedagogical theory to this work since so much of that is designed to perform in controlled, mediated settings, which is mostly antithetical to museum settings, especially exhibitions.

Some of the seminal work of early thinkers like John Dewey and John Cotton Dana, who were interested in what purpose the museum could serve for educational, democratic, and even spiritual purposes, are on a more theoretical level and are inspirational for us to read. Also, more contemporary writers, such as John Falk, Lynn Dierking, and George Hein, describe more flexible pedagogy than most school-inspired materials. The point of their work is that exhibition creators can best succeed when providing visitors with the means to build on their own knowledge (no matter how small that base may be for a specific subject) rather than trying to cram visitors with the knowledge we think it's important for them to learn.

The big idea here is that visitors will "make their own meaning," linking prior ideas, feelings, questions, and facts to the materials they encounter in exhibitions. We would be wise to concentrate our efforts on making this kind of memory and connection process as rich as possible and worry less about whether or not a new fact has been learned. It's not to say that we can't provide for the retention of new information in exhibitions, but rather that, since all our visitors are different, of different ages and interests and with different levels of

Figure 5.7: A Great White shark menacingly hangs over a young visitor's head to provide scale and better understanding of a very misunderstood and feared creature. In the words of Quint, "It could swalla' ya whole!" National Geographic Museum, Washington, DC. *Photo courtesy of Richard Cress*

knowledge of the topic we are presenting, we need to supply a variety of "ways in" to the topic, and not all of these are dependent on "getting it right." What might be of more interest and have staying power for a variety of visitors could be recalling a memory, shedding a tear, sharing personal information within the exhibition, or placing a bit of loose information in a newer, more interesting context (Figures 5.8 and 5.9).

We can also be fairly sure that individuals will have different methods for taking in new information. Howard Gardner talks about what he calls "multiple intelligences" in his book, *Frames of Mind*, which can remind us that addressing information through a variety of approaches and putting it into different kinds of media can have a big impact for visitors with a range of learning styles.

Figure 5.8: Low-tech, yet powerful, the "Talk-Back" chalkboard wall in the exhibition *Righteous Dope Fiend: Homelessness, Addiction and Poverty in Urban America* Penn Museum, Philadelphia, PA. The exhibition was curated by anthropologist Philippe Bourgois and photographer-ethnographer Jeff Schonberg, who both documented the daily lives of homeless drug users over a 10-year period. The exhibition presented visitors with three personal and revealing Yes or No questions; 1. Do you avoid interactions with the homeless? 2. Have you ever used illicit drugs? and 3. Have you ever been arrested? This provokes viewers to enter the story in a different and more personally connected way. *Photo courtesy of Polly McKenna-Cress*

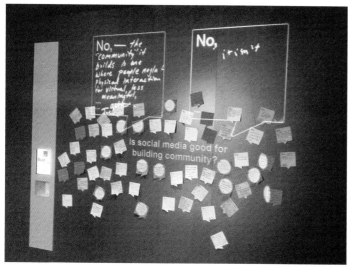

Figure 5.9: High-tech "Talk-Back" wall is a twist on the basic "Post-it"™ wall. Once visitors have written their answers, the sticky note is scanned and projected. The responses are more easily collected and archived. The projected thought-provoking questions, such as "Is social media good for building community?" can be changed easily. National Museum of American Jewish History, Philadelphia, PA. *Photo courtesy of Polly McKenna-Cress*

Research Literature on Visitor Behavior

What can we learn from research literature about visitor behavior? A number of people have written eloquently about how visitors use museums and what their overall needs are. Most thinkers on the subject have organized visitor needs into three basic categories:

- Cognitive (or intellectual or educational and/or didactic)

- Affective (or emotional)

- Experiential (or physical or behavioral or social, though some would argue that "social" should be a separate category (Figures 5.10 and 5.11).

Figures 5.10 and 5.11: The graphic lures visitors over with the title "What is in a sneeze?" and the statement "Air expelled in a sneeze travels at the speed of 100 MPH." A knob and hinge indicate that visitors should open a small door over the young girl's face. When they do . . . ahhh chooo! A sound and a spritz cause them to jump back as they get sprayed. This is an experiential interactive graphic that is funny, surprising and causes a physical response. Science Museum of Minnesota. *Photos courtesy of Polly McKenna-Cress*

However we parse these, there are three ideas that are unarguable:

1. **Visitors bring their own world with them when they visit:** This includes misconceptions about the topic and a literal social world of family and friends, who are often just as important a focus of visitor attention as the exhibition.

2. **Learning in museums is voluntary or "free choice":** No one gets a prize, a diploma, or a pay raise from viewing and retaining the salient points of an exhibition, so visitors will only look at what attracts and interests them in the landscape you have created.

3. **Learning only takes place where the cognitive and the emotional meet for a specific visitor:** If you don't care about it, you won't retain it. This juncture is where the oft-sought "relevancy" of a topic lives.

So, obviously, we can and must find ways to ask our audiences what they know, what they want to know, and what they feel about the subject matter.

Prompting Visitor Conversations

How do we go about getting insights into visitors' minds and perspectives? The techniques can be informal and evocative as well as more systematic and definitive. For example, at the very outset of a project, we might get a dialogue going by using a very informal method, such as the "prompted conversation," in which we display a few objects on a table or cart and ask visitors about them. This can take any number of forms—the table might also contain photos or questions or statements about the subject matter. What appears on the table might change over a single session or repeated sessions. There might not even be a table if you're starting with a topic rather than tangible objects. This is a highly open-ended, qualitative method—one might almost say "impressionistic"—the point of which is simply to find ways to start talking about the subject matter with visitors. We want to find out what seems to spark people's questions and imaginations, what doesn't seem to interest them, and if we are lucky, what new information might turn

disinterest around. In its most formal form, two people might be doing it together—one to engage with visitors, the other to record the conversation and any relevant visitor characteristics. This is not something we'd normally ask a professional researcher to do, but rather something that team members at the outset of a project might do. It can be a real eye-opener, especially for subject matter experts, as they discover how most visitors—regardless of age and education—often turn out to be inexpert about the topic. It can help all team members imagine where starting points might be from the content angle and where high impacts might be sought from the emotional angle. The prompted conversation method does have a danger, however. Because it is so anecdotal a form, we may "hear what we want to hear" from a single visitor and later be prepared to base an entire exhibition on this "proof"—usually an opinion that conforms to our own preconceptions!

Naturally, one will want to use more formal kinds of visitor research throughout the whole exhibition process, ideally employing a professional researcher for the more difficult qualitative and quantitative applications such as the creation of focus groups or an interview instrument and the analysis that follows. But much of this can only usefully happen when you have specific questions and/or a construct of some kind to test. At the very outset, when you are simply awash in an ocean of possibility, informal methods can be a good starting point for the team's thinking.

A Perspective on Front-End Research

by Jeff Hayward

The term "front-end research" refers to the process of systematically investigating where visitors are "starting from"—what do people think about your topic, theme, collection, whatever? You probably have a sense of whether your idea is instantly appealing or something that's odd and unfamiliar, but you might have questions about why it's appealing or not, what people actually know about it, how their expectations will matter, and so on. And therein lies the rationale for front-end

research: you have questions about potential visitors' perceptions of and reactions to your idea. "Front-end" is not a requirement, it's a great resource for you and the team. Professional guidance is likely to make such research more useful (because it's not trial and error like formative evaluation: you're only going to do it once, as the planning process will move ahead with or without these insights) by making better choices about the priorities and methods to use, and by thoroughly analyzing the data. Regarding priorities, I use this approach; choose your top two worries from these five parameters:

- Visitors' expectations and impressions

- Visitors' knowledge (including misconceptions)

- Visitors' interests

- Visitors' ability to understand key concepts

- Visitors' motivations for visiting

Regarding methods, front-end research can be approached with qualitative or quantitative research methods; either type has rigorous science behind it. Qualitative methods (usually focus groups) can be a good choice if your questions are about squishy or hazy topics that are not top-of-mind, about social attitudes, about layers of affect regarding a topic, and about subjects that are not easily and instantly visualized. Quantitative methods (any version of a survey such as interviews or questionnaires) can be a good choice if you want people's individual perceptions such as what's appealing, what they know about a subject, or rating a dozen different interests in possible experiences, or if you want to compare and analyze the perceptions of different types of visitors to define your primary and secondary audiences. As with any research, being clear about your questions, and having thorough analysis of the data collected, are key ingredients to make the effort useful. (See Chapter 8 for questions you can ask a researcher when designing and analyzing audience studies.)

In addition to all the issues regarding the integration of visitors and content, we will also need to be thinking about visitor's social needs, both the group they've come with and their relationship with the museum.

GETTING STARTED: DEVELOPING THE CONCEPTS

The very beginning of a project is exciting! It's a time of possibility in which we will be gathering as many ideas as we can and thinking big about how we might present them to visitors. All the other parts and phases of the process will be about editing down from this expansive moment. What follows are some strategies about how to best take advantage of this wide-ranging time.

Exhibition Journalism or the "Who, What, When, Where, and How?"

The audience has been defined, the team set up, the topic has been chosen, the space assigned, a draft schedule and a budget imagined—now what? How does one actually start?

Research, Research, Research, and Research, and, of Course, Documentation!

- **Content research:** In-house sources, the library, the web, the local university, national experts, and people in the local community with experience or expertise.

Figure 5.12: Introductory wall of *Lincoln: The Constitution and The Civil War* traveling exhibition recognizing Lincoln's bicentennial, from the National Constitution Center, Philadelphia, PA. *Photo courtesy of Alusiv, Inc.*

- **Visitor research:** What do they know and what might they want to know? What seems to interest people of different ages? What seems to move or touch them? What do they seem confused about? (as mentioned in the front end description earlier, what types of questions would help you with concept development?). Has any research been done in other kinds of venues about public interest or understanding of this material?

- **"Cultural Soup" research:** What's been on the History Channel or National Geographic? On the bestseller list? Anniversaries of deaths or births? The web can be especially useful here, revealing the zany as well as the serious issues surrounding the topic (Figure 5.12).

- **School curriculum:** Is this topic included in local, state, or national curriculum, and if so, how? What are the content and skill expectations? It's a good idea to align exhibit content with school curriculum, if appropriate. This will also help with audience development. Educators are in a good position to help with this.

- **Colleague research:** What other exhibits have been done and what can you find out about them? Are there any summative evaluation studies? Are there places that should be visited? What experiences have people in museums or in other kinds of venues had in working with the public around this topic?

Education is not preparation for life; education is life itself.

—John Dewey

- **Collections and other resources:** The heavy lifting on this probably comes later, but the team should, in general, know the depth (or shallowness) of materials immediately available and where—if anywhere—other resources in the form of artifacts, archives, media collections, and the like, might be found (Figure 5.13).

These kinds of tasks might be divvied up among team members or may primarily fall on the shoulders of an exhibit developer, at least at the outset. It will be important—especially if there are a number of people engaged in such tasks—that an understandable way to document the ideas and the sources of those ideas is formulated and that all research efforts conform to this. Regardless of how widely or narrowly these tasks are assigned, someone will need to confront the issue of how to get this material into working formats that the whole team can understand, contribute to, and use.

Strategies for Gathering Initial Information

Audience Research

Using informal methods (like those described earlier as "prompted conversation"), or perhaps more formal methods (such as focus groups or interviews), take the first steps in asking your audiences where their interests, feelings, and expectations lie around this topic. Make sure that everyone on the team has access to the results of such research, and has discussed it

Figure 5.13: Open view into collection storage at the California Academy of Sciences, San Francisco, CA. *Photo courtesy of Richard Cress*

and whatever implications it may have. (For more about visitor research strategies, see Chapter 8.)

Figure 5.14: Group planning retreat and brainstorming session: everyone is up, moving around, and giving input. *Photo courtesy of Polly McKenna-Cress*

In-House Researchers Meeting

Ask in-house people (expert in this particular topic or not) to choose an aspect of the topic that interests them and do some investigative work about it. Then, have the participants talk about their findings (and whatever resources they may have come across) in a meeting. Document the comments and disseminate the meeting notes (Figure 5.14).

Meeting with the Experts

Gather a group of experts in your area for a discussion meeting on the material. Ask what they think the important ideas are to get across to the public, what, in their experience, seems to interest nonexperts, and any other people or resources they think might be useful to consult. Emphasize to them that the form the eventual exhibition will take is not yet known. Since these are people you might want to consult later when you have more for them to react to, you do not want them to misunderstand or be disappointed if their first ideas discussed in this meeting turn out not to be prominently featured as the exhibition develops.

Meeting with Teachers

Gather an advisory group of teachers at the appropriate level and with the specialized content expertise to help you understand the school curriculum and how students might think about the content. This will help inform exhibition elements and programs.

It will be important to remember that, while advisors have subject matter expertise, two things are also usually true: they are not themselves experts at the creation of exhibition and must defer to you and the team, and they may not always agree with other experts. In the end, you will have to decide if or how differing points of view will be presented and then take responsibility for your decisions. Depending on the subject matter and its sensitivity, this kind of group might include community

advisors as well as scholars. If the exhibition will represent aspects of a living culture, it may be wiser to create a separate group of cultural advisors right away to work with as the process proceeds.

Brainstorming

Brainstorming can be used both to collect information and ideas in the earliest phase and, in later phases, to help organize and synthesize these ideas. You might want to invite a variety of interested people from the wider staff to early brainstorming sessions and base the activity on such questions as "What would you like to see in an exhibit about XXX?" or "If our museum had an exhibit about XXX, how might we engage our community around that topic"? (For more about brainstorming, see Chapter 8.)

STRATEGIES FOR ORGANIZING INFORMATION

"Matrix" Board

Pick a wall or a large piece of foam core and create a grid with topics at the top and long empty columns beneath. Get packets of small, colored sticky (Post-it™) notes. Name the topic categories—they may not need to be accurate the first time, but plunge ahead anyway. For example: Visitor Interests, Important Concepts, Interesting Tangents, Collections, Interactive Ideas, Team Worries, Good Books (and their big ideas), Existing Media, Beautiful Things, Common Misconceptions— or whatever seems to fit this first go-around. Have the team contribute single ideas to each or any category. Place the board somewhere that all team members have regular access to and ask that every note be dated, initialed, and if necessary, given a one-sentence explanation. Collect material for a few weeks and then meet to discuss, brainstorm, reorganize, assign further items, and potentially dump some items. Do two or three rounds of this until everyone's initial ideas, interests, and finds have been processed. (Note: this can be done on a shared computer site, but doing it in "real time" has a number of advantages. Post-it™ notes can be easily re-titled, rearranged, or dumped during the course of the group discussion and consensus.) A *Matrix Board* has some similarity to a *Mind Map* (see Chapter 8), where all forms of ideas are collected and placed on sticky notes to be assessed and sorted. However, while a *Mind Map* method is a more free-flowing random approach, the *Matrix Board*

has a more orderly starting point, structured with distinct categories, yet still providing for open-ended input within each. The ability for everyone to add thoughts at their leisure allows for a "slow stew" and longer germination of thoughts to start the kick-off discussions.

Mission and the Big Idea

The Big Idea is a fully phrased statement of exactly what an exhibition is about. "The big idea provides an unambiguous focus for the exhibit team throughout the exhibit development process by clearly stating in one non-compound sentence the scope and purpose of an exhibition."

—Beverly Serrell, *Exhibit Labels: An Interpretive Approach,* 1996.

Once you've begun the research process and had at least one or two meetings to discuss the material you are collecting, you'll need to begin to craft some statements about your overall intentions. This should include the formulation of a mission statement, a Big Idea, and a first draft of visitor goals and objectives—considered through learning lenses such as cognitive, affective, and experiential.

The exhibition's mission statement and Big Idea are used as standards to measure the relevance of individual components. The mission focuses on the topic, visitors, and what the main intention of the exhibition is. The mission may need to have an active rather than passive verb, that is, "discover" as opposed to "view."

The Big Idea also focuses on a topic but can be approached from a visitor's perspective. "Sharks are not what I thought." Does each element lead visitors to the Big Idea? Would they be thinking something close to this thought if asked, "What is this exhibition about?" Once the mission statement and Big Idea are established, the interpretive team can determine the key messages that are critical to include in an exhibition plan. The wording of the mission statement need not appeal to the public. The mission and the Big Idea should be neither too elementary to interest visitors nor too complex to be achievable in the context of the exhibition.

Creating Exhibition Goals

Visitor goals are often bundled in the same three areas mentioned before: some version of cognitive, emotional, and experiential goals that support a mission statement and/or Big Idea. Working in this way, we might state that, overall, visitors will learn three important concepts, feel specific feelings (such as nostalgia, pride, fear), and have access to some specific experiences such as trying out a skill or working together with others to create certain outcomes. So, visitor goals can

be statements that refer to outcomes we are working toward in a whole exhibition. Like an "exhibition mission statement" and a "Big Idea," visitor goals might be stated both in "team language" ("visitors will learn how rarely sharks attack humans and why they do it when it does happen") and "visitor language" ("most sharks are safe to be around.")

Later in the process, visitor goals may also be attached to specific exhibit elements to help guide their development. For instance, Deborah Perry of Selinda Research suggests that "goals" are things you want a specific exhibit element to achieve and that these statements always begin with "visitors will. . ." do, think, feel, appreciate, and so forth. These are followed by "messages," which Selinda always interprets as educational messages that fit under a "Big Idea" statement. What follows this are "Physical Engagements, Intellectual Engagements, Social Engagements and Emotional Engagements," lined up under specific exhibit elements. This kind of detail provides exhibit developers with shared ideas about the purpose of each element and provides visitor studies people with very clear aspects and outcomes to observe or test. (See Chapter 8 for more detail on mission, the Big Idea, goals, and objectives.)

Exhibition Voice

This draft should also include beginning ideas about what exhibition "voice" will be used or what tone will be struck in presenting the material, for instance, "through the voice of the miners, not the historians or the mine owners" or "tongue-in-cheek in tone" or "with the utmost respect for the victims of the cave-in." This might be organized as a brainstorming session or workshop in which the whole team attempts to create possible voice and tones during the course of a meeting or meetings, or it might be organized as a discussion (or series of discussions) to respond to and improve a draft document you have crafted beforehand about the meaning and import of the proposed work, visitor goals, academic criteria, presentation characteristics, and the like.

While the process you choose may not be this literal and specific, it is wise to identify and articulate outcomes that all team members understand and agree to. Without this kind of work, team members can find themselves working at cross-purposes.

A sense of humor, properly developed, is superior to any religion so far devised.
—Tom Robbins, *Jitterbug Perfume*

Laughing Matters

Humor attracts and sometimes even holds attention. It is an important ingredient both in the process (in meetings) and as a tool to develop an exhibition's tone and delivery of messages (if handled smartly; Figure 5.15). It can create a way into subject matter and invite participation. Too often we might think, "This is serious material. We have serious intention to seriously teach this serious material." But brainstorming exhibition ideas is playing at some level, and some people do not know how to play or have simply forgotten how. A playful and humorous openness can provide creative inspiration. If the team is enjoying each other as they develop the exhibition more than likely this will translate to the floor, and visitors will enjoy themselves too.

Figure 5.15: As a new way to discuss a traditional topic such as space sciences, The Franklin Institute's (Philadelphia, PA) team decided to find out what visitors wanted to know about and add some humor to the *Space Command* exhibition. Visitors inevitably ask about personal bodily functions, typically, "How does one go to the bathroom in space?" This graphic entitled "Fruit of the Moon" discusses "space underwear" or how the high-tech liquid cooling and ventilation suits remove excess body heat and allow astronauts to cool down (particularly during space walks). Most kids (and adults) do not forget a funny panel about underwear! *Photo courtesy of Polly McKenna-Cress*

Puns, like Judy H. Rand's panel header "Screw Worms Lead Boring Lives" encourage visitors to read on. Or the "Wheel of Adaptation" formally in the exhibition *Life Over Time* in the Field Museum that has a header inquiring, "Feel lucky amphibian?" This interactive was also a visual joke that twists the familiar *Wheel of Fortune* game show format: a lung-fish-headed and botoxed "Pat Zacek" and his many-legged crayfish companion "Vanna," stand on either side of the wheels to invite visitors to join in the shenanigans and try out the game—with all its serious educational implications. Even uptight adults can be amused enough to give the wheels a spin. They no longer feel the educationally induced pressure to "get it right," and can just try it out!

Exhibit versus Program, That Is the Question

During these early stages, many of the concepts need to be tested to see if they work better as a tangible exhibit element or as an educational program. Can the concepts stand alone and engage visitors or are the

ideas too complex and human interaction and dialogue is needed in some form. Not all concepts can be exhibits and not all concepts are suited to be programs. If individual or small group personal investigations are sought, having a staff person or volunteer may feel obtrusive. Whether this is a person in the exhibition, such as a storyteller, actor, demonstrator or interpreter to answer questions, or a feature beyond the exhibition space, such as a film night, lecture series, special tour, camp, or overnight program, these elements are vital to the life of the exhibition and extend its reach. Programs come in all forms and varieties and are only limited by the team's imagination.

SYNTHESIZING AND PRESENTING INITIAL CONCEPTS

An "interpretive framework" document lays out the basic information about the exhibition, including its target audiences; its mission, main ideas, and goals; its proposed impact on visitors; and of course its proposed benefit to the institution, size and location, and estimated budget. For review purposes, a concept or "bubble" diagram (see Chapter 8 for more details), which maps the connection and emphasis of these items, should accompany the interpretive framework document. Once the team has reviewed and critiqued it, this document serves as the approval material at the end of this phase. The work of the concept phase should result in agreement about the unifying message and the major ideas and attitudes the exhibition must include.

Things to Be Mindful of in These Early Stages

- **An inability to stop collecting information and/or a failure to begin to synthesize:** This can lead to difficulty in crafting concrete visitor goals let alone a mission/Big Idea that has legs. Here is when a deadline comes in handy, especially one integrated with a good scheme to begin to synthesize and edit.

- **An inability to create a shared vision within the group:** This is a point where badly managed collaboration can indeed, become "groupthink" (as discussed in Chapter 1), as members struggle to come to consensus with each other instead of trying to create the best outcome for visitors. In fact, people may not even perceive that they are in a "shared bubble" because they are used to working

only with each other and have not sought opinion and engagement from outside it. The results of groupthink are often either *confusing* (everyone's idea finds a place so that no team member feels "left out"), *wishy-washy* (oppositional views are brought together in a drab middle to avoid conflict), or *resigned* (whoever spoke loudest or with the most confidence creates the vision independently, and everyone else just goes along—it's easier that way. . .[sigh]).

- **An inability to collaborate leads to polarized sides:** The opposite of wishy-washy or confusing could be that unwilling and unmoving sides of the group refuse to come into alignment for the good of the end user, resulting in paralysis. In either case, here is where visitor advocates must shine, pushing the group toward the clear articulation of visitor needs, wishes, and outcomes and toward that end, keeping everyone's personal and relational issues at bay.

- **The difficulty of finding the balance between making decisions "just in time" and prematurely jumping to the first conclusion that comes along in order to make the deadline or to look good:** If these basic exhibition building blocks are not really thought through and proofed by the team, they won't be able to bear the weight of the later work and will fall apart. While the team can't dawdle, neither can it jump to unfounded or capricious end points. Finding such balance points can be hard, but being aware that they do exist can help.

ORGANIZING THE CONCEPTS INTO A COHESIVE NARRATIVE

Blocking Out Ideas, Spaces, and Potential Programs

The task in this Schematic Phase is to lay these ideas out in space, considering their relationship to one another, their relative importance to the whole, and how their individual parts add up to create a narrative that is understandable, engaging and of interest to visitors. This is considered the "conceptual floor plan," as it is not yet a fully concrete plan. This plan should have objects and some possible elements to begin to shape physical storyline with design advocates. This is an important juncture between advocacies and the team, as ideas take shape into tangible experiences for visitors. (See Chapter 6 for more on this.)

Organizing Concepts

There are a number of ways to think about an organizational strategy, and while you may not overtly use any of these in the end, it can be useful to think about the primal schemes we are all familiar with, such as chronology, numerical or alphabetical systems, seasons or directions, opposites, or easy-to-understand thematic schemes like "the Seven Deadly Sins" or "Home, School, and Work." For the most part, visitors will immediately understand a strategy that employs a well-known classification arrangement, and there may be usefulness in choosing something familiar, as it can allow visitors to spend their time and energy engaging themselves in other aspects of the exhibition instead of intellectually trying to parse a more exotic system.

It's also worth noting that transparent systems can be boring to visitors because they are so familiar. This may also depend on the material you are dealing with. The "forced march through time" for instance, which can feel so deadly in some history exhibits does not feel boring in the Holocaust Museum, perhaps because the material is so disturbing and complex that the absence of a strict chronology could leave visitors feeling completely overwhelmed. It can also be useful to think about introducing such a system (like an alphabetic arrangement) and then somehow twisting it as a way to bring surprise to the whole (Figure 5.16).

Regardless of the transparency of the system that forms this organizational structure or "spine" of the exhibition, there is also the question of the narrative that runs through the whole and rests on that spine. There is any number of devices we might employ to create a narrative that visitors will actually want to pursue. Generally speaking we are looking for a "story arc," something that provides a beginning, middle, and end in which a problem is presented for which we seek a solution, obstacles frustrate us but we eventually we come to a harmonic conclusion, be it happy or sad or simply in balance. In other words, the story follows "boy meets girl, boy loses girl, boy gets girl" or any of the thousands of variations on that theme.

Figure 5.16: Minnesota from A to Z! took visitors through the history of the state from before it was a state until modern time. Because this was such a vast history to tell and the developers did not want to go the traditionally chronologic route, the simple ABC system is instantly recognized and added some humor. Here you see Q is for quilts, an important communal and much needed craft during the long winter months. Formally installed at the Minnesota History Center, St. Paul, MN. *Photo courtesy of Polly McKenna-Cress*

Again, using the Holocaust Museum as an example, we are at first presented with a horrifying situation, then there appears to be no way out as the dread and fear builds to almost insupportable levels, until we at last discover that for all the death and horror, there were survivors, there were rescuers, there was an end to the suffering. Ideally, such a conclusion brings visitors along with it in both cognitive and affective ways. And indeed, at the Holocaust Museum visitors both report things they learned as well as feeling a deep personal responsibility to help prevent such a situation from ever happening in their world.

Telling Stories

What brings such a narrative to life makes it relevant to visitors and makes the whole interesting and engaging are smaller stories that illuminate a problem, point to possible solutions or perhaps place more obstacles in the way of a conclusion, and finally describe the conclusion. These stories also have beginnings, middles and ends. Ideally, they should be human and personal in some way, even if we are doing exhibition about straight science subjects. A narrative, whether overt or simply a way to organize the exhibition, helps visitors follow a thread and gives continuity to the whole experience. While this seems to imply a chronological or other rigid approach, this is not always the case. For instance, earlier in the book we have discussed the exhibition *Race: Are We So Different?* from the American Anthropological Association and Science Museum of Minnesota, which places stories around a core that can be viewed in any order, but all the stories are about the issues of race and racism, some more scientific in approach, others more first person experience-based in approach (Figure 5.17). Taken as a whole, all support the overall message of the exhibit: *race is not a scientific fact but a social construct that has been used to perpetuate and institutionalize racism within society.* Together, we can understand this and overcome it.

The other approach to storytelling and narrative is to be overt, taking visitors through an actual story. One of the more successful exhibitions to do this

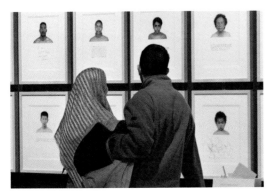

Figure 5.17: Different individuals were asked to share their personal stories and for a portrait to share in the traveling exhibition *Race: Are We So Different?* from American Anthropologic Association Washington, DC, and Science Museum of Minnesota St. Paul, MN. Poignant quotes such as "I am 100% black and 100% Taiwan" resonate with visitors as they reconsider what race and identity means. *Photo courtesy of Science Museum of Minnesota*

was the 1993 Fort Worth Science Museum's *Whodunit? The Science of Solving Crime.* Visitors happen on a crime scene in a diner set with chalk outlines and monochromatic figures sitting at counter. A radio is playing and visitors are to notice certain clues that will help them at the different crime lab interactive stations located on the other side of the diner. The stations include an autopsy area and fingerprinting match. Visitors are to follow the clues to unravel the story of what happened and who dun it!

The 10 Immutable Laws of Storytelling

By Andy Goodman

1. *Stories are always about people.* Even if your organization is devoted to saving flora, toils in the dense thicket of policy change, or helps other nonprofits work more effectively, human beings drive the action. So your protagonist must be a person. And since this person guides the audience through the story, provide some physical description. This helps your listeners form a mental picture—it's hard to follow what you cannot see.

2. *Your protagonist must want something.* A story doesn't truly begin until the audience knows precisely what the protagonist's goal is and has a reason to care whether or not it is attained. Within the first paragraph or two, make it clear what your hero wants to do, to get, or to change. And beware the passive voice—stories are driven by desire!

3. *Fix your story in time and space.* The moment you begin telling your tale, your audience will want to know: Did this happen last week or 10 years ago? Are we on a street corner in Boston or a Walmart in Iowa? Help your listeners get their bearings quickly; they will more readily follow you into the deeper meaning within.

4. *Let your characters speak for themselves.* When your characters speak to each other, it lends immediacy and urgency to the piece. Listeners will feel as if they are the proverbial fly on the wall, hearing in real time what each person has to say. Direct quotes also let characters speak in their idiosyncratic voices, lending authenticity to the dialogue. "The name is Bond, James Bond," is way better

than, "The agent introduced himself, characteristically repeating his surname twice."

5. *Surprise the audience.* Right away, you have to make your audience wonder, "What happens next?" or "How is this going to turn out?" As the people in your story pursue their goal, they must run into obstacles, surprises, or something that makes the listeners sit up and take notice. Otherwise, they'll stand up and walk away.

6. *Speak the audience's language.* According to national literacy studies, the average American reads at a sixth-grade level. Plain speaking is the order of the day. Good storytellers also have a keen ear for the colloquialisms and local slang that establish common ground between the teller and listener.

7. *Stir up emotions.* Even when you have mountains of hard evidence on your side, you must make your listeners feel something before they will even glance at your numbers. Stories stir the emotions not to be manipulative or melodramatic but to break through the white noise of information that inundates us and deliver the message, "This is worth your attention."

8. *Stories don't tell: They show.* Intellectually, your audience will understand the sentence, "When the nurse visited the family, she was met with hostility and guardedness." But, if you say instead, "When they all sat down in the living room, the family members wouldn't look her in the eye," your audience will see a picture, feel the hostility, and become more involved with the story.

9. *Include a "moment of truth."* At their essence, the best stories show us something about how we should treat ourselves, other people, or the world around us. We look to stories to be containers of truth, and your audience will instinctively look for this kind of insight.

10. *Stories must have meaning.* When the final line is spoken, your audience should know exactly why it took this journey with you. In the end, this may be the most important rule of all. If your audience cannot answer the question, "What was that story all about?" it won't matter how diligently you followed rules one through nine.[1]

[1] www.agoodmanonline.com/pdf/free_range_2007_06.pdf

Such stories can come from and be based on traditional sources such as collections items, oral histories, photographs, scientific data, and archival materials, but they can also center on more imaginative, theatrical, or artistic approaches that come out of a deep understanding and regard for the subject matter but may not be as literal.

The narrative may also be supported and enhanced by interactives that explain or demonstrate an idea or phenomenon creating still more little stories in more sensory forms. Various design applications, such as environmental treatments, inventive lighting, textural, or audio treatments can also support the narrative, sometimes in ways so subtle that many visitors may not even be aware of them but that help the presentation to add up to a functioning, harmonious whole.

The Story on Storytelling

By Leslie Bedford, PhD

We are storytellers from the time we are very small. The drive to put information into narrative form seems to be hard-wired into our brains, a biological adaptation that helps us work and create together. Or perhaps it reflects our early ancestors' urge to discern form in an essentially formless universe. Whatever the reason, we have been telling and finding stories for a very long time. So it makes sense that exhibitions draw on this foundational human habit and tool.

But beyond their familiarity stories have other characteristics that lend themselves to the art of exhibitions. Many of these qualities have been analyzed by scholars in different disciplines [related to narratology or the study of narrative]. Their ideas provide useful criteria for exhibition developers trying to choose one element—text, interactive, object—over another.

For example, stories generate stories. They open up the listener's mind—fire his imagination—so that he in turn creates his own story. Garrison Keillor, the public radio entertainer and storyteller, puts it this way:

> I find that if I leave out enough details in my stories, the listener will fill in the blanks with her own hometown, and if a Freeport girl exiled in Manhattan hears the story about Memorial Day, she'll put it right smack

there in that same cemetery with those names on the stones, and she may think of her uncle Alcuin who went to France and didn't return, and get out her hanky and blow. I'm not the reason she's moved, he is. All I can do is say the words: cornfield and Mother and algebra and Chevy pickup and cold beer and Sunday morning and rhubarb and loneliness, and other people put pictures to them.[2]

In other words, story engages our emotions. And as this chapter points out the affective is as important in exhibitions as the cognitive and physical: when our feelings are engaged we care more and are more likely to remember. The generative quality of storytelling or what has been called the *narrative* mode of thought contrasts to the *logico-scientific* mode, the way of writing and explaining characteristic of, for instance, a text book or, oftentimes, a didactic exhibition label.[3] The one is about transmitting knowledge, the other about generating understanding, and inspiring personal meaning making.

Story works for intergenerational audiences. According to the School of Imaginative Education, very young children respond to stories that involve binary opposites like fairy stories featuring good vs. evil.[4] As they mature linguistically, their thinking encompasses more complex narratives involving real-life people and struggles. Finally, as well-educated adolescents and adults, they learn to deal in meta-narratives about, for example, change over time. But the original response to story never goes away: *Star Wars* works for all.

What is the voice of the storyteller? I love the following label from a fourth-century BC sarcophagus I saw in Beirut:

In this coffin lie I, Batnoam, mother of King Ozbaal, king of Byblos, son of Paltiball, priest of the lady, in a robe and with a tiara on my head, and a gold leaf in my mouth, as was the custom with the royal ladies who were before me.

[2] Reference: Bedford, L. Storytelling: "The Real Work of Museums." *Curator: The Museum Journal* 44.1, pp. 27–34; Keillor, G. 2000. "In search of Lake Woebegon." *National Geographic Magazine*. December.

[3] Bruner, J. 1990. *Acts of Meaning*. Cambridge, MA: Harvard University Press.

[4] Egan, K. 1989 *Teaching as Story Telling*. London and New York: Routledge

Think how the author creates a picture in our mind, teaches us about burial customs, and also transports us back in time to stand next to Batnoam in her funeral finery. Similarly, one of the reasons the storyline in the Holocaust Museum works well is because the director, a former filmmaker, went through all the labels and deleted anything that told visitors what to think or feel.

In sum, stories are the most fundamental way we learn. They have a beginning, middle, and an end. They teach without preaching, encouraging both personal reflection and public discussion. Stories inspire wonder and awe; they allow a listener to imagine another time and place, to find the universal in the particular, and to feel empathy for others. They preserve individual and collective memory and speak to both the adult and the child.

Exhibition developers, designers, and educators are storytellers working with the storyteller's materials and guided by his principles. This makes sense because museums are storytellers as well. They exist because once upon a time some person or group believed there was a story worth telling, over and over, for generations to come.

DOCUMENTATION AND PRESENTATION

Interpretive Framework (or Exhibition Outline)

The Interpretive Framework places a brief description of each concept now evolving into proposed exhibits and programmatic elements in an order that corresponds to the conceptual floor plan. This can be used by team members as a checklist to make sure that all the pieces are there and everyone understands what they are and where they are.

Exhibition Walkthrough

The walkthrough describes the potential exhibition from the users' point of view, explaining what visitors will see and do, and potentially learn and feel, in each area of the exhibition. Such a document is very useful to write since it forces us to confront not just ideas and objects, but what visitors are experiencing—or not experiencing. The walkthrough should include the educational programs that are being

prepared for the exhibition to further understand how visitors will connect interpretive programs (staff people) with the less dynamic exhibition elements. Will there be a cart demo, theater presentation, storyteller, or "make and take"? How will staff interaction extend the concepts of the exhibition? Walkthroughs can also be quite compelling review documents and may also be a required element in funding proposals. As discussed in Chapter 8, they are also important design tools to flesh out lighting, sensory perception, mood, and other intangible elements that make up the experience.

Testing Approaches

Test some organizational approaches in brainstorming and discussion. What would this material be like if it were arranged chronologically, by color, by some thematic strategy? Sketch out a few different possibilities, discuss them, test them against your visitor objectives. (Of course, they will also need to be able to coexist with intelligent traffic flow solutions and conform to accessibility and safety standards.)

Once you've selected one and created a draft floor plan and narrative to describe the proposed experiences, you can also test this with the public. Jeff Hayward of People, Places & Design Research developed the method of Storyline Testing to give exhibit developers early feedback about how visitors are likely to perceive overall messages, how their expectations are likely to affect their experience, and how the visitor experience might strengthen or weaken as they move through the exhibition. (See Chapter 8 for more details.)

Brainstorm the formats that will be used to carry various stories and ideas. The exhibition developers work with the design advocates to decide: Will you use media (Figure 5.18)? Interactives? Illustrations? Environments? Will there be opportunities for users to add content to or comment on exhibit elements? Will you use models or replicas? Photos or life casts? Physical experiences (Figure 5.19)? Changes in views, lighting levels, floor elevations?

Create a proposed "criteria list" to help guide your thinking. Are we trying to take visitors to a different time and/or place, such as placing them in eighteenth-century Boston? Are we trying to help visitors see things from a new perspective such as viewing everything in a different scale or

Figure 5.18: *Mission to the Deep: Exploring the Ocean with the Monterey Bay Aquarium Research Institute*, an exhibition at the Monterey Bay Aquarium (MBA). The exhibition combines high-definition videos with simulated controllers so visitors can experience what the scientist at MBA did for the first time, remotely traveling (through underwater robots) to the deepest parts of the ocean and documenting the creatures that exist there. *Photo courtesy of Richard Cress*

viewing Earth and Earth systems from outer space? If so, what "rules" might we make about the look and feel of the spaces or the kinds of formats we'll use in our storytelling that will support this and also help us to edit?

Add advisors from other departments within the museum. This is the perfect time to get or give input to fundraising staff. Educators may need to have a say in the creation of the floor plan to make sure that program and storage needs are thought through, or that groups can be accommodated. Visitor Services, Security and Marketing, and PR may also have useful things to say starting at this juncture and continuing through at check points throughout the process.

Review your work by asking where the emotional and experiential content is. It's much easier to see where the holes are in a strictly content-driven narrative, so ask yourself where the surprises are and where the beauty, joy, pathos, fear, or laughter live. Ask where visitors can be encouraged to talk to each other or to work together. Ask where visitors can get their hands on things and do something, other than just look and listen (Figure 5.20).

Continue to check in with and stay open to information and ideas from professional, cultural, and community advisors.

Things to Be Mindful of During Development of an Exhibition

- **The basic assumptions from the conceptual phase don't hold.** As the ideas are organized in space, failures in team agreement about the purpose of various ideas become apparent and/ or it becomes clear that the proposed elements are not interrelated enough to add up to a satisfying experience—it's just a bunch of ideas. An easy-to-read symptom of this would be if we hear ourselves say "and here we will talk about x and here we will talk about y," because in an exhibition we will not be present to "talk about" anything or be able to explain to the confused

Figure 5.19: This simple idea of friction and momentum is not only illustrated but physically felt by young visitors to the Please Touch Museum, who attempt to get the large "human hamster wheel" to turn with their individual power. This wee girl actually got this large wheel cooking along. *Photo courtesy of Richard Cress*

Figure 5.20: These visitors to the exterior structures at the City Museum, Saint Louis, are involved in much more than looking and listening! *Photo courtesy of Paul Martin, City Museum, St. Louis*

or bored user how and why this idea is next door to that idea or even in this exhibition in the first place. The only fix for this is to retrace one's steps, and try to lay down a new foundation that will hold up. This may be difficult and take some bravery, as relationships within the team may be strained by the reevaluation of earlier agreements.

- **Testing with the public reveals that some or all of the material or (our approach to it) is uninteresting to potential visitors.** If probing does not begin to show us how to improve this, we'll need to completely reevaluate our proposed approach or even reconsider the topic altogether. While this sounds horrible (and it is), there is no point in carrying on with the work if we can see that the people we are doing it for simply don't care.

- **There is just too much stuff and it really doesn't all fit.** The longer we wait, the harder it becomes to edit as team members begin to work on and become wedded to certain ideas, stories, or objects. So this highest-level editing should be completed sooner rather than later. An acid test would be assessing the service of any single idea/element/story to the understandability of the main message of the exhibition.

- **Academic and/or cultural advisors are appalled at your presentation and/or you are blindsided by new voices that have completely different views from the advisors you have been consulting.** If this is going to happen, one hopes it will happen early in the process rather than later when it will be even harder to recover from. This is one reason to bring advisors in early, to really listen to them, but to be clear from the beginning that you will be the final arbiter of what is included in the exhibition.

- **While it's hard to recognize the "too far gone" developmental point it's difficult for people with little or no experience in exhibit development to respond to a completely blank slate—and dangerous for you too.** Where this balance point is for any exhibit will differ. People need something to react to and probably more than once, so you can't be too far along in development or too wedded to your ideas when you begin seeking this kind of feedback. However, you have to be far enough along for your proposals to make sense to nonexhibit people.

GETTING THE DETAILS IRONED OUT: HOW DOES THIS THING *REALLY* WORK?

The work of the Design Development phase of the process is getting all the details ironed out—exactly which object, which experience, which message, which interactive? How many labels are there and what are their rules? What kind of furniture, how big, and so forth. This is the time in which everyone really needs to dig in to get everything accounted for, budgeted for, and decided on. For exhibit developers, this will mean work in at least three major areas: crafting specific exhibit messages, testing prototypes, and obtaining continued advisor, community, and staff input.

Organization and Preparation of Specific Exhibition Messages

As the floor plan continues to become more detailed, the messaging that goes along with each area needs to keep up. We've all seen exhibits in which label text or helpful photos or illustrations are an after-thought and seem tacked on to whatever space happened to be left over in the end. To avoid this, developers need to be sure that approved outline topics and then visitor experiences are integrated into conceptual and schematic plans in those phases. In the more detailed Design Development phase, this will mean that an information hierarchy is created and the corollary physical plan for the placement of labels or other informational material is proposed (Figure 5.21). Generally speaking, the first is accomplished through close work between a graphic designer and a developer and the second, by integrating 3-D design.

Figure 5.21: These bathroom graphics at the Newseum Washington, DC are all about placement. Nothing better than reading material where you cannot miss it! Throughout the bathroom, there are actual printed newspaper headlines that were clearly not proofed before they ran. "Plan to deny welfare to immigrants still alive." *Photo courtesy of Richard Cress*

Interpretive Programs

Developers should also be working with education and interpretive staff to hone the school, group, family, and other public programs they have been

discussing since the beginning of the process. Whether the exhibition is up for six months or fifteen years, it can continue to change and grow through program initiatives; ways for visitors to comment, interact, and add to the exhibition; and other small changes that alter and improve various aspects of the installation over time.

Educator as Advocate

By Shari Rosenstein Werb, Director, Education and Outreach
Smithsonian National Museum of Natural History
Washington, DC

More than seven million people visit the Smithsonian Natural History Museum each year reflecting different shapes, sizes, and ages; different backgrounds, knowledge levels; and speaking various languages. They vary in their physical, sensory and intellectual ability. They travel from all over the world, throughout the United States, and around the Greater D.C. area to see the exhibitions. They connect with the museum via the Internet and virtual field trips. They visit by themselves, in pairs and as part of groups. Some visit frequently, and others once or twice in their lives. As renowned researcher John Falk describes in *Identity and the Museum Visitor Experience*[5], some visitors are explorers; others, facilitators; many experience seekers, rechargers, or professional hobbyists. Whichever way we choose to describe our public, we know that one size does not fit all where exhibitions are concerned. Educators who serve on exhibition and other museum project teams become advocates for their museum's diverse audiences; providing research and insights, and advising their colleagues of the basic needs, interests, and motivations of the people visiting, bringing their voices and perspectives into the conversation. Educators help to shape and customize the exhibitions to create experiences that are physically, intellectually, socially, and emotionally accessible. We accomplish this in the following ways:

Defining broad exhibition learning goals and outcomes and ensuring that each part of the project supports these goals

Asking questions that help sharpen and prioritize content and communication strategies and simplifying complex concepts through prototyping, testing, and ongoing conversation with content experts and audience focus groups

Conducting, analyzing and sharing visitor research that communicates visitor motivations, baseline knowledge, functionality of exhibit components, and physical design accessibility

Identifying and creating partnerships, collaborations, and stakeholder groups to engage schools, communities, and organizations in an effort to expand their reach and ensure relevancy

Building learning communities by engaging our internal and external networks of professional educators, museum, and other colleagues and volunteers to generate ideas, share strategies, and identify new and innovative approaches

Leveraging the investment in content creation for exhibitions and managing relationships with curators and key stakeholders and collaborators in order to create and disseminate new products, programs, and resources

Educators who are involved in exhibition development from the inception better understand the ideas, concepts, and decision-making criteria and can communicate these and integrate them into the development of programs and activities. They not only advocate on behalf of the people who will visit the exhibition but they are also advocates and ambassadors for the exhibition.

The following example represents a strong collaboration between the exhibitions staff, scientists, and educators. In May 2009, the National Museum of Natural History began developing an exhibition called *Losing Paradise*, using 43 botanical illustrations from the American Society of Botanical Artists to explore the diversity of threatened and endangered plant species, threats to plant survival, and ongoing conservation efforts around the world. The museum's exhibition development

[5] Falk, John H. Identity and the Museum Visitor Experience, Walnut Creek, CA: Left Coast Press, Inc., 2009.

team included the head of plant conservation, a botanical illustrator, an exhibit designer, a project manager, a writer, and an educator. After listening to the discussions about the goals and key issues, the educator proposed a number of suggestions. These included ensuring that the language in the exhibition was accessible for broad audiences, explaining the importance of botanical illustrations for the public, and finding ways to engage the public in the art and science of botanical illustration. The results were definitions of complex terms sprinkled throughout the exhibition, quotes from the illustrators sharing why botanical illustration is important to botanists and a large scientific illustration station with a terrarium of live specimens, and digital drawing technology (a Cintiq), materials for traditional illustration staffed by volunteer illustrators. There was also a regular program called the "Scientific Illustrator Is In," offering live demonstrations of illustration and conversation, and an iPad app and website inviting the public to share their own botanical illustrations via the museum's Flickr site. Because of the deep collaborative efforts between the educator and the team, she was able to engage them in recruiting illustrator interns and volunteers. The educator, volunteers and interns also became ambassadors for the exhibition by connecting with a broader community of illustrators, artists, schools, and those interested in botany and conservation issues.

Additionally the National Museum of Natural History is in the midst of developing its new "Q?RIUS" Education Center. It was created in cooperation with the exhibit developers, building and collection managers, scientists, IT staff, and educators. Because it contains a diverse selection of 20,000 objects, representing the museum's seven different science disciplines (anthropology, botany, entomology, invertebrate zoology, mineral science, paleobiology, vertebrate zoology), the physical space is designed like that of performance arts theater—adaptable and versatile with a structure that allows for hundreds of different configurations, frequent changes of content and experiences, and accommodation of a wide variety of seasonal and daily audiences. This learning laboratory will be an ongoing conversation between the museum's educators, scientists, exhibit professionals, public affairs, and special events staff and will be responsive to current events and visitation interests and trends, while being fueled by new scientific findings and informal learning research.

Information Hierarchies

Information hierarchies need to account for how all levels of information are handled, including the introduction of areas within exhibits, label copy itself (often in two or even more levels of detail and perhaps in, more than one language), object identification, instructions for the use of various exhibit elements, and at least a rudimentary wayfinding system, especially if a prescribed route through an exhibition is intended. A cohesive graphic system should accommodate each, provide guidance for the sizes, word counts, and image potential of each kind of panel (or other information-bearing vehicle). This system also establishes font, font size, use of color or texture, contrast, and other means of visual emphasis, all of which must be integrated into the overall physical design anticipating space, readability, and aesthetic considerations as well. As an important practical matter, environmental graphic designers should also determine a numbering system to keep track of all the details that will be used in organizing the writing, reviewing, fabrication, and installation of individual graphic elements.

Exhibit Pre-Write

Developers should be ready for this conversation with at least a rudimentary "exhibit pre-write." This is a document that tries to lay out all the information a visitor will need to make his or her way through the exhibition. It will begin to indicate where different kinds of information will be needed (an image, an instruction, a direction, a way to identify objects in a case, etc.). As it develops, a pre-write can also begin to be a vehicle for testing out the tone of label copy and the voice (or voices) the writing might employ. The pre-write is not yet label copy or scripting, however. It's a draft version of both these things and also a way to discover and resolve detail issues such as omissions, placement, or the need for other visual aids. It's a working document that grows along with detailed floor plans, elevations, and other drawings being created by design advocates that can be used as such by team members and at the end of this phase for review and approval.

Continuing Input from Outside

As the activity level goes up and more non-negotiable decisions are made, the tendency is to begin to ignore advisors outside the immediate team. Do so at your peril. Not only can they continue to help you, but they can make important contributions to confirm your final decisions. This buy-in to the process and the product can be important to you should issues arise. Therefore, it's very important that potential users, and subject matter, cultural, and community advisors be kept in the loop and given materials to review. Advisors will also need to know that the process is indeed coming to an end, and while everyone involved will want to evaluate the project once it is finally installed and open, we'll be trying to catch any issues now—not at the opening event.

STRATEGIES FOR IRONING OUT THE DETAILS

"Formative" Prototype

Prototype testing of specific exhibit elements or "try out and revise" at this formative stage can be accomplished quite informally by inviting visitors to try their hand at a physical model or allow themselves to be "talked through" a paper-and-pencil version while you observe and/or ask questions (Figure 5.22). It can be helpful to have some kind of form for documentation purposes, and a helper, especially if the material needs to be physically presented to visitors. Try to see at least 25 examples of usage—more if you have random users and need to concentrate on a specific audience segment. You can also take such tests into classrooms through the teacher advisors (where you can concentrate on specific age groups) or try them out at events. You may be looking for a variety of information: Do visitors understand how to use it? Do they want to use it? Do they enjoy using it? Have they understood what the point of the activity is? (For more about prototyping see Chapter 8.)

Figure 5.22: *Scan a Brain* prototype from the Franklin Institute Science Museum Philadelphia, PA. This "formative prototype" is to see if visitors know what to do but more importantly, why they are doing it. *Photo courtesy of Eric Welch, The Franklin Institute*

Creating the Graphic System

Developers (or curators/writers) and environmental graphic designers sometimes have trouble getting this discussion off the ground as developers are "waiting for the format" and designers are "waiting for the script" and no one is actually progressing with the work. Simply starting the discussion with whatever tools are available (such as look and feel research, a floor plan, and exhibit walkthrough document) is useful. Eventually, the discussion can become specific enough to describe the kinds of labels, the word counts, and the potential for imagery as well as more specific aesthetic and "readability treatments."

Permissions

If there are no in-house graphic designers, it is useful to have the developers working with the project managers craft a list of all the materials that need permissions (and/or licensing agreements or royalty payments) or creation from scratch. This might include noting the use of existing media, photographs, music, or illustrations or the need to create these in the production phase.

Collections

As the collections list comes together, developers in coordination with subject matter advocates need to have checked at least two things: what conservation needs are revealed, and can they be dealt with in the time and resources available? If not, where will replacements or replicas be sought and what will the costs and timing requirements for these be?

Things to Be Mindful of During Design of Exhibitions

- **Costs get out of hand as the complexity of "simple" interactives is revealed, forcing reevaluations and possible cuts.** When cuts occur, developers will need to analyze the importance of replacing elements with other, cheaper alternate approaches and how this will be accomplished within the schedule.

- **Prototype testing reveals that some elements really don't work for visitors and the decision will need to be made to either put more effort towards improvement, or to cut your losses.** Again, replacement with another technique may be necessary.

- **Worse yet, no prototyping and testing are being done because "there is no time."** This is a recurring problem that not only represents a failure of planning but also may be a way for some team members to indicate that they believe this kind of testing to be a waste of time. Once the time runs out, there is not much to be done about it but to live with the results (and document them for next time).

- **Not enough, or not skillful, enough, work was done with advisors to get buy-in and now people are unhappy.** Unfortunately, it may be too late to recover from this.

The Final Miles

As design advocates dig into construction documents, bidding and fabrication exhibit developers should now find themselves in a more reactive mode, helping to critique materials and products and tying up various extraneous details. They may also find themselves writing—or at least overseeing the creation of—final label copy for production. This text will be based on the pre-writes that came earlier in the process. They will most likely be reviewing all the final text and images during graphic production and well as assuring objects are coordinated and installed in the way they were planned, troubleshooting any last-minute details.

Figure 5.23: Graphic panel from Monterey Bay Aquarium's *Splash Zone* was developed for a young target audience. The developers/writers use a Seuss-like rhyming text such as "Ocean creatures live in homes, just like you and me, but their homes are wet and wild in the big, blue sea. Visit coral kingdoms, explore rugged rocky shores,and dive into the kelp forest to find mysteries galore." The rhyme is limited to four lines so as not to have it become a tongue-twister or just overused. It is light and memorable and prompts visitors to find and read other panels. These panels are also all translated into Spanish. *Photo courtesy of Richard Cress*

Label Writing

Label writing is its own skill and takes a significant amount of practice (Figure 5.23). There are many helpful books and articles that can support the first-time writer, even if that writer has good composition skills in other areas. Regardless of ability, label-writers will need input and review for tone and voice, content accuracy, orientation with the built environment ("to your left you'll see. . ." must be a true statement), and copyediting. They also may be asked to make small changes and minor rewrites to accommodate graphic design considerations.

Top 10 Tips for Label Writers and Designers

by Judy Rand, Rand and Associates

San Francisco, CA

For all tips: Write and design with visitors in mind.

1. State your main idea clearly, and telegraph it in a summary headline so people walking by can get it at a glance.

2. Use active voice, vivid verbs, and a conversational tone.

3. Set text in short, manageable segments . . .

4. With large-enough type and high contrast . . .

5. In a readable typeface and readable shape.

6. Use a clean layout, with lots of white space.

7. Make sure labels are well placed: within visitors' visual field, 3–6 feet off the ground . . .

8. Close to the artifact, scene or activity. . .

9. With instructions placed where, as Serrell says, the users' eyes and hands naturally go . . .

10. With titles and big bold headlines placed so that people walking by or waiting their turn can read over the crowd.

Summative Evaluation

Once the exhibition has actually opened, it will be important that team members observe what actually is happening on the floor and be prepared to immediately tend to things that aren't physically working. Close observation and conversations with visitors may also reveal that some elements aren't revealing their purpose or meaning to users because of ineffective labels or instructions. Don't be shy about putting up temporary signs to try to fix such problems.

Systematic evaluation (see more about summative evaluation in Chapter 8) can reveal much more about the overall performance of the exhibition and also about the success and failure of individual elements to

engage visitors and reach the cognitive, emotional, and experiential goals you have planned for them.

This is not an exam that you will ace or fail! ALL exhibitions have high points and not so high points—visitor research can help you improve the product no matter how good it was in the first place and can also help you to grow in your professional skill—that is, finding out what you accomplished with the strategies you used on this project.

Theory of "Closer Approximations"

Throughout this process, as we collect, organize, choose, and edit, you'll have noticed that we are always "coming closer, but not yet arriving." This is true for the work of all the members of the team. At every turn we are reevaluating, refining, and even recosting. We may know what the total budget is from the outset of the project, but until we get to the moment of commitment to fabrication, we may still be rearranging exact costs in various categories and possibly still cutting things we find we can't actually afford. Each of the strategies and documentation forms for exhibit development and design are an attempt to describe for ourselves and others what we have agreed to and what remains to be done as the process continues, so we can stay on top of the schedule, the costs, and the overall substance of the exhibition to make sure we are still on track. We will continue to ask ourselves questions even after the exhibition is open.

Some developers will argue that placing the work into a process template as we have here will stymie creativity and be a prescription for a kind of sameness and drabness in the products whose processes have conformed to it. Our response is, "Practice makes perfect." When individuals and/or teams as a whole are experienced and confident, they can—like any other maestros—throw out the rulebook and organize their work in any way they see fit. However, even experienced teams often find that some kind of template, checklist, or process document will help them work their way through a series of "closer approximations" and make sure that everything important is accounted for and there are no tough surprises at opening or beyond.

FURTHER READING

Cotton Dana, John. *The New Museum*. Woodstock, VT: The Elm Tree Press, 1917.

Dewey, John. *Democracy and Education*. Ithaca, NY: Cornell University Press, 1991.

Diamond, Judy, Jessica J. Luke, and David H. Uttal. *Practical Evaluation Guide: Tools for Museums and other Informal Education Institutions*. Lanham, MD: AltaMira Press, 2009.

Falk, John, and Lynn D. Dierking. *The Museum Experience*. Washington, DC: Whalesback Books, 1992.

Hein, George. *Learning in the Museum (Museum Meaning)*. Washington, DC: National Science Foundation, 1998.

Gardner, Howard. *Frames of Mind: The Theory of Multiple Intelligences*. New York, NY: Basic Books, 2011.

Gardner, Howard. *Unschooled Mind: How Children Think and How Schools Should Teach*. New York, NY: Basic Books, 1995.

Serrell, Beverly. *Exhibit Labels: An Interpretive Approach*. Lanham, MD: AltaMira Press, 1996.

ADVOCACY
FOR DESIGN

You can design and create and build the most wonderful place in the world.
But it takes people to make the dream a reality.
 —Walt Disney

ADVOCATING FOR THE PHYSICAL AND SENSORY EXPERIENCE

Designing the physical and sensory experience for an exhibition is an iterative process that places visitors at the center. "Exhibition design" is defined for this book as spatial problem solving to create elegant, meaningful experiences for diverse public audiences. This chapter sets the stage for the type of considerations that design advocates need to address. It covers experience design philosophies, spatial planning, visitor flow, exhibition personality, and means for selecting and shaping appropriate media, as well as ensuring that designs are accessible and environmentally sustainable.

In the pervious chapter, we discussed the needs of the exhibition developer and educator as well as the visitor researcher. The design advocate should not be excluded from considering himself or herself a visitor advocate, too. The design and physicality is as much the visitor experience as the content itself; the sensory interactions are clearly embodied by visitors for a purpose (Figures 6.1 and 6.2).

Large Image: National Leprechaun Museum, Dublin Ireland. Photo courtesy of Polly McKenna-Cress
Inset Photos: Connecticut Science Center, Hartford, CT. Photos courtesy of Richard Cress

Figures 6.1 and 6.2: Images of *Drawing Dock Creek* by the American Philosophical Society's Artist-in-Residence Winifred Lutz. This installation was commissioned as part of a walking tour in conjunction with the exhibition *Undaunted: Five American Explorers* housed at the APS. This wonderful experiential "river," installed in Independence National Historical Park, was actually made from electric blue bungee cords stretched across what was once Dock Creek. Visitors loved to romp in the river and lie beneath its surface. *Photos courtesy of Richard Cress*

Three Critical Questions

- How does the team fully respect both the content and visitors, while creating engaging, functional, and aesthetically intriguing experiences?

- How do design advocates ensure team clarity and continuity, from the big picture to fine details, both physically and visually and through multiple sensory experiences, during the process and for the final product?

- How can the team push beyond the expected to create the unexpected—visually, intellectually, physically, and emotionally?

Exhibition design is. . .

- Problem-solving at its most elemental

- Way-finding and content delivery at its most practical

- Sparking curiosity and wonder at its most essential

Exhibition design is about . . .

- Education in an informal environment

- Communication in many forms, direct and indirect

- Collaboration with many stakeholders and influencers

- Participation by inviting visitors to contribute

- Most importantly, in service to the visitors

Approach and Philosophy

Exhibition should be considered a medium for communicating with, inspiring, and educating people who come from diverse cultural, physical, and educational (and psychological) backgrounds. It has been said, "No one fails the museum." At best, exhibitions promote inspiration and confidence from the experience. But at its worst, a poorly executed exhibition can make people feel small and stupid. For this reason the design of the experience must serve the intentions of both content and audience (Figure 6.3).

The team of advocates needs to ensure the exhibition experience is comfortable, engaging, memorable and ultimately meaningful.[1] Visitors who are comfortable and confident are more likely to have meaningful experiences. Exhibitions should be planned with an underlying organizational structure for visitors to acclimate easily to the thread of the narrative content. If the physical organization synchronizes logically with the content, then it is more apt to facilitate visitors' focus on what is being communicated or implemented. They are here for an experience, and it shouldn't include confusion or frustration. Visitors need help making clear choices about where they want to be and what they want to see. Introducing a pace with primary points of interest yet sprinkled with surprises and the unexpected can create the kind of flow that helps reinforce visitors' memory of the experience. An organizational structure too obviously rigid or monotonous can quickly become boring for visitors. Creating transparency of the exhibition development and design process or revealing how the team has made its decisions can also draw visitors in and allow them to be an active participant. Beyond

Figure 6.3: The skills and tools of the designer are important to get a project done. But the results of effective design thinking—being able to have a powerful impact on others—is the true end goal. *Illustration by Meghann Hickson*

Visitors need to feel safe and smart [in museum exhibitions].
—Paul Martin, *Science Museum of Minnesota*

Design thinking relies on our ability to be intuitive, to recognize patterns, to construct ideas that have emotional meaning as well as functionality, to express ourselves in media other than words and symbols.[2]

—Tim Brown, IDEO

simply creating intuitive design, visual interest with a clear organization is at the crux of the exhibition designer's enterprise.

DESIGN ADVOCACY: WORKING WITHIN THE COLLABORATION

Design Advocacy can potentially include persons from broad range of professions and with skills encompassing 3-D exhibition design, print, and environmental graphic design, writing, AV/multimedia design, architecture, prototyping, lighting design, and acoustics and sound design, to name a few. Not all of these professional skills are necessary for every exhibition, but the team needs to recognize, consider, and advocate for any expertise needed to fulfill a particular need of the project. This should be determined early in the process by conducting an audit of the skills and resources possessed by prospective team (see Chapter 9). When needed skills are not found on the team, the consideration of and funding allocations for consultants or freelance specialists becomes important.

The early exhibition process tends to be a much more consolidated collaborative, meaning that the team is discussing and advocating for different exhibition needs and making decisions together. At this critical time, the team is formulating the foundations for the exhibition upon which most decisions will be built. Design advocates are a critical voice in creating the project foundation and should not be waiting idly "for the design to start." One of the major early considerations of the design advocate is to help the team be mindful of space limitations—how much *story and stuff* can fit in the space allotted? Designers are responsible for their own research and concept development and the way it supports the preliminary planning needs. (e.g., in tandem with the visitor experience advocate's responsibility for 'front-end' visitor research, since some questions about visitor experience might arise from design issues).

[1] Serrell, Beverly. *Judging Exhibitions: A Framework for Assessing Excellence,* Walnut Creek, CA: Left Coast Press, Inc., 2006.

[2] Brown, Tim, *Change by Design: How Design Thinking Transforms Organizations and Inspires Innovation,* New York: Harper Business HarperCollins Publishers, 2009.

Exhibition as Medium

Exhibitions have significant differences from most other direct communication media such as books, film, TV, and the news simply because of the free-form nature of exhibition. While media content can be delivered in a particular sequence via a singular format (a book is written word, TV is moving images and audio), exhibition content is delivered in multiple ways through a space that visitors physically move through and determine their own path. Even though one enters the front door and goes out the exit, the intervening experience is typically nonlinear (even if an exhibition happens to be linear) because of the visitors' choices of what they engage with. They may move back and forth in spaces based on interest, object placement, or just the size and flow of the crowd (Figure 6.4). Free-flowing visitor movement could be seen as a limitation for handling sequential content, but often the ability of a visitor to discover his/her own experience, even within a group, can be the most powerful part of the visit. Like all media, exhibitions have limitations as well as opportunities, both clearly need to be kept in mind as the physical manifestation is designed.

At the core, three essential characteristics set exhibitions apart as unique vehicles of communication. Exhibition designers should fully capitalize on one or more of the following characteristics:

- Real stuff (objects/collections)
- Authentic experiences (internal and external)
- Social spaces (discussing and sharing ideas within and beyond visitor groups)

The Real Stuff

The most obvious assets of a museum are the objects, artifacts, and collection. Real objects can have a powerfully transformative effect on visitors, and authenticity is the key. As we've evolved into a world where we experience life through technology and its interfaces, it's refreshing to be able to lose yourself in a painting, see the worn quality of a tool used by a woodworker, or feel the gravity of a pair of shackles. These "real objects"

Figure 6.4: Crowd circulation in Hall of Mammals at the National Museum of Natural History, Smithsonian Institution, Washington, DC. *Photo courtesy of Richard Cress*

that are connected to "real stories" have sway on visitors and can leave a lasting impact. An object's significance is often the reason visitors come in the first place—to see the real stuff and understand through the storytelling what and why someone values it. However, objects that do not have obvious inherent value need the designer and team to help tell their story. The juxtaposition of real objects with the communication of stories/ideas lends substance to its meaning and can give it a deeper significance. The designer's job is to understand the power of context, both physical and conceptual, and exploit it to the fullest using their creative skills as a sensory interpreters and translator for the visitor (Figures 6.5 and 6.6).

Visitors expect the things in museums to be real and can be sorely disappointed if they find they are not authentic. Ultimately, their trust in the entire museum can be damaged. But some museums must use facsimiles or re-creation when actual artifacts cannot be used. Visitors

Figure 6.5: The "Lucy" (*Australopithecus afarensis*) reconstruction by Gary Sawyer, exhibited at the American Museum of Natural History, is a powerful "destination object" that visitors come from all over the world to see. *Photo courtesy of Richard Cress*

Figure 6.6: Portions of the Berlin Wall exhibited at the Newseum Washington, DC. Though not known as an object-based museum, the objects the Newseum chooses to exhibit have a powerful emotional resonance for visitors. This exhibition presents the reporting of the fall of the Berlin Wall in 1989. *Photo courtesy of Polly McKenna-Cress*

can accept facsimiles if they are made aware of this fact. Full transparency and trust is expected from museums.

Engaging Authenticity

The Power of Place

Beyond collected objects, another manifestation of the authentic is the "place"—a location or the building itself—which can have an inherent *power of place* that evokes deep meaning. Typically tied to a significant event, person, era, or culture, buildings might include heritage sites (Great Pyramids, Hull House), historic houses (Versailles, Graceland), prisons (Tower of London, Eastern State Penitentiary; Figure 6.7), factories or industrial spaces (Mill City, MN; Edison's workshop), or places where specific events occurred (Schwenksville, PA; Lincoln's death site; Figure 6.8). The challenge for the team is to capture the power of

Figure 6.7: Eastern State Penitentiary, Philadelphia, PA, was once the "most famous and expensive prison in the world." As the first penitentiary, it was architecturally designed with physically isolating spaces originally believed to promote reflection, Quaker inner light and penitence. *Photo courtesy of Richard Cress*

Figure 6.8: The Petersen House, the actual site of Lincoln's death, is across the street from the famous Ford's Theater where Lincoln was shot. The president was carried there to a bedroom once it was recognized that he would not live. The former boarding house and the bedroom are now a popular tourist site that has been restored to the 1865 appearance, though the boarding house does not display the original deathbed. *Photo courtesy of Richard Cress*

place and translate its deeper meaning. Those exhibiting a historic prison, for example, can design methods or programs to allow visitors to think about what life may have been like in this restricted environment but also provoke thoughts about modern-day correctional facilities.

Authentic Experiences

Providing visitors with opportunities to participate in authentic experiences that cannot be easily accessed in day-to-day life makes a powerful internal connection to the content and museum. You want their reactions such as "I split a cell today at the museum!" to transcend the walls and be memorable well after their visit. Being directly involved in steering a ship or conducting a science experiment with static electricity or splitting plant cells under a microscope creates resonance for visitor understanding, physically, emotionally, and intellectually.

Immersive Environments

Immersive environments are typically external re-created spaces that have been crafted to "authentically simulate" a natural environment, period of time, or an experience that visitors may not otherwise be able to have, such as visiting tropical rainforests or underwater ocean worlds, or walking the surface of the moon (Figure 6.9). Dioramas and period rooms convey a moment plucked out of time. Living history museums such as Colonial Williamsburg in Virginia or the Conner Prairie Interactive History Park in Indiana augment the "period" experience with actors who, as characters immersed in the time, interact with visitors. These re-creations can stir a sense of wonder in visitors, not only with the environments being created, but also with the artists, scientists, and designers who craft these beautiful settings. By suspending a level of disbelief, a high-quality immersive experience can create authentic internal responses and be powerful for visitors.

Figure 6.9: Visitors immersed in the glow of the jellyfish tank, Monterey Bay Aquarium, Monterey, CA. *Photo courtesy of Richard Cress*

Engaging Authentic Emotions

This "soft" side of authenticity is to create authentic emotional responses from *within* the visitors. In the past, museums typically dealt in passive observation and intellectual contemplation. Now, they increasingly seek to capitalize on a much more emotional platform—joy, curiosity, humor, fear, suspense, sadness, righteousness—which can create connective reactions that immerse the visitor differently. If the exhibition can help visitors reflect on their own experiences, this emotional transformation has an opportunity to be attained. Once again, the Holocaust Museum in Washington, DC, is a prime example of a place evoking powerfully authentic emotions: fear, shock, and deep sadness. The design and controlled linear sequence of the entire museum was planned as an emotional journey for its visitors, with niche spaces for them to step away from the story when necessary. At the end of the experience an area was designed for visitors' reflection and transition back into present day.

> *Whatever the group, what is important is that the museum experience is, in great part, shaped by the social context. The understanding of the information in the exhibits and the message taken away are very much the results of a group effort.[3]*
>
> —John Falk and Lynn Dierking

Social Spaces

Most people tend not to talk during movies, when they are reading a book or even when they are surfing the internet for information. Although we may eventually share the books, websites or articles we have found appealing, we do not typically make this exchange at the very moment we are having the experience (one exception: reading to your kids). Many museum spaces are designed for the passive observer. Gazing in solitude is a valid and expected experience in certain types of museums or exhibitions. But by their nature, museums and exhibitions are meant to be places of social interaction. Many museums and interpretive venues depend on—and smartly capitalize on—this very quality. Social spaces where people can discuss ideas have become increasingly important as a way for visitors to deepen their connection to the content of the exhibition (Figure 6.10).

Figure 6.10: Touch table interactive where multiple visitors can work together sharing their findings. Multimedia exhibit from the Penn Museum, *Secrets of the Silk Road* Exhibition, 2011. *Photo courtesy of Polly McKenna-Cress*

[3] Falk, John H., and Lynn D. Dierking. *The Museum Experience.* Washington, DC: Whaleback Books, 1992, 54.

The design advocate can facilitate certain social behaviors for the visitor when creating physical spaces. Seating should be conducive to conversation. More socially focused institutions have created "town hall" programs, designed interactives that can involve more than one person, and provided spaces encouraging visitor exchange.

Seven Characteristics of Successful Family-Friendly Exhibits[4]

- **Multi-sided:** Family can cluster around exhibit

- **Multiuser:** Interaction allows for several sets of hands (or bodies)

- **Accessible:** Comfortably used by children and adults

- **Multi-outcome:** Observation and interaction sufficiently complex to foster group discussion

- **Multimodal:** Appeals to different learning styles and levels of knowledge

- **Readable:** Text is arranged in easily understood segments

- **Relevant:** Provides cognitive links to visitors' existing knowledge and experience

From Philadelphia-Camden Informal Science Education Collaborative (PISEC) Family Learning Research Project

One example of a clever design to spark social interaction is the use of "character cards," small information cards containing a biography of a person (or pet, special object, etc.) found in the exhibition to allow the visitor deeper connection to a personal story. Originally, a worry was that the cards would be held and used only by individuals, but in practice visitors enjoy sharing their characters with friends and family. The cards have proven to be an extremely successful, socially engaging

[4] Borun, Minda, Jennifer Dritsas, Julie I. Johnson, Nancy E. Peter, Kathleen F. Wagner, Kathleen Fadigan, Arlene Jangaard, Estelle Stroup, and Angela Wenger. *Family Learning in Museums: The PISEC Perspective.* Philadelphia, PA: The Franklin Institute, 1998.

device, creating thoughtful and memorable exchanges. The American Museum of Natural History used such cards in their 2011 traveling exhibition *Race to the End of the Earth*, a survey of the 1911 race to the South Pole between the Norwegian explorer Roald Amundsen, who arrived first, and his British rival, Robert Falcon Scott, who did not survive the expedition. That the story was a "race" where not every person returned alive gave the designers a suspenseful emotional hook to use. Having specific information on a number of individuals involved in the expedition gave these cards a substantive personality, placing visitors directly into a 100-year-old story, which was more powerful than perhaps a fact-based timeline panel would have been (Figure 6.11).

Figure 6.11: Henry "Birdie" Bowers, one of five explorers on the Race to the End of the Earth. Unfortunately, as you make your way through the exhibition, you discover Henry's ultimate demise. The traveling exhibition was developed and designed by the American Museum of Natural History team, lead designer: Katherine Powell. *Image Courtesy of National Museum of Natural History*

PRIMARY EXHIBITION DESIGN PRINCIPLES

Design advocates consider how the designed elements of the exhibition will affect the visitors' experience. Design considerations are not merely limited to how high a painting should be hung or the type of finish that should be used in a particular situation, but extend into more complex and subjective areas. The result of the design process should be an exhibition experience that addresses at least these five primary design principles:

- **To engage:** Creating and facilitating engaging experiences
- **To be comfortable:** Intellectually and physically
- **To surpass expectation:** The visitor should leave happily surprised (Figures 6.12 and 6.13)
- **To spark curiosity, resonance and wonder:** Provide opportunities to spark all three
- **To be disruptive and/or contemplative:** move beyond static or boring

On the surface these five principles may seem obvious; however, you'd be surprised how easily they can be overlooked as the exhibition development and design process rolls out over months or years. These

should be ever-present touch points throughout. When the practical demands of construction documents, structural build-out, finish choices, or data hook-up take over, these big-picture considerations cannot be forgotten.

Figures 6.12 and 6.13: The California Academy of Sciences' African Hall, with a live colony of penguins, literally brings the recreated historic hall and dioramas to life. As visitors peer into the various dioramas, they are not sure if they will be greeted with a glass-eyed stare or a squawk! *Photos courtesy of Richard Cress*

"If it ain't broke, don't fix it" is the enemy of disruptive thinking. It is more effective to start by identifying something in your business that's not necessarily a problem, in a place others wouldn't expect to look. In other words, think about what usually gets ignored, pay attention to what's not obvious, and start with things that ain't broke.[5]

—Luke Williams,
 Frog Design

Design uses *disruption* as opportunity:

- Visually

- Physically

- Intellectually

- Emotionally

When design thinking emerged more than a decade ago, it offered a response to the ebbs and flows of a global, mediatized economy of signs and artifacts; in this context, professional designers play increasingly important roles, less as makers of forms and more as cultural intermediaries or as the "glue" in multidisciplinary teams.[8]

[5] Williams, Luke. *Disrupt: Think the Unthinkable to Spark Transformation in Your Business.* Upper Saddle River, NJ: Pearson Education, 2011.

[6] Kimbell, Lucy, *Design and Culture*, Volume 3, Number 3, November 2011.

THE LAUNCH OF DESIGN

The launch of the visual design process occurs at a specific point, but in reality design thinking starts with the very first meeting. In the old-school model, an exhibition script was written and then handed off to the designers to make physical. This lack of collaboration and communication unfortunately resulted in exhibition outcomes that were, in essence, a collection of seemingly loosely grouped objects or an uninspiring textbook on a wall. In the current model, when all five advocacies are represented and respected, they form a strong team where many forms of innovation can spring forth.

The design advocates are not only responsible for the exhibition as a final project—through sketches, drawn plans, and built models—but also are physical interpreters for the team's intentions and goals. As the exhibition concepts come into focus, the exhibition should become translated through various visual forms. Mind Maps, concept diagrams, bubble diagrams, sketches, models, and scale drawings are all visual tools designers create to document the team's evolving ideas in order to see the connection and organization of complex information. (These tools are detailed in Chapter 8.)

The design advocates must also supply images, sample materials and colors, and anything else they have in their toolbox to support the team's ideas and the vision as it emerges at various points. Design advocates can also ensure the team is on the same page relative to the design of the space, which furthers clear decision making and mitigates any unhappy surprises later.

Specifics: Size and Scope of Space

One of the first steps when launching design is to define the size and scope of the exhibition space. What are the existing conditions of the physical space for which we are designing? In some instances, exhibition designers and architects will determine the space from ground up, typically in the case of a new museum, but more often the envelope is set and the exhibition must work within existing parameters. Typically, exhibition spaces range from 100 to 5,000 sq. ft., although in recent years larger spaces of 15,000–20,000 sq. ft. have become the norm for

very large or "blockbuster" traveling exhibitions (see Figure 6.14 for typical ranges). When exhibitions are larger than 10,000 sq. ft., visitors tend to think of them as small museums within the museum, and they can realistically only take in one of these shows in a day.

Considering Budget and Schedule

"We call early estimates WAGS, or wild ass guesses."
—Jeff Hoke, *Monterey Bay Aquarium*

From a design advocate's perspective, budgeting and scheduling must be done in conjunction with the institutional advocate and project and team advocate (project manager). After overall budgets and schedules are crafted early in the process, the budget may need continued refinement as the project progresses, physical requirements of the exhibition become established, and costs can be more specifically calculated. Usually opening day never moves!

Often budgeting is done once the scope and "architectural program" are roughly defined as a means to calculate square footage estimates (see Chapter 7). A project should not be developed too far before there is clarity on size, scope, budget, and schedule. The team may be wasting good time and money talking too much about a project that has no

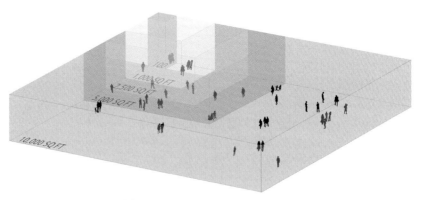

Figure 6.14: Typical exhibition space ranges:

- 100 sq. ft. for a 10' x 10' trade show booth
- 1,000 sq. ft. for a small gallery
- 2,500 sq. ft. for a medium gallery in a small/medium size museum
- 5,000 sq. ft. which is typical for most large museum spaces
- 10,000–20,000 sq. ft. which are the norm for large "blockbuster" traveling exhibitions *Illustration by Meghann Hickson*

clear budget or schedule parameters. Once the budget is established, like the opening date, it gets quickly set in stone and can become a "design to" number. That number rarely goes up but can be cut based on fundraising, so be prepared for plan B. Alternately, some museums' budgeting is set on annual allowances, where any particular exhibition design budget might be limited.

Making decisions about where money will be best spent for exhibition elements will be a matter of team-wide push and pull. Will there be more money put into the media portion, or one whiz-bang icon experience or will it be spread evenly? The team will need to decide where best to spend budget dollars to both have an impact on visitors and support the mission. Big budgets *do not* always equate to successful exhibition; to the contrary, sometimes too many bells and whistles can distract from what is important. Cleverness does not need to be expensive to spark imaginations and help visitors to engage with the content in new ways (Figures 6.15 and 6.16). Keep the focus on the mission and messages of the exhibition when making budgetary choices.

Figures 6.15 and 6.16: The "try-on a tattoo" allows visitors to see what the sights and sounds of the tattooing experience might be like. As visitors approach the table, they see the tattoo artist with his needle at the ready, they can choose to push a button and stretch out their arm prepared for some ink. A high-pitched sound of a needle starts and the first black lines appear (projected) on the arm. A minute passes as stroke by stroke a bird is vividly drawn on their arm, voilà no pain and no regrets. This exhibition element cost $10,000 to conceive, produce, and install, which places it into the "high impact–low cost" category for multimedia interactives. The exhibit is from *Skin & Bones—Tattoos in the Life of the American Sailor*, a traveling exhibition developed by the Independence Seaport Museum Philadelphia, PA under curator, Craig Bruns. *Photos courtesy of Polly McKenna-Cress*

The schedule will also be a driver of the budget and decision making. If the time is tight, this will determine what can be accomplished from team and fabrication perspectives. A longer timetable seems like it would be a dream but can actually prevent timely decision making, drag out the process, and drain budgets.

Visual Research: Look and Feel

Once scope and budget have been established, design can begin in earnest as the content is being developed with other advocates on the team. The design advocate will support the team through visual research and compilation of references to a "look & feel" for the exhibition intended to establish some possible approaches to the experience. A team brainstorming of adjectives descriptive of what the exhibition might look and feel like will be helpful to the look and feel research. Word and image brainstorming will get the team centered on ideas before sketching and modeling begins. Will visitors perceive suspense, or warmth, or playfulness? Will the exhibition be naturalistic with rockwork or slick and high tech? Will it be dark and dramatically lit or bright with white casework and natural wood? As this research progresses, the design advocate should continue to compile a collection of images of places, spaces, finishes, lighting, colors, objects, graphic styles, illustrations, or imagery as examples so the team continues to evolve and refine what the exhibition could look and feel like. Preparing look and feel boards or slides (Figure 6.17) to present this research is a device that will help the team begin to make the leap from intangible verbal concepts, mission, and goals to a tangible exhibit vision. Several choices for the team to consider are always welcome and help foster collaborative discussion.

Figure 6.17: A typical look and feel board or slide is a collection of imagery of materials, objects, textures, lighting, time period, styles, and the like to give the team and stakeholders an idea of the intended mood and aesthetic of the exhibition design. These images are invaluable to the collaboration, providing everyone reference points for the vision of the exhibition. *On My Honor: 100 Years of Girl Scouting*, National Constitution Center, Philadelphia, PA. *Photo courtesy of Alusiv, Inc.*

SPATIAL PLANNING AND VISITOR FLOW

With a framework in place, now the rubber hits the road and the exhibition needs to be considered as

a three-dimensional physical experience. Two initial planning considerations are the overall experience and how visitors will flow through the space, and both are tested and developed throughout the process. These design decisions set the stage for all other exhibition elements. The modes and details are layered into the space through direct and indirect forms of communication. How will the experience evolve through affective, physical, and cognitive goals? How will visitors respond to the physical, sensory, and intellectual experiences you have planned for them?

Scale and Views

The architecture of the space and the use of scale in an exhibition can dramatically shift visitors' experience. The scale and volume of the exhibition space (or shell) that houses the elements within is an important consideration. The space is of perceptual consequence and should not be considered as merely a container of furniture. Ceiling height alone offers a range of impressionable possibilities; soaring interior height could give visitors a sense of awe or, conversely, a sense of insignificance in a large volume of space. Lower ceilings can give a sense of intimacy and focus but could also feel tight or claustrophobic. All of these spatial impressions can be used successfully to create an affect for the visitor and support the story. For example, the claustrophobic tightness in a space could be an effective technique to help visitors to physically understand the inhumane efficiency of slave ships.

Considerations of scale come in many forms; the scale of built elements, structures and environments created within exhibition walls also support the experience. Could visitors walk in, on, climb up or crawl under different structures? How can exhibit structures articulate the space in unexpected ways (Figure 6.18)? Can a shift from a low, tightly scaled space to a large, high open space also emphasize a shift in storyline (Figure 6.19)? How does the scale of the space enhance the objects displayed and concepts/story being told (Figure 6.20)?

Figure 6.18: The *Zaha Hadid: Form in Motion* exhibition at the Philadelphia Museum of Art transformed the line between space, object, and graphic into a unified context. Ms. Hadid designed this environment to be an active and dynamic reflection of her myriad design products displayed. *Photo courtesy of Polly McKenna-Cress*

Figure 6.19: The Liberty Science Center, Jersey City, NJ, *Skyscraper* two-story high exhibition space was planned and designed for this permanent exhibition to emphasize vertical constructs within the space and allow visitors varied perspectives of scale. *Photo courtesy of Richard Cress*

Figure 6.20: American Museum of Natural History Hall of Biodiversity exquisitely displays over 1,500 specimens and models organized into different taxonomies along the 100-foot-long, glowing, sectional light box with full attention paid to the space that houses them. *Photo courtesy of Richard Cress*

All architecture is shelter, all great architecture is the design of space that contains, cuddles, exalts, or stimulates the person in the space.

—Philip Johnson

As a design advocate, you also need to think about views and sightlines in these dimensional environments. How will views be presented and framed? Scale is one form but setting up actual intentional sightlines can help support the visitors in terms of their visual engagement. How will the design of the exhibition space and views guide the visitors, intrigue them, and allow them to understand their way around? This is a form of way-finding but without the use of directive signs, an intuitive orientation, if you will. There are important physical and visual considerations. Does the exhibition offer something of interest to attract visitors at decision-making spots? As visitors turn a corner is there a planned view that pulls them further into the story and content of the exhibition? Are there framed views or slices through walls to give some hint of what is ahead? Is there a sense of suspense balanced with a sense of confidence for the visitor to feel excited but not confused? The orchestrations of scale and views to engage and excite the visitor at the same time supporting their needs are principal considerations.

Visitor Path and Flow

Visitor path, sometimes called *visitor flow* or *pacing*, is the planned route through the exhibit space from which the visitor engages with the story.

It is symbiotic with the floor plan or spatial plan. So far in the process, design advocates have been working closely with the team to develop the content of the story and create a social experience to take advantage of the physical aspects of the space. The baseline narrative needs should drive the design of the spatial plan and how visitors flow through the experience.

Designers are typically the advocates for physical comfort and overall "visitor experience" and have to plan accordingly. Is the exhibition too physically challenging? Can visitors find their way easily? Are the exhibition elements—objects, graphics, media, and interactives—accessible to all types of people? Or simply, are there enough benches for rest and reflection?

Many exhibition design books discuss different types of plans that can be used to map visitor flow. Though some exhibition floor plans are designed with directive paths (a limited or singular choice of visitor path), most are set up as "free choice" environments where visitors decide their own path. In their seminal work *The Museum Experience*, John Falk and Lynn Dierking have a thoughtful chapter entitled *The Physical Context: Visitor Pathways*. In it they state, "Visual variety and stimulations play a critical role in reducing mental fatigue." [7] Falk and Dierking outline four types of floor plans that direct visitor flow in specific ways:

> *The forced march (or directed plan)* is a design that gives visitors very limited choices of accessibility to exhibition content. Visitors are essentially led down a linear route, such as a hallway, with little or no deviation. Disney is known for their controlled approach to experience (for example, *It's a Small World* or *Spaceship Earth*), actually placing visitors into carts or on moving walkways to ensure the linear sequence of the storyline and that visitor flow moves deliberately. Another example is the Holocaust Museum in Washington, DC. From the ground floor of the museum, visitors are guided via elevator to the top floor, where the story begins, and subsequently flow back down from floor to floor on a chronological narrative path through the progression of the war, Germany, and the horrors of concentration camps.

"Benches, please don't forget to include a place for visitors to sit, rest, and reflect."

—Kathy McLean

[In planning the visitor pacing the design advocate needs to consider] "attracting, interrupting, and that flashing stuff needs to be peppered with smaller, quiet, more contemplative experiences."

—Jeff Hoke, *Exhibition Designer, Monterey Bay Aquarium*

[7] Falk, John H. and Lynn D. Dierking, *The Museum Experience.* Washington, DC: Whalesback Books Howells House, 1992.

The central core (or radial) plan has a central area from which other supportive exhibit spaces radiate. Many museums' architectures utilize this plan, where the central hub functions as a common meeting place and focal point. Well-known examples are natural history museums, including both the Field Museum in Chicago, with its iconic central atrium Stanley Field Hall, and the National Museum of Natural History in Washington, DC, with its central rotunda with the iconic African bull elephant. In both museums, the connected exhibition halls wrap around the outside of the central core space to which the path returns after visitors experience the exhibition halls. Visitors can become well oriented to this type of space because of the ease of movement in and out of areas adjacent to the core. This plan works well to emphasize a central theme, object, or idea with numerous connections. Visitors experience information in support areas and return with a new, potentially expanded view of this central theme (Figure 6.21).

Figure 6.21: The rotunda of the Smithsonian National Museum of Natural History with the African bull elephant that has greeted millions of visitors over the years, since its unveiling in 1959. Although the museum is vast (estimated over 1.5 million square feet with a mere 350,000 sq. ft. of exhibition space), this stunning icon helps orient visitors in the central atrium. *Photo courtesy of Richard Cress*

The pinball (or random) plan allows, and even expects, the visitors to choose a decidedly nonlinear path through the exhibition, intending visitor discovery and surprise. In this plan, visitors can progress through exhibition content in a staggered fashion, backtracking or overlapping. Therefore, the positions and pathways of the story and the physicality of the space, though linked, are not sequential. *KidScience: The Island of the Elements* at the Franklin Institute has a plan with four large topic areas, each with corresponding environments that visitors can explore randomly. The iconic lighthouse (light), sailing ship (air), water wheel (water), and cave (earth) each anchor spaces with objects and interactives for visitors to discover (Figure 6.22). The challenge with a pinball plan is that, with no central narrative artery, there is less museum or designer control of visitors' orientation. Often the designers will give visitors an orientation map or have an "early organizer" graphic at the entrance for awareness of possible pathways. With this aid,

visitors can also assess how much time they want to spend in an area by judging number and size. Sometimes, however, knowing what comes next creates a more boring exhibition. This plan can intentionally create some confusion or disorientation as a way to add intrigue and suspense to the space. As Falk and Dierking observed, variety and stimulations can help reduce mental fatigue.

The survey (or open) plan creates unobstructed views of nearly all exhibition content within the space, and allows visitors completely free choice of paths. Visitors are able to orient quickly to an open space, decide their pathway, and estimate how much time they want to spend in each area. The Exploratorium in San Francisco housed the Palace of Fine Arts designed by the architect Bernard R. Maybeck for the 1915 Panama-Pacific International Exposition. This vast garage-like open space was not intended to be a science museum but was reclaimed by Frank Oppenheimer as a new model of science museum. Instead of observing phenomena within prescribed disciplines or separate "themed" areas, the visitor experience is geared toward personal investigation, allowing them to derive their own connections and meaning. (The Exploratorium moved to Waterfront Piers 15 and 17 in Spring 2013; this new home has three times the exhibition space and also follows an open plan.)

Figure 6.22: The KidScience exhibition at the Franklin Institute Science Museum was designed as a random access plan where kids and their families decide their own path through the space. *Photo courtesy of Polly McKenna-Cress*

Open plans pose some risk of museum fatigue in that unobstructed views can yield few surprises, large spatial volume without visual variety can overwhelm visitors with monotony, and open spaces tend to be loud because there are few barriers to sound. These physical limitations can be addressed by designing visually compelling features in varying scales and hierarchy.

Each of these approaches has merit. Using one of them does not preclude the use of one or two of the others. Many successful exhibitions have employed different approaches in one exhibition. For example,

you may have a space and subject that might utilize a direct path for a narrow entrance space into the exhibition, arriving into a large open plan with varying choices all in one space, and culminating again with a directed path.

These different paths and plans come in and out of vogue based on the philosophy of the museum or the design firm. Ultimately, however, the content and the most useful path for visitors to experience the story, objects, and other people should drive the floor plan.

Orientation and Culmination

No matter how we plan and construct the visitor path, in reality visitors always have a "free-choice" environment; they will make their way through as they see fit. However, two things are a given for each of the visitor path types: there is an entry and an exit, a beginning, and an end. These two areas are not necessarily in two different locations, as many entries and exits are the same door. These are also not necessarily the very first or last experiences of the exhibition. There have been particularly successful exhibitions with orientation moments created further in from the entry. The American Museum of Natural History's (AMNH) traveling exhibits *Petra: Lost City of Stone* and *Darwin*, both utilized an orientation film positioned a third of the way into the exhibitions. The first section of both experiences introduced the basics of the subject, but the orientation films provided more detailed overview and wove together the complex subject relationships in a focused presentation that connected the rest of the exhibition.

The orientation and culmination areas are where the design and visitor advocates have particular focus, both conceptually and physically, to literally get visitors when they're coming and going. The orientation of ideas at the beginning is the opportunity to grasp visitors' interest, and the culminating moment of reflection at the end is where you can reinforce their interest beyond the exhibition.

GESTALT—SENSORY PERCEPTION FORMING A WHOLE

You have certainly heard the phrase "the whole is greater than the sum of its parts." Gestalt is a simple yet fancy word that represents this idea. It is the essence of a complete thing, and where exhibition is concerned, the gestalt is its personality, or the overall presence an experience will portray. Visitors perceive this whole through their senses—*all* of their senses—whether consciously or not. Looking at the parts of this exhibition whole, there are many individual "personality traits," of course, and the perception of a predominance or coalescence of one or another can give the exhibition personality—or gestalt—particular resonance with visitors.

Visual Perception

The primary form of perception is visual, and exhibitions are mostly planned to be experienced through this sense. It is one of five senses, of course, and we will discuss further on how other senses can be exploited for exhibition. What we have discussed about views, scale, and spatial considerations are visual clues to the visitor. Collections are one of the strongest visual components and are the basis of many museums' exhibitions (Figure 6.23). Ensuring the visitors can see and fully observe the objects, even when there are low-light-level conservation requirements, is an important function of the lighting strategy.

Lighting Design

Lighting can be poetry that brings the entire exhibition together and sets the experience. No matter how well composed an exhibition space is, if objects are positioned and colors coordinated without a solid and sophisticated lighting plan, the exhibition will not have the same resonance.

Figure 6.23: The jade display at the American Museum of Natural History. *Photo courtesy of Richard Cress*

The Impact of Lighting

By Lauren Helpern and Traci Klainer Polimeni, Partners, Luce Group New York, NY

> Lighting has a great impact on the museum visitor's experience. It is essential that lighting be designed alongside of, and in coordination and collaboration with, all other disciplines from the start of the creative process. Collaboration amongst the full design team has taken on an added significance today now that technology has advanced and museums have a greater desire to create more sophisticated and complex exhibitions to attract audiences and keep them engaged.
>
> *—Traci Klainer Polimeni, Partner, Luce Group*

You have been given the assignment to light an exhibition—now what? As the lighting designer, your job is to enhance and complement the exhibition design, and create mood and focus. The first step is to sit down with the whole team to determine the course of the exhibition development and define its parameters. All the design components (exhibits, lights, sound, and media) must work together seamlessly to achieve optimal results.

Lighting works both independently and in response to other elements. Light can enhance the mood or feeling of a space, help focus attention toward a specific object or area, affect the hues and saturation of color, plus much more. Conversely, unsuccessful lighting can detract from the exhibition or space: it can be harsh and aggressive, diffuse the power of the objects, and, in some instances, literally damage a collection.

Once there is the basic design, the lighting is worked through in physical and conceptual layers, balancing the different characteristics, qualities, and tones of the light. As the process continues, it is refined and becomes more specific, always responding to the needs of the project.

Early conceptual considerations or how visitors will experiences the spaces:

- What is the quality of light? Are the edges of the beam hard or soft? Is there a smooth, diffuse, even glow? Is there high contrast between highlights and shadows? Are objects framed by light (Figure 6.24)?

- What is the atmosphere? Is the light warm or cool? Is it a specific color? Are objects in pools of light?

- Will there be theatrical effects or cuing (Figure 6.25)?

Once you have established your conceptual design, you need to address the physical considerations:

- What constitutes the space? How high are the ceilings? Are there obstructions; beams, pipes or HVAC systems?

- What are the finishes/textures? Wall colors? Floor? Ceiling?

- What is the ceiling? Drop, cloud, plaster, clean?

- What are the types of fixtures? Are they recessed, track, historic (site specific), fluorescent?

- What are the many different lamp options? Incandescent? Fluorescent? Halogen? LED? Fiber-optic? Or Flood? Narrow Flood? Spot? Narrow Spot? Very Narrow Spot? With filters? Gels?

- Where are the fixtures placed? How are they attached? Are they embedded?

- Is there enough electricity in the building to accomplish what the design requires?

- Is there a need for a control system? How and where do the lights turn on and off? Do they need to be controlled remotely?

- How green are the project requirements?

- Are there light level considerations for objects or patron safety?

- Is there a maintenance plan for re-lamping lighting?

- Are you within your budget?

Figure 6.24: The Museum of Modern Art's even light with purposeful shadows does not overwhelm the furniture but allows visitors to see intricate design details. *Photo courtesy of Richard Cress*

Figure 6.25: A dramatic entry experience is created with theatrical lighting, projected title, colored up-lights on fabric and lightboxes in *Creatures of Light: Nature's Bioluminescence* at American Museum of Natural History. *Photo courtesy of Polly McKenna-Cress*

Figure 6.26: *Pandemonium*, an installation at Eastern State Penitentiary (ESP) Philadelphia, PA, by Janet Cardiff and George Bures Miller. ESP has considered many ways to humanize the prison beyond photographs, text, and audio tours. In this sound-based installation piece, hundreds of small hammers were set up to tap on the metal bed frames, porcelain pots, and other artifacts remaining in an entire cell block of this "sustained ruin" prison. Each cell was wired to an organ that allowed the artists to compose multiple otherworldly scores that brought unusual echoing life back to the otherwise silent cell block. The effect was that the cell block seems occupied, as if the inmates and guards were tapping to pass the time. One particular piece started low at one end of the block and moved down the block quickly as the sounds rose to crescendo, giving the feeling as if the sound was actually passing through the visitor's body. *Photo courtesy of Richard Cress*

Acoustics and Sound

Museums once had a reputation similar to that of libraries: quiet and contemplative. The formally silent halls where visitors walk in quiet suspension are no longer the rule. Sound has changed environments completely and has become an expected part of the visitor experience. This has become true in all museum disciplines: science, art, history, zoos, aquaria, and so forth. It is yet another tool at design advocates' disposal.

Museums have become more adept at exploiting audio technologies that give the visitors another modality for receiving and understanding information in both individual and communal senses. In recent years, sophisticated soundscapes have been layered into large spaces with surround sound and delivered in combinations of ambient and background sounds, music, and other auditory effects to create a total atmospheric symphony (Figure 6.26).

When there are many sound sources in an exhibition, they can "bleed" across adjacent spaces and create cacophony throughout. Museums have contained sound within spaces through the design of buffers in exhibit architecture, the use of mini directed speaker systems or sound cones to make it easier for visitors to hear a particular audio piece in a particular spot while not being bothered by the one next door.

Design advocates can plan for personal sound experiences using directed speakers, sound wands, earphones, or plug-in stations. Visitors who learn better from hearing auditory input have benefited greatly from these advances. The development of new technologies has allowed for individual visitor control of their own audio experiences, from simply being able to start and stop sound, to customizing types of sounds, voices, or music experienced in particular exhibit setting. Some museums have also been providing visitors the ability to create and record their own sounds as part of an exhibition. Disney has

pushed this product right to the exhibition shop, providing CDs and downloads of these recordings for purchase.

Now with the explosion of smart phones and pads and laser directed sound, designers have seemingly endless means to provide customized personal sound experiences limited only by the designer's imagination.

The Other Sensory Opportunities— Touch, Smell, and Taste

Even though exhibition design is primarily a visual medium, with audio as a close second, there is vast opportunity to create new experiences that intentionally and thoughtfully stimulate the other senses as well: touch, smell, and even taste.

Touch

Tactile sensory experiences help visitors engage with content from the lightest of surface textures to heaviest of mechanical interactives and can be immensely effective. These experiences encompass both intimate, fine motor sensory sensation and full-body activities. Where else can one feel the simulated texture of a tiger's tongue, rough enough to scrape the meat off the bone? Or feel the freezing cold frost of the living iceberg in the *Titanic* exhibition? Or touch a starfish to understand the animal's exoskeleton (Figure 6.27). What better way to understand density than gauging the weights of a section of balsa versus ebony wood?

Figure 6.27: Touch pools at the Monterey Bay Aquarium allow visitors to feel the skin of a starfish and other alien-looking sea creatures. *Photo courtesy of Richard Cress*

Consideration of touch is also critical in emerging technologies. The physical interface can make or break the visitors' use of and sustained commitment to a media device. Visitors of all ages know the ubiquitous interfaces of keyboard, touch screen, mouse, or touch pad. At the turn of the twenty-first century, it was still intriguing to interact with a touch screen. This interface is intuitive, but as a technology proliferates, it loses novelty and becomes commonplace or not "museum worthy." The keyboard is now passé in comparison with newer

technologies. With the advent of smart phones, tablets, and other similar devices, touch screens are ever present, and this interface may soon become passé as well. What will replace the touch screen? Already we see visitor comments suggesting it is too common in the museum and they want exceptional experiences that they cannot also do at work or school or anywhere else. There have been interesting forays into gestural interfaces with optical sensors that track visitors' motions and become the interface (Figure 6.28).

Lastly, the interior environment of an exhibition can also provide tactile design opportunities for communicating deeper meaning. The ambient temperature of a warm and steamy tropical rainforest diorama or a cold winter area where Washington crosses the Delaware add physical sensations to visual narratives and makes an experience unique.

Smell

Studies suggest that both sound and smell have particularly direct resonance in our long-term memory. The song from the senior prom or a particular squeak of mom's footstep on the stairs can take us to a particular experience of our past. Likewise, the *smell* of our grandmother's attic, or the aroma of hotdogs at the ballpark can trigger a sense of the familiar.

The sense of smell is a powerful tool that design advocates can utilize in exhibitions with some economy and with meaningful success. A number of exhibitions have used smell both with localized or individual scents as part of visitor-controlled interactives or ambient smells within a particular area. Careful balance in the delivery must be considered so as to not to overwhelm visitors with too much of a good thing. As a general rule, irritation is not the enhancement you want!

Figure 6.28: Multiple visitors can stand in front of the *Who am I?* gallery entrance wall at the Science Museum, London, and gesture as the projected dots follow their shadow. These dots represent the many different elements of our individual makeup. Within the exhibition, visitors learn more about how these many factors define us. *Photo courtesy of Polly McKenna-Cress*

Disgusting is another matter. A good, successfully disgusting use of smell is a core element of the traveling exhibition *Grossology: The [Impolite] Science of the Human Body.* At the "Yu stink" interactive station, visitors are asked to identify common human body smells. The graphic panel beckons visitors with curious minds and strong stomachs with the title, "Sniff, Sniff Peeeee Yuuuuu! People Stink."[8] The humorous accompanying photograph depicting a group of women in lab coats smelling the armpits of a group of men could not be more perfect. At four different spots visitors are asked to squeeze a bottle to release a puff of odor to be sniffed and identified. A graphic "flip panel" can be lifted to reveal the answer. Each spot releases a different human scent—feet, body odor, vomit and. . . anus. Although none of the smells are pleasant, many visitors keep at it and want to identify them all!

Note: Some visitors have allergies to all synthetic smells, so it is important that smells be contained.

Taste

Taste is a sense that has not been utilized very frequently in public exhibitions, perhaps because of the cost of replenishing and preserving edibles, as well as likely germ concerns inherent with anything people are to put in their mouth, however, there have been a few successful "taste" exhibitions. One good example is the Mitsitam Native Food cafe at the National Museum of the American Indian, and it also successfully advances the museum's mission. While not an exhibition per se, the cafeteria features foods from the regions of the Americas or the cultures covered by the museum mission. The Northern Woodlands serves Yukon potato codfish cakes and South American Brazilian shrimp and salt pork. Of course, the Great Plains offers buffalo chili. This menu gives the visitors more information about the taste of the

[8] *Grossology the Exhibit* website: http://www.grossology.org/museumtour/June 10, 2012.

[9] Ackerman, Diane; *A Natural History of the Senses.* Vintage Books—Random House, New York, NY, 1990.

"Smells detonate softly in our memory like poignant land mines, hidden under the weedy mass of many years and experiences. Hit a tripwire of smell, and memories explode all at once. A complex vision leaps out of the undergrowth."[9]

—Diane Ackerman,
A Natural History of the Senses

Figure 6.29: Visitors are able to sniff the tangy fresh scent of ginger to understand to influence smell has on the way we taste different foods in *Our Global Kitchen: Food, Nature, Culture*, American Museum of Natural History. *Photo courtesy of Polly McKenna-Cress*

culture exhibited in the museum than any written narrative could communicate.

Another is the Louisville Science Center's *The World Within Us* exhibition on sensory perception, which made direct connections between smell and taste senses and the exhibit content. A graphic panel described the olfactory senses and how they worked; another panel gave a diagram of the five different tastes our tongues can perceive: sweet, sour, bitter, salty, and umami. The directions asked visitors to push a button and a green jellybean was dispensed. Visitors were then told to hold their noses at first as they ate the jellybean. Through taste they could perceive sweet, but it was not until they let go of their nose that they could then smell the "spinach flavor" of the jellybean. The shift can be dramatic, depending on the visitor and his or her sense of smell. Experiencing the shift personally has an impact, but watching visitors go from a pleasant look on their face to not-so-pleasant is also a powerful and memorable experience for many people.

Dangers: Sensory Overload

Of course, with any smart exhibit design, it's important for design advocates to be cognizant of sensory overload and control how many or how few sensory experiences are utilized. Too much of a particular input in a space can create cacophony and cause discomfort for visitors. For example, if many disparate smells combine in odd ways or a single smell is simply too strong—we have all been in the elevator with someone wearing too much bad cologne—visitors will head quickly toward the exit. A discreet and deliberate use of sensory stimuli over the whole exhibition experience is essential when planning to employ these techniques.

Design advocates also need to be aware of extraneous sensory input from the general environment (not related to the exhibit) that can conflict with the planned experience. We have mentioned how audio

from one exhibit area can bleed across to others, but consider the potential interference of noise from other sources such as a loud HVAC unit buzzing above visitors' heads or proximity to a heavily trafficked hallway. The same is true for other senses: an overly hot or cold space or unplanned and unexpected smells can leave the visitors frustrated or the experience ruined. Vigilance to all details is the primary way to manage the challenges you expect and be prepared for those you don't, and ensure the intentionality of a comfortable visitor experience that keeps them involved in the exhibition, not checking out.

THE MEDIUM IS THE MESSAGE: MODES OF DISPLAY

There are several common modes typically used in museums for displaying physical, informational, and virtual content, but options are limited purely by the design advocates' imaginations and, of course, budgets. In general, baseline exhibition media include many modes of display that generally fall into the following categories: *casework*, *environmental graphic design*, *interactivity*, *multimedia*, *theater/scenic*, *immersive*, and *iconic experience*. These basic categories do not cover all possibilities; there are exceptions, push your team to find some.

Regardless of the modes you ultimately desire in your exhibition, each has to fit the story, mission, outcomes, and personality of the exhibition. Each mode should have an underlying logic to its selection within the gestalt even if the mode seems anachronistic. There are particular tools, methods, and special considerations for using each. The process of figuring it out is more than half the fun. Figures 6.30 and 6.31 are one clever way to decide!

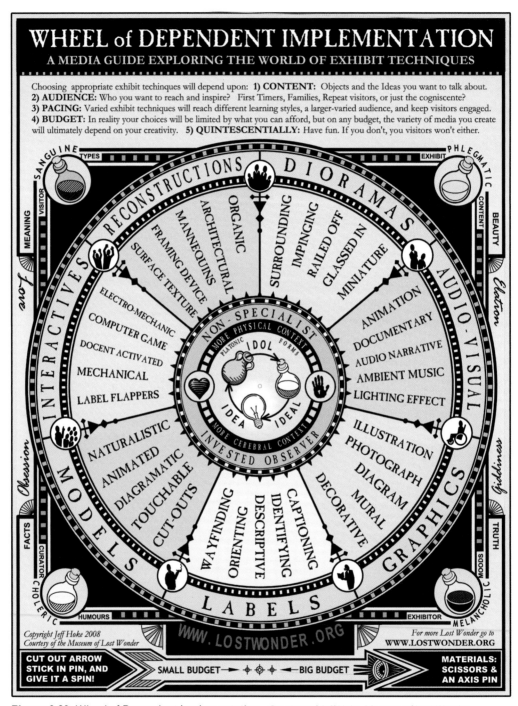

Figure 6.30: Wheel of Dependent Implementation. *Courtesy of Jeff Hoke, Museum of Lost Wonder* (www.lostwonder.org)

The WHEEL of DEPENDENT IMPLEMENTATION COMPANION

DIORAMAS Possibly the most expensive medium in your arsenal, but with these, you can give back what's been taken from all the things in your museum the context from the world they came from.	SURROUNDING	IMPINGING	RAILED OFF	GLASSED IN	MINIATURE
RECONSTRUCTIONS Think of these as touchable dioramas without the background & fugitive details. They can create a surrounding environment, with all the texture and scale to transport your visitor to different worlds.	ORGANIC	ARCHITECTURAL	MANNEQUINS	FRAMING DEVICE	SURFACE TEXTURE
AUDIO-VISUAL Many use this as a way to compress a lot of info into a compelling documentary, but a little mood lighting and music can do a lot to add real drama & feeling to your content.	VIDEO ANIMATION	DOCUMENTARY	AUDIO NARRATIVE	AMBIENT MUSIC	LIGHTING EFFECT
INTERACTIVES Interactives can turn a passive experience into a personally meaningful one. But think when you create one—is it about visitors finding their own meaning, or yours?	ELECTRO-MECHANICAL	COMPUTER GAME	DOCENT ACTIVATED	MECHANICAL	LABEL FLAPPERS
MODELS Models help offer the physical context you need, but in miniature. What's missing due to scale reduction, can be filled with an even more engaging element—the visitor's imagination.	NATURALISTIC	ANIMATED	DIAGRAMATIC	TOUCHABLE	CUT-OUTS
GRAPHICS Whatever you can't show in 3D you can usually show in two. Graphics can provide considerable immediately accessible information without having to take the trouble to read.	ILLUSTRATION	PHOTOGRAPH	DIAGRAM	MURAL	DECORATIVE
LABELS When all else fails, just *tell* visitors what you want to say. The backbone of any exhibit, labels tell people what they're looking at, and what you think it means.	WAYFINDING	ORIENTING	DESCRIPTIVE	IDENTIFYING	CAPTIONING

Copyright 2003, Jeff Hoke — Museum of Lost Wonder — www.lostwonder.org

Figures 6.31: Wheel of Dependent Implementation Companion. *Courtesy of Jeff Hoke, Museum of Lost Wonder (*www.lostwonder.org*)*

Casework

Casework includes various freestanding and wall mounted (both inset and protruding) vitrines or cabinets built for objects. The design of casework indicates the value of and gives context to the objects within (Figures 6.32 and 6.33). A highly detailed, elaborate, or custom case may indicate a greater value of the object. When the object is set alone in a case with interior lighting, this expresses the significance of this object and/or its role in the story the exhibition is telling. When there are multiple objects in a case, this can indicate that there is not one seminal example but many variations and express the significance of the quantity of these objects (Figure 6.34).

The location of the casework within a space is also a strong illustration of the museum's interests. For example, if an object case is located front-and-center near an entry then it places central emphasis on the story being told. The placement of the contents within a case also communicates importance. One object positioned on its own communicates uniqueness, whereas a case chock-full of objects tends to communicate a commonality of value to the institution or story. (It could also indicate that the curator has a tough time editing.)

Mounting and labeling can also hold subtle clues that help visitors understand before they read any text what the objects are trying to illustrate. Lighting techniques, specifically lights located within the case, can also hold clues about what is valued. A dramatic spotlight communicates a singular focus or high value, whereas a wash of ambient light projects evenness or common value.

Figure 6.32: National Museum of the American Indian, Washington, DC. To let everyone in the community know who the "favorite child" in the family is, these yellow moccasins are worn as a symbol. The design of the graphic context and the inset lit case give great value to the objects and the story they tell. *Photo courtesy of Polly McKenna-Cress*

Figure 6.33: The beautifully beaded red Converse sneakers by Teri Greeves (Kiowa), symbolize the modernization of native traditions. *Photo courtesy of Richard Cress*

Figure 6.34: The multitude of wee spun pots shown in this case does not speak to any one individual piece but the prolific nature of this ceramic artist, Museum of Modern Art, New York, NY. *Photo courtesy of Richard Cress*

Environmental Graphic Design: Word and Image

Richard Cress, Alusiv, Inc. Philadelphia, PA

Graphic design is the creation of visual communications, a synthesis of word and image generally delivered through a medium of close personal engagement (a book, a brochure, an iPad). For exhibitions, environmental graphic design is the more specialized subdiscipline. You must consider composing and displaying words and images that communicate not only in close personal space, but also in scales and spaces much larger (an outdoor sign, a video wall, an exhibit) where the effect of variable readability and perceptual conditions—such as distance, motion, lighting and the elements—come into play (Figure 6.35).

The important skills of the environmental graphic designer are to create visually engaging and meaningfully integrated graphic solutions, and understand the needs of scale, space, pacing, and placement. In exhibitions, "integrated" means not only appropriate to the exhibit's message—the design is visually attractive and meaningfully supports the exhibition story—but also is considerate of the experiential situation; so that interpretation is placed when and where visitors need it, and paced and scaled for comfortable readability. Integrated also means the environmental graphics neither dominate the experience (unless that is a purposeful tactic), nor become so subdued that they are lost to the background. Environmental graphics should be conceived as to how they add and communicate value in service to the objects, to the story, and, of course, to visitors (Figure 6.36).

Figure 6.35: Title graphics for the temporary exhibition, *Dirt: The Filthy Reality of Everyday Life* at the Wellcome Collection, London. Graphics should not be limited to two dimensions. *Photo courtesy of Polly McKenna-Cress*

Figure 6.36: The Ah-Choo! graphic at Liberty Science Center integrates word and image with the physical forms of the panel, the space, and projected textures. *Photo courtesy of Richard Cress*

An environmental graphic designer must be cognizant of the authenticity of real objects and environments and make sure his or her work supports it. Graphics are one essential vehicle for communicating the "authenticity of voice," who is speaking and from what point of view, which in the majority of instances is interpreted with words (although some exhibitions have been powerful and wordless). The best way for designers to understand where and when interpretation is needed and how to communicate the authenticity of voice is for them to work closely and collaboratively with exhibition developers and evaluators. Prototyping is crucial, from what is said, how it is said, and, most important, the context of where interpretation will be located in relationship to other exhibit elements. A useful test of interpretative need is to learn the most commonly asked questions about a topic through preliminary visitor research and then use that knowledge to place specific questions precisely with the respective object or experience. It is a means of integrating the visitors' mindset with a clear and appropriate answer at the moment they need it. When visitors can make a direct relationship between support interpretation and the object or phenomena they are observing it can create powerful new meaning (Figure 6.37).

Figure 6.37: The philosophy in the zoo field, much like a fine art museum's philosophy, is that the exhibition interpretation should support what the visitors view and experience and should not come between the visitor's experience with the animals. In the Los Angeles Zoo's *Red Apes of the Rainforest* exhibition, the interpretive graphic adjacent to the animal viewing area shows a photo of an orangutan working with blocks, an activity visitors might directly see. The panel presents information on how building with blocks mimics natural behaviors in the wild and helps the orangutans stay alert and mentally active. *Photo courtesy of Polly McKenna-Cress*

The presentation of expository information about an object or experience is a direct form of interpretation for visitors. Sometimes direct forms of graphic communication can speak volumes about what is real, valued, and worthy of discussion in an exhibition. The question is the balance between too little and too much. Either way, the environmental graphic designer must devise the means to best communicate to visitors. Frequently, museums engage visitors to communicate back, using various "talk back" techniques to allow the visual display of visitor input. These are also dynamic design opportunities (Figures 6.38 and 6.39). When objects or artwork are not accompanied by much interpretive text, as in many art museums, it is typically because the museum and curators most value the object-visitor interaction. The premise is that interpretive text can remove focus from the art object and be distracting in some cases. On the other side of this spectrum, we have all experienced the text-heavy

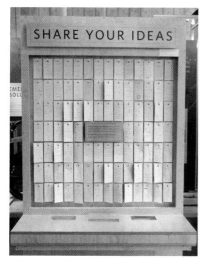
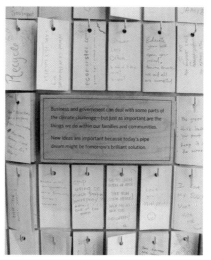

Figures 6.38 and 6.39: The classic "talk back wall" (Janet Kamien being one of the first to employ this method of visitor museum dialog). These images of the California Academy of Sciences' *Share Your Ideas* exhibit element empowers visitors to contribute their thoughts on how we can deal with climate change stating, " . . . Today's pipe dream might be tomorrow's brilliant solution." As opposed to the ubiquitous paper sticky note, visitors write on thin pieces of basswood, which can be recycled. This symbolized to visitors to take the message they write seriously because the museum does too. *Photos courtesy of Richard Cress*

exhibition where you feel overwhelmed by volumes of information at every turn—literally a "book on the walls." Exhibits are dimensional, spatial experiences, and visitors' movement through them is part of the equation. When visitors are standing still for too long reading lengthy text it can become physically exhausting as well as mentally draining. It is the job of the curators and developers to keep content short and snappy, but it is the environmental graphic designer's job to compose and position interpretive information in clear and accessible layers (Figure 6.40).

Most visitors appreciate some form of interpretation to help them understand more from the experience, to contextualize what they are supposed to see and value to position the museum's collection in their minds, and ultimately to feel their journey to the museum—and the expense of attending—is justified. Show them the goods, tell them why it was all worth it, and demonstrate why they should care.

Figure 6.40: If you want visitors to notice something . . . put it on the floor! Just do it . . . it is one location where everyone looks. If the vinyl graphics peel, pull them up and replace them. *Photo courtesy of Richard Cress*

Interactivity

Interactive experiences are opportunities for direct physical and mental interplay with a particular exhibit element for an educational purpose or to make a conceptual connection. Just as we first questioned whether a topic is best expressed as an exhibition, the question design advocates must ask before charging ahead with interactive design is if, how, and why this particular area would benefit from mechanical or electronic dynamism. Interactive designs can be expensive and maintenance-intensive, so during planning and prototyping, the team should ensure that the payoff in visitor experience is worth the effort and expense. Gratuitous interactivity can prove troublesome to visitors and create maintenance headaches for the institution for an extended period.

Figure 6.41: A young visitor rotates the air "blower" and realizes how the balanced direction of the air stream can hold the ball in suspension, and begins to understand through this physical interaction the Bernoulli principle of fluid dynamics of air. *Photo courtesy of Richard Cress*

Once design advocates determine that visitor-created interactive is essential, they should consider four functional parameters to plan the interactive: action, ergonomics, interface, and connection. What best moves the concept forward—a mechanical crank or a new technology? What psychomotor actions will help visitors to understand with their hands and bodies as well as their minds? What about interface—how will a visitor touch it, operate it, understand it? The mechanical and physical are not necessarily inherent to interactivity. Just because you can push a button to start an action does not make something a true interactive! The device must make a connection to an intended purpose and have the ability to convey, reflect, or enhance a particular exhibition message.

Sometimes, a simpler device may suffice in place of a more sophisticated interactive. For example, a two-dimensional graphic that engages visitors physically and intellectually can be a highly successful interactive. When visitors are engaged to answer questions, solve puzzles, or utilize their minds beyond reading, this mental action can stimulate visitors even without a complex physical component. Unless the action created by a visitor connects to the concepts, it may be cheaper and more effective *not* to build the interactive.

Use interactive devices judiciously. There are many physical activities currently in museums that are simply elaborate push buttons—"pedal

this bike to start a video"—which frankly are wasted interactive experiences. Quite simply, don't make visitors work hard for very little payoff. A bike that needs to be pedaled might instead be used to light up a light bulb and relate to interpretive information on energy use and efficiency. This makes the expended effort a more satisfying payoff and connected to a topic. At home, when they turn on a light switch, a visitor may think twice about how much energy it took to light that bulb, and shut off the switch when they are done. This is the type of meaningful and lasting experience that is worth the time and effort the "interactivity" demands.

Multimedia Integration into Exhibition

Richard Lewis, Richard Lewis Media Group, Inc. (RLMG)
Watertown, MA

In the last decade, multimedia has become a central element in the museum experience. Early multimedia programs were often simple menu-driven collections of content, serving as a useful vehicle for curators to nest content that was too lengthy or detailed to incorporate in graphic panels. But now multimedia incorporates a dizzying and expanding array of tools and techniques that create entirely new kinds of visitor experience. Indeed, media now engages so fully with every other element of the visitor experience that we want to raise the question of whether "multimedia exhibit" is still a meaningful term.

There is a second important shift that has taken place recently: today the most successful projects consider multimedia strategies from day one so that planning for the creation of media-based experiences is fully integrated into the overall exhibition design process. The media producer is no longer simply a technician waiting until late in the project to execute someone else's vision. Now the best media producers must be simultaneously strategists, technologists, visual artists, and content specialists, bringing a synthesis of these and other skills to every phase of exhibition and experience development.

Example of Contemporary Approaches to Multimedia: History Colorado Center in Denver

In the main atrium, visitors can gather in groups to wheel giant H. G. Wells-inspired "time machines" over a 4,000 square foot terrazzo map of Colorado. As they do so, they trigger brief media programs about the history of specific regions of Colorado. Elsewhere, visitors can execute a virtual ski jump, where subtle shifts in weight produce either success or failure, both represented on large video projection surfaces displayed in front of them. These may seem complex or ambitious experiences. Yet simplicity is neither better nor worse than complexity. Less immersive experiences give visitors the opportunity to capture their image and incorporate it into a 1919 high school yearbook, or shop for goods in the Montgomery Ward catalog from the same era.

All of these examples were developed through an iterative collaboration between RLMG, the exhibit designers Andrew Merriell and Associates and the History Colorado project team. RLMG began by listening, and by trying to understand the project's key communication goals and its audience profile. RLMG then began to develop a series of design ideas, fleshing out the initial sketches with greater and greater detail, constantly refining the concepts in response to input from project partners, always trying to create a diverse set of media experiences. Sometimes (as with the virtual ski jump) we planned to create a physical and kinetic experience; on other occasions the experience is more cognitive; still other media programs offer rich, hybrid experiences. In every case, a successful media product was the result of effective collaboration among all members of the project design team.

Many RLMG projects now incorporate another useful collaborative tool. It is now possible to create multimedia exhibitions that will let museums manage their own multimedia content in the years ahead. Now RLMG media exhibits incorporate simple and robust back-end applications that allow nontechnical staff to easily swap out text, images and video clips.

Additionally, at this writing, the most current projects see multimedia producers creating content for an integrated set of communication channels. RLMG's recent project for the Hall of Human Origins at

the Smithsonian's National Museum of Natural History involved the creation of media programs for the exhibition gallery, for an associated open source website, and for iPhone and Android smart phone apps. This allows a variety of new engagements between the museum and its users: visitors can use smart phones as a part of their experience at a given museum; and a new worldwide audience can experience aspects of the museum through their smart phones and through new components of the website.

In summary, what we feel most strongly about is that there is no longer any such thing as a "multimedia exhibit." It's simply too limiting of a description, with its suggestion of the sad, standalone kiosks of the 1990s. Now media materials must, at an absolute minimum, engage with architecture, physical exhibitry, and lighting; with web-based datapoints and datasets that express the world in real time; and with visitors' ideas, gestures, and smart phones. The challenges and opportunities are simultaneously daunting and thrilling and producers are driven by a constant urgency to imagine interfaces, displays, and experiences that as yet do not currently exist. As a result, there is apparently no limit to the possibilities that media-integrated exhibitions can offer.

Theatrics, Illusion, and Surprise

The uses of theatrics, illusion, and surprise have been staples of exhibition design as early as the first museums of Charles Wilson Peale and P. T. Barnum. The smoke and mirror illusions of a Pepper's Ghost and scrim projections have added a level of wow and wonder that have enticed audiences with a sense of the unexpected for decades (Figure 6.42). Many will say these things need to be tempered with outcomes and education as museums have a responsibility to their public. While this is true, it should not preclude visitors being entertained by experiences as they learn. Stage settings can give unique context for objects and elements of the story. Theatrics, projection, and special lighting can enhance effects that otherwise might not be tapped.

Figure 6.42: With the help of famed magicians Penn and Teller, the California Science Center, Los Angeles, CA, created this the traveling exhibition *Magic: the Science of Illusion.* This "headless boy" was an exhibit element about the science of illusion. Viewed from the front of the exhibit, your friend's head floated in midair; viewed around the back, the trick of mirror and science behind reflection was revealed. *Photo courtesy of California Science Center Foundation*

Magic and Illusion in Exhibition

By Diane Perlov, California Science Center
Senior Vice President for Exhibits

Magicians routinely combine science, technical innovation, and the art of performance and have plenty to teach exhibit designers, especially in the art of performance. Using the voice of authority, magicians weave believable stories that help the audience stretch their imaginations and enter the magician's world. Critical to carrying the audience along is the magician's ability to tell a story that connects with the cultural beliefs of the audience. The magician sets you up to look for something he wants you to see, and if he has succeeded in making what is there similar enough to what you are expecting, then that is what your brain will register. Critical to making a performance memorable is making it surprising.

Here is a great example of the importance of story, cultural resonance, and surprise told to me by one magician. A big city audience would be astounded and amazed if a magician made a horse disappear. This same illusion wouldn't fly as well in a rural community, where everyone knows that you can train a horse to do almost anything. In order for a rural audience to see a vanishing illusion that emotionally resonated as impressive and memorable, the wise magician would make a donkey disappear. Because, as anyone with experience knows, it's almost impossible to get a donkey to do anything!

Immersive Environments

The immersive environment places visitors in settings that surround them with the sensation of a particular place. Zoos have led the field in immersive themes and natural ambience for animal exhibitions. Wonderful menageries, such as indoor rainforests with live animals and walkthrough tunnels in shark tanks, are big draws for visitors. Disney imagineers created a whole new industry out of designing heavily experiential environments. Theatrical experiences saw an increase in popularity in the late 1990s and early 2000s due primarily to technological advances in theater design, projection, and sound manipulation. IMAX

theaters and filmmaking techniques heighten the sensation of being "in the moment." With advances in lasers, 3-D projection, and 4-D theater effects, which shake chairs or spritz audiences with water at the right moment, there are ample opportunities to move the visitors. But these theatrics only have fleeting emotional power if the story is not integrated at deeper levels.

Immersive Imagination: The "*Jaws* Three-Barrel Technique"

The imagination is a powerful and creative thing. Give it a little push and off it goes. Any fan of the movie *Jaws* will recall how three yellow barrels became a suspenseful omen of the killer shark's presence. Without ever seeing the shark, the appearance of the barrels on the surface of the water heightened one's imagination and frightful expectation of what was to come. That the film-maker's "three-barrel technique" was born somewhat accidentally because of the mechanical failure of the shark turned out to be an unexpected benefit. Fear and suspense are not the only emotions that can be tapped this way. These techniques should not force superficial emotions, but when our imaginations are given a little undefined space to puzzle through, fill in gaps, and draw conclusions, it awakens other synapses of the brain whose effects are more powerful and lasting. Now, museums should not all covert to haunted-house techniques, but emotional responses to enhance an exhibition experience can prove effective (Figure 6.43).

Theater in Exhibition

Theaters are used in many ways within exhibitions and include various shapes, sizes, durations and delivery methods. Whether showing formal films, mini-documentaries, pan and scan slides ("Ken Burns-style"), multimedia, presentation of objects or artifacts, live action and any combination in between, a theater, performance or demonstration provides a particularly focused delivery of content.

One of the most popular and effective uses of theater is the orientation theater that gives visitors a general overview of

Figure 6.43: The traveling exhibition *Goose Bumps!: The Science of Fear* took full advantage of visitor emotions. Setting up four "fear stations" (Fear of Animals, Fear of Electric Shock, Fear of Loud Noises, and Fear of Falling), allowed visitors a first-hand opportunity to be scared before discovering the science behind our most primal emotion. The California Science Center, Los Angeles, and Science Museum of Minnesota collaborated to develop and design this exhibition. *Photo courtesy of California Science Center Foundation*

the exhibition. As a focused seated experience (20–30 visitors lasting 10–15 minutes), this type of theater allows visitors to absorb a more complex or lengthy overview that may be difficult to present in an alternate mode. Other formats include smaller theaters for short shows (seating 10–20 visitors lasting 3–7 minutes) on a specific topic; step-in theaters for three or four visitors with limited or no seating, live performances featuring storytellers, actors, or interpreters, educational programs, cart demonstrations, make-and-takes, and experiment areas (electricity, explosions, steam/smoke are always a hit in science museums).

Theater and Immersive Environments in Museums

By Donna Lawrence, Creative Director and President of Donna Lawrence Productions (DLP), Louisville, KY

The first consideration in choosing which form of media to use in exhibition design is: what medium best serves the objectives of the piece within the overall exhibition or museum. Some exhibition objectives are most effectively communicated through interactive media with deep access to content; others through silent video projections, audio environments, video kiosks, or intimate mini-theaters that urge personal reflection, for example.

So when to deploy large-scale immersive media and high-impact theatrical productions? When the objective is to communicate a central idea or a few pivotal concepts that transform how visitors receive the larger exhibition or museum story, or how they reflect on a subject long after leaving the facility.

Project Structure

The Rosetta stone of successful theatrical productions in museums—in a dedicated theater or as an immersive walk-through environment—is *project structure*. The reference to "theater" throughout this discussion is

at the heart of the most challenging aspect of creating theatrical experiences within museum environments.

In the past, the worlds of theater, theme parks, and museums were often distinct and clearly separated by technology and expectation as to the kind of experience you might find in each of those venues. As technology began to open each world to the other, and as museums began to see other forms of entertainment competing for their audiences, more and more museums began to incorporate "immersive," "theatrical," "state-of-the-art," "environmental," or "destination" experiences into their facilities.

Theater Productions

In a dedicated theater space, the designer and filmmaker can take visitors on an unforgettable "ride" through a story. Theater and film—and their myriad hybrid forms–are time-based art forms, and in a well-designed theater, the sequence and build of the story, vibrant imagery, crystalline sound, and special effects can be perceived by the audience as intended, unaffected by ambient light, sound from adjacent exhibits or distractions that break audience focus at critical points in a production. In a dedicated theater the director's tools of dramatic structure, transporting visuals and sound, sensory impact, and emotional payoff can have powerful effect in service of a story or key concepts related to the overall museum or exhibit. A story can deftly, purposely, and powerfully unfold to great and lasting effect in visitors' hearts and minds. If that is your goal, the greater investment of time and budget these productions require will pay off for years to come.

Immersive Theatrical Environments

Immersive environments, often experienced at a visitor's own pace and open to adjacent spaces, connect visitors to stories through the power of immersive impression, discovery and reflection, rather than through the time-locked playing out of a story structure with

a particular emotional payoff at the end. In immersive theatrical environments, visitors' experience can be thought of as walking *through* a transporting theatrical set or operatic scene that plays out as they pass through at their own pace. Freely using a unique and creative mix of video and theatrical projection, programmed lighting, ambient sound effects, an evolving musical score, voices, or strategic text elements, visitors are connected viscerally and emotionally to historical moments, distant places or cultures, concepts or an idea that powerfully complements the more literal storytelling of other exhibits.

Process

The most successful projects, whether immersive environments or dedicated theaters, are produced by a show team led by: a producer/director responsible for shaping and implementing the vision in collaboration with the exhibition team project manager/designer or museum client; a production manager responsible and experienced in managing and integrating lighting, scenic, and AV and media work streams into an effective theatrical experience; and a technical director who coordinates the multiple technologies, flowing them together on-site for final installation, programming, and a smooth hand-off to theater staff on-site. Specialty roles, depending on show design, include: theatrical lighting designer, rigging engineer, theatrical scenic designer, AV system engineer, and other specialists, and the on-site installation crews for these various systems.

The tried-and-true roles that have evolved over time in myriad theatrical genres allow a show team to avoid the spokes-without-hub scenario that otherwise makes theatrical productions extraordinarily and unnecessarily difficult and fraught with technical, schedule, budget, and creative problems. A theatrical team structure that ties together talented individuals dedicated to bringing to life a story at the heart of an institution's message is key to creating experiences that can help power the arc of an institution's life over time.

Object Theater

By Paul Martin, Senior Vice President, Science Learning
Science Museum of Minnesota

The term "object theater" was coined by Taizo Miyake, who was the creative force behind the Ontario Science Centre in its early days and mentor to many (including me) through the years.

So, what is an object theater? This is a question I've asked and have been asked for 30 some years. There's no simple answer. An object theater is generally a black box type of theater space that minimizes external distractions and allows the audience to focus. It's an environment that can tell stories, create juxtapositions, provide alternative perspectives, provoke, challenge, and transport its audience to different times and places. It uses objects, images, and settings, sound, and light to physically, emotionally, and intellectually engage the audience. At its best, the most powerful images of the show are created in the mind's eye of the audience; in this respect, it's more like radio drama than film.

The early inspirations for object theater come from the grand sound and light shows done at sites like the great pyramids in Egypt, where at night the grand objects became a vehicle for story telling with narration, music, sound, and lighting providing a dramatic reinterpretation of the site not possible during the daytime.

Another early example is from the Royal British Columbia Museum in Victoria, British Columbia. You enter an alcove where there's a large wall-case full of North West Coast masks dimly lit. You sit on a bench facing the case and as light comes up on particular masks. A first-person voice simply describes what the masks represent and what they mean to those who created and use them. "This is the raven, the trickster. . ." This simple technique has seared the images of those masks into my memory.

Object theaters are great at helping visitors engage and understand in ways not possible using more conventional exhibit techniques. Some

of the things they're good at doing are showing relationships between things in new ways:

- Making something as large scale as the universe or small scale as atoms understandable

- Creating collages of stories through time and space that engage visitors on a personal and emotional level

- Simulating what it's like to be somewhere and experience something first-hand, such as being in a basement during a tornado or the room of a Tokyo teenager over the span of a day

- Representing important but not so engaging content in accessible compelling ways like a film noir send-up on buildings as systems and the deadly consequences of carbon monoxide, where the CO_2 detector is a scruffy gum shoe that unravels the mystery of what's creating this "silent but deadly" situation (Figure 6.44)

- Turning the focus of the show to the audience, challenging their visual and auditory perceptions by creating a magic show, using many of the stand-alone perception exhibits found in science centers as the objects to engage visitors more deeply in their own "brain magic"

- Addressing such difficult subjects as coping with life changes, death, and loss

There are many more examples of and possibilities for object theater, but in my opinion it comes down to the power of object theater to immerse and engage, emotionally drawing on each visitor's memory and experience to create new memories, understanding, and personal meaning. It's a great tool as we all continue to strive for these outcomes in the work we do.

Figure 6.44: The "Talking House" object theater presents a 1950s Dragnet radio style story of a scruffy gum-shoe CO_2 detector who unravels the mystery of what's creating this "silent but deadly" situation in the *Raise the Roof* traveling exhibition, Science Museum of Minnesota. *Photo courtesy of Science Museum of Minnesota*

Icon Experience

When there is one iconic object or experience that is a focal point, directly connected to or representative of the broader exhibition content, it can be the most memorable experience for visitors. This practice originated partially from traditions at World's Fairs to have a central visual feature, such as the first Ferris wheel at Chicago's 1893 Columbian Exposition, and museums have adopted it. This "icon experience" has a buzz factor—one that visitors will share with friends—and frequently it is the reason visitors decide to attend an exhibition in the first place. Typically the icon experience is an exceptional object: the Mona Lisa, Liberty Bell, Hope Diamond, an ancient mummy, shark, or T-rex skeleton. The icon experience can also be a designed feature—an element or structure built solely for the exhibition—that is large in scale, made of interesting materials, created by an artist, or all three. The corn portal created for the threshold of the Smithsonian Institution's 1992 *Seeds of Change* exhibition at the NMNH was an architectural gateway to a 500-year-old story; the Baobab "Tree of Life" is a dramatic anchor at the center of Disney's 1998 *Animal Kingdom*, and the Please Touch Museum's 2008 Statue of Liberty Arm and Torch replica in their main atrium is a 40-foot-tall presence built entirely from recycled materials (Figure 6.45).

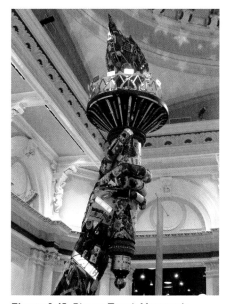

Figure 6.45: Please Touch Museum's 2008 Statue of Liberty Arm and Torch in the main atrium is a 40-foot tall replica built entirely from recycled materials and objects. This icon is a reference to the actual Liberty Arm and Torch that was first seen by visitors during the Centennial Exposition in 1876 in Philadelphia, PA. *Photo courtesy of Richard Cress*

Another type of icon experience can be just that . . . experiential. Early examples that still impress visitors today include the 1933 coal mining exhibition at Chicago's Museum of Science and Industry, where you experience the confinement of the mine, and the 1953 giant walk-through heart at the Franklin Institute, where the visitors move through as the blood cells, and in 2004 was refurbished to become the centerpiece of the institute's Bioscience gallery. In 2009, the City Museum in Saint Louis, Missouri, created an icon experience with the authentic 1940 Eli Bridge Ferris wheel, which is both an iconic object and experiential. It is a large artifact from the city and feels larger because it is installed on the roof, eleven stories above the ground. In effect, the whole museum could be considered an icon experience for the city of Saint Louis, with deference to the notable Gateway Arch.

Icon experiences become important touchstones to visitors and should be planned thoughtfully (Figures 6.46 and 6.47). Icons must connect to meaningful and tangible purposes as in the preceding examples, or they will easily become clichés, too over the top, or superficial. Disney has been an easy target for accusations of superficial "commercialism" over the years, but some museums have fallen into this trap as well. The *authenticity* of the icon and the learning experience provided by it should be a primary point of differentiation, particularly in a museum setting, as it is important that visitors first perceive the museum as an educational resource rather than as overly commercial.

ACCESSIBLE AND UNIVERSAL DESIGN

Accessibility is not simply a choice, it is the law. The Americans with Disabilities Act (ADA) enacted by the U.S. Congress in 1990 (and amended in 2008) guides the necessary considerations for building

Figures 6.46 and 6.47: As an icon object in Liberty Science Center's *Skyscrapers* exhibition, an 18–inch-wide I-beam from the Twin Towers after the 9/11/01 tragedy, no label is necessary to understand the tragic force and heat needed to render this once superstrong structure into an object that appears bent like a paper clip. *Photos courtesy of Richard Cress*

access and space planning issues, such as correct ramp angles for handicapped access or how far cases can project from a wall before they become issues for the sight impaired. These are important primary steps, but they only scratch the surface of possible variables when designing exhibitions. ADA is not as effective when it comes to mental and/or emotional challenges. For instance, accessibility in exhibitions for those on the autism spectrum can pose a new level of criteria. There are many creative ways that institutions have assessed and designed for these issues, but the most important approaches are awareness, research, and testing. Typically, it is left to the designers to make smart and empathetic decisions concerning how different groups may gain access to these experiences. When designers approach this thoughtfully, they can open up a completely new world for those who have been somewhat forgotten in the past.

Accessible Design

By Lath Carlson, Vice President of Exhibitions,
The Tech Museum of Innovation, San Jose, CA

As the authors have discussed, for a museum exhibition to be successful, it should be designed to be an extraordinary experience for almost all visitors. Museums are generally public places that should be welcoming to a broad array of people. These visitors, like human beings everywhere, possess abilities that are best thought of on a continuum. The degree to which a given person is able to utilize a sense, such as sight, varies considerably. Visitors might be color-blind (of which there are many types and degrees), farsighted, or nearsighted; have limited vision (of which there are many types and degrees), no vision, super-vision (better than 20/20 naturally, or through Lasik); or even utilize an adaptive technology to provide vision without using the eyes. Examples of these wide ranges of ability can also be found in the other four senses, as well is in the cognitive realm. How is the exhibition designer best able to create the equivalent level of experience for visitors who fall along these continuums?

The best practice is to adopt a visitor-centered, and empathetic approach. It can be helpful as you develop a new exhibition to create personas or fictitious visitors who possess a range of abilities. Staff or volunteers can then act out these roles as they imagine a visit to your exhibition. This exercise is best primed by conducting a visit to an existing exhibition, in your museum or another, while in these personas. This process can rapidly expose obstacles to creating extraordinary experiences for all visitors, and begins to build empathy for the range of people who will be visiting your exhibition. An alternative method would employ a wide range of actual visitors to test exhibitions, but this approach might be less effective in building empathy within the design team.

Employing the preceding methodology can be very effective in reducing barriers for visitors with a range of abilities within one sense, such as mobility or sight. Standards and laws such as the Americans with Disabilities Act (ADA) provide a good baseline starting point for addressing these barriers. Following ADA guidelines is mandatory in the United States and is generally focused on physical movement and navigation, not on delivery of content. Effective delivery of exhibition content poses a more difficult change in order to achieve wide-ranging accessibility.

The difference between designing for ADA and designing a content-rich experience is akin to the difference between a street sign and a novel. Exhibitions are typically deeply layered environments with architectural features, exhibition casework, artifacts, graphics, text, audio, video, interactives, dioramas, and a multitude of other elements. When designers begin to attempt to broaden the accessibility of each of these elements, they quickly find themselves in a conundrum. The very point of using a particular element often undermines the effort to make it accessible. Take a diagram for instance—a graphic showing the interconnections between historical figures. A bubble diagram is typically chosen to illustrate the complexity of relationships between items, which a visitor can explore in a nonlinear way. Now imagine an attempt to make it accessible to a visitor with limited or no sight. The very factor, complexity, that made you think to use this means of communication is what now makes it nearly impossible to create an auditory facsimile.

The title of this contribution is "Accessible Design"—and another barrier to be aware of is language. Because data shows that 1 in 5 Americans speak a language other than English at home, it stands to reason that a museum for the public needs to add this to its accessibility concerns. According to census records, Spanish is used a third more than the next most often used non-English language in the United States. Depending on the region and potential audience, the museum and advocates need to consider not just a second language but possibly a third or fourth (possibly Indo-European and/or Asian and Pacific Island languages), too. This poses an interesting design challenge for graphics and/or audio components that should be addressed and committed to early in the process.

Fortunately, there is a way forward, one that capitalizes on both the variation in visitors and the richness of content in an exhibition environment. When conducting persona exercises, and based on your own museum-going experience, you are likely to have discovered that while visitor's each go to the same exhibition, they have widely divergent experiences while there. Each experience varies based the visitor's interests, time, social group, cultural background, cognitive factors, knowledge, physical abilities, and many other factors. Well-designed exhibitions make effective use of layered content and a diversity of delivery tools to engage all visitors. No single visitor will ever experience every aspect of an exhibition. Each visitor creates his or her own experience and it is the designer's challenge to make each extraordinary.

By layering the content at many levels and using a broad array of delivery tools that engage all of the senses, a designer can best ensure broad accessibility. Not every element will be experienced the same way by each visitor, but they never would have been anyway. The efficacy of your design in reaching the exhibition's goals can be evaluated through diverse persona testing. This approach generally leads to a much broader utilization of at least four senses throughout the exhibition, as well as variation to appeal to different learning styles and cognitive abilities. Consequently, the exhibition will be more engaging for all visitors, and it will more truly fulfill the promise of universal design.

ENVIRONMENTALLY SOUND PRACTICE

Although there are many best practices emerging in museum exhibition for "sustainable design" or "environmentally sound design," there are no true standards or certifications as of this writing. Because many exhibitions' content focuses on or makes reference to conservation initiatives—especially in zoos, aquaria, and natural history museums—it becomes essential that museums practice what they preach (Figure 6.48).

Many special interest groups are formulating and standardizing what sustainable museum practice should be. A critical issue is that the customized nature of museums' exhibitions means we rarely do the same thing twice, although it is already a given that designing with an economy of green, recycled, nontoxic or non-contaminate-emitting

BROMELIAD
TREE

Figure 6.48: Sketch of deadfall tree used as a planter for the flowering Bromeliad to create an underpass. *Photo courtesy of John Coe, CLR Design, Inc.*

materials is standard practice. Planning for energy efficiencies and reuse over the long term is also an essential issue today and onward.

One of the essential needs for the exhibition designer, in terms of environmentally sound practice, is to seek out the most current resources and information. Vital information is being updated every day, and it is the ethical responsibility of the designer, as an environmental advocate, to ensure the exhibition follows up-to-date practices. The designer should specify with the general contractor and exhibit fabricator *up front* that these practices must be followed. They often come with a price tag, so these expectations should be built in to budgetary considerations from the start.

The other transformation currently happening is the way exhibitions are designed. Choices should not only be limited to changing the specifications of materials, but also extend to the very practice, process, and approach to the exhibition design business. For example, changing a graphic panel specification from particleboard to a new "green" material is good, but what if the purpose and execution of that graphic panel was fully reconsidered in this way: does it need to be solid material, or could it be more ephemeral, mounted on paper or cardboard product with a shorter lifespan and be recyclable? This would facilitate changeable content and not yield a dumpster full of nonbiodegradable laminates in a few years if the content becomes out of date or the museum decides to renovate.

Green Design Resources

One of the best resources is the American Alliance of Museums Professional Interest Committee for Green practice network (AAM—PIC Green), "Sustainability skills will be critical to all museum workers. You'll need it to make environmental control decisions, manage the garbage, choose and manage your utilities, design and select resources for exhibits and special events, and of course understand it if you are rehabilitating, expanding or building a museum."[10]

[10] Sustainable Museums Blog Spot. http://sustainablemuseums.blogspot.com/. Feb. 19, 2012.

Environmental Guidelines for Exhibition Design[11]

- Reduce the amount of materials

- Avoid toxic materials

- Design for reuse

- Use recyclable materials

- Use recycled materials

- Design for energy efficiency

- Use exhibition design to educate

 http://greenmuseum.org/

[11] McLean, Kathleen; *ASTC Dimensions*, Nov/Dec 2003 This list is adapted from an appendix in her 1993 book *Planning for People in Museum Exhibitions*, published by ASTC, 1994.

Sustainable Exhibitions

By Lath Carlson, VP of Exhibitions,
The Tech Museum of Innovation, San Jose, CA

Sustainability can be defined as *meeting the goals of the present without negatively impacting future generation's ability to do the same.* The use of "green" materials in construction is only one aspect of creating sustainable exhibitions. The choice to use natural materials, which have less of an environmental and health impact, is one of the more visible steps a designer can take, but it should be tied to a larger strategy for overall sustainability. In order for an exhibition to be truly sustainable, a total lifecycle approach should be considered. The complete scope of the exhibition should be taken into account, from the decision to create a physical exhibition: its duration, usage, content, construction, installation, maintenance, disassembly, and recycling or disposal.

A thorough "sustainability assessment" should start with a series of questions. Most importantly, as discussed in other chapters, *why is an exhibition the best way to convey this content?* Once you have determined

that an exhibition is indeed the best way to deliver the content, and reach your goals, the next step is to consider the visitors' perspectives. By understanding what elements are likely to have the most impact, your investment and subsequent environmental impact can be concentrated in these areas. If a large-scale diorama is not going to go far in reaching your goals, a large-format graphic mural will be more sustainable no matter what "green" materials the diorama is made from.

Another important question to ask is, *how long is the exhibition intended to be installed for, and what happens to it after that?* Exhibition longevity can be a key consideration in design and material choice. If the exhibition is short term, consider what existing elements can be used, if items are available for rent, if it can be designed for reuse, or if the exhibition can be built with readily recyclable materials. If your institution plans on creating a series of temporary exhibitions, consider investing in a modular display system that can be reconfigured with minimal new materials being consumed. For long-term exhibitions, other considerations should be taken into account. It may be more sustainable to use materials with a greater initial environmental impact, if this avoids the need to replace them later in the exhibition's lifespan. Likewise, there are instances where use of synthetic materials is warranted, such as in the fabrication of durable interactives. Care should also be taken to use materials that can be kept clean with nontoxic cleaners and can be refinished as needed rather than replaced. For more permanent exhibitions, final disassembly and recycling or disposal must still be taken into account. To aid in this effort, try to design components with a minimum of adhesives and painted finishes, which make disassembly and recycling difficult. Modular construction with common mechanical fasteners and few composite materials is best.

How is the exhibition to be used, will it need to be updated, and will the style become dated quickly? Exhibitions without interactive components typically see far less wear than hands-on experiences. Hands-on components present a significant challenge to the designer striving for sustainability. In order for the components to last over time, synthetic and possibly toxic materials are often needed for the maintenance to be manageable and cost-effective for the institution. On the other hand, since these exhibits are meant to be touched, typically by young

visitors, exposing them to these materials is not ideal. Judgment should be exercised in balancing these demands, minimizing the use of these materials and, wherever possible, keeping them out of direct contact with visitors. As part of the lifecycle analysis of the exhibition, particular care should be taken to identify content that will need to be updated during its lifespan. Common elements, such as timelines that extend to the present, must be designed for easy updating. Also note any content that may need revising if the scientific or historical consensus changes. For example, older dinosaur mounts were welded in an upright position, and the scientific consensus later shifted to a more horizontal posture. Articulated mounts would have made addressing this shift substantially more sustainable. The designer should also be wary of utilizing a time-bound style of design. For long-term exhibitions it is better to use color, typography, and forms that are more established, rather than current trends. For example, Mid-Century Modern looks have stood up better over time than the tortoise shell and pink plastic laminates of the 1980s.

Only after all of these questions are considered should the designer begin to think about materials and construction methods. For optimal sustainability, materials should be chosen that are derived from natural resources with minimal processing, or recycled materials. Resources that are rapidly renewing without the application of chemical fertilizers or herbicides and are not transported from long distances are best. The more processing a material has undergone, the more fossil fuel energy it has typically consumed, and the less likely it is to benignly disposable. While materials such as aluminum are readily recyclable, they require enormous energy to produce and should be used sparingly. Material finishes should be chosen that do not "off-gas" toxic fumes, and that allow for refinishing rather than replacement. The construction of exhibitions should be completed locally, with locally sourced materials whenever possible, to decrease fuel use in shipping, and air travel for installation and repairs. Care should be taken in designing elements for efficient use of materials to reduce waste. Modular elements can be used to encourage reuse. Consider designing components for reuse by other institutions, as office furniture or upcycled into gift shop items. Utilize reusable packing blankets and recyclable packing materials when transporting finished exhibition components to the

museum. During installation, plan for eventual disassembly and avoid toxic glues.

Electronics, lighting, and media in exhibitions require special consideration. The energy use, efficiency, and disposal of electronics should be planned in advance. Lighting and electronics should be selected that are energy efficient and capable of being automatically powered down when not in use; the Energy Star rating is a good first indicator. Consider using automated control systems and sensors to manage turning them on and off. For institutions with many computer-driven exhibits, a virtualized server and thin client infrastructure may be advantageous. E-waste is increasingly becoming a global problem. Try to choose electronics that are designed for disassembly and recycling, and invest in longer-lasting high-quality components wherever possible. At the end of their lifecycle, return them to their manufacturer or to a reputable e-waste recycler.

At the time of publication, no unified standard exists for sustainable exhibition construction, or "green" materials. Some museums have found the U.S. Green Building Council's (USGBC) Leadership in Energy and Environmental Design (LEED®) points based programs to be useful, although they have been developed primarily for new building construction and commercial interiors. Forest Stewardship Council (FSC) certifications are useful when identifying more sustainably produced wood product.

CONCLUSION

This chapter has covered a range of possible considerations when planning and designing an exhibition. How might the team approach and think about these options? Is the team willing to push beyond what they have produced before in small or larger ways? These considerations should be introduced into the collaborative process and reviewed for application to the project at hand. The design advocate is there to support, make concepts visual, and help craft content into a rewarding experience for the visitors and the team (Figure 6.49).

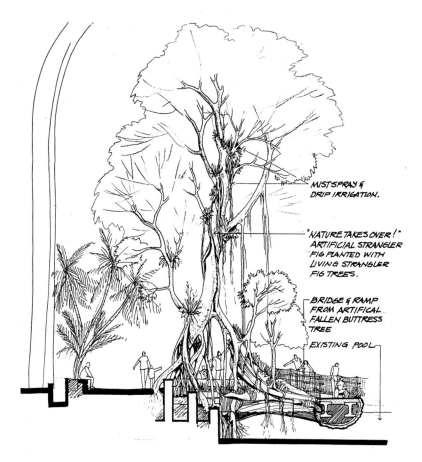

Figure 6.49: Sketch of rainforest installation. *Photo courtesy of Jon Coe, CLR Design, Inc.*

FURTHER READING

Bitgood, Stephen. *Social Design in Museums: The Psychology of Visitor Studies*. Edinburgh: Museums Etc. 2010.

Brown, Tim. *Change by Design: How Design Thinking Transforms Organizations and Inspires Innovation*. New York, NY: Harper Business HarperCollins Publishers, 2009.

Dean, David. *Museum Exhibition: Theory and Practice*. New York: Routledge, 1994.

Din, Herminia, and Phyllis Hecht (eds.), *The Digital Museum A Think Guide*. Washington, DC: American Association of Museums, 2007.

Hughes, Philip. *Exhibition Design*. Portfolio Series, London: Laurence King Publishing Ltd., 2010.

McLean, Kathleen. *Planning for People in Museum Exhibitions*. Washington, DC: Association of Science—Technology Centers, 1993.

Simon, Nina. *The Participatory Museum*. Santa Cruz, CA: Museums 2.0, 2010.

Vlarde, Giles. *Designing Exhibitions: Museums, Heritage, Trade and World Fairs*, Second Edition. Aldershot, England: Ashgate, 2001.

Beyond publications, there are key online resources: Nina Simon's *Museums 2.0*, a contemporary museum, maintains a blog focused on exhibition; the *Paul Oreselli Workshop* (POW!; www.orselli.net) is a site resource for interactives, clever solutions, tips/tricks, and the fabrication of mostly science based exhibits; and *Exhibit Files* (www.exhibitfiles.com), an ASTC funded member-based site, documents museum exhibitions through images, case studies, and critiques.

ADVOCACY FOR PROJECT AND TEAM

Trying to manage a project without project management is like trying to play a football game without a game plan.

—Karen Tate, Project Management Institute

MANAGING THE PROJECT AND TEAM

The project manager is responsible for running the project and ensuring that the team has what it needs to produce the best product possible within the time and budgetary limits set at the onset of the process. This advocacy is one of power, but this power is in service to the team, not the individual. The project manager is *not* the ultimate leader with full veto power. He or she is the guide, the facilitator, and the nag. The advocate for the project and team needs to be primarily concerned with three aspects of the project:

- The creation and management of a working budget
- The creation and management of a working schedule
- The health of the team and of the way its members do business with one another

"Cheap, fast, good: pick two."

Three Critical Questions

- How are working budgets and schedules best created?
- How are working budgets and schedules best managed?
- How can advocates for the process be part of the creative team yet remain detached from the *sturm und drang* of team disagreements?

Approach and Philosophy

It's our belief that advocacy for the project and team is a more powerful and important role than many of us imagine and that good project management is necessary to create a welcoming environment for collaboration. We also believe that this advocacy takes more skill than is sometimes realized, both technically and in the realm of human relations. In this chapter, we'll outline those skills and give some suggestions about how to tackle the basic tasks (Figure 7.1).

It's also our belief that this can be a hard role to take on overall, because the excellent project and process advocate creates and maintains the landscape for all team members to do creative work, but does not decide the outcomes of that creativity. Because the role has so much power, this detachment can be hard to maintain.

Since—for better or for worse—almost no museums keep a staff on board to do all the development, design, and fabrication tasks, some or all of these functions will probably be hired out-of-house. Even if "temporary" staff are brought in to do some of the work, your approach will still probably mean creating schedules and teams with people who do not necessarily have experience with the institution or each other. This may be true for subject matter specialists as well. Even museums with a curatorial staff may find that the absolutely correct expertise for a specific project cannot be found on staff, and that this, too, must be hired from outside. Or it may be that we are looking for a diversity of points of view and in order to to supply this, we will need to look outside our walls. Whatever the case, advocating for process and project often means juggling the contracts and schedules of outside contractors and helping to bridge the differences in working styles between all these groups.

Figure 7.1: Project and team advocate: Balancing the budget and the schedule while keeping the team on track. *Illustration by Meghann Hickson*

CREATING A SCHEDULE

Like most of the work products we discuss, the creation of budgets and schedules also begins with a research phase and goes through a series of "closer approximations" in researching, organizing, visualizing, documenting, and presenting the results to others. If you're lucky, you'll have some experience (or even documentation!) of the history of other exhibition projects within your organization to fall back on. If not, you'll have to start your schedule from scratch. There may also be other imperatives to consider: maybe the exhibition needs to be ready for a celebration or anniversary of some kind, or perhaps a new wing or whole new building is opening. If so, the end date is already established. Even if it is not, a "counting backwards" exercise is often a good way to begin a scheduling conversation and a broad-stroke outline. It goes something like this (Figure 7.2):

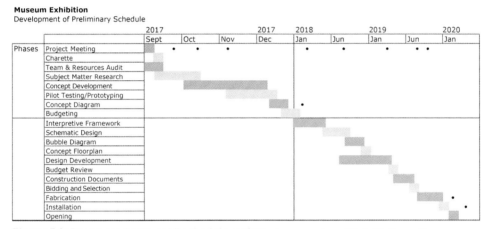

Figure 7.2: Broad-stroke "rough" schedule outline. *Image courtesy of Polly McKenna-Cress*

Establishing a Broad-Stroke Schedule

Preferred opening date: **January 2020**

Ask: **How many months to fabricate and install?** To make an informed guess about this, we'd need to know how big the exhibition is going to be, and something about its relative complexity. For the sake of the example, let's imagine it's 2,000 square feet, to be built by an outside firm.

Guesstimate: **6 months**

Therefore, fabrication begins: **July 2019**

Ask: **How many months to design and document for fabricators?** To make an informed guess about this we'd need to know something about the kind of exhibition we are going to have: heavy on interactives? On media applications? Do we have in-house design capability or will we have to find and contract with an outside firm? For the sake of the example let's imagine that we anticipate only a few interactives and only one or two videos and that we will be designing in-house (in other words, this is a less complex example, with minimal time for formative evaluation of prototypes of some elements).

Guesstimate: **12 months**

Therefore, Design Development Phase begins: **July 2018**

Ask: **How many months to create the concept and test it so that detailed design can begin?** To make an informed guess about this, we'll need to analyze how far the idea had already come before the intention to do the exhibition was approved. For the sake of the example, let's imagine that we have been working with a group of advisors for some time, have completed concept papers, and have conducted early audience research; the collections material connected to the subject is well known by staff, and further, we have one or more staff members who have been thinking about and anticipating this for some time, although we have not yet formed a team, and we don't have any specific audience input yet.

Guesstimate: **Minimum 10 months**

Therefore, Concept Development begins: **September 2017**

OOPS! **It is now December of 2017, so we already have the following decision to make:** Either the opening date cannot be January of 2020, or we have to find a way to squeeze down the number of months we've just estimated. The choice can be debated, but not for long, for as we assemble more details about the work to come, we will discover more potential impediments that will need to be considered. So, if possible, let's give ourselves some elbow room and make the opening June of 2020 instead of January. Remember that once we have set an opening date it will be hard to retreat from it, so it's wise to feel sure we can accomplish it.

The Devil Is the Details

Once a bare-bones schedule like the one just shown has been established, it is difficult, but critically important, to attend to the details immediately. In fact, setting up the team and mapping out the details will take some time, so that's your first month of the new schedule before Concept Development can begin. Some primary events to establish are:

- **Dates for milestone reviews** (and therefore the deadlines for the documents and other work products that support them)
- **Dates for various visitor research efforts** (including "front-end" research and the possible physical piloting and prototyping of various elements)

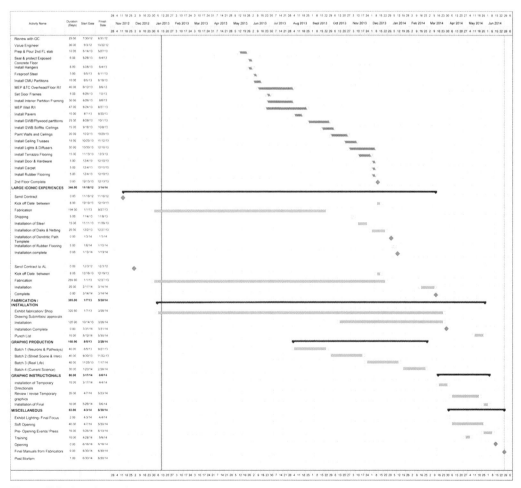

Figure 7.3: Detailed schedule. *Courtesy of Jeanne Maier, The Franklin Institute.*

- **Dates for the approval and beginning production of "specials"** (things that take a long time to create, such as large models, taxidermy, icon experiences, elaborate media, or complicated interactives)

- **Dates for vacations or other absences for primary team members** (this needs to include major holidays or museum busy times when staff may be pulled away from the project)

- **Draft due dates for other cumbersome and multistage endeavors** (such as label writing and final graphic design; final collections lists with loan agreements, conservation, and mount-making specifications; or final image or media lists, with rights purchases accounted for)

This stage may be time-consuming because each aspect of the schedule will need to be understood and agreed to by the team members who will have to carry it out. Highly collaborative teams may also be mixing and matching some of the tasks you are scheduling outside of strictly defined job roles, and this may further complicate planning.

Oops! Don't Forget

We must also always remember the quote from the beginning of this chapter: *"Cheap, fast, good: pick two"* (Figure 7.4). Managing the trade-offs in that axiom might be illustrated as *oops moments*:

Oops, we're behind: It's almost always possible to improve schedule issues by throwing money at a project. But quickening the pace can have consequences—we can move too fast to decision points and later find we are not especially happy with them.

Oops, we forgot about visitor research: If no one anticipates the need for visitor research ahead of time, it's treated as an afterthought and is often the first thing to go when we are feeling schedule pressure. Also, if you forget to line up someone to do this, it will cause more delays in the schedule when the need arises.

Oops, our commitments to quality are slipping: When this slips, other best practices can go out the window too, such as community input at the outset, thorough scholar and/or community review of final label copy, a "debug" phase during media and interactive installation, or even final approval milestones—because if there were approval issues you wouldn't have time to fix them anyway!

Figure 7.4: "Pick two." *Image courtesy of Polly McKenna-Cress*

Every one of these is a bad idea, but just the kind of thing that happens when a schedule is poorly made or poorly adhered to.

Amazing though it sounds, it's also possible to have too much time. When things don't move smoothly from stage to stage with at least a bit of urgency, team members can begin to second-guess themselves, changing their minds about details or even big things, such as the basic criteria for the exhibition. If left to boil over, this kind of abundance of time can result in confusing exhibitions that have lost their distinction in a cauldron of luxurious indecision and redecision.

The biggest problem in schedule creation is often that team members actually have no idea how much time they will require to do any specific task, so they will estimate badly. And time really is money. In the best of all possible worlds, we would have documentation of previous projects to look back on, meaning that we would have materials such as time sheets and previous project schedules. People rarely remember such things accurately, especially when they have been done over years, with other tasks or even whole projects interjected. Some people will overestimate wildly; others underestimate. When no documentation exists, it may be wise to ask colleagues at other institutions. While the idiosyncratic ways of individual museums will probably prevent your research from rendering a perfect apples-to-apples match for comparison, it can give you a place to start. This will be true in the creation of budgets as well.

Managing a Schedule

There are any number of software products that can help you to document the final schedule in order to track it and make it available to all the team members. We won't try to name any here, as new versions become available frequently. Experience tells us, however, that software that does too many things automatically—such as mechanically changing the due dates of a series of work products when one due date is changed—may look like a good idea at first, but may prove to be a bad one later. The system you choose should be malleable for your use, and you ought to be able to decide which details to change yourself rather than having them be so interdependent and automatic that the program feels out of control to you.

*Everyone needs
deadlines.*

—Walt Disney

For very large projects, it's also handy to be able to separate parts of the schedule from the whole for specific audiences. For instance, graphic designers and label writers might have a smaller, independent schedule that concerns only the steps they have to be aware of, to create text panels and not the whole complicated thing.

Conforming to the Schedule

Setting this all up is actually the easy part! The harder part may be getting team members to conform to schedules they have (theoretically) helped to create and agreed to. Short but regular meetings in which the immediate scheduling deadlines and issues can be reviewed are probably the easiest way to approach schedule management. Any problems revealed in such meetings should be attended to immediately. Highly collaborative teams will be better at this kind of problem solving, since they will be used to blurring the edges of job roles, but even these kinds of teams eventually lose patience with a member who is consistently late with work products. Because of the highly interdependent quality of most aspects of exhibit work, one person's failure to accomplish his or her goals often creates cascading problems for others, and this gets old fast.

This is an issue that will need solving by the advocate for the project and team. If the weekly meeting peer pressure of public failure is not creating the desired outcome, you can earnestly look for other reasons in a more private conversation. Is the workload just too much? Is the person experiencing other problems that eat up time and concentration? Are the skills needed to do the job somehow lacking, or is confidence lacking? Or is the individual just "not interested"? While it may not be in your power to fix any of these issues, it is within your power to identify them in the least punitive way possible, and if they are unfixable within the team, to refer the issue to another appropriate place within the institution. If an essential player simply cannot do the job, it may be your sad task to suggest a replacement in order for the project to successfully go forward. Remember, it is never in the best interests of individuals to be constantly placed in situations in which they fail.

But what if, in general, you are just not making it? What if you are so far behind that it's clear the project will never be done by the deadline?

The obvious thing to try first is to extend the deadline. What people often fail to understand about such a step is that it will cost more money, whether we are talking about extending in-house staff time or consultant time. Another more horrifying strategy is to cut aspects of the project in order to spend all the available time on the essentials for opening day. Another is to add staff—and of course, this too will cost more money. Again, cheap, fast, good: pick two.

Budget: a mathematical confirmation of your suspicions.

—A. A. Latimer

CREATING A BUDGET

"How much will it cost?" . . .
"Well, how much do you have?"

This exchange is shorthand for a perennial problem in budget creation. The client wants to know how much he or she will need to come up with to do the project (and will want to understand how the number was arrived at). The working team just wants to know how much could be available—then they'll tell you what you can have for that amount of money. Why should they labor to come up with a comprehensive budget when the client is only going to tell them they can't have that much anyway?! Sometimes we do know how much is available, but usually we don't, so we'll have to have some strategies for estimating.

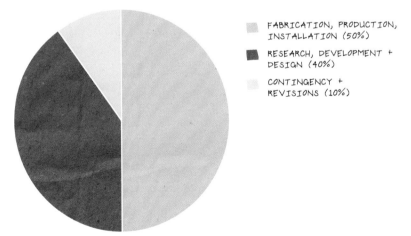

FABRICATION, PRODUCTION, INSTALLATION (50%)

RESEARCH, DEVELOPMENT + DESIGN (40%)

CONTINGENCY + REVISIONS (10%)

Figure 7.5: A way to begin big ballpark estimating is the following: Consider about 50 percent of the total as fabrication, production, and installation costs. Consider 10 percent as contingency and revision. Consider the remaining 40 percent as all research, development, and design costs. *Image courtesy of Polly McKenna-Cress*

The most common practice is to use a square foot number and simply multiply. Square foot estimations are composed of design and development costs, materials, fabrication and installation costs, and any other costs such as shell preparation work on the receiving space, contingency and revision lines, lighting costs, and so forth. But where does such a number come from?

Referencing Past Project Budgets

Documentation of previous projects can provide an excellent starting point. There are potential pitfalls to this approach, however, especially when attempting to estimate labor costs:

- **Does your institution "charge" projects for staff time that is already accounted for in the operating budget?** In many organizations this time is seen as "free," and no one documents it or knows what it is worth. Since labor costs make up the largest part of any exhibition budget, and any role on the team may need to be contracted out in any new endeavor, this is a bad practice. Start now. Find a way to document staff time spent on a project (including administration, conservation, etc.) so that you can begin to build a library of documentation to look to when planning new ventures.

- **Does your financial office provide a way to do "project-based" accounting?** This means that all the financial aspects (including salaries) of an exhibition project are shown in a single monthly report. This allows for three things:

 1. The project budget can be easily tracked by project administrators.
 2. The project leaves a complete record to use to build other budgets.
 3. Better reporting data are created for funders, especially for in-kind funds.

Very useful. So, if you don't have a project-based reporting system, work with your finance people to try to develop one. But the "belt and suspenders" approach always is the way to go with budgets—make sure you are covered. In other words, both the project manager and the financial office must keep track of allocations and spending to minimize oversights, mistakes, or any lag time in reporting that could prove disastrous. "Oh, the end of November books were not reconciled yet because

of Thanksgiving break? We thought we had an extra $5,000!" The one person who should know where the specific budget stands at all times is the project manager.

Industry Standards

In the absence of a per square foot estimate based on documentation from within, you might try turning to colleagues in other similar institutions for a look at their estimating tools. Still another strategy is to use a so-called "industry standard" number. Actual costs vary so much from place to place and region to region that such numbers are not that reliable. Also, many places reuse techniques that may have cost them a fair amount to develop when they were first created. They may also reuse materials, or be very adept at getting materials or even expertise as in-kind contributions in their community. They may have much higher or much lower expectations of "level of finish" than your institution. Any or all of these variables can make another organization's budget issues very unlike yours. However, in the absence of anything else to work with, they do represent a place to start and may help team members get their expectations in line. Figures 7.6-7.9 present a basic overview of per square foot ranges:

Figure 7.6: Low end, meaning off-the-shelf media, mechanical interactives, low-end, even "scrounged" materials, and materials reuse: $50–200/sq. ft.
Illustration by Meghann Hickson

Figure 7.7: Midrange, meaning a few media/interactive experiences, ordinary materials, some reuse of furniture, materials: approximately $200–500/sq. ft.
Illustration by Meghann Hickson

Figure 7.8: High end, meaning some bells and whistles, high-end materials: approximately $500–1,000/sq. ft. and up. *Illustration by Meghann Hickson*

Figure 7.9: "Disney," meaning all the technological and/or interactive bells and whistles and high-end, bulletproof materials: approximately $1,500–2,000/sq. ft. and up. *Illustration by Meghann Hickson*

Budget Checklists

Another useful tool in the budget creation arsenal is a simple checklist. Again, documentation and institutional memory of mistakes made in previous exhibitions will help. But if you are starting cold, the following is an overview of the sorts of costs you will need to account for:

Labor: How much time might be needed for each task? Who (inside or outside) will do it? What is their hourly wage and benefits cost, or what is their fee? (See Figure 7.10.)

Labor and staff

- Development
- Exhibit (3-D) design and graphics design
- Subject matter expertise
- Archival/collections research
- Object evaluation and potential conservation
- Visitor studies: research and evaluation

- Photo/film research/rights acquisition
- Writing
- Lighting design
- Media design and production

Consultants: If anything on the above staff labor list is needed but does not exist on the team, monies need to be allocated for consultants to fill this role.

General construction: Architectural shell: HV/AC, building partitions (walls), flooring, ramps, electrical/data wiring, water, lighting, emergency lighting/exits, wall finishing, and so on.

Exhibition fabrication and installation: Scenic, cases including object mounts, lighting, media installation, interactives (electronic and mechanical), and so on.

Graphic production: Graphics (both exhibit and print material), way finding, gallery guides, donor recognition, marketing materials such as brochures, banners, bus wraps, and so on.

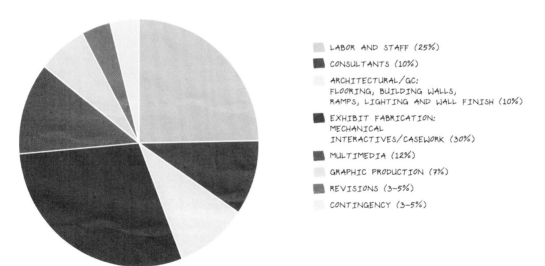

LABOR AND STAFF (25%)

CONSULTANTS (10%)

ARCHITECTURAL/GC:
FLOORING, BUILDING WALLS,
RAMPS, LIGHTING AND WALL FINISH (10%)

EXHIBIT FABRICATION:
MECHANICAL
INTERACTIVES/CASEWORK (30%)

MULTIMEDIA (12%)

GRAPHIC PRODUCTION (7%)

REVISIONS (3–5%)

CONTINGENCY (3–5%)

Figure 7.10: Knowing budget line-item categories is a helpful starting guide. This diagram shows one way a typical budget may be broken down. The budget should reflect the scope of the project and where the emphasis of spending will be: Are there high-end interactives? Is there scenic work to create an immersive environment? And so forth. *Image courtesy of Polly McKenna-Cress*

Revisions (recommended to be 5 percent of total project cost): This is the critical allocation that *cannot be touched until the end*, for the inevitable issues that need to be revised based on visitor evaluations.

Contingency (recommended to be 5 percent of total project cost): This money too cannot be siphoned off and must be left intact to the end. This money is for the asbestos/lead paint discovery, floods or acts of God, and the like, that could not have been foreseen but will add cost.

Materials, Supplies, and Other Costs (More Detailed Breakdown)

- Shell costs, including electrical upgrades, paint, carpet, sound-proofing, etc.
- Space preparation, including walls, doors, fixtures, etc.
- Space specials such as plumbing
- Rights acquisition costs for photos, media
- Media production costs such as travel, equipment rentals, captioning, etc.
- Media equipment costs
- Advisor costs, such as travel, honorariums, meeting catering, etc.
- Staff travel for research, meetings, conferences
- Books and publications purchase
- Bilingual translation services
- Program materials, including carts, expendable supplies, etc.
- Fabrication materials, such as lumber, drywall, acrylic, fasteners, paints, etc.
- Fabrication specials such as taxidermy, object reproductions, bone mounts
- Props such as costumes, décor items
- Office costs, including phone, postage, reproduction, supplies, etc.
- New staff costs, including furniture, computers, etc.

Even if your first estimates of line items like these prove wrong, you will have made a start. Matching a budget developed in this way against budgets derived from square foot multipliers, or previous exhibition

totals from your own or other institutions, can help confirm or improve your beginning estimates.

Managing Budgets

As previously noted, your partners in the finance office can help a great deal by creating reports that really help you to see how much has been spent, what is encumbered (promised to be spent), and how much remains at any given time. Whether this is possible or not, you will have to develop your own method to track the budget or run the risk of over-spending it. In order to do this, a system must be created in which all hours booked, all contracts for services, and all purchase orders are seen and documented by you: a time-consuming and duplicative task, but in most organizations, necessary. Depending on the usefulness of your institution's "chart of accounts," it may also be necessary to create a departmental chart with numbered categories that allow for items such as lumber or electronics costs, and not just postage and office supplies.

A budget is just a method of worrying before you spend money, as well as afterward. —Unknown

A real danger in midsize to large projects is that more money will be spent at the "beginning" of the exhibition (whatever is getting planned first), leaving few resources for whatever comes later. An antidote to this is to create separate "envelopes" or "accounts" for each area of an exhi-bition. At first, before all the specifics of an area are really known, this might be done by simple division. (I have $750,000 for a 3,000-square-foot exhibition that is conceptually divided into three parts. For each 1,000-square-foot part I'll set aside $125,000 for production.) Later, as the exhibition develops, the team can agree to shift money (and possibly space) over to areas that have become more important or that need one or two more expensive treatments to carry their message.

One of the milestone tasks that should be scheduled is a closer approxima-tion of the budget. If these estimates begin to look out of line (as they almost always do), it's wise to try to rein them in as you go, rather than allow the team to believe, until the eleventh hour, that they can afford an exhibition they really can't have. This kind of rigor also proves helpful in evaluating the possibility that more funds or even in-kind contributions might be found. If a specific element has been described, estimated, and then cut, there may still be time for a fundraising effort to save it or for a higher up or board member to decide that it is appealing enough to rescue.

Value Engineering (or Sharpening the Pencils)

This phrase describes the process of cutting elements from a project or of conceiving of ways to do the same work at a lower cost by, for instance, using cheaper materials than those originally planned. It's almost always a painful process. The most efficient point at which to conduct value engineering is during the Construction Document phase because design specifications have been clarified for bid. However, typically it is done post-bid as accurate cost implications become clear. Many seasoned professionals will be able to identify the elements that can be cut if necessary and also ensure there are no gaps in the story as a result.

We have to identify the elements with the "long-necks."
—Michael Levad, *exhibition developer*

The budget is very important for everyone to know and understand. It needs to be as transparent as possible to all team members. There is no surer way to cause ill will than being unclear on who is spending what—or worse, ignoring budgetary constraints—and how the funds are budgeted to various areas.

MANAGING A TEAM

A good PM has to know enough about everybody's job to insert themselves in getting people to move in their respective circles. I often say that a good meeting is one in which I say nothing but everything that I think needs to get addressed, gets addressed and solved because I did enough work before the meeting to make sure that everything is hunky dory.
—Mark Dahlager, *Science Museum of Minnesota*

A lot of the work of the project manager takes place behind the scenes. While these advocates need to know how to call, run, and document a meeting, much of the real work has already occurred before the meeting begins—through tasks such as the thoughtful creation of an agenda, checking in with individuals who will be called to present at the meeting, getting recalcitrant team members to promise to fully participate, or prepping everyone for difficult decisions. The aftermath of a meeting is just as busy: notes must go out, and anything that didn't go well or get resolved must be thought through and acted upon.

Project advocates are not usually vested with the power to decide who is on the team in the first place, although they often have a role in finding and hiring various contractors or consultants. So, one needs to be prepared to work with almost anyone on the greater staff and also prepared to help others work together, regardless of how the team is actually set up and regardless of whether or not they like each other.

Team Organization

Teams may be organized in any of a number of ways. An overall leader may be designated from the start, or individuals may be given decision-making power over specific aspects of the work or over specific phases. Team members may have the expectation that they are all equal all the time and that all decisions will be made consensually, or a "first among equals" may emerge—based on skill, clout within the institution, or simply power of personality—whom other team members defer to regardless of the structure. Each of these arrangements has good and bad points. What's important is that a decision-making process exists that everyone can live with, that moves the project along with a modicum of good will. (See Chapter 3 for some team organization strategies.)

Project Review Process

It's also important that a clear review process exist. Ideally, a single individual (the institutional advocate or "client") speaks with authority and discernment at each review stage, approving the work to go on to the next phase. Even if more than one reviewer needs to be present, the client still needs to provide a single set of instructions regarding any changes that must be made before the phase is approved (Figure 7.11).

> *Most success depends on colleagues, on the team. People at the top have large egos, but you must never say "I": it's always "we."*
>
> —Frank Lampl, *former chairman of Bovis Construction Group*

Figure 7.11: End of phase review. *Photo courtesy of Polly McKenna-Cress*

There are a variety of ways in which either of these decision-making processes can go astray—in fact, too many to mention in all their variety here. What's important to understand and act upon is the notion that all of the possible disagreements usually revolve around some kind of power imbalance, or the unwillingness of some to cede power to those who have been designated to have it. Intractable issues of this kind often have three possible treatments:

- Someone with even more authority is summoned to make a final decision.
- Visitor research is used to clarify an issue and bring end-user wishes and sensibilities into the process.
- Someone on the team (like you) invokes everyone's higher self, reviews the issue unemotionally, and invites the team to come to consensus for the good of the project without any single individual being forced to "lose face" over it.

What should never be allowed to happen is dilution of the project and its established cognitive, emotional, and experiential goals in an effort to have team members get along and feel good about themselves and their opinions. We are not doing this project for ourselves and our own sense of self-esteem, but for visitors. If we weaken every aspect by presenting only those things that have not annoyed a single team member in any way, we will probably have created something quite commonplace and even boring.

FURTHER READING

Elton, Chester, and Adrian Gostick. *The Orange Revolution: How One Great Team Can Transform an Entire Organization*. New York, NY: Free Press/Simon & Schuster, Inc., 2010.

Frame, J. Davidson. *The New Project Management*. San Francisco, CA: Jossey-Bass, 1994.

Verzuh, Eric. *The Fast Forward MBA in Project Management*. Hoboken, NJ: John Wiley & Sons, 2004.

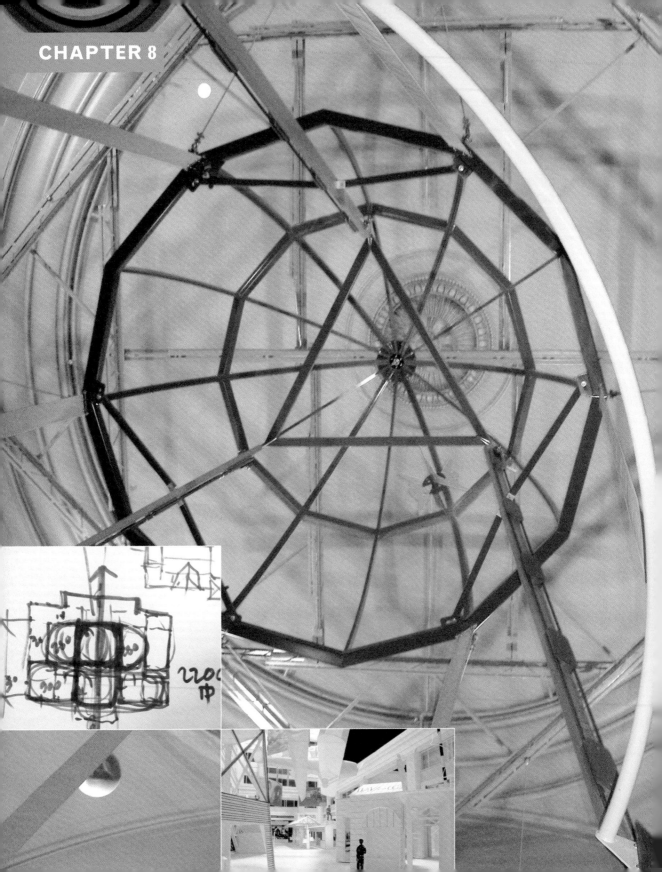

METHODS AND TECHNIQUES

The most difficult thing is the decision to act, the rest is merely tenacity. The fears are paper tigers. You can do anything you decide to do. You can act to change and control your life; and the procedure, the process is its own reward.

—Amelia Earhart

GETTING THE MOST OUT OF THE PROCESS

It is important that if you have a process, you get the most from it. A provocative topic or a cutting-edge technology may push creativity, but devising new working methods and using ones that are tried and true can give a team the means to inform new thinking, enhance team development, and create innovative exhibitions.

In this chapter, we identify several methods and techniques that can help teams throughout an exhibition creation process. Many of these methods may currently be standard operation for some readers, but we hope to shine some new light on how teams may apply them in fresh ways to stretch team thinking and practice. Use them as a springboard in your own working process or modify them for your particular needs. When you understand a plan of action for creating something as a team, you are in a better position to deliver successful results (Figure 8.1).

Three Critical Questions

- How does the team exploit process to its fullest potential?
- How and when should particular methods be employed for this specific project/audience?
- How might you add new, adjust old, or abandon methods in your team's standard operations to better achieve goals?

PROCESS DOCUMENTATION

During the entire exhibition-making process, documentation is essential. It is not enough for the team to simply have meetings, keep minutes, and return to their desks. When developing concepts and designing spaces, the team must be thinking big and have methods of documenting the process throughout.

Documentation might seem like an "extra step" that the team may not want to take on, but it is extremely useful when reviewing how things went and how long certain phases actually took. This record is important in the short and long term, so the exhibition can be updated if necessary, and also for the museum to plan effectively for the next project with what has been learned on this one. Assessment is most effective after the fact; it's difficult for a busy team to lift its head up and critically assess how things are going while in the middle of them. It's kind of like "the fish trying to describe water"!

There are several methods and techniques discussed in this chapter to aid in various phases of exhibition work and to produce either working or final documents as the end result. It is a way to keep decisions clear, move the project along smoothly, keep everyone in the loop, and ultimately create a record of exactly what has been accomplished and how. Keeping up with documentation as the project progresses means less of a burdensome pile at a project's conclusion.

Figure 8.1: Whatever process the team chooses to follow, it is important that individuals are inspired about the project, and know the plan, how they need to proceed, and that a critical path is set. *Illustration by Meghann Hickson*

WAYS TO PRODUCE AND SHAPE IDEAS

Your exhibition team needs to come up with ideas. Maybe you need to think of an exhibition topic, or maybe you need to explore one you already have. Moving this process forward must involve team collaboration at several critical points so that ideas can be produced and then shaped into innovative solutions. *Charrette* and *brainstorming* are two team-based methods to amass a lot of ideas and can be used very effectively to fully explore a range of possibilities that can express the topic.

The Charrette

We use the term "charrette" to describe an intensive group work session sustained over multiple days and that typically involves experts with a variety of skills and viewpoints. The goal of the group's focused immersion is to generate a broad range of ideas and possible solutions for a project or problem. When conducted successfully charrettes are exhausting, yet extremely productive and intellectually energizing. Since they also require a fair amount of money and planning time they should be utilized selectively, most often as a kick-off to determine possible exhibition directions or to ensure consideration of wide range of approaches to a topic already chosen. Charrette can also be used to generate new directions for institutional change or to refresh what is currently offered (Figure 8.2).

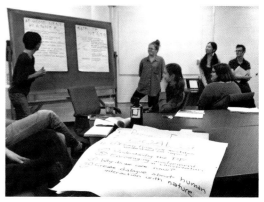

Figure 8.2: Charrette creation of initial concepts. Ideas about mission and goals and possible exhibition concepts are sketched and pinned up for group discussion. This input from the larger group helps to adjust and solidify ideas and provide developmental direction. *Photo courtesy of Polly McKenna-Cress*

Charrette (noun)

The term "charrette" comes from the French word for cart. In nineteenth-century Paris at the Ecole des Beaux Arts, proctors would circulate with charrettes to gather drawings of student apprentices for critique by the masters. Students would rush alongside the charrette (cart), still frantically adding to their drawings. The term subsequently became attached to an intense creative time within a design-based field.

Typically a charrette:

- Requires clarification of the problem(s) to be examined, and the outcomes to be achieved
- Assumes an open-ended process with no preconceived ideas for the solution(s)
- Requires the prior assemblage of initial research, data and analysis of the problem(s) and immediate access to resources to find additional data quickly
- Has a number of "check-in" moments for the larger group to provide valuable feedback
- Results in the development, analysis and presentation of more than one solution
- Broadly outlines next steps that can move a proposed solution forward

Charrette participants should be chosen carefully with the understanding that multiple points of view and expertise need to be represented. The group can include designers, developers, content experts or scholars, community representatives, someone able to sketch ideas the group discusses, and someone able to write up these ideas as they occur and later help create presentation materials. The charrette can also be structured in "competing" teams, dividing up participants into two or three smaller groups to generate the ideas.

Ideally, an objective facilitator is appointed to guide this expert team (or "teams") through the charrette process. A good facilitator will support a productive flow of conversation and intervene when it bottoms out or tangents diverge wildly from the agenda. If the agenda is clear and outcomes defined, the charrette should take no more than one or two days—beyond this, participants can lose creative energy.

Brainstorming

Brainstorming, or "group innovating," is a method in which people with various professional skillsets and different knowledge bases share ideas and build upon the input of group members. Sounds a lot like a

charrette but is really more of a subset of that method. The difference is that brainstorming is shorter, requires much less planning, and usually does not involve as large a number of people as a charrette. Brainstorming is certainly engaged during a charrette—usually a few times—but it is also a method utilized throughout the exhibition process to get past stumbling blocks or to fill holes that may become apparent along the way. For example, you might set up a quick brainstorming session with an evaluator, an educator, and two prototypers to resolve a particular issue with a concept for an interactive device.

Through the intersection of brainstormed ideas, the team can quickly create concepts and solve problems with ideas that could not have been developed by a single mind. Individuals participate by offering ideas and listening to other people's ideas, discussing connections between them, and coming up with new ideas. Though the term may seem passé because it is used so often, the method encompasses important tenets that are useful, indeed at times critical, to any creative process.

Brainstorming can also be a foundational element in team building. Teams don't typically cohere in repetitive meetings that can be draining, boring, or at worst, seem simply forums for reinforcing a pecking order. Brainstorming, on the other hand, invites contribution from all members and can be invigorating and inspiring. By considering ways for people with different personality types to contribute to the brainstorming, a more open and inclusive environment can be created, where good ideas can come from anyone.

There are two standard parts to a brainstorming session to ensure that everyone contributes: *rapid brainstorming*, and *reflection and editing*.

Rapid Brainstorming

Rapid brainstorming is quite literally a rapid-fire discussion of possible ideas. Some critics worry that rapid brainstorming is weighted toward the extroverted personality—only the loudest person in the room or the one with most authority has his or her ideas heard, defeating the aim of inclusion. Since it's often true that introverted personalities who have been thoughtfully listening may have the best input, it's important that

Regular brainstorming is as critical to an organization as exercise is to your health. It creates a responsive, innovative culture.

—Tom Kelley, *The Ten Faces of Innovation*, IDEO

Figure 8.3: Top of the funnel. At the beginning, the rapid brainstorming process should generate a wide array of possible ideas that will then be edited and sorted as to the merit and usefulness of each for the project (inspiring, good, mediocre, irrelevant). You want inspiring ideas. If the team only generates a few mediocre ideas, then narrowing process will, of course, yield less than mediocre results. *Illustration by Meghann Hickson*

facilitators ensure the session is not monopolized. There are ways to gather input from the whole group through other means such as offering opportunities through written responses, reflection, and editing. It's also useful for all participants to take a few minutes after a brainstorming session to clarify and document their thoughts, review what they heard and add other contributions they may be now considering (Figure 8.3).

These guidelines can be reviewed upfront with the group to set the tone for the brainstorming exercise. They become a form of group agreement to ensure a trusting environment where ideas can flow freely.

Rapid Brainstorming Guidelines

- **Don't censor yourself.** Anything that occurs to you is okay, even if it doesn't make sense at the time.
- **Don't be logical.** Follow your intuition.
- **Don't try to solve the problem.** This will only inhibit you.
- **Be playful.** Relax, and don't worry if an answer hasn't happened yet.
- **Listen to everybody.** Don't mentally "rehearse" your responses while others are talking.
- **Write and sketch the ideas as they come to you.** If you don't you will forget them.
- **Avoid the following phrases.** These can shut ideas down without any evidence or support:

 It's been done.

 I can't use somebody else's ideas.

 It's corny, trite, or cliché.

 It's a bad idea.

 It's too expensive.

 Somebody (visitors, director, funder, board member) won't like it.

 It has nothing to do with the problem.

Reflection and Editing

Reflection and editing are counter to the freeform style of rapid brainstorming, and elicit deeper contemplation, further clarification and building upon ideas. Participants are asked to group ideas that seem similar, to prioritize ideas in the order of their perceived importance, to choose the top three or four ideas they think work the best, or to eliminate three or four ideas they think are the weakest, and to articulate big themes. This is typically done individually but can also be done in small groups. What were some of the more salient points from the brainstorm? How do these seemingly disparate ideas come together to move the project forward? This part may not seem quite as fun or creative as rapid brainstorming, but is an imperative to apply critical decision making and reasoning to what has been produced. Facilitators can now begin to articulate the session's outcomes. Every participant will see how this has been done and why one or two ideas have risen to the top. These ideas can now be further developed and tested with a larger public group.

Planning a Brainstorm

Finally, consider these points in planning a brainstorm:

- Don't have too many people—a dozen is pushing the envelope for this method.
- Don't spend more than 15–20 minutes on any one topic—ideas and people get fatigued.
- Review, discuss, and agree upon the principles of brainstorming—if participants are not committed to the process, sessions may not be productive.
- Ideally, participants should have somewhat different expertise so that everyone has a chance to contribute something new to the proceedings.
- Everyone must be committed to contributing in some way—if not verbally, then in written words or sketches.
- Everyone should try and focus on making connections, hearing what others are saying and building those ideas—not just their own—in order to create something new (Figure 8.4).

Figure 8.4: Sticky notes are a great way to quickly document ideas—individual words, references, and complete thoughts—and easily group and regroup them into new connections to build more complex concepts. *Image courtesy of Polly McKenna-Cress*

CONCEPT ORGANIZATION AND VISUAL DOCUMENTATION

Concepts that are created for an exhibition need to be clearly organized and the process documented so the team has visual and tangible references to the flow of ideas and decisions. Capturing ideas from charrette

and brainstorming sessions, paring them down, and shaping them into a few good ideas are aided by a number of different organizational and documentation methods, including sketching, "mind-mapping," and the creation of concept diagrams, bubble diagrams, and exhibit framework and outline documents. The following methods are invaluable for garnering initial feedback and approval from the team and stakeholders, and for having the team build good ideas into great ones.

Sketching

Everyone on the team needs to sketch—not just designers. Sketches are fluid expressions, intended to be redrawn, developed into various iterations, or be easily discarded. Sketching is the visual form of brainstorming, and documentation of rough ideas that can be a source of inspiration and reflection. By their very unrefined nature, sketches are very freeing and allow the team and outside stakeholders to feel that they can make suggestions. Sketches allow others in on the visual conversation and help us to think more openly and creatively even if we feel we "can't draw."

The purpose of early sketches is to communicate possibilities and quickly explore visual options, thoughts, and gestures. Developing iterations of visual ideas through sketching is like drafting a written text, literally giving rough tangible form to ephemeral thoughts for later refinement (Figure 8.5). Sketch drawings should be rough since too much detail tends to elicit overly detailed responses. Designers can help the whole team form the exhibition vision and make more meaningful decisions by offering visuals and imagery early in the process.

Twenty-five years of helping business leaders around the world develop ideas has taught me three things:

1. There is no more powerful way to discover a new idea than to draw a simple picture.

2. There is no faster way to develop and test an idea than to draw a picture.

3. There is no more effective way to share an idea with other people than to draw a simple picture.

—Dan Roam on napkin sketching

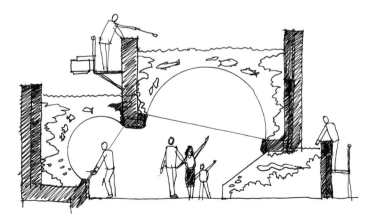

Figure 8.5: Napkin sketch of walkthrough aquarium concept. *Image courtesy of Jon Coe, CLR Design, Inc.*

Sketching as a Team Visualizing Tool or "A Picture Is Worth a Thousand Words. . ."

By Dottie Miles-Hemba

Sketching is a fundamental drawing technique to engage your team and stakeholders in planning the visual, physical, intellectual, and emotional experience you are developing together. It is a medium through which you can imagine and articulate your ideas, problem-solve, and build consensus.

There are few different places during the process where concept sketches, diagrams and illustrations are the best way to show meaning. Sketching is visual problem solving at its most basic, and a simple drawing can be more efficient and effective at reaching a shared understanding. After all, many of us understand concepts best when we can visualize them, and a sketch can unlock the answers.

The act of sketching is a tool for everyone on your team—not all forms require an artists' or designers' skillset. For those who have life experience drawing, it can be a natural way to articulate ideas, but for those who do not, there may be some hesitancy in taking their first steps. Here are a few pointers to inspire you:

- *Keep it simple.* Although details are helpful, the intent of a sketch is to happen quickly and in situ. Napkin sketches are celebrated for this purpose, informally documenting a keystone design concept or the origin of a larger idea.

- *Sketches are conversation starters* to provide visual input that inspires or adds momentum to the further development of ideas. A sketch can be completed by one individual or many contributors, on the corner of a notebook or large-scale on a drawing board. You don't actually need to pick up a pen to participate in the process and provide input that inspires or adds momentum to the further development of ideas.

- *Sketches are not final.* They should evolve over time to share greater detail, or be thrown out if you discover a better solution. It is not uncommon for several iterations of drawings to occur to refine an idea over the course of a project.

- *You should pin up and save the sketches that capture your ideas.* They are a visual documentation of this type of ideation process and will be useful again and again as you move through the various phases of the process. These sketches can help you remember and articulate how ideas evolved.

Once you've captured your ideas visually on paper you should feel confident to share them and reference them often in presentations or informal settings. You will find that sketches with fewer hard lines and details will be seen as "less final," so as you continue to refine your planning, be prepared to refine these sketches further using greater detail. These sketch ideas will later become the foundation of construction drawings, graphics, and more formal documentation (Figure 8.6).

As an exhibition planner, there is no greater reward than to see your collective ideas take shape and develop into a tangible experience. You'll find each project requires its own approach to the essential tools that are required to best communicate and develop ideas, and sketching is an important part of this process.

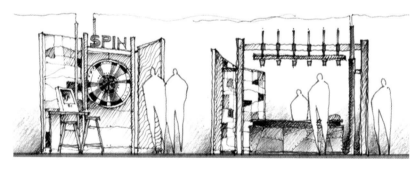

You Bet Your Life Bed of Nails

Figure 8.6: Elevation sketches for the *Risk!* traveling exhibition developed by Fort Worth of Science and History and Designed by Hands On! Design Firm. *Images courtesy of Hands On! Inc.*

*Linear thinking is
about sequences;
mind maps are about
connections.[1]*

—Tim Brown, *IDEO
Palo Alto, California,
May 2009*

Mind Mapping

The early-stage project ideas can be varied and abstract without obvious
connections. So how does the team begin to sort? There are different
methods to approach this task. One of the best collaborative ways is to
be big and visual—put it all up for everyone to see!

The Mind Map is a loose visual composition of the concepts and their
connections. It should also reflect more research and detail, showing the
breadth of the exhibition's potential landscape—collections, characters,
target visitors, settings, conflicts, facts, dates, significant events, key terms,
objects, important quotes, colors, feelings, moods, and so forth. The Mind
Map is an excellent technique for visually organizing each item (Figure 8.7).

Figure 8.7: Mind Map of concepts for a possible exhibition about sharks. *Image
courtesy of Polly McKenna-Cress*

[1] Brown, Tim. *Change by Design: How Design Thinking Transforms Organizations and Inspires
Innovation.* New York: Harper Business HarperCollins, 2009.

The Mind Map can be created by the whole team, by a small subset, or by the exhibit developer and presented to the group for input and feedback. The best-case scenario is for the map to be placed in a location where the team can study it individually or together, add ideas, shift and regroup notes, or remove items. With central access, these activities can happen in real time with transparency. If team players are not in the same physical location, there are electronic options to document the mind-map using online tools, touch boards or other digital media (for other tools see "Matrix Board" in Chapter 5).

Interpretive Framework (or Exhibition Outline)

Through the methods of development thus far, a new level of sophistication should be taking shape, more complex ideas emerging. During the Conceptual Development phase, the team is forming the organized whole that should be perceived as greater than the sum of its parts. From initial discussions to brainstorming to mapping of clusters and connections, this method of working and refining ideas will solidify overall organizing principles for the exhibition and make for a richer and more substantive experience.

The documentation of the refinement of your planning concepts is called an *interpretive framework (or exhibition outline)*, and it will include known parameters of the exhibition, such as criteria that will guide further development, including drafts of exhibition mission; "big idea" statements; visitor goals and objectives stated in cognitive, affective, and experiential terms; and ideas about approaches to the content; collections; possible juxtapositions of objects and concepts; possible narrative threads; and the size and location of the exhibition.

As we have previously discussed, with exhibition experiences, the team must be mindful that the enterprise is to develop a space and experiences that most likely will not have a controlled sequence. This form of visual organization and process documentation is a different approach from a largely linear sequence in the development of books, films, and other complex-narrative media. Although the exhibition experience has an important underlying organization—there is typically a beginning (entry), middle (content), and end (exit)—there is a quality of

random access that prevails in this "free-choice" learning environment. Exhibitions are more akin to websites and multimedia branching than anything else.

The interpretive framework that is established needs both a written document (a developer's job) and a visual representation (a designer's job). This document will be refined several times through workshops, meetings and review by team members and outside advisors.

Messy and In Progress

Although we are discussing visual and organizational methods, it is important to note at this point in the process that nothing is expected to look too refined or finished. Ideas are coalescing, and typically the flow of research and other input must be considered. There are also psychological implications for diagrams that look too finished—many team members and/or stakeholders may not question or want to change something that looks polished and too done.

Concept Diagram

The *concept diagram* (Figure 8.8) is an organizing technique seeking to further refine the initial mind-mapping work. This is done in concert with the development of content from initial *interpretive framework* to a finalized *exhibition outline*. The concept diagram refines the broader concepts and connections made in the mind map, and it is drawn and labeled in more detail to establish "conceptual clusters" of ideas that make sense working together. For example, if a number of "clusters" have relevance to one another, draw a bigger shape around them and name this bigger combined group. One technique to assess the concepts and determine conceptual clusters is the classic game of "Who? What? Where? When? Why? and How?" These questions get to the heart of a subject and will help the team confirm how ideas can be connected. The concept diagram will be used to create a finalized *bubble diagram*.

Figure 8.8: Draft concept diagram for a possible exhibition about sharks. Sticky notes from mind-mapping process rearranged to determine a more organized system with logic trails and connectors between each idea. Naming the connections between the formerly disparate ideas is an important method to clarify the organization. *Image courtesy of Polly McKenna-Cress*

Bubble Diagram

The bubble diagram (BD) is a technique to finalize the interlocking visual concepts developed in the concept diagram so that it reflects the exhibition outline. This is the last method of refinement before the

designer tackles a *conceptual floor plan.* Some designers skip the bubble diagram and go right to the floor plan. The advantage of the bubble diagram is to ensure the concepts are integrated and thoughtful, that the developer and designer can effectively move from the exhibition outline into a floor plan and not lose the continuity of the content.

The BD is the representation of thematic organization, diagramming transitions from one conceptual area to the next, grouping and sequencing items from the collection, considering a logical relationship of concepts. It is truly the final road map for the exhibition experience, helping the team see how the concepts, storyline and material culture coalesce with the experiential elements that will be the expression of them (Figure 8.9).

Bubble diagrams can include, but are not limited to the following:

- **Overarching concepts:** Is there a big idea that visitors are to understand?

- **Introduction area**: How and where are visitors introduced and oriented to exhibition?

- **Thematic areas:** What are the themes that organize exhibition? Three to five should be the maximum, if visitors are to remember them.

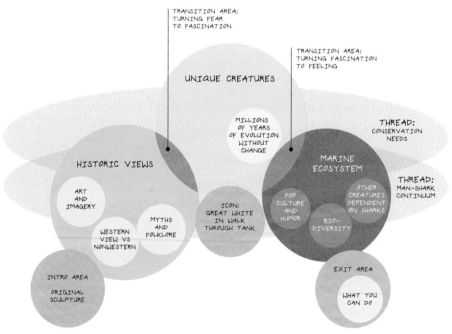

Figure 8.9: Bubble diagram for a possible exhibition about sharks. *Image courtesy of Polly McKenna-Cress*

- **Subtheme area:** Are there smaller themes that supplement thematic areas?

- **Icon experience:** What is the most memorable experience or object in exhibition? (See Chapter 6 for more on this topic).

- **Thematic threads:** What are the themes that run throughout the exhibition?

- **Transition areas:** How will visitors segue from one thematic area to the next?

- **Exit areas:** What is the culminating experience and inspiration for visitors to take away?

Despite the name, the forms in the bubble diagram do not have to be round. In execution, one should devise visual forms that allow themes, their subsets and links to be efficiently contained and grouped, with these elements loosely sized as to their importance and amount of content. Larger "bubbles" may represent a main thematic concept and can contain several possible subthemes. The size or shape of "bubbles" should also represent how much space and time should be devoted to this idea or area. Objects, critical facts, possible activities, and other details to the story should punctuate the BD to give the concepts tangible reality. Bubbles should touch or overlap when the concepts they represent are connected. What is the transition concept that connects two bigger concepts? Similar to a Venn diagram, a BD typically contains bubbles that intersect other bubbles in some proportion relative to their relationship to one another; the intersection should be a named transition and given its own content. Some bubbles may reside inside other bubbles as subthemes and should be positioned in relation to one another. Others needn't be interconnected if they represent standalone concepts. Many exhibitions have threads or concepts that run throughout the entire experience so bubbles that run through or connect all the ideas are used.

The BD should be developed *before* the team creates an exhibition floor plan. Although related to the floor plan and created with an awareness of an exhibition space, your BD *should not be laid out like a floor plan!* Why? Because physical space of rooms and galleries has particular dimensions and proportions that you do not want limiting your consideration of how *ideas* can be communicated. You are not simply plugging content into a square space. It is important that you plan how the ideas

work *before* the physical and spatial issues (columns, ramps, and square footage) of floor planning are factored into the equation.

The final BD is the base upon which a floor plan will be constructed. These visual documents should be accompanied by the exhibition outline that is the charge of the visitor experience advocate or exhibit developer.

Conceptual Floor Plan

Once the bubble diagram is agreed upon and approved, the concepts are adapted into a physical plan. This *conceptual floor plan* is a working method for determining the sequence of visitor flow in the physical space relative to the experience expressed in the bubble diagram. If you are working with an existing space some content connections may need to be shifted; if you are working with a brand new space the bubble diagram should give some direction to how the space might best be designed. Very basically, most exhibitions introduce an idea and orient visitors in the *beginning*; elaborate on the story in the *middle* with objects, interactions, and elements to see, read, and do; and provide reflection or have a culminating experience in the *end*. As the old marketing adage goes: *Tell them what they will see, tell them what they are seeing, and tell them what they saw.* This is not an absolute approach to conceiving floor plans, but it has been proven by visitor researchers to work well to communicate concepts that visitors retain beyond their visit (Figure 8.10).

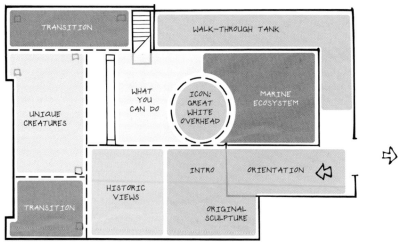

Figure 8.10: Shark bubble diagram adapted into an existing space to create a conceptual floor plan. *Image courtesy of Polly McKenna-Cress*

Visitor Walkthrough

The Visitor Walkthrough is a written narrative describing an exhibition from the point of view of a visitor's first-hand experience of it. The point of view of the Walkthrough is important to ensure the story and experience have continuity and are not overly objectified. Typically, the exhibit developer writes the walkthrough, working with input from other key teammates. It is intended to help the team's consideration of the ephemeral or affective elements of an exhibition such as smell, sound, lighting, and mood. It is an important development and design tool that can help the team visualize the entire experience, more clearly understanding how the concepts are connected to the physical experience of the space.

Start the narrative from the first moment the exhibition is imprinted on the visitor. We often forget that the visit starts long before visitors actually walk through the door. Consider what form of marketing communications may have been seen or heard, or maybe how a visit to the web site has set visitors' expectations. Why would they decide to come to the museum? What are their expectations when they arrive and will those expectations be satisfied by what they actually experience? The narrative should provide description for each area of the exhibition from icon experiences to individual details, interactive devices, and concluding features.

Divergent and Convergent Thinking

These different methods of *concept organization and visual documentation* provide opportunities for critical assessment of ideas and decision making by the team but also, and perhaps more importantly, for the team to share awareness and ownership of all the decisions and emerging experiences. For a successful project, the team must be flexible in their approaches, recognizing appropriate times for thinking in *divergent* ways (expansively) and for thinking in *convergent* ways (making connections) (Figure 8.11).

The methods discussed so far have been to facilitate team-based tasks for planning and creating conceptual directions in the first two project phases (Conceptual Development and Schematic Design). In the overall process, a point is reached where team-based tasks shift to individual

Figure 8.11: Once ideas have been collected, they should be sorted and organized according to their usefulness, to form a cogent story and viable project goals. Many seemingly divergent ideas go into the top of the "team processing funnel," where the team sorts, connects, and edits these individual ideas to form richer, more complex concepts. Remember, the visitors are key team members in the funnel too. *Illustration by Meghann Hickson*

advocacy tasks. At this "collaborative shift," individual advocates will likely be working apart yet still must report to the team on specific deliverables. Yet, team collaboration is still engaged through regular conversations, presentations, and review and critique of each other's component work to ensure that everything is meeting the project criteria. In the last half of this chapter, we discuss methods related to individual advocacy work, and how methods for effective meetings and presentations continue to drive collaborative efforts.

Process Cross-Reference

If you want to continue review of the next sequence in the overall process (Design Development) refer to Chapter 9 to understand where in the process your team might decide to have a collaborative shift, if at all.

MAKING DECISIONS AND CONDUCTING EVALUATION

There are several methods and techniques the team might utilize for conducting more effective "everyday" activities, such as meetings, presentations, and evaluations. It may seem obvious to get together and talk, but how many times after a meeting have you been exasperated to hear: "What did we talk about last time?" "What did we decide?" or "Why wasn't this taken care of?" How can you be effective at eliminating these reactions?

Have you watched as visitors scratch their head staring at a wall of text, or worse, walk by an expensive computer interactive without engaging with it? *Visitor evaluation* and *prototyping* are evaluation methods used to check the viability of the team's work. By placing aspects of team's preliminary work in front of potential users, and documenting and analyzing the feedback and reactions of these encounters, the team can gain valuable insights for the refinement of exhibition content and concepts.

Good clear presentations are much more likely to beget good clear feedback. Taking all that is collected and analyzed and putting it into a concise presentable form is an important step during the process.

Presentation methods work in tandem with *review or critique* methods—if you show something, someone will inevitably tell you something. It is important for the team to hear this critical feedback on presentations in order assess what is useful and respond properly.

Running Effective Meetings

This may seem like a no brainer . . . everyone knows how to run a meeting, right? Well, not everyone knows how to run an *effective* meeting. Although seemingly of little importance, running effective meetings can be key to the ultimate success of a project by supporting a collaborative environment in which decisions are made and communication between players is strengthened. Meetings can be the lynchpins of the entire process, keeping the team on course or derailing the process altogether. You have an agenda, you discuss it thoroughly, and everyone leaves knowing what is needed. If meetings are not planned and executed well, the very vitality of the project can be imperiled. The following are some effective ways to get the most from every meeting.

If you had to identify, in one word, the reason why the human race has not achieved, and never will achieve, its fullest potential, that word would be "meetings."

—Dave Barry

Define each member's advocacy and role. This is the first step of the overall project and once established is not necessary to repeat at every meeting. However, it can be helpful to reiterate this at different checkpoints along the way, if the team composition or responsibilities shift or new team members come aboard. It keeps communication open and direct, and responsibilities in check.

Appoint a meeting facilitator. The best facilitator is usually the best listener. The project manager may typically fill this role, but it can shift as the project progresses and responsibilities shift. The facilitator is responsible for calling the meeting, drafting an agenda, and ensuring all the critical players attend and that discussions stay focused on agenda issues. This person is less likely to drive input or be the focal point of the discussion because his or her role is to listen to the participants and move the discussion along to get the most out of the meeting.

Develop goals and an agenda in advance of each meeting. The meeting facilitator should be responsible for creating and distributing this information. The agenda should be flexible and open to suggestions from other team members, but it should be neither too generic nor too lengthy.

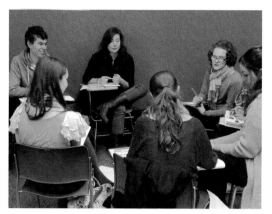

Figure 8.12: Face-to-face meetings and group discussions should be essential at times for brainstorming and particular decision making. *Photo courtesy of Polly McKenna-Cress*

Appoint a meeting note taker. A wasted meeting is one ending in the question, "What did we just talk about?" Documentation and dissemination of meeting discussions requires accurate note-taking. This is *not* a secretarial role. The note-taker isn't creating a detailed transcription of every utterance. Rather, he or she is creating a summary of the discussion, what issues remain open, what decisions have been made, and action steps for the whole team. The note-taker should complete and disseminate this record within a day or two for team members' response, clarifications, or questions—everyone is responsible the content and its accuracy. Responses are incorporated into the notes and a final version reviewed at the next meeting (Figure 8.12).

Organize the meeting notes by the following items:

- Agenda from meeting, date, time, and location of meeting, who was present or absent

- Review and approval of last meetings notes with any clarifications

- Review of action steps, deadlines; and deliverables; what's been met or not met

- Discussion of agenda items

- Review of salient points and decisions from these discussions, planning to deal with any unresolved issues or the need for further discussions and who may need to be involved

- Review of action steps: who is responsible for each item and deadlines for resolution

Make team documents accessible. It is important for transparency, efficiency, and flexibility that all documents be easily accessed and readily reviewed by team members. Whether through shared electronic files, notebooks, or common paper files, documents should be preserved, identified according to source, and organized. A best practice is to designate a *project room* that can be a central repository for all sketches, drawings, images, models, and copies of reference materials. This

facilitates meetings as the team can pick up where they left off from meeting to meeting and also facilitates individual working sessions, for those who need to review and respond to materials outside of an official meeting time.

Decision Making

In any collaborative process, there are typically several players critically dependent on clear and timely decisions. People whose main workload comes at the end of the process—such as fabricators or label writers—can be brutally crunched if other team players do not commit to timely deadlines. Teams should be aware of and agree upon the type of decision making they will employ at various critical times during the process to ensure that deadlines are met. The distinction is not just about knowing when decisions should be made but *how* they will be made.

Different types of decision making that teams typically employ are:

- **Authoritative:** Team members agree to abide by the decisions of a leader they have elected or who has been appointed by a higher-up in the organization. This also means the leader will be responsible for the consequences of these decisions. Although this model is efficient and effective it can become much less so if the leader cannot or does not delegate some authority, insisting instead on complete involvement at every level.

- **Consultative:** Decisions are made by one person but in consultation with others. Most leaders, even though they have all the information they need, will consult with others to make sure they understand all the implications of a decision. A pitfall can be an overreliance on continued feedback, which pushes off commitment or fuels indecisiveness.

- **Delegative:** The team gives responsibility for specific kinds of decisions is to different individuals or smaller subgroups within the team. This method can expedite the process and create a sense of ownership for team members. However, it can also create friction if the delegates are not careful to keep the rest of the team informed, or when the timing of decisions by various parties doesn't conform to the larger schedule.

- **Democratic or majority vote:** Decision making is conducted by discussion of the options and facilitated through a vote until 51 percent or more of the team is in agreement. Although this can make teammates feel the decision is derived equitably, it still can leave team members feeling unsatisfied, as the focus can easily become "winning" rather than the creation of the best possible product.

- **Consensus or joint:** Decisions are achieved through an effective and fair communication process—all team members provide input that is acknowledged, considered and valued. Although each person will not get "his or her way," the team agrees to concede to a solution that everyone can actively support. Decision ownership resides with the team and can lead to a higher level of commitment. However, this can be a time-consuming process, and the team must be sufficiently skilled and committed to larger project goals do it well.

Visitor Evaluation

As concepts are being refined and decision are being made, we cannot forget about the most important voice—the visitor's. So how do we gather information from the public we want to reach? The following methods give teams some direction needed and offer ways to approach evaluation.

Evaluation: Rationale, Methods, and Negotiating the Course

By Jeff Hayward

People, Places & Design Research, Springfield, MA

So you want skills in exhibit evaluation? I'm glad, because having *some* knowledge and skills will help you realize that evaluation is as integral to your creative thinking and success as many of your other skills are. A great revelation of most exhibition creators I've worked with is that evaluation is not to be feared like a trip to the dentist or a meeting with an auditor. One big difference is that you—as a team, and sometimes in individual roles—can direct the evaluation process (try saying that to your auditor!). By that I mean that a good evaluation process should:

- Be designed to meet your needs (Do you know what your needs are?)

- Fit in with the timing of your decisions and process (Have you included evaluation in your schedule, just like every other important activity?)

- Help you get to the outcomes you want (which means you need to be clear about the outcomes you want)

Skills to start with:

Skill 1: Be able to sort through your hopes, goals, worries, and priorities to identify your Key Issue (s) for evaluation.

Skill 2: Understand where, when, and why evaluation fits into your process (i.e., put the Key Issue(s) in perspective).

Skill 3: Be able to hold up "your end of the conversation" with a specialist about evaluation.

Skill 4: Be able to participate in evaluation, interacting with your audiences.

Skill 5: Be a good "client" of evaluation, including your responsibility to know about the quality of evaluation being done by you and for you.

Skill 1: Identify the Key Issue(s)

If you're advocating for your area of responsibility, and thinking about the eventual experience for visitors, you should be raising tough questions: How familiar are people with this topic? Why will they like it, and what does that say about their expectations? Who's our primary audience going to be, and is there an audience that we want to attract who aren't going to naturally be attracted? Is our "main message" going to be something that will resonate with them or that they understand already, or is it too complex or counterintuitive? Do we care what the takeaways are? How confident are we about what people will think, and how do we know that?

Brainstorming questions is useful; sorting out your priorities is also useful; organizing your thoughts around a Key Issue (you might call it a worry) can guide a whole planning process. Here's an example of a great Key Issue statement, from the first time that the Monterey Bay

Figure 8.13 Wayang Kulit or Indonesian Shadow Puppet. *Photo courtesy of Richard Cress*

Aquarium did an exhibition about jellyfish: *We're afraid that people think jellies are worthless blobs of slime. We want you to find out if that's true, and if it is, what can we do to make them think otherwise? Here are four strategies we've thought of.* Another example, from the Museum of International Folk Art Santa Fe, New Mexico: *We worry that people won't know or care what Wayang Kulit is (Indonesian shadow puppets;* Figure 8.13*) and that the traditional practices will be too complex and strange—how will people find ways to access this subject?* (With audience research, they did figure it out: *Dancing Shadows, Epic Stories* won a best exhibit award from AAM.)

How do you figure out what your Key Issue is? My answer: *go for your worries.* Your team's collective intuitions are crucially important in directing the scope and objectives of an evaluation process. Raise the sticky questions, and rising to the top of all your concerns, all team members should ideally agree on one Key Issue, which might have more than one part (institutional advocate, this is your job). Don't toss out your other concerns, questions, and worries, but with a Key Issue you will be better focused on how evaluation will help your planning process.

Skill 2: Understand How Evaluation Fits into Your Process

Before you started reading this book, you might have already known about front end, formative, and summative evaluation—but did you know that the reason these concepts became standard practice is because they fit well with the timing of when information about audiences can be used effectively in a planning process—in other words, they emerged as a way of collaborating within a planning and design process! So you and your whole team should be asking: When do we need information? What types of information would be useful? and What decisions are we trying to inform? Evaluation for evaluation's sake (i.e., just because "it's required") will marginalize a useful resource for your organization and may lose much of the value that you could have put into it.

For a practical and collaborative process, think of the "three phases" of exhibit evaluation as broadly described by timing and relevance to decision making:

1. Early in the planning process

2. During design decision making

3. After the exhibition opens to the public

 The rationale for each of these phases can be quite different and
 may be led by different advocates, as suggested by the accompanying
 chart.

PHASE	WHO LEADS THIS?	PURPOSE	TYPICAL ISSUES/NEEDS
Early in the process ("front-end" research)	Institutional advocate and/or exhibit developer	Broad foundation for the planning process, find out what you know and don't know about audience perceptions of your topic.	Will audiences be interested? What will they expect? What do they know already? Will they be able to understand key concepts? What types of people will be your primary audiences, and why? Who's unlikely to be attracted, and why?
During design decision making (storyline testing, formative evaluation)	Exhibit developer and designer; perhaps project manager	Get early reactions to what you propose, on overall experience as well as specific elements that are crucial to the goals or risky or expensive.	How will people's expectations affect their reactions to your ideas? Are people likely to get your main message(s)? Can they easily use and understand the interactives? Will the media help deliver some of the message(s)?
After opening to the public (remedial and summative evaluation)	Exhibit developer and/ or project manager, with all-team input	Find out what you've accomplished; if this was an experiment or risk, how did it work out? Results can inspire your next project.	What value does your exhibit have for your audiences? Are some people benefitting more than others (happier, understanding, repeat visiting)? Are those the people you planned for? What are the highlights and disappointments?

Skill 3: Understanding the Basics about Evaluation Methods

The best evaluations are customized to your team's needs, including
the character of the exhibition project and the Key Issue that you've
expressed. To customize the evaluation, you need to work with someone
who has experienced with a number of different research methods. Here
are some of the most common evaluation methods, and a brief intro-
duction to what you get, and don't get, from them.

Qualitative Methods

Focus groups: a series of group discussions with about 10 people per group, who don't know each other but represent a specific target audience, led by a facilitator. This method is primarily used for front-end research. It's almost always stimulating to watch strangers talk about your topic, but well-planned focus groups can be expensive, so make sure it's the right method (or one of the right methods) for your needs. This method is good at: getting people's first impressions and going into greater depth, assessing affective reactions, exploring relevance and finding themes that resonate with people, and investigating different perceptions among different known audiences. Focus groups are typically not good at: testing individuals' knowledge, producing percentages or other yardsticks as measures of comparison, and investigating perspectives that might not be socially acceptable (e.g., prejudice, resistance to learning/science/art).

Comment books/talk-back boards (Figure 8.14): Visitor-generated comments, unstructured or prompted by a question that you post. This method is usually low-tech, inexpensive, and good at taking the pulse of visitors' opinions, possibly on controversial questions that you might be hesitant to include in the formal text of the exhibition, and visitors enjoy reading other people's comments. However, it is not usually from a representative sample of visitors, it needs some managing, and some of the value is lost if there is no systematic analysis of what people write.

Open-ended, unstructured interviews: (Imagine the format of oral histories). These are usually in-depth conversations focused on a topic (for example, 15 staff do a "buy your friend a beer" interview with three friends each). Such open-ended interviews are good at: finding what's meaningful about a topic and practicing questions that you might use next in a more systematic study. The downside of unstructured interviews are that it's easy to bias these interviews; your "data" might feel like apples, oranges, and kiwis; and without some parameters to elicit and analyze what people say, each interviewer's findings might just reflect his or her own opinions, meaning that you wouldn't have learned anything more than sitting around at your own meeting.

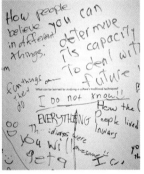

Figure 8.14: This "talk-back board" at Penn Museum's *Imagine Africa* installation is where the museum asks provoking questions to find out what a visitor may want to see in an exhibition about African objects. *Photo courtesy of Polly McKenna-Cress*

Quantitative Methods

Intercept interviews: A person representing the museum approaches visitors or potential visitors and asks a series of questions; the same questions are asked of everyone in the sample. This could be any type of survey and is typically used in front-end research and summative evaluation, but sometimes in formative evaluation too (e.g., "Excuse me, I'd like to ask you about that exhibit mock-up you just looked at"). Intercept interviews are good at getting randomly selected people's opinions, knowledge, and ability to understand key concepts (don't forget that interviewers need training to avoid bias). Also, survey data might be easy to tabulate, at a basic level anyway. Limitations include the fact that you are primarily getting "top of mind" answers, and the extent of time and labor to accumulate a large sample, if warranted.

Observations: This consists of watching visitor behavior, which might include counting, timing, tracking, or noticing how people approach and use something, such as an interactive exhibit (Figure 8.15). Observations can be paired with interviews (watch someone do something, then ask them about it); they can be "cued" (invited) or "naturalistic" (people do something on their own, not aware that they're being watched). Observations are good at finding out what people DO, which can be a useful supplement to what they THINK. However, if you're most interested in the meanings and take-away messages, observations alone won't tell you much.

Online surveys: This is the new version of written questionnaires: give people a set of questions for them to answer on their own. This has advantages in being less labor-intensive, and also makes it possible to contact people at home, away from the museum (which is good for studies of awareness, knowledge about a topic, decisions to visit, and follow-ups to museum visits). It's limited because of much lower response rates than most interview methods, which means questionable representativeness, and because there's no "quality control" by interviewers (e.g., getting answers to open-ended questions, following up on meaningless answers).

Figure 8.15 Observation of a visitor interacting with an exhibition element in the Connecticut Discovery Museum and Planetarium, Bridgeport, CT. *Photo courtesy of Richard Cress*

All these methods are tools; they are a means to get information to inform decisions and stimulate the team's thinking. My personal favorite sentence about choosing a set of research methods came from proposal guidelines by the National Institutes of Health: No amount of methodological sophistication can bring to life a sterile idea. Whoa, you said it! Let's be driven by the team's most compelling ideas, and use research and evaluation to pave the path to a successful experience for visitors.

Skill 4: Participate in Evaluation, Interact with your Audiences

If you support the idea of exhibit evaluation—that is, getting and using information from visitors to inspire and inform your project—then you should want to do some of the listening and questioning. For example, in "front end" research where the point is to find out where potential visitors are "starting from," your intuitions will be much more alive if you've actually heard people talk about their knowledge, expectations, interests, and motivations.

You can start informally and feel your way as long as you are conscious of a few points: really listen to people to understand their views (don't cue them as to what you want them to say), try different phrasings of questions to see if you get different answers (choose the one that produces a good array of answers), approach different types of visitors (older adults, families with school-age kids, young adult singles, etc.), briefly explain what you're doing and why you're interested in their opinions (because their experience with clipboards and surveys in general has probably not been interesting), and don't draw big conclusions from a handful of interviews (there's a lot more diversity of opinion than you might expect).

Skill 5: Be a Good "Client" of Evaluation

Developing your own skills related to evaluation will, I hope, be stimulating for you in your creative teamwork or management roles. However, with just a little bit of experience you're not going to be an expert, so

the next best thing is to also be a good "client" and user of evaluation. Participating in an evaluation process by interacting with your audiences (the previous skill) will actually help you be a good user of evaluation because the information you're getting will be more tangible and meaningful to you.

Similar to other roles who are not core team members (e.g., marketers, fabricators, fundraisers), you will benefit from the expertise of a specialist to do a credible job of evaluation, whether that means an in-house specialist or an independent consultant. These two sets of questions could help you be a better "client" when working with that specialist:

A. Questions to ask your researcher when PLANNING audience research/evaluation:

- Which of our questions and objectives are feasible to investigate within the budget that we have? (And do you have additional questions, prompted by what you know about our concerns and the project in general?)
- How do our goals and priorities become realized in your recommended method(s)? (What are their advantages and disadvantages?)
- What's your sampling plan? Will your sampling plan allow an analysis by audience segments? (If not, is there any reason why that wouldn't be important?) (Analysis by audience segments is feasible in either quantitative or qualitative research.)
- Will you be able to deal with variations in visitor patterns by seasonal or other factors?

B. Questions to ask your researcher about ANALYZING data and finding results:

- What's the quality of the data look like? How do you know?
- How will you judge the representativeness of the sample?
- What audience segments are you able to analyze? Why those?
- Which findings are based on a pattern of results, and which on a single question? (Patterns of results, with overlapping or complementary results, tend to be stronger and less likely to be shaped by the wording of a single question.)

- How do these results relate to previous research findings we have available?

- What implications do the findings suggest, as you see it?

Raising Your Game with These Skills

How will you know when you have arrived at the professional and useful practice of visitor-oriented evaluation? Keep these criteria in mind:

- Do you know why people will value your exhibition? You should know this long before the opening (and ideally, you will have defined "people" in terms of some realistic visitor types, not just a vague sense of "everybody").

- Have you identified some challenges or weak points in your proposed exhibition experience, then conceived of options and alternatives, and used information about audiences to choose strategies for dealing with those challenges?

- Do you have questions about visitors' perceptions and experiences after opening? Every project is an opportunity to learn about how your ideas and strategies turned out, which might prompt revisions to that project or inform your choices in future projects.

Prototyping: Ideas into Action

A "prototype" is a test model. In the museum field, prototyping is loosely defined as the "process of testing out ideas with others," particularly end users. This is frequently done in regard to physical objects but shouldn't be limited it to just interactives. Prototyping can be used in any phase as a part of the larger visitor research effort. Generally speaking, in exhibition work there are three kinds of prototypes:

- **Conceptual prototyping (pilot testing):** The best time to test fundamental concepts with visitors is in the conceptual development

phase of an exhibition project. Instead of spending endless meetings hashing out assumptions, getting initial ideas out on the floor early can yield informative and worthwhile results (Figure 8.16).

- **Formative prototyping:** Typically conducted during both schematic design and design development phases to test the utility of a chosen communication method, exhibit element or metaphoric approach.

- **Engineering prototyping:** Examines how the device will finally be built and helps determine if it can hold up under repeated visitor use. This more detailed prototype occurs in the later phases, after concepts have been tested, assessed, and edited for functionality and a physical form determined. Ideally, this kind of testing will involve the people who will build the final device as well as the people who will have to maintain it (Figure 8.17).

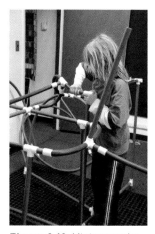

Figure 8.16: Visitor works with tubing and joints to play with, forming different structures. Conceptual prototyping or piloting is not, by definition, outcome based, but it gives the exhibition team a chance to see what visitors come up with while investigating new materials or ideas. *Photo courtesy of Dana Schloss.*

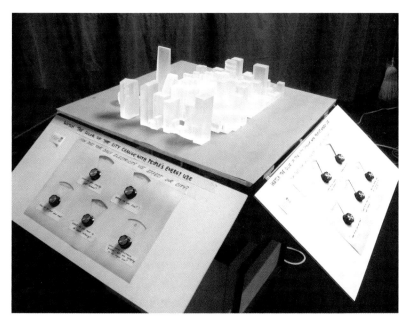

Figure 8.17: Engineering prototype to test how it will work in reality, from the *Electricity* exhibition development and design process at The Franklin Institute. *Photo courtesy of Erika Kiessner*

Prototyping for Developing Concepts: Pilot Testing

By Katherine Ziff and Dana Schloss

TELUS Spark Science Centre

Calgary, Canada

Pilot, v: to lead, guide, or conduct, as through unknown places, intricate affairs, etc.

When ships' crews need to navigate difficult waters, they don't go it alone. They hire a pilot who knows the local waters to steer them to safety. Piloting during exhibit development offers similar guidance. Testing a broad swath of potential exhibits is a way to sound the depths of how visitors engage with a topic. The process alerts you to rough patches, identifies ways around them, and can even suggest solutions you may not have considered without it. Piloting makes visible the previously unknown terrain of visitor response, allowing exhibit development teams to set their course with confidence (Figure 8.18).

Piloting operates under a simple proposition: you don't really know how well an idea will work until you've tried it with visitors—so you should go try your ideas with visitors. As many ideas as possible. So many that you run out of "good" ideas and have to test ones that seem ridiculous. It turns out that scraping the bottom of the barrel is the way we found some of the most original and interesting exhibits we've developed. There another bonus to testing so many potential exhibits. When you have a long list of alternate exhibits to choose from, the team doesn't face the pressure to keep an exhibit that is a dud.

If you want your team to pilot, be prepared to trade time spent in meetings for time spent mocking up, testing, iterating, and documenting potential exhibits. Stock up on the key piloting materials: cardboard, duct tape, sharpies, and whatever other plastic bits or simple electronics you can gather. Building a prototype with cabinetry-quality finish can be useful—but it's not piloting. Instead, working with simple, adaptable materials helps you stay focused on getting as many potential exhibits in front of visitors as possible.

Finally, tap into your inner stores of humility. You'll need it for two reasons. First, you have to acknowledge that you, the brilliant and creative

Figure 8.18 Compass rose to help us pilot our route. *Illustration by Richard Cress*

people on the exhibit development team, don't know everything. Only visitors can show how they will use and understand an exhibit. Second, you have to be ready to test some half-baked, unpolished and possibly stupid ideas, in public. Your ideas could fail in front of peers and visitors over and over again—and that means you're doing it right. The exhibits you choose to build in the end will be more interesting and less likely to fail as a result (Figure 8.19).

Piloting an activity called *Adapt an Outfit.* This pilot was very successful when we tested it in the shop but didn't work in the gallery when we opened the science center. The other adjacent fashion exhibition, *Unconventional Fabrics,* was too much of a draw and the materials migrated. We eventually took the mannequins from our pilot and added them to *Unconventional Fabrics*, since that's how everyone wanted to use them anyway.

When you separate your pride from the ideas you're trying, piloting can teach you important lessons. Some of our most compelling exhibits originated as pilots we tested out of desperation, because we literally could not think of anything less stupid-sounding to try that day. We even piloted a puzzle without a solution—absolutely confident, as we

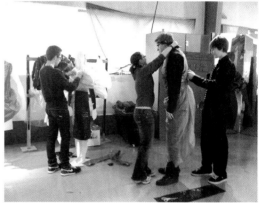

Figure 8.19: Piloting an activity called *Adapt an Outfit,* TELUS Spark Science Centre, Calgary, Canada. *Photo Courtesy of Katherine Ziff and Dana Schloss*

mocked it up, that visitors would revolt (or at least scowl at us). Instead, they loved it, sticking around to try just one more solution until peer pressure from other visitors waiting to try it made it too awkward to stick around. Next time you find yourself in a meeting, listening to colleagues debate their predictions of how visitors will use an exhibit, just imagine how refreshing it would be to have someone in the room who has observed visitors try it? It's within your grasp. Go ahead. Try out some ideas. Be prepared to prove yourself wrong. In the end, you may be surprised by how productive and satisfying it can be.

Prototyping as Research

A prototype can be used to test the "look," feasibility, utility or usability of a multitude of elements and modes: concepts, processes, systems,

graphics, labels, educational programs, marketing strategies, or any other plans that are directed to an end user. Prototyping can be utilized from initial concept development through to near-final iterations. In some instances, the prototype may end up as the final product on the museum floor.

Simply building stuff, placing it in a public space, and asking for feedback is not enough, however. Prototyping empirical research needs to be viewed as such, forming a hypothesis (concept or physicality to be tested), setting up a structure for the test, testing, documenting, revising, and testing again. It can be a resource-consuming process, so it must be well planned and have clear goals.

While it's preferable to have access to a fabrication shop to create prototypes, not having this luxury is not an excuse to forgo such testing. A lot can be accomplished with paper, cardboard, and images or simple sketches of materials. We're trying to ascertain four things:

- Do people know how to use the exhibit element?

- Do people want to use it?

- Does it deliver the intended outcomes?

- In the end, did people enjoy doing it?

Of course, you can't test everything. One rule of thumb is to spend prototyping money on the elements that will be delivering the most critical content or exhibition intentions. Another is to test the most expensive elements, especially if they are not straightforward. If a potentially expensive experience fails, the remaining elements may not be able to support the exhibit.

The team should approach this process with flexibility and an open mind. Change, after all, is a main function of prototyping and revision is a necessary outcome. The team must be prepared to focus less on their favorite features and more on what developments will best address the visitors' needs. Accepting this fact is the only way to be successful at prototyping. What follows are examples of two approaches to using prototyping in the development of exhibition experiences.

To effectively conduct prototype testing, consider these questions first:

- **Structuring and conducting a test:** What are the needs of effective prototyping including tools, materials, people?

- **Strategic questioning:** What's level of information needs to be provided while keeping the outcomes open-ended?

- **Acute observation of and listening to all involved:** Are both team and test participants able to participate objectively?

- **Responsiveness to outside input and critical assessment:** Are we willing to make difficult adjustments to improve the exhibition?

- **Recognizing that test failures are necessary to achieve smart and informed results.**

Just as it can accelerate the pace of a project, prototyping allows the exploration of many ideas in parallel. Early prototypes should be fast, rough, and cheap. The greater investment in an idea, the more committed one becomes to it.[2]

Tim Brown, *IDEO 2009*

Prototyping to Test Ideas

By Erika Kiessner

After the exploration of piloting to develop ideas, testing those ideas is the purpose of prototyping. If piloting is finding out the "what" of an exhibit, then prototyping is figuring out the "how."

It is the process of finding the best way to keep the delight of your concepts alive in the final form. Start with the idea you want to share. Picture the experience that you want visitors to have. Next, you start to build something. Make it out of unfinished wood or plastic, use a borrowed touch screen and improvised graphics. It may be clamped to a table. The first iteration is mostly about getting the parts together. It doesn't have to be robust or especially pretty, but it does need to stand up to being used by teams of visitors, and simple enough that making changes is easy. Finish it off with a little background information and some instructions on how you think it should work. These will change

[2] Brown, Tim. *Change by Design: How Design Thinking Transforms Organizations and Inspires Innovation*, New York: Harper Business HarperCollins, 2009.

a lot over the course of your testing. A small white board can be really handy. Now invite some people to try it (Figure 8.20).

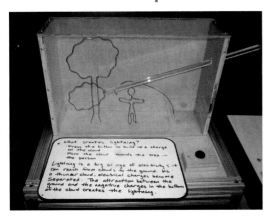

Figure 8.20 Prototyping a lightning interactive for the Franklin Institute's *Electricity* exhibition. *Photo courtesy of Erika Kiessner*

Starting with members of the exhibit team can be both good and bad. They aren't very objective because they are highly invested in what the exhibit will look like in the end. On the other hand, they know what it is about and what it is supposed to do, so they can jump right in. This is also the time when you take the evaluator through the prototype and start to figure out what kinds of questions you want to answer in the first round of testing. Begin with "do the visitors know what this exhibit is about?" Then move on to specifics like: "Is this button big enough?" "Are the controls placed in a way that suggests their sequence or use?" "Do the visitors miss any part of the content or interface?" and one of the best questions: "Where are the visitors getting stuck?"

Answering questions like these is what the prototyping process is great for. It may reveal surprising things about what your prototype is communicating, sometimes even things you didn't mean to put in there.

After testing review the issues you discovered and look at the results for hints at design improvements. Sometimes, the testing will suggest a solution. Sometimes you want to have a chat with the designer about what to do next. Sometimes you just have to guess. Then, take it back to the evaluator, determine your next round of questions, and test it again.

For the first few iterations, the list of questions will just seem to get longer and longer, but at some point your design changes start to click. The visitors start to really get it, and you have the satisfaction of knowing that you got it right for your audience.

This cycle of test and redesign is the heart of prototyping. Making design decisions, testing them out, watching them fail, and having the insight to salvage what is great in them while discarding the rest, is a much more powerful method than simply designing in a vacuum.

Presenting

Good, clear presentations are much more likely to beget good, clear feedback. No matter how hard the team works or how brilliant the plans for the exhibition, if the team cannot present these ideas concisely and convincingly, then you may be unnecessarily giving yourself a lot more work to do. Being energized and upbeat is key. Emoting the passion for the subject can make or break the reaction to the presentation. Presentations require passionate energy because there are a number of different types that must be executed during the process, and one is no more or less important than another. If the team is outwardly passionate about the project, it can be infectious and help decision making and achieve positive feedback. As a colleague used to say, "Your attitude affects your altitude."

The essential presentations are those at the end of a phase when review and approval are necessary for proceeding to subsequent phases of work with full confidence. The Process and Phases Diagram (found at the start of Chapter 9) shows the different end-of-phase reviews. During early planning phases ideas must be approved by the executive director, executive staff, board of directors, and potential funders to receive the capital needed to produce the project. Development presentations should involve museum staff, volunteers, floor staff, and maintenance crew that will be in charge of staffing and upkeep of the exhibition. Exhibit fabricators should clearly understand how the exhibition is to be built and installed. Last, but most important, visitors' feedback must be gained through different phases of review, from focus groups to prototyping the way the information will be presented to determining how the exhibition will hold up over its lifetime.

Maintaining the energy through each of these stages can be challenging, but like the Rolling Stones performing "Satisfaction" for the ten-thousandth time, presenters must persevere and have the same energy at the end as at the beginning of the project. The same creativity that goes into the development of the exhibition should be applied to creative ways of presenting the information (Figure 8.21).

Process Review and Critique

A vigorous review and critique process will strengthen the team's ability to critically analyze and discuss the project thoughtfully with each other

Figure 8.21: Example of a creative presentation: Exhibit Design student Dan Streelman plucks an origami bird from a wire as part of a charrette presentation of concepts for a passenger pigeon installation. *Photo courtesy of Polly McKenna-Cress*

to help the project evolve and be innovative. During the process there are numerous points at which to glean constructive feedback in various forms. Critique is not only in response to formal presentations to decision makers, but also includes more informal day-to-day feedback with teammates, staff from other parts of the museum, or facilitated with outside reviewers (many times they will do this for free if you give them lunch!).

How Do We Use Critique Properly?

- Being flexible and open to different forms of critique and establishing review points

- Finding a shared vocabulary to discuss work and build critique language

- Utilizing objective criteria to assess the exhibition against

Establish Review Points

How do we establish the points during the process to arrange reviews/critiques? It is most important that intervals begin early and are frequent, utilized at different phases in the development and design as well as for the "final" experience. Too much time should not elapse without review of the work being done. If critique is delayed to the end there will be a lot of wasted effort, and little hope for learning and mediating issues.

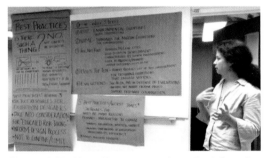

Figure 8.22: Maya Hartmann giving a "quick-and-dirty" smart presentation . . . no PowerPoint or Keynote here! To get concepts across for discussion, big, bold butcher paper and markers can be the answer. It allows the team to feel they can make comments and have a discussion as opposed to a slick presentation that can communicate, "This is final, we are done." Consider the phase the process is in to determine the best form of presentation. *Photo courtesy of Polly McKenna-Cress*

The most important critique "milestones" are the end-of-phase reviews that culminate each main working phase of the project. These critiques should be established early in the process. They are the formal presentations typically to the client, CEO, funder, or board, and presenters are expected to be professional, dress nicely, and come completely prepared.

In addition to milestone critiques, less formal opportunities arise before and after these milestones and can be helpful in preparing for them. These can be as impromptu as a desk crit where a team member or supervisor is asked to come and review specific details. Or, there is an informal "pin–up" crit, where a team member or small internal group pins up their work on a wall or projected from a computer

to elicit feedback (Figure 8.22). It is very useful when the team has been working through different individual deliverables. More involved is an "stakeholder pin-up crit," which might include a broader internal group (those not working directly on the project) as well as outside stakeholders or other museum professionals, which can prove to be immensely useful and cost effective over the long run (Figures 8.23 and 8.24).

Solid and useful information comes from all sources; from highly intellectual to practical and functional, all important to address before the exhibition is completed. Brown bag lunches can be arranged with the extended museum staff such as the volunteers or floor staff who will be taking care of the exhibition, or cleaning and security staff who provide different operational services the exhibition will inevitably be dependent on.

Building Critique Language

Build skills and language to create useful critique. Expand your knowledge base. There is no better way to provide critical feedback than to have shared reference points. Take field trips with colleagues and assign a critical analysis to each participant. Visit a lot of different types of exhibitions, experiences, displays, and environments, be they theme parks, theaters, restaurants, retail stores, or other cultural and social spaces such as churches and synagogues. All of these spaces are interpreted at

Figures 8.23 and 8.24: This is a presentation of concept or sketch model as a way to mock up object's scale and visitor path. Again, not too much time is spent on craft as it is not needed. *Model from Independence Seaport Museum's It Sprang from the River: Everyday Objects with Maritime Secrets, Philadelphia, PA, under Curator, Craig Bruns.*

various levels in service to the visitor and have implications on the way we think about spaces that communicate different thoughts and ideas.

Objective Criteria to Review Exhibition

The museum field struggled with the issue of objective criteria for years in fear that exhibitions would all become too standard and dull. However, the critical distinction is to use objective criteria as a baseline guide during the process, not as a checklist for accomplishment. For many years, there was little awareness of minimal expectations because the field did not build upon its history and experience. Many obvious issues, such as readability of text or visitor comfort, were ignored or not even considered. When best practices become standard practices, energies can be used to create exceptional experiences that can move the field forward.

There have been several individuals and groups who have created criteria over the years. The criteria that stand the test of time and incorporate most every other is Judy Rand's *Visitor Bill of Rights*. In it, Ms. Rand establishes 11 criteria that are a general but insightful means to assess any exhibition.

The 227-Mile Museum, or, Why We Need a Visitors' Bill of Rights

by Judy Rand, Rand and Associates, San Francisco, CA

Presented at the Visitor Studies Associates, 1996. First published, *Curator* magazine, vol. 44(1): 2001

A list of important human needs seen from the visitors' point of view:

1. Comfort—"Meet my basic needs."

Visitors need fast, easy, obvious access to clean, safe, barrier-free restrooms, fountains, food, baby-changing tables, and plenty of seating. They also need full access to exhibits.

2. Orientation—"Make it easy for me to find my way around."

Visitors need to make sense of their surroundings. Clear signs and well-planned spaces help them know what to expect, where to go, how to get there, and what it's about.

3. **Welcome/Belonging**—"Make me feel welcome."

Friendly, helpful staff ease visitors' anxieties.

If they see themselves represented in exhibits and programs and on the staff, they'll feel like they belong.

4. **Enjoyment**—"I want to have fun."

Visitors want to have a good time. If they run into barriers (like broken exhibits, activities they can't relate to, intimidating labels), they can get frustrated, bored, confused.

5. **Socializing**—"I came the spend time with my family and friends."

Visitors come for a social outing with family or friends (or to connect with society at large). They expect to talk, interact, and share the experience; exhibits can set the stage for this.

6. **Respect**—"Accept me for who I am and what I know."

Visitors want to be accepted at their own level of knowledge and interest. They don't want exhibits, labels, or staff to exclude them, patronize them, or make them feel dumb.

7. **Communication**—"Help me understand, and let me talk, too."

Visitors need accuracy, honesty, and clear communication from labels, programs, and docents. They want to ask questions, and hear and express differing points of view.

8. **Learning**—"I want to learn something new."

Visitors come (and bring their kids) to learn something new, but they learn in different ways. It's important to know how visitors learn, and access their knowledge and interests. Controlling distractions (like crowds, noise, and information overload) helps them, too.

9. **Choice and Control**—"Let me choose; give me some control."

Visitors need some autonomy; freedom to choose, and exert some control, touching and getting close to whatever they can. They need to use their bodies and move around freely.

10. **Challenge and Confidence**—"Give me a challenge I know I can handle."

 Visitors want to succeed. A task that's too easy bores them; too hard makes them anxious. Providing a wide verity of experiences will match their wide range of skills.

11. **Revitalization**—"Help me leave refreshed, restored."

 When visitors are focused, fully engaged, and enjoying themselves, time stands still and they feel refreshed: a "flow" experience that exhibits can aim to create.

In addition to these 11 criteria, we suggest that a 12th should be added: *a sense of awe and wonder.* Possibly more of a desire than a "right," it is still a standard for which most exhibition creators should ultimately strive. Because in the end, why would you engage the time, expense, and operation of exhibiting anything of which you did not want others to be inspired?

The evolution of critical thinking, constructive exhibition criticism, and useful criteria to assess exhibitions has come a long way. The tenants of the criteria have been consistent but as exhibitions continue to evolve, so must the criteria to assess them.

Evaluating Outside Services, Budget Planning, and Cost Estimation

Various portions of exhibition work will require the participation of outside service vendors. Although large museums may have internal staff for a variety of things, this need typically arises with the design and fabrication areas (exhibit designers, multimedia designers, graphic designers, or exhibition fabricators), and sometimes for other professional services as well (developers, evaluators, or writers).

There are two standard methods for requesting, evaluating, and selecting outside services for any contract work, as well as obtaining cost estimates for use in preliminary budget planning and final competitive bidding for the project.

Request for Qualifications (RFQ)

A *Request for Qualifications (RFQ)* is a document the institution disseminates to potential vendors requesting information essential for understanding the services and capabilities that venders can provide. The RFQ is intended to cast a wide net to potential vendors that have done similar work or worked for similar types of institutions and see what talent and skills are available. It is a first round of selection to determine who may be best suited to understand the museum's mission, work with the museum team, and provide a proposal of services. When writing a RFQ it is important for the institution to delineate specific qualifications needed for a particular project as more often than not each exhibition has its own specialties. Which vendor has done similar work to the museum's project? Which has the experience, skills, and staff to accomplish it? Have they completed their work on time and on budget?

Request for Proposal (RFP)

With a fair amount of RFQ submissions received, the team should narrow down a selection of the top five. The institution will send these "prequalified bidders" a detailed *Request for Proposal (RFP)* document. The RFP may be the most critical document to the project. To secure the most accurate proposals, it is up to the institution to write a concise and smart request document that outlines the project parameters in detail: who the institution is, focused project intent and requirements, anticipated audience and attendance, the institutional team (specifically, the ultimate decision maker), client-provided resources, skills required, content expectations, scope of work, time requirements, and budget parameters, to name just a few! Clearly delineating what the institution will do from what you expect the firm to do is critical. The more the firm knows the better; there is no benefit to keeping secrets even about budget. This is another form of collaboration so transparency and communication are the direct routes to the project's success.

There are different theories regarding how many RFPs should be sent, and some institutions feel they need more than five to make the best decision. However, given the complex nature of exhibitions and the potential review and decision-making process, five is a reasonable target to get competitive bids. The team can truly only absorb five proposals in

a thoughtful way before the exercise becomes exhausting. Ten proposals will surely create some confusion between the content from different vendors. Lastly, if potential vendors are aware that dozens of bidders may be participating, more may decline to bid simply because they want to be reviewed seriously and deliberately. When writing proposals, it takes considerable time to address the diverse informational requirements outlined, so it is important to respect that time to critically analyze what each vendor submits.

Writing Successful RFPs

by George Mayer

What Do I Need to Know?

- The firm's experience and how it matches your project.

- A portfolio of the firm's work.

- The firm's current work load and how it's likely to affect your project.

- The key personnel who will be assigned to the project, their experience on other projects, and their length of time with the firm.

- How the firm will accomplish the work. What is its work plan?

- A schedule of key milestones and how those milestones match the schedule that has been established for the project.

- The financial conditions of the firm. This information can be gotten from a company's current financial statement.

- References, references, references . . . and not just the ones that are shown on the firm's reference list. Make some calls to representatives of other projects from the firm's project list.

- Why does the firm want to work on this project? This is a question that is not often asked by prospective clients. Most clients assume that any project would be of interest, because it represents an opportunity for business. This can only take the team so far. Strong professional or personal passions for the project can sustain energy

and drive success. When the going gets tough, relying on the passion of the participants can yield better results.

- A great resource for writing an RFP is the National Association of Museum Exhibitors (NAME) *Journal the Exhibitionist* Spring 2007 issue (online PDF copy), which outlines the needs and philosophies behind creating a solid RFP.

FURTHER READING

Brown, Tim. *Change by Design: How Design Thinking Transforms Organizations and Inspires Innovation*. New York: Harper Business/ HarperCollins Publishers, 2009.

Edwards, David. *The Lab: Creativity and Culture*. Cambridge, MA: Harvard University Press, 2010.

Doorley, Scott, Scott Witthoft, and Hasso Plattner. *Make Space: How to Set the Stage for Creative Collaboration*. Hoboken, NJ: John Wiley & Sons, 2012.

IDEO. *Human-Centered Design Toolkit* (Open Source).

Kelley, Tom, with Jonathan Littman. *The Art of Innovation: Lessons in Creativity from IDEO*. New York: Currency/Doubleday, 2001.

Kolko, John. *Thoughts on Interaction Design*. Burlington, MA: Morgan Kaufmann, 2010.

Suri, Jane Fulton, and IDEO. *Thoughtless Acts?: Observations on Intuitive Design*. San Francisco: Chronicle Books, 2005.

PROCESS AND PHASES DIAGRAM

How can the process be comprehensive yet flexible enough to allow for serendipity?

The five exhibition advocacies and the work each must entail to achieve a creative and successful exhibition typically follows a basic sequential structure of phases. The following *Process and Phases* chapter is an examination of each of these phases and the teams responsibilities within each. Very simply, the exhibition process is based on the simple logical reasoning 'something needs to happen before something else'. But there is no absolute checklist and the information outlined here should be used as a guide and not as a rule. Every project is different, and every working team is different; a team should establish their own process tailored to their own particular conditions.

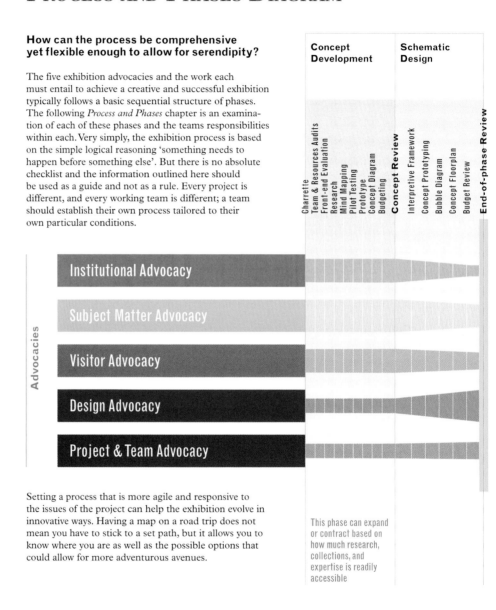

Setting a process that is more agile and responsive to the issues of the project can help the exhibition evolve in innovative ways. Having a map on a road trip does not mean you have to stick to a set path, but it allows you to know where you are as well as the possible options that could allow for more adventurous avenues.

This phase can expand or contract based on how much research, collections, and expertise is readily accessible

Figure 9.1: Process and Phases Diagram. *Illustration by Richard Cress*

Design Development

- Exhibit Outline
- Visitor Walkthrough
- Formative Prototyping
- Formative Evaluation
- Budget Review
- **End-of-phase Review Important Sign-off**

Construction Documents

- Engineering Prototyping
- Budget Review
- **End-of-phase Review Important Sign-off**

Bids, Fabrication, Installation

- Budget Review
- Soft Opening
- **Opening**

Opening, Post-opening, Revisions, Documentation

- Documentation, Debriefing
- Maintaining & Evolving
- Summative Evaluation

This phase has serious cost implications because of labor required to make CDs

This phase has cost implications because of labor and material costs required to construct

Figure 9.2: Process and Phases Diagram. *Illustration by Richard Cress*

PROCESS AND
PHASES

HOW DO WE SET UP OUR PROCESS?

In previous chapters we have discussed the need for collaboration among individuals or small groups to advocate for particular areas and the considerations they need to address during the exhibition process. So how and when is this all tied together? What happens in what sequence? How does the team create a clear and strategic process to achieve its goals?

The planning, developing, and designing of an exhibition are complex. As the museum exhibition profession has become more established, more collaborative, and more complicated, the stakes have become higher, creating the need for a shared and effective process. These exhibitions require coordination of multiple professionals and a planned sequencing of phases. "On time and on budget" is the mantra of all institutional and project and team advocates. To accomplish this, the team needs a clear yet flexible process (Figure 9.3).

The illustration preceding this chapter features a Process and Phases Diagram, which charts the five exhibition advocacies and the typical sequential structure of phases of work to create an exhibition. In this chapter, we offer an examination of the process phases and the team's responsibilities within each. Very simply, the exhibition process is based on the simple logical reasoning "something needs to happen before something else." But there is no absolute checklist, and the information outlined here should be used as a *guide* and not as a *rule*. Every project is different, and every working team is different; a team should establish their own process tailored to their own particular conditions. We outline some

Large photo: Glasgow Science Center, Scotland. Photo courtesy of Polly McKenna-Cress
Inset photo 1: Prototyping lab. Photo courtesy of The Franklin Institute
Inset photo 2: Brainstorming process. Photo courtesy of Polly McKenna-Cress
Inset photo 3: Materials samples. Photo courtesy of Polly McKenna-Cress

standards and considerations for all different museum discipline types from art to science to children's to zoos. Of course, there are very different approaches, depending on the content and collection, particularly as one institution works with conservation-sensitive objects while others have "collections" that eat, sleep, and poop!

The advocate of primary focus here is the project and team advocate (project manager), but that does not let other advocates off the hook. Each advocate needs to understand the many steps and phases that go into creating the entire exhibition, not just the phases involving his or her individual responsibilities.

Figure 9.3: The many divergent thoughts, objects, facts, and stories need to be filtered through a set of expectation channels and "visitor-need considerations" so that the most concentrated and powerful experiences will be created. *Illustration by Meghann Hickson*

Three Critical Questions for Developing and Implementing Your Process

- How do people with different working styles and approaches keep their integrity while creating a cohesive whole?

- How can the process be comprehensive yet flexible enough to allow for serendipity?

- How can a flexible process stay on schedule and on budget?

Why Do We Need a Process?

Critics have questioned the concept of having a formalized process out of fear of limiting creativity. But if the team does not clearly understand how progress will be achieved, how and when decisions will be made, and the required sequence of events to reach milestones, it will not fully capitalize on creative potential. It can also run the risk of spending more time or more money than allocated. Setting a process that is more agile and responsive to the issues of the project can help the exhibition evolve in innovative ways. Having a map on a road trip does not mean you have to stick to a set path, but it allows you to know where you are as well as the possible options that could allow for more adventurous avenues.

Laying out the process and phases can be daunting if a team isn't clear about where it is headed. We wish we could offer simple "ready to wear" solutions. Although we cannot provide the one perfect process we can outline typical phases and sequence. Above all, the process must be transparent for everyone on the team. Unclear operational procedures tend to breed anxiety and fear, which will kill collaboration and innovation.

Even the Best-Laid Plans Should Be Flexible!

There are very few times in life that initial plans are followed to the letter. There are always unforeseen interior issues and exterior conditions that cannot be anticipated. For this very reason, you should not preclude your team from having a plan. It's not a bad thing for plans to be revised along the way; there are also plenty of serendipitous opportunities that should be considered. When the team tries to adhere too closely to a plan, it can encounter more issues in the long run or, worse, create a dull exhibition. Yet without any plan at all, obstacles and surprises can derail progress or even halt the exhibition entirely. When

The process of scientific discovery is, in effect, a continual flight from wonder.

—Albert Einstein

teams are flexible yet understand the critical path they need to follow, they will be in a much better position to deal with the unexpected. In some cases, the best skill is being able to call upon creative ingenuity to make lemonade out of lemons.

Leave Time for Receiving Feedback

Another key reason for a scheduled plan is to ensure the opportunity for review and feedback from the larger group of stakeholders. If the exhibit team goes off and creates without checking in with key stakeholders such as administrators, coworkers, or funders, there may be good work that ends up on the trash heap. We could share plenty of horror stories about exhibition teams or design firms that have moved forward without review meetings only to find they have to completely reconsider the project. This is a difficult position nobody wants to be in once money, time, and energy have been expended. In addition to lost time and money, the emotional blow can permanently derail the project.

PROCESS OUTLINE

So, how does one go about organizing a schedule and process? The advocate responsible for managing and documenting the process and schedule is the project and team advocate. Although this advocate is a manager, he or she should not be a dictator! The whole team has responsibility for accepting and giving input into establishing how the process will run. By creating and discussing the collaborative process with the team early, there is a shorter learning curve, potentially less confusion, and much less complaining. Typically a schedule is created by one person with input from key collaborators and then reviewed and approved by the whole team.

Appraising the Team and Resources

Launching a project with an appraisal of the team and resources is a smart place to start. In Chapter 2, we discussed the paradigm shift in the museum field from a disciplinary model in which team members vie for their field of expertise to an advocacy model in which team members advocate for key goals and visitor meaning. These should be considered as a set of important drivers of the process. The team should review the five advocacies of this model so that responsibility for each can be assigned and owned.

Team Audit

One of the best ways to launch any collaborative process is to conduct a team audit of the skill sets and time commitments required of the members involved. Taking stock early can avoid uncomfortable situations and frustration or even serious breakdown of the team or the process. The team audit should establish strengths and competencies of members, and assign advocacies according to the roles that need to be filled whether by an individual or a group.

Skills assessment should not be limited to work production (i.e., good writer, graphic designer, researcher, drafting, etc.) but also should consider the different working styles that team members employ. Some people are verbal thinkers, some are super organized, some adept at brainstorming, and some are morning people while others shine in the afternoon. Although everyone will not align, building awareness of skills and working styles can provide clearer expectations of how each team member works.

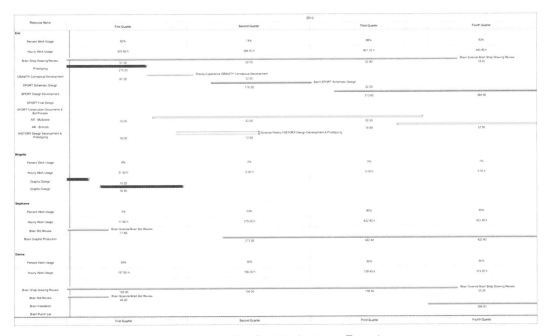

Figure 9.4: Team resources schedule from The Franklin Institute. To understand the complex scheduling of time, skills and staff needed to complete multiple projects, the project manager creates a detailed schedule to visualize and manage everyone's time effectively. *Schedule courtesy of Jeanne Maier*

At the same time, a solid sense of who the core group is and what skills and talents each individual brings to the process should reveal the skills that may *not* be represented on the team. Particular exhibition goals or unique content may require special attention. How will those needs be met, and by whom? Should you budget for an outside consultant? The holes should be recognized and addressed.

Assessing personality types is another tool that can help to synthesize the characteristics of the team. Myers-Briggs or Jung personality tests are well known and freely offered on the web in different forms. Although not completely necessary, these tests can yield some understanding of traits, can be help teammates work together, and inevitably yield interesting insights for those taking the test.

Additionally, there may be potential institutional partners and advisors that need to be selected strategically. Every new partnership requires management time just simply in back-and-forth communications. So while collaboration is essential, be aware that sometimes too much of a good thing could be draining or frustrating to the process.

Resources Audit

Exhibition resources are typically considered to be people, collections, space, skills, tools, funds, and, of course, time. As with the Team Audit, a clear picture of the conditions and circumstances of these resources should be understood. It is reasonable and perhaps most efficient to conduct a Resources Audit at the same time as the Team Audit.

For each of the resources, the team needs to consider questions such as:

- **People:** Do we have the right staff expertise, labor hours, consultants, content experts, community liaison, education staff, volunteers, interpreters in and staff to maintain the exhibition and so on? (Figure 9.5)
- **Collections:** Do we have enough or the right collection to support this whole narrative? Will we need to borrow objects? Do we know who, where, and what we can find and ask to fill in what we need? (Figure 9.6)

- **Space:** Is the space large enough? How is it configured? Where is it located in the museum? What does it offer in terms of design opportunities?

- **Skills/tools:** What did we learn through our Team Audit process?

- **Funds**: This is a major issue. Are there enough funds to budget for all we hope for and want to accomplish with this exhibition? Are there funds for continued updating and refreshing after opening? If not, are there other resources to tap for more funding?

- **Time:** This is another major issue. Is there enough time to accomplish all the elemental phases of work—research, development, design, fabrication, and installation—of this exhibition? Have we allowed enough time during post-opening to update the content/elements to keep the exhibition fresh? Although we have the skilled staff to accomplish this project, can their time be appropriately dedicated to this project?

Figure 9.5: Team planning for not just creating the exhibition experiences, programs and marketing strategies and also who will ensure the exhibition lives beyond opening day. *Photo courtesy of Polly McKenna-Cress*

Establish Advocate Goals

Once team skills have been established and the Resources Audit run, the advocacy goals should be shaped. Is the team headed for the same target and aware of how different parts and members will work to get there? What are the goals for each of the five advocacies? What factors inform these goals? The optimal time to establish goals, of course, is at the

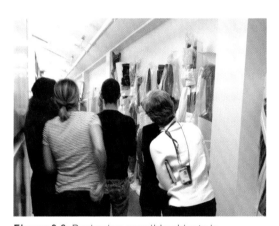

Figure 9.6: Reviewing possible objects in collections storage area. *Photo courtesy of Polly McKenna-Cress*

beginning of the project. So the team should work deliberately on goals when embarking on the mission and big idea that will be the main criteria driving the project. The individual advocacy chapters in this book outline particular goals and needs of the five different advocates.

PROCESS PHASES

(Refer to Process and Phases Diagram, Figures 9.1 and 9.2 preceding this chapter.)

Planning Phase

The Planning phase of an exhibition typically follows an institution-wide strategic planning and/or master planning session, where the institutional advocate with support from the board, and inside and outside stakeholders, develops a short- and long-term strategic plan. Through this, the institution establishes its course and understands the audience it wants to reach through its many offerings, specifically exhibitions. Using the institutional mission and vision (both developed during the strategic planning process) as springboards, the Planning phase is when an exhibition team formulates the best ways to reach these goals through brainstorming discussions, research, and charrette.

During the Planning phase there are different forms of research to be conducted in several key areas:

- Subject matter that will address community needs, support institutional mission, and be the most effective and useful
- Audience and their anticipated attitudes about the subject
- Existing material and collections on the subject matter focus (Figure 9.7)
- Available resources (including expert labor and funding sources)
- Schedule and plan for constructing the exhibition

Planning Phase Questions to Answer

- How will this exhibition support the museum's institutional mission?
- Is this topic going to help advance the institution's goals in terms of collections, scholarship, current or intended audience, and resources?
- Who will be affected and how?
- What's special about the institution/exhibition, and why should people care?
- How long will it take to create the exhibition?

- How much might it cost?
- What funding resources are available and align with our intentions?

Planning Phase Deliverables:

- Grant proposals
- Presentations for funding
- Planning documents with visuals

Concept Development Phase

The Conceptual Development phase is where conceptual approaches are more clearly considered and formed. During this phase, the team will draft the exhibition's mission, big idea, goals, objec-

Figure 9.7: Reviewing pottery fragments at Thomas Jefferson's Poplar Forest. *Photo courtesy of Richard Cress*

tives, and target audiences and will begin using this foundation as the basis from which to assess decisions. The subject matter and/or visitor advocates lead the development of exhibition content and the direction from which the narrative will flow. The team should place visitor evaluation at the forefront and test new ideas with visitors before they are developed too far. When initial concepts emerge in this process, the team should consider "pilot testing" them to understand how visitors might best approach them. The team should also make an opportunity to present to stakeholders, specifically the institutional advocate and funders, while also ensuring the project budget and schedules are being defined and developed as the project evolves.

These elements should be thought of as guiding criteria, not rigid rules.

Concept Phase Questions to Answer

As your team begins this phase of the process, the following questions will be useful for the whole team to consider in advancing the project.

- What is the mission and Big Idea of the exhibition? (See Chapter 8 for details.)
- What are the goals of the exhibition, including the more abstract or grand ideals for both the team and visitors?

- What are the objectives, including the observable/measurable outcomes, of the exhibit? For the team and visitors?

- Who is the intended audience(s) for your exhibition? (Figure 9.8)

- What are the visitor "walk-aways"—the things you want/expect your visitors to remember or be saying as they walk away from the exhibition?

- How might the narrative unfold?

- How will you map and document decisions visually?

- What is the mood or personality of the exhibition?

Typical Deliverables for Concept Phase:

- Background Research (including Market, Audience, Content, and Media Research)

- Sketches and loose renderings of overall views illustrating the emerging character or mood of the exhibition (done typically by the design advocate)

- Exhibition outline

- Results from pilot testing and concept testing

- Creation of visual diagrams: concept diagrams and bubble diagrams (See Chapter 8.)

- Draft timetable/schedule (with opening dates and phases blocked out)

- Draft overall budget (in large round numbers with minimal detail, for example, square footage costs)

Concept Development End-of-Phase Review

The end-of-phase review for the Concept Development phase is when the team presents the overall concepts and direction of the project including initial design to the key stakeholders, the institutional advocate, subject matter advocate, funders, and in-house and external professionals who need to approve the project to move forward. If the project is not approved, the team may have to go back to the drawing board or to the last phase that was approved.

Figure 9.8: Visitors, more specifically tourists, waiting in line for tickets at Mt. Vernon Visitor's Center. *Photo courtesy of Richard Cress*

Schematic Design Phase

With concepts approved, the project moves to the Schematic Design phase, where the loose ideas, images, and desired outcomes begin to be shaped into a cohesive experience for the visitors. Pilot testing should continue through this phase as a means for understanding how visitors connect with the evolving concepts. During this phase, the team is loosely blocking out the flow, the narrative, the graphic approach and color schemes, and so on, taking another step closer to a fully formed exhibition. The narrative is outlined and concepts are given initial physical form. The vision—and how it could be expressed in an experiential way with consideration of individual moments, collections, interactions, and visitor flow—is being fleshed out. Numerous details express the vision through materials, colors, and textures as well as possible graphic treatments.

Although "Design" is in the title of this phase, the work is not limited to that done by the design advocate. Developers, evaluators, subject experts, prototypers, educators, and the rest of the team are highly involved at this stage to ensure all the components are addressed and advocated. The project and team advocate ensures that progression of all work is on track, including most importantly, opportunities for timely feedback and forward movement.

Schematic Design Questions to Answer

During this phase of the process, the following questions will be helpful to consider in order to advance the project:

- What is the draft title of the exhibition?

- What is the voice of the exhibition?

- What is the overall exhibition personality? For example, rich saturation and dramatically lit or bright with clean lines? A steampunk aesthetic or Japanese anime? (Figure 9.9)

- What is the narrative basis for your exhibition? Who is telling the story?

- What role will visitors have in the exhibition? How will they understand that role?

Figure 9.9: The Franklin Institute Science Museum, The Train Factory exhibition. *Photo courtesy of The Franklin Institute*

Figure 9.10: The Franklin Institute Science Museum, The Train Factory exhibition's graphic panel. *Photo courtesy of The Franklin Institute*

- What consistent elements or threads will provide a sense of connection and continuity between all of its parts?

- What will be the visitor path, directed or more open ended?

- What are possible graphic approaches that align with the exhibition's personality (Figure 9.10)?

- What modes might be best employed to tell the story?

- What programs and/or interpreters will facilitate the next level of engagement?

- Is the building structurally sound for what is being installed? There are instances where the building might not be structurally sufficient to support the weight of a heavy element; tanks of water or stone/metal artwork fall into these categories. Better to find out before it is installed!

Typical Deliverables for Schematic Design

In the Schematic Design phase the content and possible physical experiences are framed up and initial design approaches established. Most of the elements created in this phase should and will evolve over the course of the process:

- Front-end material refined: The overall mission, Big Idea, goals, and objectives

- Content organization

 - Objects and narrative

 - Interpretive plan

 - Conceptual diagrams/bubble diagrams

- Pilot and concept prototyping being conducted

- First draft of walkthrough, which should include the following:

 - Description of the threshold experience that happens at the entrance of the exhibition to set the stage for the rest of the exhibition (i.e., What intrigues and invites visitors in? see Figure 9.11)

 - Lighting scheme (See Chapter 8)

 - Objects and plans for display

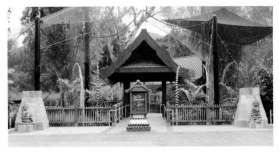

Figure 9.11: Red Apes of the Rainforest Orientation Plaza at the Los Angeles Zoo, Los Angeles, CA. This exhibition threshold welcomes visitors and begins their immersion into the treetop Indonesian world of the orangutans. The graphic greets visitors with the phrase "selamat datang"—Indonesian for welcome. *Photo courtesy of Polly McKenna-Cress*

- A plan for how sensory perception can be employed (see Chapter 8)
- Description of the physical relationship/activity of the visitor within the area (e.g., If visitors walk over a literal bridge, what does that symbolize conceptually for them?)
- Description of the transition/thematic overlap between areas that will provide continuity for your exhibition
- Conclusion (i.e., the exit, reflection or culminating experience)
- Visitor walk-aways (i.e., what thoughts/impressions will visitors leave with?)
- Narrative of facilitation

- Draft exhibition identity: Brand; look, including logo; typography use, and the like (Figure 9.12)
- Look-and-feel image boards
- Loose renderings/perspectives of overall views
- Typical graphics—one of each different type of graphic treatment
- Schematic floor plan—bubble diagram blocked out in plan view/ existing space
- Sketches of important views, perspectives (Figure 9.13)
- Draft thoughts on multimedia and mechanical Interactives
- Concept prototyping/continued pilot testing
- Refined schedule to complete the project broken down by milestone dates with key deliverables, dates, and deadlines called out
- Next draft budget and OPC (opinion of probable cost). OPC is the rough ballpark estimate that can be derived from experience or estimating by fabricators, often referred to as a ROM (rough order of magnitude), or when all else fails, the WAG (or wild ass guess)

KidScience

THE ISLAND OF THE ELEMENTS

Figure 9.12: KidScience exhibition logo at The Franklin Institute, Philadelphia, PA. *Image courtesy of The Franklin Institute*

Budgeting

The draft budget created in the Concept Development phase should be tested against the exhibition that is evolving. The team should know, at least

Figure 9.13: Initial perspective sketch for the KidScience exhibition at The Franklin Institute, Philadelphia, PA. *Photo courtesy of The Franklin Institute*

generally, where budget will be allotted. Now is the time to determine how you will be spending budget dollars and where you might reallocate them based on current direction. You'll need to know basics, such as whether you will need more money for special multimedia consultants or special handling of unique objects. Documentation for where the money allocations are being distributed must be made so that there is no confusion or concern expressed later.

Schematic Design End-of-Phase Review

The end-of-phase review for the Schematic Design phase is when the core team presents the content framework, possible physical experiences and design approaches to the key stakeholders, the institutional advocate, subject matter advocate, funders, and in-house and external professionals who need to approve the project to move forward. If the project is not approved, the team may have to go back to the drawing board or to the last phase that was approved.

Collaborative Shift

Through the first two phases of the process (Conceptual Development and Schematic Design), the team has been working together in collaborative development to establish the various foundational frameworks that will define the exhibition (mission, goals, bubble diagrams, and exhibition outlines) and make team decisions. With these determined, the collaborative procedure, depending on the team, likely will need to shift away from team decision making as the work of each team member will not be on the same materials and deliverables and not necessarily in the same space. At this "collaborative shift," individual advocates will likely be working apart yet still must report back to the team on specific deliverables.

As the number and scale of tasks grow and considerations expand, this shift gives the advocates unfettered focus to approach their particular components of the plan, to have the autonomy to work through the details, and employ their skills and expertise to create the best solutions. Yet, team discussions must continue to ensure the different puzzle pieces will fit together. Team collaboration is still engaged in through regular conversations, presentations, and reviewing and critiquing of each other's component work to ensure that everything is meeting the project criteria. As in baseball, each player is performing his or her

specific job—pitcher, catcher, right fielder, and designated hitter—while also working together and having influence on one another. The process and team advocate has responsibility at this point to facilitate the management of the individual advocates' work, and coordinating schedules ensuring deadlines are met.

Design Development (DD) Phase

The design development phase is where details are defined and refined in all areas of the exhibition. After the institutional advocate and other appointed stakeholders sign off on the Schematic Design phase, the team must focus on detailing all the elements, modes, media, educational programs, staffing plans, and so forth; assess them with real budget requirements; and set timeframes. The key is for the team to be able to really "see" the exhibition experience and how it is coming together as a whole. This way, the team can make smart choices and exploit any last minute opportunities.

Although "Design" is also in the title of this phase, it too is not limited to the design advocate only. The rest of the team and all stakeholders are still heavily involved, as review and critique of all critical design development decisions are being finalized in this phase.

The project and team advocate ensures that everyone has had input when and where appropriate and that approval from powers that be has been garnered and documented. The largest proportion of nonconstruction labor dollars are typically spent in this phase, and the process accelerates in terms of decisions that will have cost implications from this point on. Without proper approvals, good money could be spent after bad if major changes need to be made.

Design Development Questions to Answer

During this phase, the team should consider the following typical questions as it advances the project toward completion. These are good starting points but do not necessarily encompass every detail that would need to be considered, depending on the project:

- What is the overall gestalt of the exhibition? How will all of the disparate parts come together to form a whole?

- Will the environment be in service to objects and story, set the stage, or be a benign backdrop? Will you use a metaphor, such as a crime scene, train factory, or abandoned logging camp? Or a time period as a setup, such as the future, a period room, or surreal environment?

- How will the exhibition be delivered, and what modes will be used? Is this interpretation going to be delivered through a graphic, multi-media element or live actors? Once the larger elements are decided, smaller details need to be considered.

- What materials and finish choices can you afford, and are they safe (are fire retardant, do not off-gas, are bug free, etc.), green, and ADA compliant?

Figure 9.14: Exhibition elements/objects in the Rotunda at the Smithsonian's National Museum of the American Indian, Washington, DC. These exhibit elements help orient visitors in finding their way through the museum, both intellectually and physically. *Photo courtesy of Richard Cress*

- Will the content be offered in multiple languages or modalities to increase inclusiveness?

- What will the impacts of the exhibition be on the building shell and systems?

- How will the exhibition affect visitor traffic flow throughout the institution (Figure 9.14)?

- Who or what is the voice of the exhibition? Is it the actual scientist doing research or the teenage intern who can relate better to the target audience?

- Does the exhibit maximize visitor participation? Is there too much?

- How will the objects be valued and presented? Will you use one precious object alone in its own case or position multiple objects together in one case for comparison? What will that presentation and juxtaposition say about those objects?

- What activity level is demanded? Are there too many full-body engagements (Figure 9.15)? Too few fine motor activities? Too much of one type in one area? Too much reading? Not

enough interaction with others? How do all the planned activities add up for an overall experience?

- What might this exhibition cost? Establishing opinions of probable (OPC) cost.

Typical Deliverables in Design Development

In the Design Development phase, the final interpretative framework and final object lists are decided, all elements and graphics need to be defined. Construction documents and groundwork for special elements that need longer lead times need to be underway.

- Formative evaluation (continued)/formative prototyping.
- Renderings/perspectives: At this stage the team and the institutional advocates and other stakeholders need to understand the fuller picture that is being shaped. A full-color rendering can effectively show the lighting strategy and mood of the space; either computer generated or hand-drawn renderings are typical tools (Figure 9.16). These images should also illustrate visitors in the exhibition spaces, along with their anticipated behaviors: active, engaged with the exhibit, perhaps pointing. If the visitors are depicted as enjoying the experience, the drawings can further sell the exhibition.

Figure 9.15: A young girl making her way along the rock-climbing wall in The Sports Challenge exhibition at The Franklin Institute, Philadelphia, PA. *Photo courtesy of Polly McKenna-Cress*

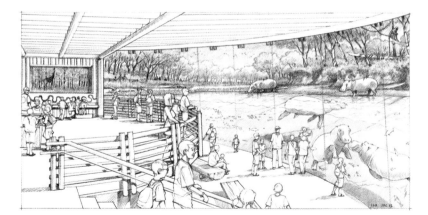

Figure 9.16: Full-color rendering of Polar Bear habitat underwater viewing for Utah's Hogle Zoo Salt Lake City, Utah. *Illustration by John Collins Jr. Courtesy of CLR Design, Inc.*

- Models: Good old-fashioned three-dimensional models are effective design tools for your team to envision the end result as well as useful for presentations (Figure 9.17). Many museums and firms still use the physical techniques of modeling because they are still one of the most effective design tools for the whole team and can also be repurposed as smart fundraising tools.

- Drawings (which become the construction documents the exhibition will be built from):

 - Detailed floor plan with locations, objects, cases, interactives, and graphics all noted and marked.

 - Elevations and sections of overall walls and areas.

 - Detailed drawings of how elements are to be built and what materials they will be finished with should be underway though the true detailing will be done in construction documents (Figure 9.18).

 - Preliminary Facilities Impact Report, which outlines how the exhibitions construction will interface with the building envelope and systems.

 - A good picture of the experience from the overall effect to the individual elements.

Figure 9.17: Model of a 5,000 sq. ft. object based exhibition built by Rebecca Fell, Zach Mosley, Kim Nichols, and Jamee Vasil while in the Museum Exhibition Planning and Design MFA program at the University of the Arts, Spring 2010. *Photo courtesy of Richard Cress*

Figure 9.18: Materials need to be selected, configured to a plan, and potential costs estimated during the design development phase. *Photo courtesy of Palumbo Associates, Inc.*

- First draft of all graphics laid out, including environmental and way-finding graphics.

- Formative prototype testing: This phase of prototyping will work out the details of how information and ideas are presented, including what means, media, and modes will be used. Elements need to be clustered and prototyped together if association is important in the final exhibition.

- Media and technologies are decided on, mapped, and storyboarded, including theater, soundscapes, projections, and so forth.

- Mechanical interactive design—from flip lids to complex interactives.

- Environmentally sustainable design review.

- Accessible design: Meeting visitors "where they are," whether in a different language or to address a learning disability or learning style, or accommodate those with a physical challenge.

- Educational programs are prototyped and tested with visitors. (Figure 9.19)

- Exhibition facilitation drafts and staffing/docent labor plan.

- Material and finish samples and "specs."

- Rough budget.

- Exhibition element spreadsheet/schedule: This lists every element that needs to be produced for the exhibition; cases, graphics, interactives, media, and so forth as a way to manage, price, and keep clear track of all the elements.

- Team schedule: The team schedule should show the final version of a timetable to complete the project broken down by research, conceptual development, schematic design, and design development, with key deliverables, dates, and deadlines called out.

Figure 9.19: Educational materials for a program where kids use borax to form crystals at the Fairmount Water Works Interpretive Center, Philadelphia, PA. *Photo courtesy of Richard Cress*

Budgeting at the End of Design Development

When your team is nearing the end of design development, the drawings should be shared with fabricators to request early review and rough ballpark figures to ensure the project has not gone way over or way under budget (rarely the latter). The team should have a good understanding of where the money is being spent and how much various elements cost,

in order to review and make final decisions about where monies will be allocated. A clear breakdown of costs will allow the team to determine where to spend money to have the most impact, say, on a multimedia experience versus the custom carpeting, for example.

Design Development End-of-Phase Review

At the end of the Design Development phase, the final interpretative framework and final object lists are decided, all elements and graphics need to be defined and approved by the institutional advocate and other appointed stakeholders before the Construction Document (CD) phase is fully underway. Construction documents are time-consuming and expensive, so you do not want to get too deep into their production if the designs are not fully approved. If the project is not approved, the team may have to go back to the drawing board or to the last phase that was approved.

Construction Documents (CDs)

This phase is straightforward. The design advocate and project and team advocate create and manage final detailed drawings that will be supplied to in-house or contracted fabricators to build the exhibition. Often designers will send out drawings with expectation that the fabricators simply build to the drawings, but there is another opportunity for collaboration here. Fabricators are important partners, and they should be brought in to understand the culture of the institution, the vision, mission and goals of exhibition. They can support the team's efforts in thoughtful ways, offering smart efficient solutions, and suggested approaches or alternate means for construction.

During this phase, the visitor advocates, developers, educators, and others are not sitting idly by waiting for the exhibition to appear. They are also prototyping and preparing all the materials and training activities necessary for the programs that will extend the life of the exhibition, either in the exhibit or beyond the museum's walls, such as exhibit facilitation, tours, cart demos, live actors, storytelling, lecture series, film nights, special tours, school groups, and summer camps that focus on this exhibition. Any and all print material should be developed and designed at this time, including press kits, teachers' packets, family guides, visitor guides, and so forth. Within the exhibition, it is important that they review all finalized graphics (both panels and any printed

material) that the graphic designers are preparing for fabrication with the correct photos, edited copy, final illustrations, and so forth. In our experience, this process can take longer than anticipated and, without careful review from all parties, can cause schedule delay.

The subject matter advocates are triple-checking accuracy of content, conducting all conservation needed on objects, and securing outside objects that will be on loan for this show. Institutional advocates are talking to the press, board, and outside funders to create the buzz for the exhibition's launch. They are also organizing opening events.

Construction Document Questions to Answer

- Has the team documented and detailed (through the construction documents and specifications) the project adequately to get several competitive bids?

- Do the specifications clearly define the quality and level of detail required for this project?

- Has all the exhibition copy and text been edited by different readers to ensure accuracy and continuity? Have translations been created and reviewed with native speaker content experts?

- Has the team done engineering prototyping to feel confident of visitor outcomes, and that the devices are durable for public use? (Figure 9.20)

- Have educational programs been developed and prototyped with visitors and interpretive staff? (This is predominantly the visitor advocate's job.)

- Are the exhibition elements built for environmental sustainability?

- Has the exhibition been adequately tested and designed for maximum accessibility for all types of visitors?

- Are all multimedia elements approved and in production? Have final specifications of hardware been determined to ensure they are housed and ventilated properly? (Figure 9.21)

Figure 9.20: Engineering prototype of a brain function interactive for The Franklin Institute, Philadelphia, PA. *Photo courtesy of Eric Welch, The Franklin Institute.*

Figure 9.21: Specification of actual hardware needs to be decided for finalization of exhibit housing construction documents to ensure proper fit and access. *Photo courtesy of Palumbo Associates, Inc.*

- Has the team acquired approvals from all stakeholders?

- Are budget breakdowns and allocations clear?

Typical Deliverables for Construction Document Phase

During the Construction Document (CD) phase all exhibition elements, cases, interactives, experiences, final text, images, and graphics are all finalized and documented. All elements and programs needing to be built, purchased, printed, or created must be listed and prepared for pricing. Any special elements that are complicated or need longer lead times for such considerations as space preparation, (e.g., floor needs to be reinforced for weight) may need to be underway.

- List of qualified bidders for this specific type of construction project. If there are specialty items with particular skills needed (such as rockwork or intricate mechanical interactives), specific fabricators need to be researched.

- Construction documents (CDs) consist of all detailed design intent drawings needed for bid. All design intent drawings should take into account accessibility and sustainable practices.

- Detailed specifications, or "specs," are the material callouts and standards by which the exhibition elements must be built (taken from the 16 division architectural specifications). These specs accompany the CDs to become the contract that is agreed upon between the museum and fabricators.

- Include a bidding sheet, which itemizes each element and different cost estimates requested of the bidder. Provide the bidding sheet as an electronic spreadsheet to make analyzing and facilitation of bids much easier.

- All content should be finalized. Sizes of panels or graphics cannot change but information can be edited and photos and illustrations can be refined up to fabrication release. Editing of content after art has been released for fabrication can prove complicated or costly.

- Finalized Object List, including object case layouts and a mount schedule; case costs should be estimated as changes post-CDs can prove costly.

- Formative evaluation continues (see Chapter 8 for the description of evaluation phases).

- Engineering prototyping completed for any element of significant expense or critical to the exhibition goals.

- Multimedia and mechanical design contracted.

- Educational programs scripted and scheduled, and floor staff trained.

- Messaging and external communication material should be fully prepared, including press releases, for distribution to press to build early awareness.

Construction Document End of Phase—Send to Fabricator

The end of CD phase is reached upon final review of all construction details, spreadsheets, and plans. The entire package is prepared for bidding and release to a final selected fabricator.

Bidding

With CDs detailed and completed, bids must be requested from fabricators. This is very detailed work, requiring significant time, and the project and process advocate kicks into full gear. Requesting qualifications and proposals from potential fabricators is the first step (refer to Chapter 8 for detailed discussion of RFQ and RFP methods). It is expected that, by this point in the process, an RFQ for fabricators has already been conducted and that the final RFP can be sent out to three to five fabricators. As part of the RFP, the CDs are typically provided to ensure solid, detailed information for review and parity between fabricators.

Depending on the size of the exhibition, the bidding work can be a month-long period (or more) so that fabricators have adequate time to comb through all of the documents. If there are any discrepancies in the documents, fabricators will ask for clarification through a request for information (RFI) system, which is a formal procedure for asking salient and detailed questions and receiving responses. The project and team advocate is responsible for managing this procedure. All submitted questions and answers should be shared with all bidders. There must be adequate time expected and allowed for this back-and-forth review by all bid participants to ensure equitable information and consistent bids. After bids are in, the team will need time to evaluate each one.

Engage a minimum of three and maximum of five bid participants to ensure you get accurate, high-quality, competitive bids. Some

institutions ask more than a dozen fabrication companies to bid, but this amount of requests creates problems. First, when the bidders learn there are so many others, they tend not to put forth as much effort because their chances of being awarded the contract are lower. Second, because of receiving, potentially, hundreds of questions from all of these bidders, the project advocate will quickly become overwhelmed and potentially not provide high-quality answers. Third, your institution should be most interested in maintaining its reputation as a place with which vendors want to work. Preparing a bid is a significant, time-consuming and costly task, and vendors are less likely to participate if their chances of success are low.

Finally, the project advocate must be able to manage, compare, and contrast the various bids received. Make sure to do some homework up front to understand the capabilities and capacities of the selected group of bidders. Again, keep your list of bidders short! Fabrication and installation commence once you've chosen the fabricator.

Bidding Questions to Answer

- Is there a reputable and equitable list of fabricators to send packages to and ensure competitive bids?

- Will those fabricators work with the team as fellow collaborators to ensure the project is completed on time and on budget and to the museum's standards?

- Is there a clear critical path for the fabricators to ensure time for the inevitable give-and-take negotiations?

- Does the schedule allow enough time for bidding, fabrication in the shop, and then installation on site?

- Do the graphic designers have shop-drawing measurements to work from for final design and production?

- Has the team's project manager met the fabricator's project team up front before contracts are signed to ensure a solid understanding of the project?

- How will the fabricator deal with change order requests?

- Has the team shared all of the same information with all the bidders so that they are comparing "apples to apples"?

Fabrication

Fabrication is a dynamic process in which the construction ball is set in motion, the physical exhibition literally takes form, and many other components are in varying states of final completion. Work with fabricators as your collaborators. Although the situation is one in which one team has hired the other, even an in-house situation—a fabricator is a working partner. The more input fabricators have early in production planning, the better. Fabrication requires up to several months in the shop, depending on the size of the exhibition (Figure 9.22).

The team must provide fabricators a detailed scope and budget for the project. One of the most notorious problems that fabricators face is "scope creep," a term that means incremental expansion of parameters or addition of elements to a project. Often, it is easy and seemingly innocent to think, "We can just add this one little thing, it's just like that thing and it shouldn't cost anymore." But this is a dangerous and slippery slope for two reasons. First, in essence it is asking to get something for nothing. Labor and materials cost real money; clients should respect the work the fabricators do. If they are good fabricators, they will work with you to get what you want within the budget you've set. Second, the addition of one thing and then another will soon compound into bigger problems, affecting budget and constraining time. The team and institutional advocate must always be mindful of sticking with the job's parameters.

Conversely, the fabricator must be up front about the cost of the project. There are many horror stories of fabricators who "low ball" a bid, because they can see the potential for change orders they can charge for later when they are not in a competitive situation. It is unfair for museums to bear this unexpected burden. While such companies may make a few extra dollars on this project, it will more than likely not lead to further business in the future. Fabricators with these practices quickly gain a bad reputation. The best defense against this practice is a highly detailed bid package that leaves little room for interpretation or substitution.

Figure 9.22: View of a fabrication shop. *Photo courtesy of Palumbo Associates, Inc.*

Once the bid is awarded to a fabricator, construction documents are released to it. The fabricator will review the design intent drawings and create "shop drawings" so it has accurate drawings from which to build. The design advocate and project advocate must have regularly scheduled reviews with the fabricator to ensure that everything is being built to the drawings and intentions of the designer. Approval of shop drawings and other production proofs can begin final fabrication. Also at this point, media consultants will be finishing their production work and going into post-production for multimedia. Visitor and subject matter advocates (developers and curators) must provide final edited and approved labels to graphic designers so that they can complete production prep for fabrication.

Maintain clear and transparent methods of communication. It's a good idea to require that all requests, questions, and answers are handled through email so that the team has written record of details and decisions. When money is involved, you will meet face to face and get sign-off. Phone calls should be used only for clarification of details. It's also smart to utilize specific project management software to ensure the team has access to the most current and complete information, such as a wiki (a collaborative, user-created website for information sharing) to keep everyone in the loop (Figure 9.23).

Other than details of the exhibition, the fabricator must also have assurance that the building is prepped and structurally sound to accept what has been designed. The basic operational procedures of the museum for the delivery of components, the traffic of materials in and out of the exhibition space, and any limitations must be confirmed. The fabricator must take all field measurements and assess these conditions.

With the fabrication of exhibition elements in progress, visitor and subject matter advocates will need to make sure that all the proper advocates, stakeholders, and funders are thanked and invited to opening festivities. They will be involved with education or interpretive staff to create and test programs or work with PR and marketing staff to plan promotional strategies. They will also be planning for a summary evaluation of the exhibition after opening and a subsequent phase of revisions.

Figure 9.23: Project management informational database created in Filemaker Pro. *Courtesy of Jeanne Maier, The Franklin Institute*

Also during this time, visitor advocates continue preparation and production of materials such as gallery guides and programmatic items, as well as training the staff and conducting dress rehearsals for educational programming. All print collateral and promotional material should be developed and designed, such as press kits, teachers' packets, family guides, visitor guides, and the like. Start the marketing buzz so that the press and public are primed for opening day. Billboards and other marketing materials should be designed and set for production, and ideally posted with opening dates well in advance.

Fabrication Questions to Answer

- What are the strategies for efficient and effective communication?
- Who are the point people who will be working on this project?
- What is the critical path to completion?
- What is the detailed schedule? For submissions and responses? And deadlines?
- What is the detailed budget? (after project award, the fabricator should not mind sharing his or her detailed cost estimates)
- How will change orders be handled?

Installation

Installation is a point of convergent activity, as all components of the exhibit come together to be built into the space. It can reach a fever pitch as the opening date looms, and seemingly everything still needs to get done. It will be important to ensure there is *one* designated person to answer all questions and keep a record of decisions. "Too many cooks in the kitchen," as it's said, can be disastrous. This point person is typically the project and team advocate (project manager), and keeps close track of the budget, making sure the all expenditures and committed monies are logged. That way, if (and when) unexpected charges and change orders arise, the project manager knows exactly how much can be reallocated to cover these expenses.

Be sure the space is fully prepped and ready for seamless installation (Figure 9.24). Document and track the schedule and where the team is in the process. As the installation occurs, the team needs to understand what can be finalized by opening, because time often seems to run short. Complete all conservation and object mounts, so you can schedule object installation when the fabricators are gone and space is clean and dust free.

Once the installation is largely complete, design advocates should inspect all aspects of it to determine if anything has been installed incorrectly or is missing, minor damage, or other issues with any component, or other adjustments that may be necessary. These items should be compiled into a "punch list" to review with the fabricator.

Figure 9.24 Installation of the exhibition *On My Honor: 100th Years of Girl Scouting* at the National Constitutional Center. *Image courtesy of Alusiv, Inc.*

The marketing buzz should be in full swing by the time the exhibition is being installed if the press and public are expected to be primed for opening day. For museum visitors during this time, there will be no doubt that a new installation is occurring. So, while the "construction zone" may affect some impediments to the museum, it can also be used as an opportunity to promote the new exhibition in interesting ways. A simple friendly sign "Pardon our

appearance while we are under construction, but soon you'll have access to this amazing new exhibition" speaks volumes.

Installation Questions to Answer

- Does everyone understand the hierarchy of decision making? Is it clear who has the authority to sign off on items?

- Is the base "shell" or space prepped and set for the installation? Is demolition completed? Are all architectural elements finished, such as new partitions (walls), ramps, acoustical, fire treatment, sprinklers, exit signs, window coating, and the like? Is flooring laid? Are walls coated (painted, fabric covered, and so on)? Environmental lighting installed? Is HVAC in position? Are data and electrical cables (and water and air if needed) pulled to correct location for exhibition and media hook up? Has the media been configured and tested in actual space? (Figure 9.25)

- Have ALL field measurements been double-checked by the fabricator? Small measurements compound over a long distance; was the original measurement taken from the edge of the windowsill or the glass? Was the shoe molding calculated into the measurement?

- What sort of trade labor needs to be utilized in the installation space? There are many rules, based on union contracts, where two trades (e.g., general contractors and exhibition fabricators) cannot occupy the same space at the same time. Most trades want to "turn over" the space to the next group so that there is a clear delineation of responsibility.

- Can all of the built components be efficiently transferred from the loading dock to the exhibition space? Will they fit through doors and on freight elevators? It seems obvious, but it's an issue that has tripped up many an exhibition team during installation.

- Are there any special needs for the objects in terms of installation? Do some objects need to be sequenced for installation before others?

Figure 9.25 Ancient nighttime sky projection being configured and installed in exhibition space, *Maya 2012 Lords of Time* at the Penn Museum, Philadelphia, PA. *Photo courtesy of Bluecadet Interactive, Inc.*

- Has the building been prepared with signage and caution tape to ensure that visitors are safe and can find their way through the building if passages are now closed off?
- Have you turned the disruption of construction into a marketing opportunity?

Soft Opening (Beta Testing)

It is a frequent assumption that opening day is the end of the process, but those who work and live in the museum know it is just the beginning. An exhibition schedule must be planned to include a buffer of time—called a "soft opening"—after installation is completed and a punch list has been issued to the fabricator, but before the public is invited into the space. This "soft opening" or beta-testing period is essential so that the team can be fully prepared for opening day. Many museums take full advantage of this time to invite VIP guests, or have a members' event or educator's preview, for an advance tour of the exhibition. This is not only an added bonus of their status or membership, which can be an important sales tool, but it is also an important opportunity to conduct pre-opening evaluation with select groups and determine any last bugs to be resolved.

This is also the time when the PR and marketing departments can conduct press previews, to allow critics in for write-ups to be published for opening day, and to photograph the space for opening promotions. Ensure all of these events are coordinated with the project advocate and do not significantly disrupt the other work still taking place.

Punch List

This term may be familiar from home construction projects. It refers to a list of items that need to be addressed for the project to be completed (e.g., the baseboard molding is missing in one small area, the paint needs to be touched up, etc.). The client or project and phases advocate creates the "punch list" after fabrication and before the opening of the exhibit so that these issues can be resolved.

Opening Day

After you've had sufficient time for beta testing and addressing the punch list items (typically no more than a month depending on the size and scope of project), it's time to cut the ribbon and let the general public through the doors. The opening is a time for celebration, a time to congratulate colleagues and staff for all their hard work and efforts, and a time to party. It is critical to recognize this first major public moment because everyone involved needs the energy of a positive launch to cultivate and nurture the exhibition. Now the true test begins! Opening day is not the end only the beginning (Figure 9.26).

Figure 9.26: Opening event at the Liberty Science Center, Jersey City, NJ. *Photo courtesy of Richard Cress*

Post-Opening: Remediation and Revision

In the words of designer Taizo Miyake, the opening is "not a deadline but a birthday." And although the baby may be beautiful, at some point it will become fussy. Despite the most careful planning, sometimes a device might break down on the very first day! Or initial observation of a visitor experience may reveal something that is not working the way the team had intended. While these things are disappointing, they are to be expected. What to do? Post-opening remediation and revisions can be considered in a couple ways.

First, if the project advocate and team have not planned for work to be done post-opening—and reserved resources of time, money, and energy to do so—the exhibition will not stay fresh and current for long. Having adequate budget dollars beyond the opening day is important to these efforts. Post-opening, you'll need money to address short-term and also longer-term adjustments over the life of the exhibition. The team needs to be prepared to fix and adjust the least expensive and most problematic issues as they are revealed.

TIME + MONEY + ENERGY must be left in reserve for remediation to happen post-opening.

The work of the visitor advocate is never done. The visitor advocate, with the support from the team, must observe issues as visitors spend high-quality time in the exhibition after it is open. Wait to make any big changes until you are able to have a formal summative evaluation done, and then apply reserve funds that have been held for this eventuality.

The project advocate's job is to ensure the team's "finish line" does not coincide with the opening day. It is human nature to maintain a push of effort up until the time the project is deemed "officially done." If the "finish line" date is set for opening day, the team will burn to this date but have little reserve. It is nearly impossible to refresh their energy to the same level to continue work afterward. People are worn out. But if the expectation is set that the "finish" date is sometime after the opening, the team will operate toward that goal.

In more recent practice, many museums have shifted their thinking away from a "highly finished product" model to considering the exhibition as a "living organism" suspended somewhat indefinitely in a prototype state (Figure 9.27).

Rather than spending all the money up front to achieve a highly polished exhibition that still may not fully work as intended, the "living organism" model makes the prototyping process part of the exhibition experience for the visitors. Exhibition elements are developed on the floor with visitor input, rather than in the back of the house to be revealed when complete. This model is not for every institution, and would need the institutional advocate's approval and the team's commitment to make this model work. It also may or may not be more cost efficient, but if conducted right, it does ensure better exhibitions and also provides invaluable professional development and deep learning for the whole team.

Figure 9.27: The Testing Zone is a prototyping lab that functions as both a workspace for staff and an area where visitors are invited to test and provide feedback. *Photo courtesy of The Franklin Institute*

THE POSTPARTUM: EVALUATING, MAINTAINING, EVOLVING, AND DOCUMENTING

Once the glow of opening day has receded, and the day-to-day operation of the exhibition is in gear, there is typically a post-opening review that is often referred to as the "postmortem" discussion. In this sense, the term has been borrowed from the theater industry, but to follow our opening day as "birthday" analogy, we think the postmortem may be better stated as *postpartum*. Although the exhibition is done, we should not be using terminology that implies that it is dead! We should, in fact, be considering the post-opening time as the most creative time of all and take full advantage of ways we can continue to nurture the exhibition.

Summative Evaluation

Summative evaluation is a misunderstood exhibition method. Some people may be afraid of the results, and sometimes the team that created the exhibition is no longer working together. It is frequently perceived to be an obligation (e.g., for grants) rather than a resource for team thinking. It should not be considered a "grade" of success or failure; think of it as an analysis of how and why visitors are experiencing your content and exhibit strategies. It's a great opportunity for institutional learning from your own initiatives. You've spent all this time, money, and creative energy; don't you want to know what you accomplished? Furthermore, your grant writer will gobble up useful information about effective visitor experiences to use in fundraising for future projects. All of that aside, summative or remedial evaluation can reveal things that simple nonstructural tweaks can improve for visitor experiences.

Without a committed project manager initially allowing some budget space for summative evaluation, money for it will likely be spent long before the exhibition is complete. Plan for it at the beginning. Designing a summative evaluation is the same as our discussion of evaluation process earlier in this chapter: identify your key issue(s) and other tough questions, choose one or more appropriate research methods, be guided by a specialist, get team members involved, thoroughly analyze the results, and think about implications (for this exhibition as well as future ones).

Maintaining and Evolving

We have discussed remediating the exhibition post-opening, but you will also need to be concerned with the maintenance and evolution of the exhibition. Your exhibit will require continuous nurturing in order to keep up with contemporary audiences in an ever-changing society. Having a plan from the start about who will maintain the exhibition and how they will do it will save so many headaches for all advocates and the entire institution. All the energy and efforts put into the creation of the exhibition cannot be negated by having no plan to keep it working and viable for visitors. The process and team advocate should have a maintenance plan as part of his or her deliverables and more importantly money built into the museums operation budget to cover the costs associated with upkeep.

Example: One smart example of maintenance planning is the Fairmont Water Works Interpretive Center in Philadelphia. Located literally on the river in a building where water was expected to flood the space

several times a year, they needed to plan their exhibitions to be completely submerged in river water. During initial exhibition planning, design and multimedia developers took these criteria seriously. All the exhibitions have been built so that they do not corrode and can take the impact of debris that might float in. The true cleverness is with multimedia system that is either on a winch system or key-lock quick disconnect so that monitors and electronics can be easily hoisted or removed from harm's way within 20 minutes from when they get word of a flood coming from upstream. Additionally, the media group has all devices monitored remotely at central office so that if any interactives go down they can quickly get them back up and working. Forward-thinking ideas like this are invaluable to organizations like this who want to have updatable multimedia interactives but face challenges in maintaining them (Figure 9.28).

Figure 9.28: The Fairmount Water Works Interpretive Center, as a renovated facility on the river, actually floods more than 6 feet in some parts of the building. The red winch on the wall controls a hoist allowing the staff to raise the flat screen monitor to a safer height when flood warnings are initiated; staff can also easily remove touch screens from the face of the reading rails. *Photo courtesy of Richard Cress*

Anecdote

A noninteractive object-based museum called one day to ask, "Hey, everyone has these great interactives in their museums. We need to get with the times, so we need to design and install some of these; we have some money, can you help us?" I responded, "Sure let's start with your maintenance plan and staff who will be in charge of keeping the devices working." The person quickly hung up. That was the best guidance anyone could have given. Be aware of what you can maintain, both financially and in terms of expertise, *before* you build and install it!

The public can get the most up-to-date information on most subjects instantaneously. Not only that, but changes in cutting-edge technology, a new understanding or practice can make certain exhibitions obsolete in short order. Many of the newest museums and exhibitions have addressed this problem by installing technologies that allow for more instant updating of information. A few museums, such as the Newseum in Washington, DC, successfully update traditional ink jet vinyl graphic signage on a daily basis using new technology. As always, the way to stay ahead of the curve starts by dedicating staff and funding resources up front, and planning the chain of responsibility for updating and keeping the exhibition fresh after its opening.

Example: Newseum, Washington, DC

The Newseum is a museum dedicated to the news and media, and its core mission is to provide the most current and up-to-date information to visitors. Labels and graphics are adjusted and reinstalled whenever there is an update to a story. One of the ways it provides the latest news is the installation of front pages from major newspapers all over the globe every morning in front of the building. When an important story hits—for example, President Barack Obama being reelected—many viewers gather in front of the museum to see how the story was covered in different parts of the world (Figure 9.29).

Figure 9.29: Front of the Newseum building with daily installation of front pages from major newspapers all over the globe. *Photo courtesy of Polly McKenna-Cress*

Example: Science Museum of Minnesota's (SMM) *Science Buzz* (www.sciencebuzz.org)

"Science Buzz blends up-to-the-minute science news with interactive experiences, object-based displays, science activities, games, resources, and community perspectives and opinions."[1] As a way to ensure their science content is current and relevant, the SMM installed an exhibition station in the museum as well as access online to the most current issues, questions, and interesting facts that relate to their mission and exhibitions in the museum. So topics might include information on "quackery" based on the fact that SMM houses the collections from Bob McCoy's *Museum of Questionable Medical Devices.*

Documentation

As part of a continuing maintenance plan, it important for those who need to fix or rework exhibition elements to know how they were originally made, with what materials and specifications in order to maintain cohesion. It is no fun to try to repaint a "white" wall with eight different shades that never match, or fit a larger replacement device into a small hole. Accurate and accessible documentation is the key.

Documentation should include, but is not limited to: as-built drawings, paint specs, final collections list, photo rights bible, maintenance manual, collections rotation schedule, final costs (including staff time), relamping schedules, cut sheets for parts, summative evaluation, and revisions plan (Figure 9.30).

Who built what, where was the data line pulled from, are there warranties on elements or devices? If parts and electronics will eventually need replacing, documentation will have locations to find replacements (although the hope is that there were several purchased in original order!).

It is important for the collections manager to have documentation of *object rotation*, which is the record of when objects on loan must be returned to the loaning museum or individuals.

1 www.smm.org/visit/buzz

Figure 9.30: Sample page spread from a "maintenance bible" for the crew in charge of maintaining the exhibition. The bible contains detailed reference information needed for color, material, and hardware specs; installation guidelines; replacement parts; manufacturer order info; and contractual info such as warranties. *Image courtesy of Palumbo Associates, Inc.*

Accessibility of the documentation is as important as the documentation is itself. Information on the exhibition should be clearly organized and stored convenient forms, whether physical or electronic.

Lastly, documentation provides helpful influence for more people beyond the life of the exhibition. Everyone works so hard on these exhibitions it is critical to have a record as legacy. It should also be a record that helps future exhibition teams reflect on both successes and failures and so they can benefit from shared knowledge versus reinventing the wheel. Documenting failure might sound like a foolish proposition, "We don't want people to know we blew it!" But documenting when things go wrong is actually much more helpful to the team and to others to really learn and grow. Failure teaches you everything whereas success makes you feel good.

If you're not failing every now and again, it's a sign you're not doing anything very innovative.

– Woody Allen

Success is going from failure to failure without losing your enthusiasm.

—Abraham Lincoln

EXHIBITION CLOSING

Eventually the "fat lady does sing"; the whole grand production is over, and the exhibition has run its course. Although the exhibition was beautifully maintained and updated, the time will come to make room for the new. In the past, exhibitions took so many years to produce that it was several decades before the museum had the money or time to do it all over again. Now exhibitions are a much more dynamic medium and change more frequently to stay viable for ever-changing audiences and latest and greatest technology.

But there is something to be said for installations and exhibitions that maintain some classic tradition. To be sustainable, we have to consider repurposing those things that are still viable, for example, the diorama, and not necessarily leap into tearing them down and rebuilding them. If the thinking and interpretation stays fresh and meaningful, destroying installations just for the sake of change does not seem wise, environmentally conscious, or the best use of funds.

Always remember, exhibitions are not only about some*thing* but for some*one* and should be planned deliberately, created collaboratively, and advocate for diverse ideas, people, and communities.

INDEX